By Any
Other Name

By Any Other Name

A Cultural History of the Rose

Simon Morley

A Oneworld Book

First published by Oneworld Publications in 2021

Copyright © Simon Morley 2021

The moral right of Simon Morley to be identified as the Author of this work has been asserted by him in accordance with the Copyright, Designs, and Patents Act 1988

All rights reserved
Copyright under Berne Convention
A CIP record for this title is available from the British Library

ISBN 978-0-86154-052-5
eISBN 978-0-86154-054-9

'Roses' and 'Bowl of Roses' © David Need, reproduced from *Roses: From the Late French Poetry of Rainer Maria Rilke* with the kind permission of David Need and Horse & Buggy Press.

Illustration credits: Nightingale and Rose, Pompeii © Accademia Italiana, London / Bridgeman Images; Sandro Botticelli 'The Virgin Adoring the Sleeping Christ Child' © classicpaintings / Alamy Stock Photo; Agnolo Bronzino 'Allegory with Venus and Cupid' © Ian Dagnall / Alamy Stock Photo; Jean Marc-Nattier 'Manon Balletti' © Album / Alamy Stock Photo; Hilye of the Prophet Mohammad © The Picture Art Collection / Alamy Stock Photo; William Blake 'The Sick Rose' © The Picture Art Collection / Alamy Stock Photo; The Lover and the Rose (Harley 4425, f. 184v) courtesy of the British Library, Jan Davidz. de Heem 'A Vanitas Still-life' courtesy of Nationalmuseum, Sweden; 'Dat Rosa mel Apibus' courtesy of Wikimedia Commons; Pierre-Joseph Redouté 'Rosa Canina' courtesy of the Library of Congress; Parks' Yellow Tea-Scented China © RHS Lindley Collections; Dante Gabriel Rossetti 'Lady Lilith' and Vincent van Gogh 'Roses' courtesy of the Metropolitan Museum of Art; Edward Burne Jones 'The Briar Rose' © The Faringdon Collection Trust; Tyne Cot Cemetery, Belgium by Robyn Mack is licensed under CCBY2.0; Mottisfont Rose Garden © Jonny Norton; Gertrude Jekyll Rose © David Austin Roses; Rose Harvest in Kashan by Mostafa Meraji is licensed under CCBY4.0; Cy Twombly 'Roses V' © Cy Twombly Foundation; Dries van Noten Winter Collection © Dries van Noten

Typeset by Hewer Text UK Ltd, Edinburgh
Printed and bound in Great Britain by Clays Ltd, Elcograf S.p.A.

Oneworld Publications
10 Bloomsbury Street
London WC1B 3SR
England

Stay up to date with the latest books, special offers, and exclusive content from Oneworld with our newsletter

Sign up on our website
oneworld-publications.com

Contents

Preface		vii
INTRODUCTION	'A rose by any other name'	1
ONE	'*Rosa*': MEETING THE FAMILY	13
TWO	'There are many kindes of roses': LIVING WITH THE SPECIES AND THE 'SPORTS'	23
THREE	'Then bring me showers of roses, bring' PAGAN ROSES	43
FOUR	'Rose Without Thorns' MONOTHEISTIC ROSES	56
FIVE	'And so I won my bright red rose' LOVE AND THE ROSE	73
SIX	'Gather ye rosebuds while ye may' DEATH AND THE ROSE	83
SEVEN	'*Dat Rosa Mel Apibus*': MYSTICAL ROSES	95
EIGHT	'Oh Rose! Who dares to name thee?': POETIC ROSES OF THE NINETEENTH CENTURY	105
NINE	'A Basket of Roses': PAINTED ROSES	119
TEN	'Parks' Yellow Tea-Scented China' EASTERN ROSES GO WEST	135
ELEVEN	'Pedigree Hybrids of the Tea Rose' MODERN ROSES	147

TWELVE	'The perfect rose is only a running flame' MODERNIST ROSES	163
THIRTEEN	'What is the heart's goal when looking at the garden World?': ROSE-GARDENS AND GARDENING	181
FOURTEEN	'Rose N'Roses': THE ROSE BUSINESS	207
FIFTEEN	'Silronzem Rosea': THE ROSE, TODAY AND TOMORROW	225
CONCLUSION	'Flower Power'	243

Notes — 249
Acknowledgements — 279
Index — 281

Preface

'Man hands on misery to man', writes the English poet Philip Larkin with stoic resignation.[1] But man also hands on pleasure, love, beauty, compassion, enchantment and hope and, to these propitious ends, flowers have proved to be steadfast allies for thousands of years.

But of all the flowers, it is the rose that has been most often co-opted to 'whisper of peace, and truth, and friendliness unquell'd'.[2] The rose has helped create atmospheres conducive to the heart, and gives beautiful material form to the tenderer dimensions of our lives. As a gift, a symbol, a focus of aesthetic attention, a medicine, a distilled oil, a perfume, a culinary ingredient and as a plant lovingly cared for and cultivated, the rose has participated in social transactions that help establish, nurture and sometimes commemorate relationships between the living, the dead, the divine and the everyday.

Today, the rose is the world's favourite flower. It is no exaggeration to say that at least in the Western world, roses may be one of the very first things a newborn baby sees, so common a gift is it for new mothers. From there, roses will enter our lives in many guises – homegrown, foreign, painted, sartorial, aromatic, imaginary. In fact, roses are likely to be present at many of the most important moments in your life: births, birthdays, courtships, intimate dinners, weddings, anniversaries, funerals.

The US adopted the rose as its official national flower as recently as 1986 during the Reagan administration when a powerful pro-rose lobby won out against the botanical competition which included the marigold, dogwood, carnation and sunflower. This statement, in support, says much about the ubiquity of the rose today:

> They grow in every state, including Alaska and Hawaii. Fossils show they have been native of America for millions of years. The only flower

recognized by virtually every American is the Rose. The name is easy to say and recognizable in all western languages. It is one of the few flowers in bloom from spring until frost. It has exquisite colors, aesthetic form, and a delightful fragrance. Growth is versatile, from miniatures a few inches high to extensive climbers. Roses mature quickly and live long. They add value to property at minimal expense. The range of varieties is such that there are roses to suit everyone. As no other flower, the rose carries its own message symbolizing love, respect, and courage.[3]

The iconic American hippy rock band Grateful Dead had a penchant for roses, and would no doubt have agreed with this accolade. The cover of their second album, released in 1971, shows a drawing of a skull garlanded with red roses, lifted and adapted from an illustration in an early translation of the Sufi classic, the *Rubaiyat of Omar Khayyam*.[4] We will be encountering the Sufis and their roses on several occasions in this book. 'I've got this one spirit that's laying roses on me,' said band member and lyricist Robert Hunter. 'Roses, roses, can't get enough of those bloody roses. There is no better allegory for life, dare I say it, than roses.'[5] Grateful Dead and the United States' government didn't agree on very much, but they seem to have agreed on this.

My personal fascination with the 'Queen of Flowers' began one gloomy afternoon in London in November 2003 while I was walking home from the Tube and feeling sorry for myself. Suddenly, and for what seemed like the very first time, I noticed how many of the small front gardens of the terraced houses I passed every day had roses growing in them. I was especially struck by the fact that many of these rose bushes were still in bloom even in late autumn.

The discovery of colourful November roses cheered and inspired, and from that moment I started paying closer attention to roses. Soon after, I planted my first rose bushes in my east London garden: 'Peace' and 'Zéphirine Drouhin'. I also began to study the history of the rose in

earnest. When we moved to central France in 2005, I set about planting a very modest 'history of the rose' garden there, focusing on nineteenth- and mid-twentieth-century hybrids, but also including, at one extreme, wild species roses, and at the other, contemporary 'English Roses'. Since 2010, I have lived much of the year in the Republic of Korea, where I teach at a university. Here too, I grow roses. But I also regularly return to our house in France and, with help, manage to take care of and develop the garden. I'm certainly lucky that, on the whole, roses seem to thrive on neglect.

By Any Other Name is not written by a botanist, horticulturalist, or an especially devout gardener. My professional background is fine art and art history. But an avid interest in the status of the rose as both a beautiful plant and a cultural icon has compelled me to write about it. This book, therefore, is the result of intellectual curiosity about the rose's hold on our psyche, combined with my emotional responses to the arresting presence of roses in our gardens and parks, and my experience of growing them. It is also founded on the belief that exploring this subject will illuminate much more than simply the 'Queen of Flowers'.

INTRODUCTION

Juliet: "What's in a name? That which we call a rose / By any other name would smell as sweet."

William Shakespeare, *Romeo and Juliet*[1]

In May 1912, the twenty-five-year-old English poet Rupert Brooke was sitting in the Café des Westens in Berlin, missing home, and composing a poem that would become one of his best loved: 'The Old Vicarage, Grantchester'. In the poem, Brooke uses the tulip and the rose as metaphors for national character. The conformist Germans, he declares, live in a society where 'tulips bloom as they are told', while in his own homeland, 'Unkempt about those hedges blows / An English unofficial rose'.[2]

Earlier that same year, in Lawrence, Massachusetts, a strike of female textile workers became known as the 'Bread and Roses strike'. Not long before, the American women's suffrage activist Helen Todd had made an inspiring speech in which she declared: 'woman is the mothering element in the world and her vote will go toward helping forward the time when life's Bread, which is home, shelter and security, and the Roses of life, music, education, nature and books, shall be the heritage of every child that is born in the country, in the government of which she has a voice'. The phrase 'bread and roses' quickly became a rallying cry for those advocating for women's and workers' rights, and went on to inspire both a poem and a popular song.[3]

Soon after the First World War, in which Rupert Brooke died, Ernst Jünger, a citizen of the land he derided and against whom the war had primarily been fought, also appropriated the rose. But to very different ends. In *Storm of Steel*, Jünger's memoir of fighting on the Western Front, published in 1920, he reflects on the restless spirit that made young men like him (and Brooke) so eager to go off to war, and to exalt in death. 'Grown up in an age of security,' wrote Jünger, 'we shared a yearning for danger, for the experience of the extraordinary. We were enraptured by war. We had set out in a rain of flowers, in a drunken atmosphere of blood and roses.'[4]

Also, in 1920, the French rose breeder Joseph Pernet-Ducher, the 'Wizard of Lyon', marketed a rose called 'Souvenir de Claudius Pernet'. It was a floral memorial to Pernet-Ducher's eldest son, who died fighting the Germans, and in the early 1920s must have stood for much more than just the memory of one rosarian's dead son. But in the event, this particular rose would have an impact well beyond the usual new rose, because 'Souvenir de Claudius Pernet' became one of the parents of the most important rose of the second half of the twentieth century – the yellow Hybrid Tea called in France 'Madame A. Meilland', in the homeland of Ernst Jünger 'Gloria Dei', and in Britain and the United States, 'Peace'.

These early-twentieth-century people clearly belonged to a culture in which the rose had a powerful, resonant presence. For Rupert Brooke, the juxtaposition of a wild rose with the domesticated tulip became a way to evoke the differences between a nation that permits Romantic rebellion and encourages individualistic liberty and one that he believed imposed social conformity. For Helen Todd, struggling for the rights of working-class women in the United States, the domesticated garden and cut roses were adopted as well-established symbols of the kinder, more pleasurable and sophisticated rewards of life which were being denied the workers. For Ernst Jünger, these same cultivated roses, filtered through a rich corpus of poetry and art, were emblematic of the heady union between romance and violence that fed the myth of heroic martyrdom, an indication that the rose sometimes blossoms close to the dark and dangerous origins of our social values.

For Pernet-Ducher, in stark contrast, roses were a livelihood, plants that were the result of thousands of years of co-evolutionary development with humanity, and which in Pernet-Ducher's time had become the flowers of choice in gardens large and small across the Western world, an indispensable sartorial accessory for ladies and gentlemen, as well as a mainstay of poetry, art and design.

A poet sees a metaphor, a social reformer a symbol of the good life, a rose breeder a cash-crop, a lover his beloved, a scientist an endangered ecological habitat, a writer a limitless subject for his book. What we see depends on our individual, professional and communal perspectives, and also on unconscious influences exerted by our upbringing. Once the rose becomes cultural, it ceases to be just a beautiful plant; it can never be divorced from some kind of ideology. In cultural terms, we will always be considering a *pagan* rose, a *Christian* rose, an *Islamic* rose, a *mystical* rose, an *alchemical* rose, a *national* rose, a *capitalist* rose, a *patriarchal* rose and, most recently, a *Westernizing* rose.

The rose family is native to the entire temperate regions of the northern hemisphere, and when our ancestors first migrated tens of thousands of years ago from Africa to environments located between the Tropic of Cancer and the 60th Parallel north, they also began living alongside roses. Eventually, the active domestication of roses, along with other plants, was first undertaken in two regions – China and the Fertile Triangle (which today includes Iraq, Syria, Lebanon, Israel, Palestine, Jordan, the northeast and Nile valley regions of Egypt, the southeastern region of Turkey and the western part of Iran). Here, within relatively complex societies which prospered through the use of irrigation agriculture, and that were characterized by social stratification and advanced record-keeping skills, there evolved a 'culture of flowers'.[5]

Most especially in the Fertile Triangle, the rose became intimately involved with key social values. The earliest references to domesticated roses are from 2200 BC in Sumeria, a Mesopotamian civilization

situated between the Tigris and Euphrates rivers. Gradually, cross-cultural interactions led to the spread of both the rose plant and the evolving symbolism associated with it across far flung geographical regions. Love of the rose spread westwards, first to ancient Greece, then to Rome. A tablet excavated in Pylos on the Peloponnesian peninsula, likely from the thirteenth century BC, mentions aromatized oils that include rose extract. The Greeks encountered roses in a wide variety of contexts, and incorporated them into their social practices and, over time, in a feedback loop, individual and communal ties were established and reinforced. The Romans largely seemed to have imitated the Greeks, but they added some features of their own to the romance with the rose, and as their empire expanded, the rose went with them. Much later, after an initial campaign against the paganism of the 'culture of flowers', the Roman Catholic Church embraced the rose, and eventually it took on other significances within secular modern society.

We can trace the spread of the rose as a plant of special interest to humanity by studying the origins of the words that different cultures have evolved to describe it. Nowadays, the English and French languages share the same word, *rose*. Italian and Spanish have *rosa*. In German, it is *rosen*, in Russian, *роза* (*roza*). All these words are rooted in the Latin *rosa*, which in its turn derives from the Greek *rhódon* (so an expert in roses is called a 'rhodologist'). In Arabic it is *warda*, in modern Persian, *gol*, and in Turkish, *gül*, which all also mean more generally 'flower', a sign of the rose's pre-eminence within the cultures of the Near East. The spread of Islamic culture ensured the growth of more etymological branches. In India, for example, the Hindi word for rose is *gulab*, a borrowing from the Persian, and an indication that the adoption of the rose within Indian culture was largely due to the Mughals, Muslim invaders from Central Asia who brought the love of the rose within Islam with them when they invaded the region. The direct linguistic origins of all these non-European words is also, probably, the Greek word *rhódon*, which may have evolved from the Old Persian *wrd-* (*wurdi*), which is linked etymologically to the Parthian *wâr* (the

Parthian empire covered the region of what is now Iran and Iraq from the end of the BCs to the beginning of the Christian era). Then again, some etymologies find the roots of the Greek word in *vardhos*, one of the Aryan dialects of the Middle East, in which case it derives from the name of thorn bushes in general.

In many of the etymologies stemming from the Greek, although not in Arabic, Persian, Turkish and Hindi, the same word is used to signify both a plant *and* a colour. English is the major exception of all the European languages, as we normally say 'pink' for the colour, not 'rose', although this is in fact a surprisingly recent secession, dating from the eighteenth century. The standard homonym linking a specific area of the colour spectrum and a specific family of plants reminds us that traditionally the rose was considered in Europe to be primarily a pale red flower, and that long ago a link was established between one area of the colour spectrum and one particular flower. Along with this colour, came specific feelings and associations. So, when Homer in the *Iliad* talks of the 'rosy-fingered dawn', and Edith Piaf in the middle of the twentieth century sings of '*la vie en rose*', in both cases a plant and a colour are being simultaneously evoked. Homer makes an analogy with a natural phenomenon, and Piaf with the unrealistic state of mind associated with being in love.[6] This colour-plant link is still maintained in English to some extent; for example, when we say a sunset has 'rosy' hues, or use the phrase 'rose-tinted glasses'. If you want to make a clear distinction between a colour and a plant in French, for example, you say *un rosier* for the plant, but for the flower it is still *une rose*, just as the colour is *rose*.

This complex etymological tree reveals that cultural awareness of a group of plants characterized by mostly light-red-coloured flowers, prickles and hips (fruit), first emerged in the Fertile Triangle, and spread westwards. But there are other, independent, etymologies and histories to consider. In China, which was another important centre for the domestication of flowers, wild roses were traditionally called either *qiangwei* or *meigui*, and perpetual or repeat-flowering roses were *yueji-hua*. Nowadays, all flowers from the genus *Rosa* are named *meigui*. In

Japanese, a rose flower or flowers is *baranohana*, or today also often *rozu*, a loan-word from English. In Korean, the rose is called *jangmi*, a borrowing from the Chinese. The rose is also native to other regions – North America, for example. The Anishinaabe or Algonquin tribal peoples, whose culture once stretched from Minnesota to Maine, and Indiana to Hudson Bay, Ontario, referred to the *Oginiiminagaawanzh* (pronounced *o-ginee-mina-gaw-wunzh*), meaning 'Mother Fruit from a Small Bush', a term that encompasses several different indigenous rose species, and draws special attention not to the plant's flowers but to the shared property of usefully edible hips.[7]

Today, scientific descriptions of the various members of the rose family use the system of binomial nomenclature invented in the eighteenth century by the Swedish botanist Carl Linnaeus, in which plants are described by, usually, two Latin words, one denoting the genus, the other the species. So, the species rose known in English as the Dog Rose (or dogrose) is designated botanically as *Rosa canina*, or simply *R. canina* (*canina* is Latin for 'dog'). A further classificatory level is sometimes involved when several roses of the same group have different characteristics but are still botanically of the same line. In the Damask Rose group, for example, there are varieties called *Rosa damascena semperflorens* and *Rosa damascena bifera*.

Before Linnaeus, however, several of the plants referred to now collectively as 'roses' might not have carried the same generic name. For the ancient Greeks, what botany calls *Rosa canina*, and the English-speaking world the Dog Rose, was known as *cynosbatos*. It was only the domesticated roses, such as the Gallicas, that were referred to as *rhóda* – 'roses'. In Shakespeare's time, the Dog Rose and other wild roses were commonly called 'briars', 'briers', or 'canker-blooms', and the word 'rose' tended to refer only to domesticated garden varieties. In other words, prior to Linnaeus, a major form of classification was to distinguish between those thorny flowers which humans for one reason or another had chosen to domesticate, and those they had not. The former were called 'roses', and cherished, the latter were something else.

In fact, historically speaking the difference between the 'domesticated' and the 'wild' was of paramount importance in determining the value given to the non-human world in general. When we dedicate our time and effort to a specific rose, or indeed anything non-human, we are, in a sense, 'imprinting' human culture on it. In Sonnet 54, Shakespeare makes a distinction between the garden roses, like the Damask, and the canker-blooms, like the wild hedgerow Dog Roses, which 'live unwoo'd and unrespected fade, / Die to themselves.' Because we attend to and care for the 'sweet roses' that grow in our gardens, they outlive their 'show' within our imagination and memory – within culture: 'Of their sweet deaths are sweetest odours made.' Antione de Saint-Exupéry makes a similar point in his famous fable *The Little Prince* (1943), but shifts the emphasis from collective to personal value. As the Little Prince learns from the fox, compared to his own special rose, all the other roses 'are beautiful but you are empty', and what makes his rose unique is that 'she is the one I have watered . . . And it is for her that I have killed the caterpillars . . . And it is she I have listened to complaining or boasting or sometimes remaining silent.'[8]

Because of the special attention lavished upon them, domesticated roses often end up with several aliases, depending on where they grow and who is naming them. For example, in Shakespeare's time an important rose known today as *Rosa gallica officinalis*, had several aliases in the English language: Apothecary's Rose (*officinalis* means 'apothecary'), Gallica Rose, Gallic Rose, French Rose, or Provins Rose, these other names referring to the rose's close association with France, and in particular with the town of Provins, where they were cultivated as a cash-crop. In Persia, the Damask Rose was and still is often called the the *Gol-e-Mohammadi* – Mohammadi Rose (Muhammad's Rose) – and in Levantine Arabic it is *al-warda*, while in Europe it is often known as the 'Rose of Castile'. As mentioned above, newer roses can have more than one name; the rose called 'Peace' in the UK and US is known in France as 'Madame A. Meilland'.

The philosopher and novelist Umberto Eco called his celebrated novel *The Name of the Rose* (1980) knowing full well that the title could have any number of interpretations. In the novel's Postscript, Eco noted that the word 'rose' conjures up such a multitude of different meanings that it fruitfully 'disoriented the reader, who was unable to choose just one interpretation'.[9] In the academic world, Eco is primarily known as a champion of 'unlimited semiosis', that is, for celebrating the fluid meanings of the signs and symbols we use. He chose the rose precisely because it could mean so many different things and thereby opened up greater freedom of interpretation. The last line of Eco's novel is the Latin couplet: *Stat rosa pristina nomine; nomina nuda tenemus* ('Yesterday's rose endures in its name; we hold empty names'), a phrase that the medieval protagonists in the story would have understood as making reference to the impermanence of life. But for Eco, the emptiness is meant to be semiotic, a reflection of the fact that the rose can mean more or less anything. Or nothing. For, as we will see, the condition of 'unlimited semiosis' – of the rose meaning so many different things – clearly also has less positive and liberating connotations.

Ultimately, all the various cultural associations the rose has accumulated over the centuries are grounded in human encounters with its natural beauty. A fragment once attributed to the Greek poet Sappho, who died around 580 BC, translated here by the Victorian poet Elizabeth Barrett Browning, confirms the rose's pre-eminence in relation to beauty for the ancient Greeks, but even more so for the Victorian English:

> If Zeus chose us a King of the flowers in his mirth,
> He would call to the rose, and would royally crown it;
> For the rose, ho, the rose! is the grace of the earth,
> Is the light of the plants that are growing upon it!
> For the rose, ho, the rose! is the eye of the flowers,
> Is the blush of the meadows that feel themselves fair,
> Is the lightning of beauty that strikes through the bowers
> On pale lovers that sit in the glow unaware.[10]

But while recognizing and celebrating the central importance of humanity's relationship with the rose, it is important not to lose sight of the fact that in this story we will often be confronting what seem to us, the people of the present, the unacceptable prejudices of the past. So, for example, while historically men are compared to strong and clever animals like lions or foxes, women are likened to pretty plants like the rose. Behind such analogies lie specific cultural ideas about roles and status. Also, as we will see, the symbolic meanings attached to the rose often reflect the sexual obsessions and insecurities of men down the ages. Furthermore, we need to take into account the fact that even something as seemingly innocuous as a rose can be deployed as a tool of aggressive cultural expansionism. The rose may be today the world's favourite flower, but this has much to do with the fact that historically it is a flower of significant symbolic and horticultural importance primarily in the West, and that alongside Western power, this cultural value has been exported and imitated globally over the past one hundred years.[11]

When seen as a cultural sign the rose can be described as a very potent pattern of information that has been replicating prolifically in human memory, and more in some cultures than others. The rose in this sense is what the evolutionary biologist Richard Dawkins terms a 'meme'.[12] These days, we are familiar with this word thanks to its use to describe the contagious sharing of attention-grabbing data over the internet. But in a deeper sense, a meme is how a culture's ideas and beliefs get perpetuated in ways that are similar to how the gene is involved in biological natural selection. As patterns of information, a meme replicates across the memories of individuals largely because people imitate each other. It travels down through the generations, and within societies in the present day, thereby helping to bring social unity. Some memes prove more successful than others, and as a result they will spread and grow through a process of contagion or imitation, replicating prolifically. The less successful die out. All a meme needs to survive and spread is sufficiently robust cultural attributes that give it an advantage over other memes. In this sense, a meme takes on a life of its

own. Dawkins also coined the term 'memeplex' to describe cultural formations in which a number of compatible memes consolidate in mutual support to become a more powerfully effective cultural force, one which can, as a result, outperform other less powerful memes. We can call the rose a powerful amalgam of memes, a very successful memeplex that has evolved or copied itself by adapting to new cultural conditions, building in protections for different aspects of the memeplex, while always remaining connected in the human mind as a significant pattern of information.

This rose memeplex has proven especially useful in giving tangible form to the subjective qualities of sensation and emotion, to abstract concepts related to our tenderest feelings, aspects of human life that cannot be 'grasped' or easily 'seen'. We use something tangible and familiar that is accessible to the senses to give them comprehensible and communicable structure. But just like a gene, the rose meme is 'selfish', in the sense that its goal is replication or self-propagation. Some aspects of the rose memeplex are inspiring, some are useful, some are neutral, and some are even actively harmful. When the rose helps us express our genuine feelings of love for someone, this is certainly an inspiring and useful meme. When roses decorate a room, they are probably best described as 'neutral'. But sometimes roses can be involved in fraudulence and falsity. In and of itself, the rose memeplex's only goal is to pass itself on, to replicate.

Any self-proclaimed cultural history of this special plant must be ready to engage with the notion of 'culture' in the two senses defined by the Merriam-Webster Dictionary: 'the customary beliefs, social forms, and material traits of a racial, religious, or social group', and also 'the act or process of cultivating living material'. When approached as a plant the rose is primarily something of interest to the botanist and gardener, and related to the various meanings given to the care and cultivation of the natural world, and to the practical and economic considerations that

arise from this attention. Engaging with the rose as a plant means recognizing its dependency on the soil, the elements and, often, the imperfect regard of concerned humans. We will then be interested in the ecologically and biologically particular, which is determined by time and characterized by uncertainty, and this has the effect of rooting us in the earth and keeping us in contact with the tangible.

Crucial to the story of this organic rose is the fact that before the second half of the nineteenth century, as the British horticulturalist Jack Harkness writes, 'nearly all European roses flowered for a few weeks like the cherry, the lilac, the hawthorn, the apple and the broom.' But then, in the late nineteenth century, 'the miracle of flowering again and again made the rose a very special plant.'[13] For, in what often seems like an obsessive quest for a 'master race' of marketable roses, breeders created rose plants that would be significantly different from (what they saw as an 'improvement' upon) the roses of the past. In practice this meant that, equipped with the scientific knowledge that allowed for a more reliable outcome, and encouraged by very favourable market forces, modern rose breeders aimed to take the best characteristics of the roses traditionally native to Europe and the Near East and blend them with the roses of China. The result of such dedicated attention is the dominant roses of today; recent, humanly engineered mutations, the products of artificial selection. They are very different from the roses Shakespeare must have had in mind when he imagined Juliet likening Romeo to one. The word Shakespeare used is the same we use, and symbolically speaking the associations it conjures up remain closely allied with those of Shakespeare's time. But the plant is very different. In fact, the roses of today are even significantly different from the ones our four representative voices from the beginning of the twentieth century would have known. So the impact on the physical nature of the rose of this sustained human interest cannot be underestimated. Roses are thoroughly 'people plants', in the sense that many of them are wholly intertwined with human interests and values.

In thinking today about how the rose might continue to replicate and reinvent itself, we must also consider how humanity's relationship with it is being changed in the light of the current ecological crisis. Once upon a time, human historical narratives (traditionally narrowed to the stories told by and about powerful male humans) were characterized by overt or implicit praise of humanity's uniqueness, superiority and essentially benign role. We could claim to be custodians of God's creation, or of Earth's bounty. But today in the Anthropocene, we have become painfully aware of the devastating effects humanity is having on the Earth's ecosystem, and especially of how the failure to address the crisis will impact on future generations. The logic of the techno-scientific system – the domination of fauna and flora, but also other peoples and cultures – has increasingly set humanity at odds with nature. But this tacit assumption of our superiority to the rest of the natural world is being profoundly challenged, and while the exceptional character of the human 'animal' when compared to all the others, even our closest mammalian relatives, is beyond question, we are now coming to terms with the realization that in the not too distant future we might become extinct along with millions of other organisms, and that this collective demise to a significant extent will be due to our monumental stupidity. Seen from a non-anthropocentric perspective, and from the midst of today's ecological crisis, human 'reason', perverted into a rigid and nature-abhorring 'rationalism', looks worryingly malign.

You might think that this tragic situation, and the soul-searching it makes necessary, need not trouble us while considering something as innocuous as the cultural history of the rose. But it seems obvious to me that if we are to do the rose full justice, it needs to be seen within this wider contemporary context of ecological crisis, just as we must consider the history of the rose in relation to the perceived prejudices of the past, and not simply as a delightfully coloured and sweetly scented escape from these realities.

ONE

'Rosa'

MEETING THE FAMILY

The longest living rose is thought to be one thousand years old. It is the species *Rosa canina*, and it climbs up the wall of the apse of the Cathedral of Hildesheim in northern Germany, where, like all *Rosa canina*, for a couple of weeks in the spring it produces a profusion of pale pink, five-petalled, flowers. The rose at Hildesheim was recorded in 815, when the cathedral was founded, which means it must already have been growing there before the structure from that period was erected, and was deliberately preserved by the builders. A fire destroyed most of this building in 1046, and the rose survived that setback. The most dangerous period of its life was quite recent, however, and again had nothing to do with old age or any of the natural enemies of the rose. In March 1945 the cathedral was completely destroyed by Allied bombing and fire, but after the war, when rebuilding began, it was discovered that the rose was still growing amid the rubble from the suckering roots which survived the conflagration. Therefore, despite the rose's substantial size today, it is actually only the growth of seventy or so years we can see.

Why is a rose called a 'dog'? One theory is because of an ancient belief that the root of one form cures the bite of a rabid dog. Another theory draws attention to the shape of the prickles, which bring to mind canine fangs. But to the people who built Hildesheim Cathedral the plant growing up the wall was probably called something completely different. Today in German, a Dog Rose is often called simply a *Heckenrose* – Hedge Rose.[1]

This impressive, dare I say, 'dogged' rose is clearly an exemplary model of adaption and longevity under extreme circumstances. From birth, it has been surrounded by all the insects and herbivorous animals that want to eat it, and numerous other kinds of predators, and other competitive plants, as well as various potential air- and soil-borne bacterial and fungal diseases. Meanwhile, of course, it has needed to somehow propagate and disperse its offspring. But despite what must seem to us to be some serious evolutionary disadvantages, like all plants, the ancestors of this Dog Rose evolved in order to prosper maximally, using very different ways of getting what it needed when compared to humans and other animals. In fact, somewhere around 400 million and 1 billion years ago, the plant world of which the rose family became a part started evolving very differently to the fauna. Animals move, while plants are stationary. Animals consume, while plants produce. Animals make carbon dioxide, while plants use it. Plants developed the ability to grow towards essential resources, which are light, water and mineral nutrients, and to move towards the sites of photosynthesis and growth. They are therefore capable of harvesting sunlight's energy, converting it to chemical energy and storing it in organic structures.

As a distinct species within the plant world, the Dog Rose and its relatives also came up with several of their own unique solutions, ones that set them apart from most other plants. Roses evolved to self-pollinate (they contain both male and female sex organs) using the wind, insects and birds to propagate by dispersing seeds. To further this goal, they display colourful flower petals, and often secrete an alluring scent to attract the attention of insects, such as honey bees. Some roses, like

the Dog, can withstand the pull of gravity by structurally reinforcing themselves through growing their long, arching canes into other shrubs and trees, and, as in Hildesheim, they can enlist the assistance of a stone wall or other useful human-made vertical structures. At some point in the rose's evolution, a chance mutation led to leaves becoming prickles (or thorns), which proved an excellent additional means of self-defence, and also added to the rose family's ability to reach into trees or other structures to anchor itself and thereby increase height and stability of growth. A Dog Rose is moderately thorny, with fang-like prickles at intervals all along its cane. Some roses, such as the Damask family and the Rugosas, are very thorny, while at the other extreme there are a few roses that are almost or even completely thornless, such as the Bourbon Rose 'Zépherine Drouhin'.

Botanically speaking, since Linnaeus, roses have belonged within the broad classification of plants called *Rosaceae*, which contains a staggering 3,100 species and 107 genera worldwide, which include apples, plums, pears and strawberries, among others. The reason the apple and the rose belong together is because Linnaeus named and grouped plants according to their sexual organs; all the plants in the *Rosaceae* family have similarities in their stamens and pistils, their male and female aspects. Thanks to Linnaeus, botanical taxonomy became extremely well organized, but also frighteningly complex. The genus *Rosa* is divided into four subgenera, plus *Rosa* proper, which is then further subdivided into ten sub-sections.[2] According to Peter Beale's classifications, these include, for example, *Caninae* (native to the Middle East and Europe and nudging further east towards Afghanistan), and of which the Dog Rose is a member; *Gallicanae* (native of the Middle East and Europe); *Cassiorhodon* (native to pretty much the whole of the world between the Tropic of Cancer and below the Arctic Circle, except North Africa and the southern and western states of the USA); *Synstylae* (similarly prolific, but avoiding the cold north, North Africa and most of

Russia and the USA); and *Chinenses* (native to only China, Kashmir and Nepal).[3] Each genus is distinct, having its own special but linked characteristics, such as the shape of prickle, flower, leaf and hips. But for us amateurs, roses can be more conveniently divided into just three basic categories: 1. species roses, 2. classic roses, sometimes referred to as old garden roses (those in existence before 1867) and 3. modern roses. The longest living roses are the species roses (like the one in Hildesheim). Old garden and modern roses can live for up to two hundred years. The shortest lived is the Tea Rose, native of southern China, which only survives for between thirty and fifty years. In general, the old shrub roses that flower just once can survive much longer than their modern relations which are bred primarily for continuous or repeat flowering.

Here, working from the top of the rose plant to the bottom, are the key technical descriptive terms: the corolla, or flower (consisting of petal, petaloid, anther, pistil, stigma, sepal, calyx), peduncle, prickle, bract, side bud, bud union, hip, leaf, leaflet, stipule, cane (stem), crown, sucker and feeder roots. Rose flowers can be just an inch in diameter or as much as six. Their appearance on the shoot (their 'inflorescence' is the technical term) can be in dense clusters or individually. A species rose's flowers are usually clustered in groups of one to three, but some East Asian species, like *Rosa multiflora*, bloom in large panicles. Garden roses, like the modern Floribundas, bloom in panicles of 50 to 100 flowers on a single shoot. Flowers come on the ends of long, arching stems, straight, or short, stocky ones. Flower structure is described as 'single', where there are blooms with 5 to 7 petals each, like the Dog Rose, which has 5; 'semidouble', meaning the flower has more petals (between 8 to15); 'double' (16 to 25); 'full' (26 to 40); and 'very full' (up to 100, hence the name of one species rose – *Rosa centifolia*). The shape of individual flowers also vary enormously. They are usually classified as 'flat', with petals opening wide to expose the stamens, like the Dog Rose and most species roses; 'cupped', where there are more petals and the outer ones are slightly longer than those towards the centre and curving inwards

forming a cup shape so the stamens are hidden; 'globular', with even more enclosed blooms that completely hide the stamen amid a plenitude of petals; and 'quartered', where the blooms consist of many petals tightly packed into a cup shape, standing straight up and flattened against each other. The ensemble of petals tend to divide into four equal parts; 'high-centred', in which the petals at the centre stand above the outer opened petals; 'rosette', which comprises double flowers with slightly overlapping petals of different sizes which maintain an open form; and 'pompons', which are small, rounded blooms made up of numerous tiny petals. The typical cut rose given on Valentine's Day is 'high-centred'.

As mentioned, traditionally the period of inflorescence of European species roses is limited almost exclusively to a short period in late spring or early summer, with the exception of the Autumn Damask or Four Season Rose, whose name indicates its special feature, and the Musk Rose, *Rosa moschata*, which blossoms in late summer or early autumn. The inflorescence of East Asian roses, by contrast, can last for extended periods, even into winter, which is called 'remontancy' or 'repeat-blooming'. One interesting question, which I return to, is how and when this remontancy gene reached western Europe.

The flowers of the longest resident species roses of Europe are coloured pink or light red, but can also be white. By contrast, in addition to pink, light red, and white, there is a Near Eastern species rose that is yellow, and also long-established orange and deep red hybrid varieties. Technically speaking, the way colour is specifically expressed in the petals of a rose is determined by various chromatic pathways, but only the surface of the petal is actually coloured, and this is made chiefly of sugar brought under the influence of enzymes which ferment the sugar until a compound, which will be the colour directed by the gene, is obtained. This is not done all in one step, but in a series of reactions, and in each case an enzyme is employed until the dye is mixed to its proper hue.

A rose's prickles can be infrequent and small, or extremely nasty-looking and plentiful. They are shaped like needles, or are curved,

hooked, or wing-shaped with dilated ends. Some are not so much prickles as bristles, while other species mix bristles and prickles, and yet others have prickles of different sizes on the same stem. A rose's leaves can be glossy, satiny or matte, and of various sizes, textures and shades of green. But the form of the leaves – or, more precisely, leaflets – is generally ovate or elliptical. The base is rounded, wedge form or heart-shaped, the apex tapering to a point, blunt or long-pointed, the edge margins simply or doubly serrated. A rose's hips vary in size and form from egg-shaped or spherical to elongated or bottle-like.

The total structure and habit of plant growth also varies considerably. These days, plant structure is usually classified under seven headings: climber, rambler, bush, shrub, standard, ground cover and miniature. Structure tends to be overlooked in accounts of the rose, as the main focus is, understandably, on the flowers. Furthermore, the pre-eminence of certain rose classes – especially the Hybrid Teas and Floribundas – has led to an overall uniformity of plant structure which has obscured the truly remarkable variety of possible rose growth habits. There is a huge difference between a climbing rose and a shrub rose, or between a Dog Rose and a typical modern garden rose. The importance of structure is also obscured by the role of pruning in relation to the newer roses, which is important to ensure tidy growth and maximum inflorescence, but robs them of any structural value during the winter season.

The species roses are shrubs, climbers or ramblers, and have been around for a very long time, evolving 70 million years ago. It remains unclear just how many there are globally and current estimates vary. One estimate puts it at around 160: 48 native to China, 42 in the rest of Asia, 32 in Europe, 6 in the Middle East, 7 in North Africa, and 26 in North America.[4] Another, suggests as many as 220 kinds of wild rose.[5]

These roses almost always have only five petals, and are normally white or pink, sometimes with yellow stamens. But in referring to species or wild roses we shouldn't make the mistake of assuming that this defines a group that is somehow pure and unchanging. More accurately, they are simply roses that evolved long ago through natural selection to their current state which has endured for thousands of years.

All plants possess the ability to randomly mutate to produce 'sports', which are mutations from the same parent plant, or to hybridize, which involves two different parent plants. A 'cultivar', meanwhile, is a non-wild reproduction, that is, a mutation planned by humans. In general, mutations tend to have a bad reputation, as the colloquial terms 'mutant', 'mongrel' and 'bastard' demonstrate, but far from being nature's mistakes, and a pollution of inherent purity, a chance mutation can be a vital aid to evolutionary success, because through the sharing of beneficial genes, an animal or a plant mutation contributes new adaptive strategies that increase the capacity to handle vastly different environmental conditions. But most mutations die out in the struggle for survival, and at various points in the distant past species roses mutated more than five petals, and may well have failed to pass on their genes had not some been taken in hand by humans because they took a fancy to and carefully cultivated them. In other words, the oldest domesticated garden roses were originally mutated species roses, and while many plant mutations have been selected by humans because of their usefulness (like rice and wheat), some (like the rose) have been selected largely thanks to our human predilection for beauty.

But why do we find the rose in particular so beautiful? The botanist would point out that the rose seems exceedingly successful at capturing more than just the attention of pollinators, and that for both the bee and us, the rose's flower has basically the same function: it is a strong visual stimulus, a vegetal tool of attention-capture. Through the logic of natural selection, flowers have adapted to invite and hold attention so as to profit from it. They use their shape, colour and scent to

communicate with other species, and to attract insects and birds. The purpose of a flower is to send chemical signals, but it must also look and smell in distinctive ways so as to hold the attention of preferred pollinators. This means that all flowers are fundamentally oriented towards the satisfaction of the desires of other creatures, because success in garnering attention leads to an important payoff: more offspring for the plant. When wild roses in the hedgerows during the spring come into bloom, you have the impression that they have suddenly advanced into the world in order to grab the attention of their pollinators. But this 'standing out' is also effected on an olfactory level through an alluring scent. Then, once the task is done, the blooms fade and fall, and the plant recedes again into the uniformity of its undifferentiated green background.

What works for the honey bee also seems to work for us, and over time some flowers, especially varieties of roses, absorbed into their survival protocols the benefits accrued through satisfying the desires of humans and, above all, the human desire for beauty. While a honey bee gets pollen in reward for its attention to a rose, we humans get beauty. And, as Michael Pollan writes in *The Botany of Desire* (2002), we 'in turn did our part, multiplying the flowers beyond reason, moving their seeds around the planet, writing books to spread their fame and ensure their happiness. For the flower it was the same old story, another grand co-evolutionary bargain with a willing, slightly credulous animal – a good deal on the whole, though not nearly as good as the earlier bargain with the bees.'[6]

But just what *is* 'beauty'? The experience seems intimately linked to the conviction that despite plentiful evidence to the contrary all is well with the world, which is why the French novelist Stendhal wrote: 'beauty is only a promise of happiness'. From the point of view of a domesticated rose what we call beauty is really nothing more nor less than the ground upon which its survival as a species is founded and furthered. Humans protect what they find beautiful, and so beauty is a passport to special benefits. When a five-petalled species rose first mutated into a rose with bigger or more petals, like

a Gallica or a Damask, this was not necessarily an advantage from the point of view of evolution. But with the intervention into the evolutionary process of the artificial selection planned by humans, such mutations were suddenly given a considerable advantage, and as a result, they prospered. For the rose, being judged beautiful is a survival strategy.

TWO

'There are many kindes of Roses'

LIVING WITH THE SPECIES AND THE 'SPORTS'

In Roman times, the British Isles (minus Ireland) were known as Albion, and Pliny the Elder (23–79 AD) thought this meant 'Island of White Roses', on account of the white roses growing there. *Alba* means 'white' in Latin, and the white roses in question were probably *Rosa pimpinellifolia*. But nowadays it is believed that the pre-Celt reference to Albion may have derived from another prominently white feature of the island, one that is especially striking if invading from across the Channel – the chalk cliffs of Dover.[1] *Rosa pimpinellifolia*, aka the Scots Rose, Burnet Rose or Prickly Rose which, as the colloquial names suggest, is very bristly, is also very floriferous. One would probably also have been able to see in Albion, or Britannia, as the island was more officially known, members of the same rose family growing today up the wall of the cathedral in Hildesheim, the pink *Rosa canina*, the related species called the Sweet Briar or Eglantine (*Rosa eglanteria*), and the Field Rose (*Rosa arvenis*).

Rosa canina is still a common sight today in southern England and Wales, and probably was in Roman Britain, while *Rosa eglanteria*

especially grows on the chalkland of southern England, which in Roman times would still have been largely forested. *Rosa eglanteria* has flowers that are deeper pink than the Dog's, and the unusual characteristic of possessing fragrant leaves, which smell rather like apples. A probably more recent import to Britannia is *Rosa arvenis*, from the Latin 'of cultivated fields', which suggests its favoured habitat. This is similar to the Dog Rose but paler pink, almost white, and has a tendency not only to ramble into hedges and shrubs, but also to climb. Recent research suggests *Rosa arvenis* originates in the Middle East, and is one of several species roses that migrated a considerable distance, perhaps with the Roman settlers. There would no doubt have been other roses which the Romans bought with them to the barbarous north. For example, one of the oldest species roses common around the Mediterranean basin is *Rosa sempervirens*, which also originates farther east, and could have been growing in the south of England. This rose is also white, with bright yellow stamen and evergreen leaves, and is very floriferous. The growth habit varies from short bush to large climbing shrub extending up to fifteen feet.

In the more southerly regions of the Roman Empire, Pliny the Elder describes twelve varieties of cultivated roses, which are mostly named after the places where they were best known to grow, such as Preaneste, Miletus, Cyrinae, and Carthage.[2] The roses of Miletus are described as red, and are probably *Rosa gallica*, which was very common around the Mediterranean, but is indigenous as far east as Uzbekistan. The Gallica is also recorded as having been imported into Britain by the Romans. The species variety is a small shrub, and the flowers, which cluster together in groups of up to four, have a fruity scent, and each one consists of five deep pink petals with yellow stamens. The Gallica possesses characteristic hairs rather than prickles. In Roman times, this family already included sports or natural hybrids with double petals, and they have been identified in frescos on the walls of houses in Pompeii and Herculaneum, such as those depicted on the south wall of the House of the Golden Bracelet in Pompeii, now entitled 'A nightingale on a cane holding a rose'.

In the fifth century BC the Greek historian Herodotus made the earliest reference to a specific *cultivated* rose that has come down to us. The philosopher Theophrastus (c.372–c.287 BC) noted that already in his day chance hereditary mutations were being domesticated, and were grown near Philippi from shrubs dug up on Mount Pangaeus. What were these roses? It is thought today that Herodotus was probably referring to *Rosa damascena*, the Damask Rose, but as recently as the 1970s it was still widely considered that this species rose was a much later arrival in western Europe, settling in the thirteenth century, courtesy of returning Crusaders who found them growing as a cash-crop in the Near East.[3] But nowadays, the Damask Rose is credited with a much longer period of residence in western Europe, certainly growing there in Roman times.

Unlike the Gallica, the Damask Rose is a large, straggly bush. Flowers of the varieties included in this family can be single or semi-double, and look quite similar to the Gallica, but have a more delicately pink hue, and nod rather than stand stiffly upright like Gallica Roses. But most importantly, as far as usefulness is concerned, the Damask has a strong, pleasantly sweet fragrance, and was from ancient times much sought after for rose water, rose oil and cosmetics. In the Roman period, Persia was a major centre for the cultivation of roses and the Damask perhaps takes its name from the city of Damascus in what is now Syria. In these regions it was cultivated profusely as a cash-crop for the manufacture of rose water and rose oil (more on this in Chapter 14). Recent DNA analysis has revealed that the Damask is the result of the union not of two but of three species roses, and two distinct stages of pollination, involving *Rosa moschata* (see later in this chapter), *Rosa gallica* and *Rosa fedtschenkoana* (a white species rose with grey-green leaves that is native to central Asia and western China, and which, very importantly, has the remontancy gene). In the first stage, a *Rosa moschata* was pollinated by a Gallica, and this mutation was then pollinated by a *fedtschenkoana*, bringing into existence the rose we now call the Damask.

One variety – the Autumn Damask or Four Season Rose – is important because it introduced the remontancy gene into the Western rose

gene pool, that is, the capacity of a rose to repeat-flower over an extended period. So, there is the summer-flowering *Rosa damascena* var. *semperflorens*, the Summer Damask, and also the repeat-flowering *Rosa damascena* var. *bifera*, the Autumn Damask. Both are genetically and morphologically indistinguishable, apart from their different flowering periods. Perhaps the roses of Carthage mentioned by Pliny the Elder were *Rosa damascena* var. *bifera*, as he mentions they blossomed in winter. Virgil (70–19 BC) in the *Georgics* also refers to '*biferique Rosaria Paesti*', the twice-flowering Roses of Paestum, in southern Italy. However, as is so often the case with the history of roses, there is no consensus that this was the Autumn Damask, or indeed that Virgil really meant that the roses were naturally remontant.[4]

Another rose probably growing in Roman Britannia was *Rosa alba* – the 'White Rose' – which was widely cultivated by the Greeks and Romans. The Alba is an upright shrub, the species variety has big semi-double or double white blooms, which are sometimes also the palest pink. It is also very fragrant. We now know that the Alba's origins as a natural hybrid probably lie in the Crimea region, and that it is a cross between a white variety of *Rosa canina* which occurs naturally as far east as Kurdistan, and *Rosa damascena*, although it is believed by some authorities that the Gallica Rose is also involved.

The question of the rose's remontant capacity is especially interesting because there are only three wild roses that have this characteristic: *Rosa fedtshcenkoana*, which is native to central Asia and northwest China; *Rosa chinensis*, native to southwest China; and *Rosa rugosa*, native to a large area of East Asia, including China, Korea and Japan (more on these later). Roses do not trans-migrate latitudinally due to their phototropic (tendency to grow towards or away from light) and thigmotropic (directional growth movement in response to touch stimuli), so how did the repeat-flowering gene reach Europe?

It seems increasingly likely on the genetic evidence that it could only have occurred with human assistance. Until recently, it was believed that northern Persia is the only region where all three of the parents of the Autumn Damask grow together, so it was assumed to be the birthplace of the new species, and that with human assistance the Autumn Damask

subsequently spread east towards India, south to Arabia and west into north Africa and Europe, bringing with it the remontancy gene.

But new research has pushed the origins of the repeat-flowering Damask even further east to the Amu Darya River in the Aral Sea Basin in northern Turkmenistan and southern Uzbekistan, an area north of Afghanistan, which was known as the Transoxiana in Alexander the Great's time, or the River Oxus of classical Latin and Greek. This discovery, in its turn, leads to the hypothesis that the remontancy gene from *Rosa fedtschenkoana* which is necessary for there to be the Autumn Damask, comes from farther east still, in central Asia or northwest China. The Aral Sea Basin was the centre of Bactrian civilization between 329–125 BC, and was an important point of interface between Central Asia and the Chinese Han Dynasty.[5]

Such is the disparity in the geographical distribution of the roses that hybridized to produce the Autumn Damask that it seems probable their crossing could only have been facilitated through artificial selection, that is, conscious human intervention. This hypothesis would then imply that Asiatic rose genes have been an unacknowledged part of the Western rose gene pool since at least Roman times. For centuries, traders had been making their way into China and back again along the caravan routes, and plants and seeds came and went with them. Roses could easily have travelled from China along the trade routes which traversed 6,440 kilometers, and linked China with the West from the second century BC to the fourteenth century AD, and attempts could have been made long ago to cultivate remontant roses. When seen primarily as a cash-crop, remontancy in the rose is a very desirable trait, as it greatly extends the harvesting period, and therefore the quantity of the crop available for the production of what was, before the modern period – and still is today beyond the West – a major rose product: rose water (see Chapter 14). A crop of once-flowering roses extends to six weeks, while a repeat-flowering crop can last twenty weeks, a more than threefold increase in yield.

So, the Gallica, Damask, and Alba Roses were all perhaps growing in Roman Britannia in the gardens of nostalgic functionaries from the south, or Britons eager to adopt Roman customs. After the fall of Rome, one can imagine the descendants of these plants lingering on into the so-called Dark Ages. However, the consensus now is that by the medieval period the Damask was no longer growing in European gardens, and so would have to be reintroduced.

If we were to travel to Elizabethan London in the early seventeenth century to find out what roses were familiar there, we would discover that after five hundred years during which the 'culture of flowers' in general went into eclipse after the fall of the Roman Empire, roses have already become a well-established and popular domesticated plant in western Europe. To help us find our way around we can borrow the then recently published treatise by the botanist John Gerard, *Herball Or Generall Historie of Plants* (1597).

Gerard writes:

> [T]here are many kindes of Roses, differing either in the bignesse of the floures, or the plant it selfe, roughnesse of smoothnesse, or in the multitude or fewnesse of the flours, or else in colour and smell; for divers of them are high and tall, others short and low, some have five leaves, others very many. Moreover, some be red, others white, and most of them or all sweetly smelling, especially those of the garden.[6]

Gerard was especially interested in the medicinal properties of the rose, which we will consider in greater depth in Chapter 14:

> The distilled water of Roses is good for the strengthening of the heart, and refreshing of the spirits, and likewise for all things that require a gentle cooling . . . It mitigateth the paine of the eies preceeding of a hot use, bringeth sleep, which also the fresh roses themselves provoke through their sweet and pleasant smell . . . the conserve of Roses, as well that which is crude and raw, as that which is made by ebullition or boiling, taken in the morning fasting, and last at night, strengtheneth the heart, and taketh

away the shaking and trembling thereof, and in a word is the most familiar thing to be used for the purposes aforesaid.[7]

In his descriptions of roses, Gerard refers to the 'White Rose', *Rosa alba*, which, he writes, possesses 'very faire double flours of a white colour, and very sweet smell, having in the middle a few yellow threds or chives'.[8] In fact, by Gerard's time, the Alba had two important sports – *Alba semi plena* and *Alba maxima* – and was on its way to becoming the archetypal white Western garden rose. In the *Herball* the 'White Rose' is followed by a short description of the 'Red Rose', which must be *Rosa gallica*. The Gallicas have also become a quite varied family of related natural hybrids, and the specimens Gerard could see were white, pink, and deep purple, and the petals could be semi-double or double. By this time, the Gallica family was common in gardens in southern Britain, as the plant has a compact upright habit of growth, is very hardy, flourishes in all soils and is easy to grow – all important characteristics it will subsequently pass on to the Hybrid Teas that were bred from the second half of the nineteenth century. The most famous Gallica is the *Rosa gallica officinalis*, the Apothecary's Rose. This is semi-double, and the esteemed medicinal value lay in that it was thought to be helpful in treating a weak liver, kidneys and stomach, and was also used to staunch and cleanse wounds.

In Gerard's time it was believed that the *Rosa gallica officinalis* made its way from the Near East with returning Crusaders, and that the Count of Champagne brought specimens back with him to his castle in Provins southeast of Paris, and encouraged into existence a thriving rose cultivation business in the area around the town, which explains why in Gerard's day the Gallica Rose was also called the Provins Rose.[9] But, as I noted, the consensus today is that this rose had already been growing in western Europe for some time, and was well-known to the Romans. When Edmund, the younger son of Henry III of England, was Provins' suzerain in the thirteenth century, he made the flower the heraldic emblem of the House of Lancaster in a deliberate provocation to the House of York, who had adopted the then recent sport of *Rosa*

alba, the *Rosa alba semi-plena*, which became known as the 'White Rose of York'. As an act of reconciliation, the House of Tudor, who in Gerard's day was the royal house, adopted a double form of petal structure as their emblem to indicate that the York and Lancaster roses had been united. The poet John Skelton wrote: 'The rose both white and red,/ In one rose now doth grow.' Elizabeth I used the Tudor rose as her emblem, and appended a motto: *Rosa sine spina* – 'the rose without a thorn', an allusion to her virginity, and a brazen Protestant appropriation of the Roman Catholic symbolism that casts the Virgin Mary as 'the rose without thorns'. (Much more on this in Chapter 4.)

Gerard next mentions the Damask, of which there were several varieties now in existence in Europe. His contemporary William Shakespeare was certainly familiar with the sweet-smelling Damask Rose, as he wrote of it on more than one occasion. For example, in Sonnet 130 he employs an already well-worn poetic trope in which a beautiful woman is compared to a rose, and has fun unpicking the cliché: 'I have seen roses damasked, red and white, / But no such roses see I in her cheeks; / And in some perfumes is there more delight / Than in the breath that from my mistress reeks.'

Another new and very important species rose was *Rosa centifolia* (Hundred-petalled Rose) *aka* the Cabbage Rose, Holland Rose, Provence Rose, or Rose de Mai. As *Rosa gallica*, *Rosa moschata*, *Rosa canina* and *Rosa damascena* were all participants in parenting the *Rosa centifolia*, it can claim to be the most truly communally European rose, although conception occurred somewhere in the Near East. The Cabbage Rose is shrubby with long, drooping canes, and before the nineteenth century it was unique in having round, globular flowers comprised of numerous densely overlapping petals, hence the name – it resembles a cabbage. These petals are usually pink, but sometimes white or dark purplish-red.

It used to be assumed the Cabbage Rose was quite ancient and was known to the Romans. The English nurseryman and author Thomas Rivers, for example, in *The Rose Amateur's Guide* (1837), writes:

This rose has long and deservedly been the favourite ornament of English gardens; and if, as seems very probable, it was the hundred-leaved rose of Pliny, and the favourite flower of the Romans, contributed in no small degree to the luxurious enjoyments of that great people, it claims attention as much for its high antiquity, as for its intrinsic beauty. 1596 is given by botanists as the date of its instruction to our gardens.[10]

But it seems Rivers was mistaken. The consensus today is that Dutch traders introduced the Centifolia to western Europe in the sixteenth century from Persia. Long before it became a favourite in Europe, *gul-i sad barg* (Hundred-petalled Rose), was already a much-prized species in the Islamic world, and had important economic and cultural significance, as its sweet, and honey-noted fragrance made it highly valued in the production of rose water. One of its names in western Europe, Provence Rose, is an indication that this region of southern France became important for the rose's cultivation for the perfume business.

Another new arrival in Britain in Gerard's time is the only garden climbing rose, the *Rosa moschata*, or Musk Rose. Gerard writes: 'The Muske Rose floureth in Autumne, or the fall of the leafe.'[11] I already noted it as a parent of the Damask Rose, and it originates in Persia, although some sources argue for even farther afield in India or China. The Musk Rose probably also came to northern Europe via Spain, and only arrived in England in the early sixteenth century, which means it was quite a new immigrant in Gerard and Shakespeare's time. The pinkish-white flowers grow in clusters, and their semi-double petals are more closed than the single wild roses mentioned so far. As the Musk blooms in late summer and early autumn, it is also known as the Autumn Rose, and it would go on to parent not just the Damask but more recent hybrids, like the Noisettes and Hybrid Teas. The name comes from the fact that the white flowers have a pronounced 'musky' scent. What is 'musky'? This aroma is originally related to the glandular secretions of certain animals, especially the odour of the male musk deer, and the root of the word is connected to the Sanskrit for 'testicles'. This means the word implies that the fragrance is of a more 'masculine',

mellow, kind. As such, *Rosa moschata* would become much in demand in the perfume industry as a way of moderating or deepening a fragrance.

Shakespeare evokes both the Musk and the Eglantine in the famous lines from *A Midsummer Night's Dream*:

> I know a bank where the wild thyme blows,
> Where oxlips and the nodding violet grows,
> Quite over-canopied with luscious woodbine,
> With sweet musk-roses and with eglantine:
> There sleeps Titania sometime of the night,
> Lull'd in these flowers with dances and delight[12]

But it seems the Bard is misleading us. As the author of one of the definitive books on roses, the horticulturalist Gerd Krüssmann observes: 'Shakespeare, although a lover of nature, was no botanist and his terminology is often unreliable.'[13] Graham Stuart Thomas, one of the most eminent experts on old roses in the second half of the twentieth century, and a catalyst for their general rehabilitation in modern times, agrees. Shakespeare's Musk is almost certainly actually *Rosa arvenis*, because in Shakespeare's time, and until the first half of the nineteenth century, the Musk Rose was recorded as blossoming late in the summer.[14]

Gerard also mentions a mysterious rose he describes as being 'without prickles' and with fully double flowers 'of a colour between the red and damask Roses, of a most sweet smell'.[15] It is unclear to what rose Gerard is referring, and he concludes: 'All these sorts of Roses we have in our London gardens, except that Rose without prickles, which as yet is a stranger in England. The double white Rose [*Rosa alba semi plena*] groweth wilde in many hedges of Lancashire in great aboundance, even as Briers [meaning five-petalled flower species roses like the Dog Rose, Sweet Briar, Burnet Rose and Field Rose] do with us in these Southerly part.'[16]

Gerard also reminds us that for the Elizabethans, as for the Greeks and Romans, and the societies of the Near East, roses were of culinary

use. The Romans produced rose wine and jelly, and ate candied rose petals and puddings. Gerard writes that in his time roses 'put in junketing dishes, cakes, sauces, and many other pleasant things, giveth a fine a delectable taste'.[17] Of the hips of wild roses he notes: 'The fruit when it is ripe maketh most pleasant meats and banqueting dishes, as tarts and such like; the making whereof I commit to the cunning cooke, and teeth to them in the rich man's mouth.'[18]

Another rose mentioned by Gerard, but not, I think, by Shakespeare, is what he calls the 'Yellow Rose'. In the illustration in the *Herball*, this looks to be *Rosa foetida*, the Persian Yellow or Austrian Yellow Rose.[19] This was the only yellow rose known in Europe during that period. But if we were to take a look at England in the early twentieth century we would find that, thanks to the efforts of the French rose breeder Joseph Pernet-Ducher (whom I mentioned in the Introduction), yellow has lately become a more familiar colour in garden roses. Once again, we can employ a then recently published guide to roses to help us find our way around: *Roses for English Gardens* (1902), by the gardening expert Gertrude Jekyll, the most important advocate of the rose to the late Victorians and Edwardians.

Here is what Jekyll has to say about the Gallica Rose:

> Of the old Provins Roses (*R. gallica*) there are a number of catalogued varieties. They are mostly striped or splashed with rosy and purplish colour. I have grown them nearly all, but though certainly pretty things, they are of less value in the garden than the striped Damask Rosa Mundi. But there is an old garden Rose, the Blush *gallica*, much more double, and that grows into very strong bushes, that is a good Rose for all gardens. It will put up with any treatment. I have it on the top of a dry wall where it tumbles over in the prettiest way and blooms even more freely than the bushes on the level.[20]

But Jekyll's summary is rather off-putting: '*Rosa gallica*, the garden kinds being mostly striped; pretty, but not of the first importance.'

As Jekyll reveals, the Damask had also become a mainstay of the garden, and she writes: 'No Rose surpasses it in excellence of scent; it stands alone as the sweetest of all its kind, as the type of the true Rose smell.'[21] Jekyll also mentions a recent sport – the Moss – which takes its name from the soft furze covering its stem, bud and calyx. This is an important variety of the Cabbage Rose. The Moss, Jekyll writes, has 'its own delicious scent, of a more aromatic or cordial character'.[22] Along with the Gallica, Damask and Centifolia Roses, *Rosa alba* was also another popular presence in the garden. 'This capital Rose is often seen in cottage gardens, where it is a great favourite', notes Jekyll.[23]

But by Jekyll's time, a major revolution had occurred in rose cultivation, one that will change the way we think about roses forever, and in whose vanguard can be found the new yellow roses of Pernet-Ducher. So, let's go to east London around the time I had the rose epiphany I mentioned in the Preface, on a late November afternoon in 2003, and let's bring along William Shakespeare, and have him take a look at the roses in those suburban front gardens with us. What will the Bard make of them?

The flowers of the roses Shakespeare sees are likely much more closed-cup in shape, and more strongly coloured than anything he was familiar with. The roses of his time, as described by John Gerard, had petals that typically opened flatter, exposing the central stamen. They were also softer coloured, not so intensely dyed as modern roses, which also come in many more varieties of hues. Some are deep crimson, bright yellow, orange and bi-coloured. These modern roses' flowers are also bigger, and attached to a straighter stem, some of which have no or very few thorns, and which belong to a neat shrubby plant very different in shape from those typical in Shakespeare's day. Their fragrance is modest or non-existent, while the roses of Shakespeare's time were especially cherished and cultivated for their strong and varied

fragrances. ('A rose by any other name would *smell* as sweet.') But what would have probably been most extraordinary for the Bard is that he is looking at so many roses in bloom in late autumn. For as we have seen, one of the characteristics of almost all the roses that were residents of Elizabethan England, in fact characteristic of almost all of the roses of the Near East and Europe since as far back as we can discern until the late nineteenth century, is their short period of flowering.

Shakespeare may flatly refuse to believe these plants are actually roses, and one would have to explain that the reason they differ so much from the Elizabethan roses is because the ones growing in these east London gardens are mostly from the Hybrid Tea and Floribunda families. The former did not exist before the second half of the nineteenth century and were just becoming popular when Gertrude Jekyll was writing, while the Floribundas date only from as recently as the 1950s. These are thoroughly modern roses, the consequence of the conscious interbreeding, or crossing, of the traditional roses of Europe and those of the Near East (such as the yellow *Rosa foetida*), but most especially, those of China.

So, let's now move on, and travel to the other side of the world. In China, the domestication and cultivation of roses was well-established at least as long ago as the third century BC, especially in central and southwest China, the most fertile growing areas. In the Song Dynasty (960–1279) there are references to *Yuejihua*, an extensively cultivated perpetual-flowering rose, *Rosa chinensis*. The preferred method of propagation of roses was in pots rather than in open ground, and these were then often placed on verandas. In fact, rose culture in China was the most advanced in the world until the nineteenth century, and natural- and human-assisted hybridization among species roses in gardens led to a wider variety of petal pigmentation than in Europe with hues rare or unknown, such as yellow, lilac, apricot, scarlet and crimson.

An important species rose in China, Korea and Japan is *Rosa multiflora*, which is similar to the Dog Rose, but with white flowers rather than pink, and it would certainly have long been a common sight beside roads and paths bordering forested hillsides and rivers. The small single flowers are sometimes tinged with pale pink, and have large yellow stamens, and they come in very profuse clusters on long, arching canes. The petals are serrated and often heart-shaped, with a very delicate fragrance.[24]

Another large and ancient East Asian rose species family is *Rosa rugosa*, which range from pale to fuchsia pink with yellow stamens, and unlike most East Asian roses they are often powerfully fragrant. Traditionally, Rugosas were used to make jam and various desserts, and as a potpourri. They are spring and summer flowering, very prickly, and have big showy hips throughout late summer and autumn. *Rugosa* means 'wrinkly' in Latin, and the term describes the characteristically corrugate leaves, which are dense and green and turn golden yellow in late autumn. In Chinese, the Rugosa is known simply as *meiguihua* – 'rose' – a sign of its predominance. In Japanese it is *hamanashi* (Beach Aubergine – a reference to the large hips), and in Korean, *haedanghwa* – ('Flowers Near the Seashore'), also a reference to the fact that the Rugosa can tolerate sandy soil and the salty air of the seaside). In the West, the Rugosa is also known colloquially as the Letchberry, Beach Rose, Sea Rose, Salt-spray Rose, Japanese Rose, Ramanas Rose and, in the UK, the Hedgehog Rose – on account of its thorniness. In Japan it was traditionally planted in coastal areas to help stabilize beaches and dunes by retaining sand in the root cluster, and it arrived in Europe from there in 1784, hence the primary association with that land. The name 'Ramanas' seems to be a distortion of the Japanese name, which somehow metamorphized into 'Hamanas' and then into 'Ramanas'. The Rugosa is very useful as a hedging rose, and since its introduction in the West, it has spread rampantly throughout Europe and North America. In fact, nowadays, in some regions of the world, it is seen as a troublesomely invasive plant and measures are taken to deter it.

Rosa gigantea is another important indigenous Chinese species, and it too was unknown in the West before modern times. *Rosa gigantea* is a climbing shrub with large (up to 6 inches) single white flowers, and a pleasing fragrance, and can grow to immense proportions – as high as 90 feet! It likes a humid climate, and thus is a native of Burma, Laos, Assam and western China. Long ago in China, *Rosa gigantea* naturally hybridized with other local species, and it went on to become an important ancestor for the repeat-bloomers, and in western China they can also be yellow or pink.

As already noted, in terms of botanical differences, an important feature of East Asian roses was that many varieties had evolved a much longer flowering period than those of the West and Middle East. These characteristics would become avidly sought after from the eighteenth century onwards. *Rosa gigantea*, for example, was recognized as combining what Western rose breeders coveted as four important characteristics in one plant – vigour, fragrance, colour variation and a long period of flowering – and it was this species rose that was in part responsible for making possible the transformation of the old European garden roses, which typically have numerous petals born in an open cup, and a short flowering period, into the repeat-blooming, semi-double and cupped flowers we associate with today's Hybrid Teas and Floribundas.

But the most important species rose from China is *Rosa chinensis*, the China Rose, an especially extensive family which comprises varieties that are characteristically lanky bushes and short of leaves, and flowers that are small and lack distinct fragrance. But they come in long flushes until late autumn, and some are yellow and also deep crimson, which were virtually unknown hues among the native Western roses. Indeed, a long time ago, this family spanned the deep crimson to the almost pure white, through a combination of natural and artificial selection undertaken by Chinese cultivators. But as far as the future of the rose for the West is concerned, the principal advantage of the China Roses was their extended flowering period. What is the original species China Rose like? Remarkably, until recently no one in the West knew, largely because the Chinese communist takeover in 1949 closed China's

doors to botanists. But, as we will see in more detail in Chapter 10, the mystery has quite recently been solved.

Another important species rose native to China is *Rosa odorata*, the Tea Rose, which is also a large group comprising 93 different species. They also have a repeat-flowering habit. Tea Roses often have weak necks below the flowers, but the blooms are large (up to 5 inches across) and silky and creamy, with delicate fragrances. On the whole, these roses are averse to frost, so they don't do well in northern Europe. But why are they called 'Tea' Roses? No one knows for sure, and there are conflicting theories. One of the great experts on old roses, Graham Thomas, said: 'I can only say that a sniff of a good flower reveals the same aroma as a fresh packet of China tea.'[25] But another expert, Peter Beales offers an alternative possibility:

> It seems that the early Tea Roses as well as the Chinas arrived in ships of the East India Company who were of course primarily concerned with the transportation of tea but since a small part of their cargo yielded another new race of roses, it is possible that this, coupled with their unusual scent, led to the term 'Tea-Scented Rose' as a nickname coined perhaps by the sailors whose job it was to tend them. I grow several varieties of 'Teas' and have yet to detect any real resemblance to the scent of tea in any of them.[26]

Like everywhere else, roses in China were grown for medicinal purposes, especially *Rosa chinensis*. But it is a striking historical fact that despite China being home to a vast number of different species roses and having an advanced 'culture of flowers' from an early period, roses were never given the same symbolic or aesthetic value they received in classical Persia, Greece and Rome, within Christianity and Islam, and later in secular modern culture. This isn't to suggest that the rose was of no cultural significance. The poet Bai Juyi (772–846) seems to be the first in China to compare, in verse, the rose to a beautiful woman; so the familiar analogy between feminine beauty and the rose is also traditional in East Asia. Paintings of roses occasionally feature within the popular 'literati' or scholar-painter genre of flower-and-bird

painting, but when compared to the countless paintings and poems featuring peonies, chrysanthemums, orchids and bamboo in China, roses are an exceedingly rare presence, as indeed they are in Japanese and Korean art and poetry. We will return to this interesting cultural difference in future chapters.

While the oldest rose in the world today is the *Rosa canina* in Hildesheim, the largest is another species rose that is native to China: the rambler, *Rosa banksiae alba plena*, which is a double-petalled sport of the true species, *Rosa banksiae normalis*. In a rare instance of a rose depicted in Chinese art, the Song Dynasty painter Ma Yuan (1160–1225) shows a branch containing five beautiful blooms of *Rosa banksiae alba plena* amid clusters of leaves highlighted against a bare silk background. But this huge living specimen isn't actually in China: it's in Tombstone, Arizona, of all places, where it was sent from Scotland in the 1880s. By 1919 the rose had already extended to about 800 square feet, and by 1964 was covering 5,380 square feet. Today, it extends over 8,000 square feet, and boasts a trunk more than 12 feet in circumference! But it is largely the support given by humans, in the form of an impressive wooden trellis, that has allowed it to prosper. In a region of arid desert where shade is at a premium, this particular rose has become a much- appreciated setting for weddings, anniversaries and birthday parties, and it is known locally by the charming title 'The Shady Lady of Tombstone'.[27]

Finally, let's consider American species roses. What would have been familiar to Native Americans? And what roses would have welcomed the Pilgrim Fathers when they arrived in the New World in 1620? The English soldier, explorer and colonial governor Captain John Smith (of Pocahontas fame) at the beginning of the seventeenth century described the Native Americans who inhabited the James River Valley, growing wild roses in their villages as ornamental plants. Perhaps this was the deep-pink-flowered *Rosa nitida*, aka the Shining Rose,

indigenous to the northeast, which has glossy leaves, hence the colloquial name, or *Rosa blanda*, aka the Smooth Rose, Meadow Rose, Wild Rose or Prairie Rose, which is similar to the Dog Rose. One of its aliases is due to the fact that it is an almost thornless shrub. Or perhaps the roses were *Rosa setigera*, also native to central and eastern North America, which, rather confusingly, shares the name Prairie Rose, and is a very hardy climber that also looks similar to the Dog Rose, but has deeper pink flowers and fewer thorns.

Estimates now put the total number of species roses of North American origin at twenty-six. For example: the pink *Rosa virginiana*, which has a tidy growth habit and light green foliage; the pink *Rosa palustris*, the Swamp Rose; and *Rosa Carolina*, which also has clear pink petals. These three are all rather similar to *Rosa blanda*. In the milder eastern and southeastern regions is to be found the large flowered pink *Rosa foliolosa*, and native to the southwest including Mexico, *Rosa california*, which closely resembles the Gallica Rose. All these roses blossom later than the European roses, and have more colourful autumn foliage. They also all sport very rich red hips. The native Americans knew of the benefits of these vitamin C-rich hips, and made teas and syrups to treat ailments.

American readers may be surprised that I have made no mention of the Beach Rose, the Wreath Rose, the Cotton Rose, *aka* Dixie Rosemallow or Confederate Rose – whose flower is white in the morning and changes to vibrant pink in the afternoon then red by the evening – and the white-petalled and gold stamen climber *Rosa laevigata*, the Cherokee Rose, emblem of the State of Georgia. But the Beach Rose is actually *Rosa rugosa* and the Wreath Rose is *Rosa multiflora*, both of which, as we saw, are natives to East Asia, and subsequently spread prolifically in America after European importation. But what about the Confederate Rose and Cherokee Rose? These are surely natives, for their name seems to imply as much.

The truth about the Cotton Rose is revealed when one looks at the plant: it isn't actually a rose, although its big open blooms are reminiscent of old roses, hence the name. It is in fact a member of the *Hibiscus*

family, and furthermore, it too is a native of China not America. *Rosa laevigata*, the Cherokee Rose, certainly grew among the Cherokee clans in their traditional homelands. In some accounts it is so named because the Cherokee had long planted a trail with this rose as a marker to guide them on their seasonal migration from east Texas to northern Arkansas.[28] Other accounts emphasize that the Cherokee Rose took on special poignancy for the Cherokee people in 1838 when they were driven from their lands in Georgia, westward into Oklahoma, because gold had been discovered and they were forced on a journey that became known as the Trail of Tears. One legend tells that where the tears of Cherokee women fell, a rose grew; the white petals were the tears, the golden stamens the gold prospected on Cherokee land, and the seven leaves on each stem the seven Cherokee clans forced to move from their ancient homelands. In fact, botanists have confirmed that *Rosa laevigata*, although fully naturalized, also comes from far away China, and just like the Rugosa and the Multiflora was imported to America in the eighteenth century. There is another possibility, however, at least if one subscribes to the theory that Chinese explorers in the fifteenth century came to America before the Europeans in the seventeenth century. In that case, it could have been intrepid Chinese who are responsible for first transporting *Rosa laevigata* to the New World, and perhaps also other roses that are native to the Far East.[29]

THREE

'Then bring me showers of roses, bring'

PAGAN ROSES

Many years ago I worked as an official tour guide at the National Gallery in London. One of the most striking, and for some, rather too erotically charged, paintings I liked to talk about to visitors was the Florentine artist Agnolo Bronzino's Mannerist masterpiece, *An Allegory with Venus and Cupid*, painted between 1540 and 1550, which is also known as *Venus, Cupid, Folly and Time* and *A Triumph of Venus*. One's eyes are drawn, as if by some magnetic force, to the hand fondling the breast of Venus, a hand that belongs to Cupid, which means the amorous embrace is decidedly incestuous, as he is her son. At the top left of the painting there is a horrified-looking woman with only half a head, and below her a man or a woman screaming in agony. At top right is an old bearded man, Father Time, pulling round or pulling back a blue curtain. The little boy on the far right, who symbolizes Folly, is holding a bunch of pink rose blossoms in his hand and seems about to shower the lovers with them. Behind Folly is a pretty little girl holding a honeycomb, who on closer inspection turns out not to be a girl at all but a bizarre hybrid creature with a nasty looking lizard-like lower half.

Allegory, indeed. But in the present context, Bronzino's masterpiece is a fitting way to begin our exploration of the rich symbolism of the

rose and, specifically, the rose's intimate alliance with the pagan goddess of love, which is tacitly being acknowledged every time roses are given on Valentine's Day or to a lover.

The Romans identified their Venus, goddess of agricultural fertility, vegetation and springtime, with the older Greek goddess Aphrodite, the controller of all the arts that helped to enhance beauty and love-making, the protector of courtesans. The domain of Aphrodite/Venus was perfumes, incense, love-charms and potions, oils and cosmetics, and knowledge of aphrodisiacs.[1]

Many myths refer specifically to the rose in relation to Aphrodite. At her birth, she causes the sea-foam to become white roses as it fell onto dry land. The rose becomes red through the spilling of Aphrodite's blood. While running to Adonis, her lover, Aphrodite scratches herself on the thorns of a rose bush and turns the white roses to red. In another myth, Adonis is mortally wounded by a wild boar while out hunting, and from the mixture of his blood and her tears there grows the first red rose. But in another myth the transformation is caused by the blood of Aphrodite's son, Eros (the Roman Cupid or Amor, with whom in Bronzino's painting she is cavorting), the god of love, youth, vitality and fruitfulness. The thorns on the rose were also added by Eros who, it is said, in yet another myth, while kissing the most beloved of his as yet thornless roses, is stung by a nectar-gathering bee concealed inside the flower (the bee is another symbol of Aphrodite). His mother gives Eros a magical quill of arrows so he can take revenge, and Eros shoots at the bees on the rose bushes, and the thorns appear where he misses his mark.

Aphrodite was married to Hephaestus, but she was never faithful to him, and had numerous affairs, including with the god of war, Ares (Mars to the Romans). In one myth, Aphrodite names a flower created by Chloris (Flora to the Romans) and dedicates it to Eros, who then offers the rose as a bribe to Harpocrates (the god of silence), hoping to keep secret his mother's perpetual sexual indiscretions. As a result, the Latin term *sub rosa*, 'under the rose', links the rose to silence, secrecy and the unknowable. As this and many other myths suggest, Aphrodite/

Venus may personify sexual pleasure and love, but her unpredictability led sometimes to wanton lust and violence. In fact, she was also a warrior goddess, and sometimes went by the name the Black One, Dark One, and Killer of Men. Such was her power that acts of honouring her brought reward, but disrespect or disregard meant brutal punishment.

But the rose had begun working its special kind of beauty and magic in relation to pagan religion long before Aphrodite, in Babylonia, where it was dedicated to the goddess Ishtar, signalling her immortal nature and alluding to her by sight and scent; and also in ancient Egypt, where it often appears alongside the lily and the lotus as an attribute of Isis, mother goddess and protector of the dead. Gradually, the rose supplanted these other beautiful flowers, becoming considered the most sacred to Isis.[2] Among the Greeks, the mother goddess Rhea (known as Cybele to the Romans), wife of Cronus and mother of Zeus, and goddess of wild nature, fertility and protectress in time of war, was often represented at her festivals by a statue carried in procession covered with live roses. Artemis (Diana to the Romans), goddess of wilderness, wild animals and the hunt, is also shown in a statue at a temple in Ephesus from the fourth century BC with a rose hemming her robe.

These goddesses are all manifestation of what the Romans called *Magna Mater* – the Great Mother, Great Earth Mother, or Earth Mother Goddess – the primordial deity who personifies in her various incarnations the rising, growing and dying of all life, the subterranean and mysterious powers that drive life forward. She is the queen of chthonic nature (from the Greek *chthōn*, meaning 'earth'), of what dwells in or under the earth, unseen and unseeable, unpredictable, fecund but dangerous. She is loving, protecting and inviting, but also fierce, destructive and terrifying, a reflection of the fact that nature is both the source of human security and happiness, of light and life, but also of anxiety and unhappiness, darkness, destruction and death. The Great Mother Goddess is therefore supreme, and humanity owes her everything.

In the Homeric 'Hymn to Demeter', the oldest of which probably date from the seventh century BC, it is in a lovely 'soft meadow', amid a profusion of natural beauty, that Persephone is cruelly raped by Hades, god of the underworld. As pagan myths like this show, human existence was envisaged as a struggle from the moment of birth with nature, the begetter of life – the life-giver and life-taker, the regenerator all-in-one. The mythological figures also indicate that for the pagan, the world was conceived as fundamentally in process and relational, where animals, plants and stones interact with humans reciprocally in ways that imply a kind of kinship. The physical and conceptual distinctions we today are accustomed to making between the human world and that of plants and animals, and the hierarchy in which humanity reigns over the non-human, was not so definitive, and was open to metamorphosis. 'In these woodlands the native Fauns and Nymphs once dwelt, and a race of men sprung from trunks of trees and hardy oak', writes Virgil in the *Aeneid*.[3] But by the time Virgil wrote these lines somewhere between 29 and 19 BC, the Great Mother Goddess had already long ago been joined and largely usurped by the male gods, such as the Hellenic king of the gods, Zeus (Jupiter in Roman mythology), Apollo, the god of light, and Dionysus (Bacchus), god of divine frenzy, become the focus of sacred rituals. The various manifestations of the Great Mother Goddesses were now seen as subordinated to the worship of male deities, who are their sons or lovers, or both – such as Adonis, Attis and Osiris – and whose death and resurrection symbolize the regenerative powers of the earth. Aphrodite is a manifestation of the Great Mother Goddess within this new dispensation. In one version of Aphrodite's birth, it is Zeus, the king of the gods who is her father, and Dione, another Earth Mother Goddess, her mother. Alternatively, Aphrodite is said to have been born from the sea foam, when Kronos, the destructive and all-devouring god of time, castrates and slays Ouranos (or Uranus), his father, the sky god.

The plants and animals considered to be sacred companions of these gods and goddesses were chosen not only to symbolize salient aspects of a divinity's character and to reveal the domain over which

they exercised their power, but also through their close kinship with them to be active conduits, so that contact could be made with the divine. Several flowers and fruit, such as the red anemone, myrtle, apple and pomegranate, were sacred to Aphrodite/Venus, as were birds such as the dove, sparrow, swan, goose and duck, and shellfish. The importance of waterfowl indicate that this is the daughter of Poseidon, and that Aphrodite means 'born from the sea', that is, from the womb of the Great Mother Goddess. She was said to have floated to land on a conch shell accompanied by dolphins – two more of her animal associates. But it was the rose that would become especially sacred to the goddess of love. The *Odes* of Anacreon (c.582–c.485 BC), which contain the earliest poetic reference to the rose, refer directly to the goddess of love and her intimate relationship to this special flower: 'The gods beheld this brilliant birth [of Aphrodite], / And hail'd the Rose, the boon of earth!'.[4]

The special relationship of the rose to the sacred empyrean was also encoded on a linguistic level. The Greek word *rhódon* is connected phonetically with *rheein*, meaning 'to flow', linking the rose's life cycle and scent to endless effluvious life, and thereby making it closely associated with the metamorphosis that is characteristic of humanity's relationship to nature. In Latin, *rosa* sounds like *ros* – 'dew' – which is an especially ethereal natural phenomenon also closely associated with the realm of the gods. The words *rhódon* and *rosa* refer to the colour of light itself, and so the plant was deemed to originate in the world of the gods. In relation to sexual love, the word *rosa* sounds very close to the Greek *eros*, the name of Aphrodite's son, which means 'love' or 'desire', and which was also used by the Romans, and this provided another linguistic basis for the association. These interconnections, reinforced by a purely visceral delight in the visual and olfactory beauty of the rose, meant it was understood to be both an earthly creation and a material sign of the world of the immortals.

But the rose's relationship to the goddess of love was also cemented on a ritualistic level, and was directly related to more general social practices. It was deemed to be an earthly thing both beautiful and

valuable. But it was also pleasing to the gods, who were imagined, described and depicted wearing floral garlands and dresses, and emanating intoxicating scents from anointed oils. In a poem fragment, Sappho summons Aphrodite to her temple on the island of Crete, and describes the setting in a sacred grove of apple trees, blooming with roses and spring flowers, where the altars are smoky with the sweet fragrance of roses. At the end of the *Illiad*, Aphrodite is described as using immortal rose oil to protect the body of Hector from savage dogs. She 'anointed him with ambrosial oil of roses that his flesh might not be torn'.[5] As already mentioned, the first recorded reference to a rose, on a tablet excavated in Pylos, mentions aromatized oils that included rose extract. Rose oil was used by priests and priestesses during sacred rites to generate a heady atmosphere conducive to communion with the Olympians, but it was also used by amorous lovers, who anointed themselves when they met for trysts. The female poet Nossis, writing in the third century BC, declared: 'There is nothing sweeter than love: all other blessings / Take second place. I even spit honey from my mouth. / This is what Nossis says. / Whomever Kypris has not kissed, / Does not understand her flowers, what kinds of things roses are!' Evidently, the appeal of the rose easily spanned the sacred and the profane.

The symbolic connection of the rose with the goddess of sexual love was also tangible in obvious ways. After all, the rose flower is literally the plant's sex organ – a hermaphroditic one, like 80 per cent of all flowers. Pollination in a rose occurs through the interaction of the anther (female) and the stamen (male), and fertilization results when the sperm from the pollen unites with an egg in the flower's ovary. In this, the rose is the direct vegetal equivalent to the human sexual organs, with which it also has clear physical similarities – the arrangement of petals to the vagina, for example. It was also easy to make direct visual analogies between the rose and specific human attributes and behaviours. The shape of its flowers, spatial arrangement of petals, stamens, leaves, prickles and cane meant the rose was closely equated with femininity, youth, vivacity, fecundity,

love, beauty, pleasure, desire, the delicious pain of passion, and also the waning of these things, and, as we will see in Chapter 6, with death.

It is less well known today that in the pagan world the rose also had a close relationship to a male pagan god: Dionysus (Bacchus to the Romans), god of wine, intoxication, revelry and ritual madness, and foil to Apollo, god of clarity, order and light. In order to worship Dionysus it was deemed necessary to become intoxicated, so as to lose one's reason – one's habitual ties to relative dualities – through ecstatic abandon, thereby returning to the bosom of nature. In effect, Apollo personified humanity's dominance of nature, and Dionysus reminded the Greeks and Romans of their tutelage as he erases the clear and controlling Apollonian line, and instead of clarifying light brings obscuring darkness. Like Aphrodite in one of her aspects, Dionysus is also the principal of chaos, of creative destruction.

But significantly, Dionysus is also responsible for the union of people and nature, and is the god who brought about domestication of plants and animals. One myth has Dionysus growing the first vine while planting a plant he had discovered next to a rose bush. But by being the god who brought the wildness of nature within the bounds of civilization, he is also a reminder of how fragile that civilization actually is. It was largely through its association with drunkenness and revelry, the province of Dionysus, that the rose was commonly used to decorate tables at banquets, worn as head garlands and wreaths, and the petals dropped into wine bowls.

Anacreon in his *Odes* sees Aphrodite and Dionysus/Bacchus as delightful co-conspirators in the field of love:

> Then bring me showers of roses, bring,
> And shed them round me while I sing:
> Great Bacchus! in thy hallow'd shade,
> With some celestial, glowing maid,
> While gales of roses round me rise,
> In perfume, sweeten'd by her sighs,
> I'll bill and twine in airy dance.[6]

In sum, the rose in the pagan world was associated above all with sensual pleasure, and especially sexual pleasure. When judged together, Aphrodite and Dionysus are not so much personifications as physical and emotional powers or forces. As such, there was clearly a dangerous side to their magic. When the concern is pleasure and fertility, Aphrodite casts golden light and brings the well-being and happiness that come through sexual satisfaction, but she also has a darker aspect which makes her destructive, driving people to madness and murder. Similarly, the divine madness of Dionysus is ecstatic, and could easily lead to wanton destruction.

The forces that Aphrodite and Dionysus channel are therefore potential threats to the stability of society, and were increasingly considered in a negative light as the Greeks sought to elevate the virtues of reason to the highest level, and the wildness associated with them became more and more difficult to assimilate. In Plato's *Phaedrus*, Socrates talked of 'divine madness', said the highest form is the madness of the lover, of Aphrodite and Eros, her son, and warned of the dangers of such madness. In the *Symposium*, he argued that there are two kinds of love: one heavenly the other carnal. Aphrodite is equally responsible for both, but in a clever sleight of hand, Socrates proposes that there are actually two Aphrodites:

> No one, I think, will deny that there are two goddesses of that name – one, the elder, sprung from no mother's womb but from the heavens themselves, we call the Uranian, the heavenly Aphrodite, while the younger, daughter of Zeus and Dione, we call Pandemus, the earthly Aphrodite. It follows, then, that Love should be known as earthly or as heavenly according to the goddess in whose company his work is done.[7]

Urania is Aphrodite when she is the goddess of a spiritualized and idealized kind of love (what we would call 'Platonic'), while Pandemus is her venal, lustful manifestation. She too is worthy of veneration, but only by the common people, where she is also called *Porne* – 'titilator' – which is the origin of the word 'pornography'.[8] In the *Symposium*, the ideas of the prophetess Diotima on the nature of love are also presented.

She declares that all humanity seeks to engender or to procreate in order to achieve immortality, but only the lower orders conceive this in terms of physical generation through sexual intercourse. Carnal impulses drive men towards women, and women towards men. But, by contrast, the higher soul seeks spiritual love, the beauty that engenders wisdom.

At the bottom of the ladder of love envisaged by Plato grow the sensuous roses that provoke fleshy desire, while at the top, blossom the refined roses that encourage spiritual exaltation. Subsequently, the distinction Plato makes between profane and sacred love would be developed and further radicalized within Neoplatonist philosophy, which serves as the context for understanding the strange story *The Golden Ass* of Lucius Apuleius, written towards the end of the second century AD. *The Golden Ass* tells of a man transformed into a donkey. Eventually, the goddess Isis orders him to eat a rose, and as a result he instantly returns to human form. But he is now imbued with an understanding of the transformative power of divine, spiritual love, of the spiritual passion that characterizes humanity's noblest ideals.[9] So the rose evoked in *The Golden Ass* is clearly associated with Aphrodite Urania.

The Greek and Roman myths still have meaning and continuing psychological potency for us today because they give symbolic form to important and perennial human values. Psychoanalysis argues that the pagan myths explore the psyche through narratives that address universal and timeless human anxieties and desires. In a strictly Freudian reading, Aphrodite and Dionysus would demonstrate how nature insinuates itself into social life via the instincts, and especially through the dual destabilizing forces of sex and violence. Aphrodite Pandemos represents the libido – the instinctual drives – a word whose etymological roots are the Latin for desire, eagerness, longing, excessive desire, sensual passion and lust. Aphrodite Urania, on the other hand, symbolized the attempt by the superego – the ethical sense

within the personality – to divert these instinctual drives towards more ideal ends. As a composite, Aphrodite therefore personifies the profound ambivalence humanity experiences in relation to sexuality.

For Carl Jung, Aphrodite is to be understood in relation to the theory of archetypes. The Great Mother Goddess is an example of a 'primordial archetype', that is, a personification of the 'Archetypal Feminine'. According to Jung, an 'archetype' is what furnishes the structure of our moods and beliefs, unconsciously determining our behaviour and linking us to the instinctual level of existence. Jung argued that these archetypes reside within each individual psyche, representing aspects of a man or woman's personality, but that they are also transpersonal in that they function collectively within a culture. They are in a sense visualizations of the instincts.

Jung suggested that in very early stages of the development of human societies, the instincts dominated, and the ego was incapable of differentiating itself fully from its surroundings. What to the more socialized mind seems mutually exclusive dimensions of the psyche, at this earlier stage appeared side by side as a primordial archetype – and one of the most vivid ways of expressing this was in the anthropomorphic image of the Mother Goddess. This unity subsequently broke down into more discrete, individual archetypes that are then more easily manifested to consciousness, and it is only when consciousness has learned to look at phenomenon from a certain distance, to differentiate and distinguish, that this separation occurred, and groups of symbols organized themselves into binary pairs, and single archetypes become recognizable.[10] When arraigned more separately, the various aspects of the primordial archetype become mutually exclusive, dividing into positive and negative, male and female, and so on. Jung termed the feminine aspect, the 'anima' – the soul – and the male, the 'animus', but he emphasized that both aspects reside in every human being, and require integration. Aphrodite represents the archetype at this later stage. But she is more than simply an external force of nature. She resides within every woman, personifying love, beauty, pleasure and the arts. She is involved with moments of intimacy and emotional

needs and vulnerability. To ignore the needs of Aphrodite, Jung argued, is to risk emotional disturbance, and to invite illness. Each woman possesses facets of the Great Mother within their psyche.

From a Jungian perspective, the symbolism of the rose, as it developed within pagan Greece and Rome, can therefore be interpreted as a powerful archetypal image of the anima which, Jung argued, is divided into four transhistorical persona. First, there is Eve, the earth woman, the object of sexual love, the one to be impregnated. Second, is Luna, the moon woman, who is the object of romantic love, sublimated and idealized sexual love, and the goal of Eros. Third, there is the Divine Virgin, the heavenly woman, spiritual, holy, elevated, who embodies carnally uncontaminated love, transcending sex and Eros. Fourth, is the Mother of God, who personifies mystic love, transcendental and ethereal, which is far beyond sex, Eros, and even holy love. This is the anima when it is filled with spirit, and for Jung, when the archetype reaches this refined level, gender distinctions collapse and it acquires again its hermaphroditic features as a primordial archetype.

In this chapter we have encountered the roses of Eve and Luna. In the next chapter, it is the turn of the symbolic roses of the Divine Virgin and the Mother of God.

FOUR

'Rose Without Thorns'

MONOTHEISTIC ROSES

A Roman Catholic church is an especially good place for a rose hunt. Almost any will do, and it certainly doesn't need to be a Gothic cathedral with a huge rose window. In the village where I live in central France the church dedicated to St Étienne is a mishmash of styles ranging from the Romanesque to the Baroque, and within you will find real roses arranged in vases by parishioners, alongside more permanent carved and painted ones. Most memorably, there is a seventeenth-century altarpiece of the Adoration of the Virgin Mary, in which she is shown surrounded by a garland of Damask Roses in an aureola – a luminous cloud. There is also a statue of the 'rosiest' of all the saints, St Thérèse of Lisieux, a Carmelite nun who was born in 1873 and died aged twenty-four of tuberculosis. She was canonized in 1925, and is known as the 'Little Flower of Jesus', and in the standard iconography St Thérèse is depicted in a nun's habit, looking blissful, and clutching a large armful of pink roses. 'My mission – to make God loved – will begin after my death,' St Thérèse announced. 'I will spend my heaven doing good on earth. I will let fall a shower of roses.' Pope Francis, has a special devotion to St Thérèse, and talks of receiving roses from her in answer to his prayers. On a flight to Colombia in 2017, he received a

white rose, although not from on high – but from a journalist who was aware of the Pope's affection for the 'Little Flower', and so presented him with one.

The Church essentially rebranded the symbolism of the rose forged in the pre-Christian pagan world to make it compatible with the beliefs and practices of the new religion. A story about St Francis of Assisi (d.1226), founder of the Franciscan monastic order at the beginning of the thirteenth century, demonstrates how the pagan rose of pleasure and sensual joy was repurposed as the Christian rose of piety and spiritual victory. St Francis was so haunted by the memory of a beautiful woman that he threw himself into a brier bush as an act of penance, and for this action was rewarded by a vision of Christ with the Virgin Mary at his side, and immediately the thorns on the brier turned into roses.

Further evidence of how Christianity absorbed the old pagan goddesses into its monotheistic creed can be found in a legend associated with the Dog Rose of Hildesheim, mentioned in Chapter 2. In the summer of 815, Emperor Louis the Pious, son of Charlemagne, was out hunting when he fell from his horse, got lost in an immense forest and eventually found his way across a river to a mound that was sacred to the ancient Saxon fertility goddess Holda (also known as Hulda, Hukda, Holla and Frau Holle), a version of the Great Mother Goddess from pagan tradition beyond the Greek and Roman world. The mound was covered in Holda's sacred flower – the wild rose. Louis prayed for rescue over his portable reliquary of the Virgin Mary and then fell into a deep sleep. When he awoke, the mound was covered in snow, but the roses were blooming more vigorously than ever. When Louis tried to pick up his reliquary, he found it was frozen fast in the midst of the rose bush, and he saw this as a sign that rather than her, the goddess wanted the Virgin Mary to henceforth be worshipped on this spot. Eventually, Louis was reunited with his hunting-party, and resolved to build a cathedral to the Virgin Mary on the spot where the wild rose grew. As is often the case, the legend is based on historical fact: the place where the present cathedral is built was indeed once sacred to the pagan religion that preceded Christianity, and Louis did transfer the See to the site in 815.[1] But in becoming a legend, the events take on deep symbolic

meaning, signalling through the rose the conversion of a pagan people to Christianity.

Every year at Pentecost, in May or June, thousands of red rose petals are dropped from the oculus of the Pantheon in Rome upon the congregation gathered for Sunday Mass. As the rose petals flutter to earth from high up in the oculus, pagan pleasure and luxury are transformed by faith into piety, sacrifice, fidelity and spiritual love. Pentecost is fifty days after Easter, and celebrates the moment when the Holy Spirit entered the Virgin Mary and the apostles during the Feast of Weeks in Jerusalem. The tradition in the Pantheon, which probably began in 607 when the pagan temple became a Christian church, is clearly a throwback to Roman custom. The tradition of showering rose petals from above onto a crowd dates back to pre-Christian times, and so does Pentecost, which evolved from the Jewish custom celebrating the early harvests. The Roman *Rosalia* festival, which was dedicated to the rose, was also in May or June.

Surprisingly, even though the rose is indigenous to the Near East, it has almost no presence in the Bible. In the Old Testament mention is made of the 'Rose of Sharon', but this turns out to be an entirely different plant – hibiscus. The general lack of interest in the rose can largely be attributed to the fact that in Judaic tradition it was held in low esteem, being tainted by an association with pleasure. The rose's sensuous beauty was linked with luxury, lasciviousness and frivolity. Its wide-scale use as a fragrance, and notorious role under the Romans in orgies and extravagant banquets, and its sacredness to the pagan goddesses and gods of love and revelry, clearly also informed such disdain, which would subsequently be carried over into Christianity. The Old Testament made clear that humanity's role was the taming and overcoming of nature, a task that was also pleasing to God. Nature in this cosmology was something to be exploited as a useful resource, providing bodily sustenance. In Genesis for example, it is written: 'And God

said, Be fruitful and multiply, and fill the earth and subdue it; and have dominion over fish of the sea and over birds or the air and over every living thing that moves upon the earth.'[2]

The Christian worldview assimilated this Judaic principle of the separation of humanity from nature, and also absorbed Platonist and Neoplatonist philosophical arguments concerning the purpose of human life, and the need for the subjugation of nature as a lower order of existence compared to that attainable by the spirit. The instincts, which are 'nature' within humanity, were deemed sinful, and therefore to be assiduously resisted and overcome. Christianity is, paradoxically, a religion of love that is hostile to the human appetites, and the good Christian must show his or her love for God through piety and abstinence, in a continuous struggle to be liberated from enslavement to the body's cravings. As a result, *eros* was supplanted in the human heart by *agape* – 'charity' or 'selfless love', the love of a parent for their child, of God for humanity and humanity for God.

So, when Emperor Constantine made Christianity the state sanctioned religion of the Roman Empire in 380, the rose found itself growing on the wrong side of the new religious divide. Its associations with sensual beauty, pleasure, sex, luxury and hedonism, and with the pagan goddess of love and god of revelry and excess, made it for the early Christians an explicit floral symbol of all that they sought to reject. Clement of Alexandria (150–215) declared crowns of roses to be excessively and dangerously pagan, and Tertullian (b. 160) advocated strongly against them. But as time went by, the Church Fathers came to recognize that as long as pagan symbols like the rose were translated into allegorical symbols that bound them securely to the Christian message, they could be rescued from their sinful association with lascivious pagan beliefs and put to good use in communicating the Christian message.

A poem by the English poet George Herbert called 'The Rose' (1633), speaks of the essential double-sidedness of the Christian rose through juxtaposing a rose of 'pleasure' with a 'gentle rose' of Christ. The rose may be sensually 'sweet', Herbert writes, but it also 'purgeth',

and 'biteth in the close'. That is, the Christian religion had transformed the rose into a beautiful image of love envisaged as a struggle against and overcoming sin, and as an image of forgiveness through Christ.[3] As long as the Christian was taught to see through the world of sensual seductiveness, and they concentrated on how the manifold things of the world all play their role in the great allegory of faith, it was permissible to incorporate elements of the natural world into religious practice. Nature as a whole was cast as God's 'second book'. 'I want creation to penetrate you with so much admiration that everywhere, wherever you may be, the least plant may bring to you the clear remembrance of the Creator,' wrote St Basil the Great in the fourth century. 'If you see the grass of the fields, think of human nature, and remember the comparison of the wise Isaiah. "All flesh is grass, and all the goodliness thereof is as the flower of the field."'[4] Rather than sensory presences, roses were to be memory aids or prompts guiding the believer to higher thoughts concerning their salvation.

Slowly, a new Christian allegorical rose began to sprout multiple branches – layers and varieties of meaning that related to different aspects of the faith and contexts.[5] Garlands of roses returned to festivals, now symbolizing heavenly rather than earthly joy. The red rose symbolized sacrifice and expiration, Christ's suffering or the martyrdom of the saints. It represented Christ's wounded sacred heart. Christ's blood was said to be 'rose coloured', and his wounds corresponded to the rose's petals. Christ was described as 'the rosebush', in which 'each drop of his precious blood is like one of its blossoms'. The thirteen-century Dominican Albertus Magnus wrote of 'the rose made red by the blood of Christ in his passion', offering the Christian version of the perennial story of how the first red rose came into being. The rose's prickles were the crown of thorns worn by Christ on the cross. The cross upon which he was crucified was itself a rose-tree. A popular medieval English carol has the following refrain: 'There is no rose of such virtue / As is the rose that bare Jesu; / *Alleluia*.'[6] Christ's resurrection could be likened to the splendour of a blossoming rose. Roses and thorns were also commonly associated with the martyrs and saints.

Roses bloomed from the blood drops of St Francis of Assisi. In the *Golden Legend*, a thirteenth-century collection of the lives of the saints, the stories of the female martyrs St Cecilia and St Dorothy describe heavenly roses sent from paradise. As a white rose symbolized purity it was also worn by a new Christian bride as a crown. Another medieval hymn has the following refrain: 'Mary the Wheat-sheaf, Christ the living Bread; / Mary the Rose tree, Christ the Rose blood-red.'[7]

Because of their connotations as pure and splendid floral creations, lilies and roses were especially dedicated to the Virgin Mary. In depictions of the annunciation, the Archangel Gabriel holds in his hands a lily to signal the Virgin's perfection, but it is above all thanks to the rose's multi-layered associations with the Virgin Mary that it has become such a significantly sacred flower within Roman Catholicism. A profusion of Latin hymns and sequences slowly accumulated invoking the rose in order to praise the Virgin Mary. She is the 'noble rose', 'fragrant rose', 'chaste rose', 'rose of heaven', 'rose of love', 'never-wilting rose'. She is the 'woman for all seasons', the 'new Eve', the supreme model for all times, the '*Rosa Mystica*', the 'eternal feminine'.[8] St Bernard of Clairvaux (1090–1153), founder of the Cistercian monastic order, compares Mary's virginity to a white rose and her chastity to a red one. In the *Golden Legend*, the miracle of the Virgin Mary's assumption is heralded by the white roses of the martyrs.

Within Roman Catholic doctrine women have a problematic status.[9] After all, Eve was deemed responsible for bringing about the Fall and causing original sin. The Letters of St Paul reflect his belief that the baptismal creed erased the pagan hierarchies that subordinated women, and so made it acceptable for women to take an active and more equal part in worship. But Paul also argued that women were all tainted by the sin of Eve, who 'was deceived and became a transgressor'. As a consequence, Paul wrote that a Christian woman must be silent and cover her head in church, not 'have authority over men', and could only be 'saved through bearing children' (1 Timothy 2.11–15). Women's role in the rituals of intense piety and asceticism was therefore inevitably subject to control, and in seeking to firmly

subordinate them while also forging an aspirational spiritual narrative, the cult of the Virgin Mary was intended to refashion woman in a form acceptable to Roman Catholic doctrine by representing her as a new role model. The Virgin Mary is simultaneously the Mother of God, including the 'Mater Dolorosa' or the suffering mother, and the Blessed Virgin. She is the 'second Eve', who cleanses humanity of the sins of the first Eve. In the fourth century, St Ambrose wrote: 'Let, then, the life of Mary be as it were virginity itself, set forth in a likeness, from which, as from a mirror, the appearance of chastity and the form of virtue is reflected.'[10] St Jerome (347–420 AD) emphasized Mary's perpetual virginity, even as he also praised her as Christ's mother, saying that 'the mother of the Son [of God], who was a mother before she was a bride, continued a Virgin after her son was born'.[11] Mary was called upon to personify the virgin, bride, mother, queen, mourner. She was full of divine grace, a spiritual intercessor, dispenser of grace to the faithful and principle of transcendent spiritual union. Mary was, indeed, 'alone of all her sex', as the fifth-century poet Caelius Sedulius wrote.

In order to help give tangible form to the complex symbolism of the Virgin Mary, the Church evolved a 'Marian' rose, progressively neutralizing its associations with paganism through downplaying its sensual perfume and symbolically removing its dangerous thorns, so that a flower that had been closely allied with the Mother Goddess, and especially with *eros*, was replanted in the Christian garden as the flower of *agape*. St Jerome described Mary as the *rosa pudoris*, 'the rose of modesty', and argued that the roses that grew in the Garden of Eden were without thorns, and gained them only as a result of the Fall. Eve is the thorn bush, and Mary the rose flower. The prickles therefore symbolize original sin. This is why a common term of address for the Virgin became the 'rose without thorns', since she was immaculately conceived. The sixteenth-century composer of sermons, Cornelius van Sneek wrote: 'And as in the morning the rose opens, receiving dew from heaven and the sun, so Mary's soul did open and receive Christ the heavenly dew.'[12] She was the model of faith in the word of God. It

was said that on the third day after the Virgin Mary's burial, mourners at her tomb found her body had vanished and that her shroud was full of roses. 'Mary is the most beautiful flower ever seen in the spiritual world . . . and therefore, is called the Rose, for the rose is called of all flowers the most beautiful', wrote the English Catholic convert Cardinal Newman at the end of the nineteenth century in an essay that sought to explain the multilayered symbolism of the Marian rose as it had coalesced by that period.[13]

Mary was also dubbed 'God's rose garden'. In the Old Testament's Song of Songs there are the lines: 'She is a garden enclosed; / My sister, my promised bride', and this served as the scriptural basis for referring to the Virgin Mary as a *hortus conclusus* – 'enclosed garden' – a symbol of her perpetual virginity. After the institution of the Feast of the Immaculate Conception in 1140, the *hortus conclusus* became the standard symbol of Mary's womb. Eventually, the symbol of Mary as enclosed garden became one of the most frequently used in devotional writings and, as we will see in more detail later, in pictorial representations.

As she represented perfection, Mary was also exemplary among mortals; a model indicating how women must strive to be in daily life. But she was also the *Rosa Mystica*, the 'Mystic Rose' – a transcendent vision for all humanity. She embodied the fulfilment of the soul's journey on earth, personifying the aspiring, ascending principle. The title *Rosa Mystica* dates to early Greek Christian litanies, and reappears in the twelfth-century Latin litany of Loreto.[14] Here too the rose is invoked. In mystical writings Mary is described as the perfect soul, the one who has 'attained the rose'. Dante Alighieri (1265–1321) in the *Divine Comedy* praises Mary as the 'Rose in which the Word of God became flesh'. In the third part of the *Divine Comedy* – *Paradise* – Beatrice leads the pilgrim Dante to a rose that is formed from a ray of light reflected off the outer surface of the *Primum Mobile*, a huge white sun-like rose composed of countless petals of holiness – saints, angels, and all those who embody goodness and virtue:

> Into the yellow of the eternal Rose
> that slopes and stretches and diffuses fragrance
> of praise unto the Sun of endless spring,
>
> now Beatrice drew me as one who, though
> he would speak out, is silent. And she said:
> 'See how great is this council of white robes!'[15]

The queen of this gigantic rose is the Virgin Mary, and St Bernard, who was noted for his love of rose symbolism, gives the pilgrim a tour. This Mystic Rose is a huge structure a thousand tiers high and the circumference at its base is described as wider than the sun. There is no time, and natural laws do not apply. This rose is, in effect, a vision of eternity, and symbolizes the fulfilment of human destiny through communion in the love of God. The angels fly like bees between God and the rose, carrying his love. Beatrice enters the rose, and the pilgrim expresses his gratitude for the experience grace has brought him, a grace that leads him from bondage to sin and worldliness into the presence of God in paradise. Dante's Mystic Rose is the sublime material portal through which divine love enters the material world, bringing it to fulfilment, and Dante's final vision represents the summation of the many symbolic meanings of the rose in the medieval period.

The most commonly recited private devotion for Catholics is the Rosary, an oral repetition of a serial meditation comprised of 150 *Ave*'s ('Hail Marys') in groups of ten, punctuated by the 'Our Father' prayer, during which the worshipper meditates on different aspects of the Christian story and faith. Physically, a rosary is a string of knots or beads, to be touched or moved one by one. *Rosarium* was a term used to describe hymns of praise, most particularly of the Virgin Mary. In Middle English, 'rosary' means 'rose garden'. Collections of texts were known as 'posies' and 'flower-gardens'. For example, in the fourteenth century a Benedictine abbess composed a *Rosarium Jesu* – a 'Jesus Rose Garden' – of fifty rhymed prayers. Eventually the term 'rosary' or a 'chaplet of roses' came to be used for the prayer beads. In

the Proper Mass for Rosary Sunday, the phrase 'like a rose planted beside waters', which is taken from the Song of Songs, is recited, indicating that the string of beads is conceptualized in Catholicism as a rose-garden, and embodies the wisdom of the Virgin Mary. As Eithne Wilkins writes succinctly: 'A rosary is both a rose-garden and string of beads.'[16]

The architectural equivalent to the rosary is the rose window, the glory of many Gothic cathedrals, such as Notre Dame in Paris, Chartres, St Albans, Durham and York. The mullions radiate from a central roundel and are filled with stained glass, a form that evokes the symmetry of the five-petalled species rose, transforming it into a vision of coloured light, of God's grandeur and the Virgin Mary's powers of intercession. Dante probably had the huge stained-glass rose in mind when he imagined the mystical rose in the *Divine Comedy*.

But Catholicism is not alone in revering the rose as a flower with profound religious symbolism. In fact, the deeper engagement with the rose in Catholicism was also encouraged through the intimacy forged by conflict with the new rival monotheistic religion, Islam, which was formally sanctioned by the Church through the Crusades spanning the period 1096–1217 in the Holy Land, and extending until 1492 with the defeat of the Moors' caliphate, *al-Andalus*, on the Iberian peninsula. In the seventh century Muhammad received what he claimed was God's literal speech and last revelation – the divine message of the Qu'ran. By the eighth century, Islamic rule extended from Iberia in the west to the Indus River in the east, and by the thirteenth century the Christian Byzantine Empire in Eastern Europe had fallen, and by the sixteenth century, under the Mughals, almost the entirety of South Asia was under Muslim control.

The rose is barely mentioned in the Qu'ran, no doubt because it wasn't a common flower in the desert region inhabited by Muhammad and the first Muslim converts. Nor was it noted as a flower in the

detailed descriptions of paradise. However, eventually, the rose would come to have special spiritual significance in Islam. It is the flower of Heaven, and to this day during the Muslim pilgrimage to Mecca, the Hajj, the black cloth of the Kaaba is sprinkled with rose water, and fragrant rose oil is burnt in the Kaaba's oil lamps.

For, long before Islam, in what are now Iran, Turkey and Syria, the rose was deeply loved for its utility – culinary and medicinal – its symbolism and for aesthetic reasons. Rose water and petals had been an important part of daily life for centuries, and these conventions were wholly embraced by Islam. When Saladin triumphantly entered Jerusalem in 1167, he ordered the floor and walls of Omar's Mosque to be washed with rose water to purify it of the stench of the Crusaders. It was said that five hundred camel loads of rose water were needed, and that much of it came from Damascus. When Sultan Mehmet II conquered Constantinople in 1453, he had Hagia Sophia cathedral washed with rose water before converting it into a mosque.[17] Rose water was also used throughout Muslim lands as a flavouring ingredient for drinks and desserts such as ice cream, jam, Turkish delight, rice pudding, yogurt and sherbet. As we will see in more detail in Chapter 14, rose ointment and rose water were used for their medicinal benefits. Roses motifs also adorned Persian carpets, featured in miniature paintings, and were incorporated into architectural decoration. As Islamic tradition spread and assimilated the indigenous cultures of conquered lands, the rose also travelled. When the Mughal dynasty invaded India, it eventually merged Persian with indigenous Indian culture, making the rose an important feature of Indian life.[18]

As also occurred within Christianity, the pre-monotheistic rose of the Near East was assimilated into Islamic belief, becoming a botanical exemplar of the divine because of its beauty, a physical and olfactory manifestation of the Creator worthy of praise and celebration because divine and physical beauty were conjoined within it. The pink of the Damask Rose, the *Gol-e-Mohammadi* – Muhammad's Rose – mixes red and white, and was understood in religious terms as

symbolizing the light of the divine mixed with the red of humanity, as an encounter with God through love, which transformed Muhammad into a man who is mortal not divine, but without equal and beyond physical likeness. The glory of the Prophet therefore transcends physical matter, making him a problematic and often forbidden subject for portrayal, and one solution was to use the rose to allegorize his inexpressible, incommunicable qualities. Within Islam the rose came to serve as a visual relay through which the faithful could be transported from the material world of the senses to the invisible spiritual dimension within which Muhammad exists. Thus, Muhammad's physical appearance was frequently compared to the rose. The sweet scent is a reminder of his beauty. His appearance was also likened to a blossoming or rosebud in the garden of paradise. Muhammad is recorded as declaring: 'he who desires to smell my own perfume, let him smell the red rose', and was said to have plucked a rose and placed it on his eyes.[19] One story tells of how the rose grew out of a drop of perspiration which fell to earth during the Prophet's heavenly journey. Through its potent fragrance in particular the rose transcends both the visual and the verbal, activating profound memories and experiences by drawing on the most insubstantial of our senses. The twelfth-century Persian poet Nizami directly addresses Muhammad, saying, 'If you are a rose, send us perfume from your garden.'[20]

The word 'rose' in Persian – *gul* – is written the same way in Arabo-Persian as *kull* – 'all' or 'cosmos'. As a result, the rose also became a metaphor for the mystery of the infinite universe. The thirteenth-century Sufi mystic Jalallub-din Rumi was especially skilful at exploring the metaphor of the rose in poetry to evoke the journey of the seeker after spiritual enlightenment for what he called the 'Beloved', 'like roses within roses'. Another Persian Sufi, Hafiz, from the fourteenth century, writes: 'The rose has flushed red, the bud has burst, / And drunk with joy is the nightingale / Hail, Sufis! lovers of wine, all hail!'[21] In Persia, the rose and the nightingale traditionally symbolize the lover and the beloved, and could be understood in both a profane and a sacred sense – love of another person and love of God. Like Rumi, Hafiz also uses the rose in

order to envisage pain and loss, beauty and joy, within a single process, as part of the same total cycle of existence:

> From Canaan Joseph shall return, whose face
> A little time was hidden: weep no more
> Oh, weep no more! in sorrow's dwelling-place
> The roses yet shall spring from the bare floor!
> And heart bowed down beneath a secret pain
> Oh stricken heart! joy shall return again,
> Peace to the love-tossed brain oh, weep no more![22]

As we will see in more detail in Chapter 13, the rose garden evoked in the poems of the Sufis was not just symbolic. It was a *real* hermitage to which to retire from the material world, that was at once tangible and a resonant spiritual symbol; a metaphysical garden, but also one firmly rooted in the physical experience of the actual rose gardens which were such a feature of Islamic culture. Much more than within Christianity, Islam's vision of paradise takes the material form of an actual garden, cast as the Garden of Eden. In fact, the word for paradise in Arabic is *al-janna* – 'the garden'. As a result, for the faithful, the life to come is understood to take place in a real garden of delight, where the pleasures or repose denied during this earthly existence of struggle is enjoyed for all eternity. So, the terrestrial garden provided not just a symbolic rendering of the paradise to come but also a *physical* glimpse of what it will actually be like.

The contact with Islam helped to nurture a renewed 'culture of flowers' in medieval Christian Europe, but the Protestant Reformation of the sixteenth century, with its emphasis on an ethos of intense piety, once again placed the rose on the wrong side of the religious divide. In relation to the natural world, Protestant belief ruled that anything not 'useful' to the furtherance of God's purpose for humanity was inherently evil, and

the pious faithful were compelled to adopt a much more sober relationship to Christian doctrine than the Roman Catholic, one which ensured that firm emotional boundaries and ascetic and frugal social decorum were rigorously maintained. An ascetic, devout and unadorned relationship to truth was demanded, one that encouraged plainness and frugality of oral language, and the banning of sacred imagery. Protestantism also entailed a radical form of iconoclasm, and it was far more hostile to flowers than Islam. The enforced imposition of the second commandment led to the banning of anything that might encourage or be deemed a residue of 'decadent' paganism within the Catholic religion.

Protestantism was especially detrimental to the Marian rose, because devotion to the Virgin Mary was judged to have no biblical sanction. It was a reversion to paganism that endangered the true religion's teaching concerning the faithful's direct relationship to Christ, the Son of God. The rose's beauty, like that of all flowers, seduced the eye and led the faithful away from the word of the invisible God, and so it must be shunned. In the reformed Church of England, the use of flowers in churches became strictly censored. But Protestant attitudes relaxed during the nineteenth century, and churches would be increasingly decorated with floral offerings. By the late nineteenth century, floral tributes at funerals became the norm, supplemented by porcelain flowers beneath glass. Among the stricter Nonconformists, however, resistance to such sensual display prevailed, and to this day often continues. Flowers are considered an unnecessary luxury, a frivolous distraction from the true spiritual goals of life.

In reaction to the threat posed by Protestantism, which led to the Wars of Religion in the sixteenth and seventeenth centuries, the leaders of the Catholic Counter-Reformation made it their doctrinal goal to reinforce the very aspects of their religion that the Protestants sought to reject. The Catholic Church set about dramatizing spiritual emotion, inviting the empathy of the devout believer through verse, homily, narratives of the lives of the saints, and in paintings, sculptures and architecture. In effect, the Church had decided that the best way to fight the challenge posed by the Reformation was by means of ever

more extravagant displays of stylized and exaggerated spiritual emotion. The senses of the faithful were to be aroused and even overwhelmed in the service of spiritual transformation. Protestants pejoratively described this Catholic position as encouraging dangerously empathetic 'enthusiasm', which risked drowning the faithful in an ocean of uncontrollable feelings.

The post-Reformation Church therefore actively encouraged the religious and ceremonial uses of flowers, and embraced the use of religious images as aids to worship. Paintings and sculptures of roses proliferated. Marian devotional roses in particular multiplied across many fronts, and the Church laid renewed emphasis on the Virgin Mary's capacity to directly intercede in human affairs, especially through apparitions and their attendant miracles. The Marian rose became not just a sign of the authenticity of the Virgin Mary's message, but also an active participant within history as an important sign – an apparition. The scent of a rose where none should be, for example, became a special sign of the Virgin Mary's miraculous presence.

The first recorded apparition of Mary to be closely associated with the rose occurred in Guadalupe, Mexico, in 1531, that is, very soon after the first Spanish settlers and their religion began to colonize the region.[23] A native peasant whose Spanish name was Juan Diego is said to have had a vision of the Virgin Mary on a hill near his home. Speaking in his language – that of the Aztec empire – she instructed Juan Diego to speak to the local bishop and ask for a chapel to be built on the site of the appearance. When Juan Diego did as he was bid, the Spanish bishop was sceptical and demanded a sign. The Virgin Mary instructed Juan Diego to look for flowers to pick, though it was winter, and to place them hidden in his cloak until he saw the bishop. These flowers were roses – the Virgin Mary's flower – and as it was winter, their appearance was therefore miraculous. When Juan Diego opened his cloak before the bishop the roses fell to the floor, and in their place, it was said, was an image of Mary (henceforth known as the Virgin of Guadalupe) imprinted on the fabric.[24]

Two other important rose-related apparitions of the Virgin Mary

occurred in 1858 at Lourdes in southwest France and Fatima in Portugal in 1917. Given the relationship of the rose to the iconography of the Virgin Mary, especially the importance of the rosary in Marian devotion, and the precedent set in Guadalupe, this is not surprising. At Lourdes, it was recorded that a peasant girl named Bernadette Soubiroux heard a noise like a gust of wind, and when she looked up towards a grotto saw, as she later recounted, 'a lady dressed in white, she wore a white dress, and equally white veils, a blue belt and a yellow rose on each foot'.[25] She was also standing on a wild rose bush, which as it was winter, was not in flower. The local parish priest asked for the mysterious lady's name, and demanded a test: to see the wild rose bush flower at the grotto in the middle of winter. He was evidently invoking the precedent set by the miraculous roses of Guadalupe. Later, the apparition extended her arms towards the ground, joined them as though in prayer, and said in the local dialect, *Que soy era Immaculada Concepciou* ('I am the Immaculate Conception'). The wild rose bush, however, did not bloom, although this failure did not prevent the rapid growth of the cult of Our Lady of Lourdes.[26] At Fatima, witnesses claimed to have seen a shower of rose petals during and after the apparitions.[27] In 1965, 2010 and again in 2017, the Shrine of Fatima also received a Golden Rose, the last one being delivered in person by Pope Francis. This is a distinction a pope grants to a person or shrine, church or city, as a token of recognition for noticeable services to the Church or the good of society. On his pilgrimage to Fatima in 2017 Pope Francis declared: 'Hail Queen. Blessed Virgin of Fatima. I implore to the world the concord between all peoples. I come like a prophet and messenger to wash the feet of all, around the same table that unites us. Together with my brothers, for you, I consecrate myself to God, O Virgin of the Rosary of Fatima.'[28]

In the devotions of the faithful to Christ, the Virgin Mary, or to the saints, it is the power of faith that is at work, and the distinctions that are familiar within rational, secular thought are no longer valid. The various symbolic

meanings given to the roses are often understood within contexts in which the people looking at, reading about, or using them are fired by the expectation that they shall witness something extraordinary, something miraculous. Confronted by the uncertainties and suffering of life, the devout find relief from disappointments and anxieties through faith in a benevolent and miraculous force. They seek spiritual sustenance and reassurance through their belief in what is, rationally speaking, impossible. Superstition, the survival of magical cult practices, suffuse the believers' responses to the sacred artefact, the associated narrative and the devotional practice that results. They find safety under a sacred canopy which protects them from life's inevitable cruelties. For them, belief is a covenant, and not merely ascent to a proposition.[29] In such circumstances, piety turns the rose into a sign of an extraordinary reality. Indeed, it is precisely the irrational or miraculous dimension that makes the sacred so compelling. Believers consider the gift of an answered prayer to a saint or Our Lady to actually be the scent of a rose, or even a *real* rose.[30]

Protestants were correct to perceive that subliminal allusions to the old pagan beliefs that preceded Christianity suffuse Catholicism. Such continuities connected it to a more primordial sense of the sacred. The Roman Catholic hierarchy, while initially sceptical, felt it politic to cautiously embrace the various miraculous manifestations of 'Our Lady', and the cults that grew around them. They wanted to make a stand not only against Protestantism but also against the scientific spirit of the modern age through condoning and embracing a radically contrasting worldview. The apparitions of Our Lady often involved illiterate or poor children, and were especially cherished by the female faithful, and the Church came to see them as a way of restoring, via the intense religious experiences of people of low status, older ways of experiencing nature within modern life, ways that connect human life to the cyclical processes of propagation, birth, fecundity and nurturing. The 'miraculous' apparitions of the Virgin Mary therefore reflect a deep-seated yearning for harmony with the wholeness of nature that is denied by the patriarchal hierarchy of the Church, but even more so by rationalistic and secular modern culture.

But from the point of view of both Christian and Islamic theology the rose's characteristic botanical morphology can also be seen to potentially pose a basic theological problem: why does the God of love make us suffer? The roses in the Garden of Eden are said by the Church to be thornless, just as the Virgin Mary is the 'rose without thorns'. It was the Fall that produced the thorns, and the Virgin Mary, the Second Eve, intercedes to help redeem humanity from sin. But, as the historians Anne Baring and Jules Cashford observe: 'Mary has what divinity she has not because she offers an image of the whole nature in all its manifest and unmanifest mystery, but only by virtue of being set apart from the laws of nature within which humanity is held.'[31] When it is imagined without thorns, the rose is no longer very closely linked to any real rose. In a sense, this is precisely the point.

In 1854, the Catholic Church declared Mary's 'immaculate conception', a condition which four years later Bernadette Soubiroux would announce to the world that the Virgin Mary was herself pleased to acknowledge. In 1954, the Church proclaimed Mary the 'Queen of Heaven'. But she is not also the 'Queen of Earth'. Although in her role as intercessor Mary acts as mediator between Heaven and Earth, she is unlike the pagan goddesses, who are queens of *all* of nature, both sacred and profane, benevolent and merciless. Through the Virgin Mary, the Church celebrates only the benevolent aspects of the mother archetype, revoking the ambiguous multiplicity afforded to the rose by the pagan goddesses, which embody the whole life cycle of the natural world. The Marian rose is purely allegorical, and is, like the faithful, safely sequestered from the messiness of organic reality.

FIVE

'And so I won my bright red rose'

LOVE AND THE ROSE

I began writing this chapter just before Valentine's Day, which in the United States was worth $20.7 billion in 2019. The average American spent $161.96 on gifts, meals and entertainment, and men spent twice as much as women. In 2018, according to the Society of American Florists, an estimated 250 million roses were produced for the special day in the USA alone. But people also gave and received huge quantities of products with red roses emblazoned on them – cards, chocolates and lingerie.[1]

That's quite a tally for an anniversary that seems to have been invented by the English poet Geoffrey Chaucer in the fourteenth century. His *The Parliament of Fowls* includes a love debate among birds who choose their mates on 'St Valentine's Day', and this is the first known mention of the annual festival of love. He seems to have consciously fabricated the festival, introducing it to the English court as a special courtly love anniversary, loosely derived from Catholic tradition.[2] The historical precedents include the fact that in the fifth century, Pope Gelasius made 14 February St Valentine's Day, after a martyred bishop, St Valentine of Terni. There is some documentary evidence supporting a link between this saint and ideas of fertility, but

it isn't substantial enough to warrant the forging of a concrete alliance that makes Valentine's Day the day of lovers. But thanks to Chaucer, by the middle of the eighteenth century friends and lovers were exchanging small tokens of affection or handwritten notes on 14 February.

The arrival of printing technology capable of mass-producing greeting cards, the emergence of the advertising industry and cheaper postage rates, encouraged the channelling of expressions of amorous affection towards this one particular anniversary. Roses were already traditionally associated with love, a fact reflected in the nineteenth-century vogue for floriography – the 'language of flowers' – where different flowers stood for different emotions. The red rose was associated with deep love, becoming the flower of choice to signal one's love for someone. In this way, therefore, the grounds for the co-opting of the rose for an anniversary celebrating love became more or less inevitable, despite the fact, of course, that February is not a month known for its rose blossom. (More on the 'language of flowers' later on.)

Historically, Chaucer's fabricated festival is to be seen within the context of the growing social tension between the obligations of sacred and profane love during the Middle Ages, and it specifically emerges from the attempt to establish a union of the two in the medieval courtly love tradition. In 1074 Pope Gregory VII had affirmed that sexual intercourse was a sin, that women were by nature temptresses and that priests must be celibate. Sexual desire was understood to come from a lower source shared with animals, one which the Church Fathers judged women to be especially susceptible, and they therefore had to be carefully controlled. But as time went by, doctrine slowly shifted towards a somewhat more realistic position, and at the First Lateran Council in 1123 it was declared that divine grace was not just reserved for virgins, and that married woman could also experience it, and in 1204 Pope Innocent II proclaimed that marriage between man and woman was one of the Seven Sacraments.

Meanwhile, crusading knights returning home, influenced by their encounters with Arab culture and by the troubadour tradition that had spread across the Occitan region of southern France among the

heretical Cathar sect, created the context for the emergence of an aristocratic art of love, a highly structured set of conventions within which the 'beloved' was regarded with Platonic love, as a chaste ideal to be approached with worshipful adoration. Physical passion and sexual desire played no direct part in the courtship rituals, although always remaining latently present. But from this overtly asexual loving desire the aristocratic lover believed he achieved a heightened sense of virtue and purpose, a purification of his worldly status.

Within the courtly love tradition that emerged, animals and plants were often used to allegorize significant states of mind and intentions of the noble lover. A falcon, for example, represents the nobler aspirations.[3] But the rose in particular became an important symbol, as it was cast as the object of desire, the beloved's unobtainable body, but also her pure, invisible and immortal soul. The rose was the heart, indescribable beauty shifting back and forth as a signifier of 'pleasure' and 'gentleness'.

The most famous product of the medieval art of love is the *Roman de la Rose* – *The Romance of the Rose* – first published c. 1230, then republished c. 1275 with a long supplement by another author. In keeping with the conventions of the period, it is an elaborate allegory cast as a lover's dream quest. The Lover yearns to pluck a rose which he has seen on a rose bush reflected in the Fountain of Love at the centre of a walled garden. But he is initially unable to reach his goal because a thicket of thorns protects the rose. This first part of the *Roman* was written by an aristocrat, Guillaume de Lorris, who was deeply attached to the noble code of love. At the beginning of the story Guillaume writes: 'The matter is fair and new; God grant that she for whom I have undertaken it may receive it with pleasure. She it is who is so precious and so worthy of being loved that she ought to be called Rose.'[4] But Guillaume's narrative, which most scholars believe is unfinished, ends before the Lover plucks the rose – that is, before he attains the object of his desire. The continuation of the *Roman* was by a very different author, one Jean de Meun. In between the moment of the first sighting and the final deflowering of the Rose, as described by de Meun, the story the two authors share tells of various trials and recounts advice given by a

host of allegorical figures including Reason, Chastity, Jealously, Fair Welcome, the God of Love, False Seeming, Constrained Abstinence, Evil Tongue, Courtesy, Largesse and, of course, Venus. Jean de Meun was a university man rather than an aristocrat, and he effectively turns the story into a long and often didactically digressive account that, in many ways, mocks Guillaume's and the whole courtly love tradition's delicate and noble goals. Jean concludes his story as follows:

> I grasped the branches of the rose-tree, nobler than any willow, and when I could reach it with both my hands, I began, very gently and without pricking myself, to shake the bud, for it would have been hard for me to obtain it without thus disturbing it. I had to move the branches and agitate them, but without destroying a single one, for I did not want to cause an injury. Even so, I was forced to break the bark a little, for I knew no other way to obtain the thing I so desired.
>
> I can tell you that at last, when I had shaken the bud, I scattered a little seed there. This was when I had touched the inside of the rose-bud and explored all its little leaves, for I longed, and it seemed good to me, to probe its depths. I thus mingled the seed in such a way that it would have been hard to disentangle them, with the result that all the rose-bud swelled and expanded. I did nothing worse than that.

Then, a few lines later, the Lover declares: 'I plucked with joy the flower from the fair and leafy rose-bush. And so I won my bright red rose. Then it was day and I awoke.'[5]

'Few books have exercised a more profound and enduring influence on the life of any period than the *Romaunt of the Rose*. Its popularity lasted for two centuries at least,' wrote the historian Johan Huizinga. 'It determined the aristocratic conception of love in the expiring Middle Ages.'[6] And, as the *Roman* was usually lavishly illuminated, its influence was felt on both a textual and visual level. In the pictures, floral imagery is pervasive, not only because of the importance to the allegorical narrative of the garden setting and the rose bush, but also as a more abstract decorative motif. In one such illuminated version, we

see the moment just before the Lover finally plucks his rose. The deep-pink roses are clearly the Provins Rose – the Gallica Rose – which would have been very familiar to the readers of the *Roman*. But it is represented as many times its normal size.

One reason for the success of the *Roman* was the scandal it caused. Insofar as the medieval art of love was all about sexually unconsummated, spiritualized desire rather than conquest and successful physical gratification, Jean's ending deliberately seems to throw down a challenge to the conventions of courtly romance. The Lover's desire is very clearly satisfied. In 1399 the female poet and author Christine de Pisan, writing from within the circle of the court of King Charles VI of France, penned an influential *Epistre au Dieu d'Amours* (*Epistle of the God of Love*) in which she condemned the *Roman* as slandering woman, describing it as nothing better than a handbook for lechers. In effect, Jean had restored love to the world of male adventure and aggression, in which the goal is the indulgence of predatory sexual pleasure and the fulfilment of the prerogatives of procreation.

One fervent and influential admirer of the *Roman de la Rose* was Geoffrey Chaucer. As a young man, he began a translation into Middle English, but for reasons unknown only got as far as finishing fragments of Guillaume's text. The lines I quoted above from the modern English translation to the beginning of Guillaume's part to the *Roman* are rendered by Chaucer as follows:

> And that is she that hath, ywis,
> So mochel pris, and thereto she
> So worthy is biloved to be,
> That she wel ought, of pris and ryght,
> Be cleped Rose of every wight.[7]

The huge success of the *Roman* reflects the fact that the 'art of love' played such an important part in the lives of the nobility on an imaginative, intellectual, moral and behavioral level. This may seem surprising, because the medieval world was a very violent place. War, either

on the vast scale sanctioned by kings or popes, or unleashed randomly as a consequence of local animosities, was endemic. But the fact that love was elevated to such a high position is really just the complement to this bellicose reality. For in medieval culture, rather than pride or physical might, love was the recognized source of beauty, and as Huizinga noted, 'had to be elevated to the height of a rite. The overflowing violence of passion demands it. Only by constructing a system of forms and rules for the vehement emotions can barbarity be escaped.'[8]

By Chaucer's time, the convention that linked the rose to beauty, and then to the beloved, was evidently already very firmly established. In Dante's *Divine Comedy*, for example, the Pilgrim's guide to paradise is the mysterious Beatrice who, as we saw, leads him to a gigantic white Mystic Rose, symbol of spiritual love. Dante was clearly influenced by the *Roman de la Rose*, and the love Beatrice shows him is pure divine love; a 'Platonic' love that has banished sexual love.

Increasingly, it is an abstract, spiritualized rose that is evoked in European literature, one that stands for a vision of pure, carnally purified love. In Renaissance poems penned by noble lovers it became almost routine for the lady's eyes to be compared to the sun, her lips to coral and her cheeks to roses. The Elizabethan composer of song-books Thomas Campion writes: 'Rose-cheek'd Laura, come, / Sing thou smoothly with thy beauty's / Silent music.' In fact, the rose and the beautiful woman were by this period so closely linked in the male imagination that it amounts to a pervasive rose-woman hybrid image, one that is also strikingly described by Campion when he wrote: 'There is a Garden in her face, / Where Roses and white Lilies grow.'[9] In the works of Campion's famous contemporary William Shakespeare, for example, the potential of this woman-rose composite is much exploited. In *Love Labour's Lost*, Shakespeare writes: 'Fair ladies masked are roses in their bud: / Dismasked, their damask sweet commixture shown, / Are angels veiling clouds, or roses blown.'[10] In *Twelfth Night*, Shakespeare again plays with the poetic conceit. Orsino says to Viola: 'For women are as roses, whose fair flower / Being once displayed, doth fall that

very hour.' To which Viola replies: 'And so they are; alas that they are so. / To die even when they to perfection grow!'[11]

By the end of the eighteenth century, the English clergyman and nursery owner William Hanbury was therefore following a very well-established convention when he wrote of the Alba Rose, 'Great Maiden's Blush', and observed: 'As to its colour, can we justly form an idea of the finished beauty of a young lady, who is in every way perfect in shape and complexion, and whose modesty will give occasion (without any real cause) for the cheeks greatly to glow? Form yourselves an idea of such a colour at that time, and that is the colour of the rose we are treating of, properly termed "Maiden's Blush".'[12] Similarly, when the Scottish poet and songwriter Robert Burns around the same time described his lady love as 'like a red, red rose', he was clearly employing a very familiar trope.[13] Indeed, by the nineteenth century a man's love for a woman would be described in floral metaphors more than perhaps any other. Love is 'seeded', 'buds', 'blossoms', and is 'fragrant'. But love is also brief – it 'withers' and 'dies'. Love also 'pricks' like a rose thorn, bringing jealousy, anguish and sorrow. In fact, the rose's thorns add to the flower's rich source of amatory metaphors, and contributed to the rose's pre-eminence as a symbol of both the joy and pain of love. The thorns can speak of woman's cruelty, but it can also be a reminder of the physical dangers of unbridled carnal love. The Victorian poet Algernon Charles Swinburne writes: 'No thorns go as deep as the rose's, / And love is more cruel than lust.'[14] As we will see in Chapter 8, Swinburne's poetry shows that floral metaphors sometimes turn decidedly prickly, giving birth to a more dangerous species of eroticized rose-woman.

While love is central to human life, it is so wholly intangible that it depends on analogies like these to fix or clothe it, to make it substantial and communicable. The most basic strategy is to attribute the characteristic properties of love to a discrete entity and, to this end, the rose has proven extremely amenable. It is a beautiful, delicate, fragile,

fugitive, highly valued living organism, but one that is also, seemingly paradoxically, equipped with prickles, which make it also tough, potentially dangerous and to be treated with caution. The rose is a useful metaphor related to the fires and passions of bodily desire, but also the more ethereal realm of permanent and eternal love, in which the body fades into a refined passion for the immaterial. Love is conceptualized as existing within a hierarchy, and so the rose finds itself co-opted by the occupants of all the rungs of the ladder of love – from the licentious copulator and pornographer at the bottom via the romantic lover to the spiritualized communicant at the uppermost reaches.

In modern psychological terms, the allegorical personifications that appear in such profusion in the *Roman de la Rose*, for example, represent aspects of the Lover's psyche – Freudian symbols of the id and the superego battling for the control of the ego or, for the Jungian, aspects of the anima and animus, the male and female principles, and the light and shadow sides of the psyche. The conflicting 'inner voices', which are competing to control the Lover's thoughts and actions as he struggles with the emotional and ethical ambivalence generated by his powerful desire for a beautiful woman still seem surprisingly familiar, even to those of us in the twenty-first century coming to terms with the implications of the Me Too movement. We don't need Freud, or an especially dirty mind, to recognize that the quotation from Jean de Meun's finale to the *Roman de la Rose* is a thinly disguised fantasy of sexual dominance, of the aggressive deflowering of a virgin by a man who doesn't seem very concerned with how she feels, and that he might impregnate her.

Love, the noblest human aspiration, is all too often compromised and sullied by human baseness, and in this regard roses have proven very useful metaphors. Bronzino's seemingly delightful painting *An Allegory with Venus and Cupid* turns out, on closer examination, to be a good deal more complicated than just a pleasingly erotic frolic. If you look closely at the child holding the rose petals, you notice that his right foot is being pierced by a rose thorn. The symbolism is ambiguous. Perhaps the thorn simply alludes to the inevitable emotional

suffering of reckless and foolish love. But it is rather odd that the child's face shows no sign of the pain the thorn must have caused. One theory put forward, which at first may seem implausible, is that the child is suffering from syphilitic myelopathy and nerve damage, known as *Tabes dorsalis*. This is not so far-fetched as it might seem. Just fifty years before Bronzino's painting, the venereal disease syphilis arrived for the first time in Europe, perhaps from South America, and was recognized as the dreadful fruit of the 'act of Venus', hence the name for sexually transmitted diseases – 'venereal'. Note also the pain-wracked figure middle left in Bronzino's composition. Apparently, he displays all the signs of syphilitic anchonia. What is going on? Perhaps Bronzino is issuing simultaneously a come-on and a warning, which means his roses are also emblems of the far from innocent world of sexual risk.[15]

SIX

'Gather ye rosebuds while ye may'

DEATH AND THE ROSE

Many British people will have strong memories of the mountains of flowers left as a memorial to Princess Diana in September 1997; and many Americans, those left at Ground Zero after 9/11. Not long after the terrorist attacks of November 2015, I was in Paris and happened to walk past the Bataclan club, where more than 100 people attending a pop concert had recently died at the hands of Islamist terrorists. All along the railings on the opposite side of the road were various forms of tribute, including plenty of roses in many colours. These instances of memorializing flowers are directly symbolically linked to recently excavated graves near Mt Carmel, Israel, dated to between 13,700 and 11,700 years ago. For the site reveals the impressions made by the flowers and other plants that seem to have been deliberately placed under the bodies prior to interment.[1] But the modern-day use of roses as a tribute in relation to death is even more closely linked to a garland discovered in 1880 in a tomb in Hawarra, Egypt, which is today preserved in Kew Gardens, London. The date of the burial is put at 170 AD. When archaeologists rehydrated the dried flowers in the garland, they found it to be a species rose named *Rosa richardii*, which is also known as *Rosa abyssinica* or

Rosa sancta and, more colloquially, as St John's Rose, and Holy Rose of Abyssinia.[2]

Within the context of rites surrounding death, flowers have an obvious practical function. Their pleasant odours mask the fetid ones of putrefaction. But for the living, the visual beauty and beguiling scent of flowers also stimulates happy memories, a primordial sense of the joyfulness of life in the face of loss. Flowers establish emotionally affirming relationships. They remove some of the sting of death through merely being beautiful, and thus spaces of ritual mourning become places where the living can share time with the departed among symbols of joy. But in leaving flowers as token of remembrances, the living plant has also first to be picked – plucked – just like the human has been 'plucked' from life. Then again, the convention of offering flowers can satisfy the desire to control and overcome nature, to reaffirm the power that regulates the community, bringing order through contesting the unruly forces that lie beyond human control. In fact, the strewing of roses and other flowers can be a way to fabricate within the minds of the living an ideal world in which no one dies. Flowers belong to external nature, but are made part of an internal, imaginatively fired reality where nature does not necessarily hold sway.

A rose lends itself almost as readily as a metaphor referring to death as it does to love. It renders visible in an acceptable form the ineffable otherness of death. It contains death. By budding, blooming, withering, dying and decaying in such a short period of time, one can say the rose (or any flower) actually *enacts* death. Furthermore, the brief flowering period of the Western roses made them especially poignant in this regard. 'So passeth, in the passing of a day / of mortall life, the leafe, the bud, the flowre,' writes the sixteenth-century poet Edmund Spenser of a rose.[3] Sir Richard Fanshawe, a century later, directly addresses a rose, and his use of erotic imagery only serves to drive home more powerfully the sobering message:

> Thou blushing rose, within whose virgin leaves
> The wanton wind to sport himself presumes,

> Whist from their rifled wardrobe he receives
> For his wings purple, for his breath perfumes;
> Blown in the morning, thou shalt fade ere noon,
> What boots a life which in such haste forsakes thee.[4]

Human life, Fanshawe laments, is so vulnerable we should not place too much value in its transient pleasures and indulgences. Then again, intimations of mortality might also lead to the heightened desire to 'seize the day', in which case the fugitive nature of the rose's bloom is not so much a *memento mori* as a *memento vivere* – 'a reminder to live'. In *The Faerie Queene*, Spenser writes:

> Gather therefore the Rose, whilest yet is prime,
> For soone comes age, that will her pride deflowre:
> Gather the Rose of love, whilest yet is time,
> Whilest loving thou mayest loved be with equall crime.[5]

A century later, Spenser's words are closely echoed by Robert Herrick, who invites the young, whom he calls 'the Virgins', to enjoy sensual pleasures now as, soon enough, they will be old, and then dead:

> Gather ye rosebuds while ye may,
> Old Time is still a-flying;
> And this same flower that smiles today
> Tomorrow will be dying.[6]

By the second century AD, when the garland was placed in the tomb in Hawarra, the role of roses within the Roman Empire in the context of mourning, memorialization and commemoration had become quite sophisticated. Funerary associations visited tombs regularly to scatter roses on graves, and to deck funerary portrait-statues. By adorning a tomb with roses in springtime, the cyclical nature of life was

demonstrated in a beautiful manner. Many inscriptions record foundations for the annual strewing of roses, poppies and violets on graves, and those who could afford it gave instructions for the creation and upkeep of the gardens next to their tombs. As one poem-epitaph puts it:

> Sprinkle my ashes with pure wine and fragrant oil of spikenard:
> Bring balsam, too, stranger, with crimson roses.
> Tearless my urn enjoys unending spring.
> I have not died, but changed my state.[7]

On the walls and vaults of tombs, paintings of red roses on white grounds and images of rose gardens were also common, allowing the Romans to step more firmly outside the natural order. For while a real rose was an ephemeral offering, a painted one remained unchanged all the year round, and so was a pictorial 'unending spring', at least for as long as the paint remained, and the tomb was not destroyed.

The Roman epitaph above reflects the belief of pagans that the departed have simply undergone metamorphosis rather than vanished. But pagan Romans also believed that sometimes the dead remained among the living as spectral souls or presences, and needed appeasement. So floral tributes were also offerings to please and placate. The Romans believed in the *di inferi* – 'those who dwell below' in the chthonic darkness. Some lost souls took on demonic form and tormented the living, and flowers could help moderate their haunting of the living. But once Christianity became the dominant religion in the Roman Empire, attitudes to death and to the rituals concerning death changed radically. The problem of the 'wages of sin', Adam's curse, and the absolute necessity for salvation, were now central to the lives of the faithful. St Paul writes: 'O death, where is thy sting? O grave, where is thy victory? The sting of death is sin; and the strength of sin is the law. But thanks be to God, which giveth us the victory through our Lord Jesus Christ.'[8] As Paul's letter to the

Corinthians makes clear, death for a believer in the new religion was no longer comparable to death for a pagan. It was now the beginning of eternal life in paradise.

For the Christian, human affairs must be approached only through reference to God's will. Material offerings to the dead were especially forbidden, in this context, because they implied that the dead could influence the lives of the living, and needed appeasing. As a result, making floral tributes and employing them in any kind of ritual fell out of favour, and when the use of flowers within Christianity gradually returned, commemorative roses and other flowers laid on tombs and graves were not so much understood as offerings made to the dead, which aimed to communicate and appease them, as signs of the devout piety of the living. In the period of the Reformation and the Wars of Religion, even the tradition of decorating tombs with flowers fell into disuse, especially among Puritan Nonconformists. Cemeteries were often neglected, and some became threats to public health.

It wasn't until the nineteenth century that the convention of floral memorial offerings really revived. By this period greater sums were being spent on funerals, and the expression of loss was increasingly accompanied by the decking of graves with flowers at regular intervals, a convention that nineteenth-century florists, just like their Greek and Roman forebears, eagerly exploited. The first modern garden and municipal cemetery, Père Lachaise, opened in Paris in 1804, and became a popular destination – for the living as well as the dead – and stalls and shops selling flowers opened nearby to serve the new clientele. But in 1847, the American Protestant and rose lover S. B. Parsons wrote disapprovingly:

> At the well-known cemetery of Père la Chaise [sic] which has often excited the ecstasy, admiration or praise of many travelers, but which in reality exhibits neither elegance, sentiment nor taste, wreaths of roses and other flowers are frequently seen upon the thickly crowded tombs, either as mementos of affection, or in compliance with a popular custom; while the

street leading to the cemetery is filled with shops in which are exposed for sale the wreaths of flowers.[9]

Today, Père Lachaise covers 45 hectares, and is full of elaborate family sepulchres in all the representative architectural styles: Greek, Roman, Byzantine, Romanesque, Gothic, Baroque, Neo-Classical, Modernist. As a result, by walking around it one also receives an architectural history lesson. Many of these edifices have startlingly realistic sculptures, some incorporating stone or metal roses. There are also real roses, newly laid or withered, placed by mourners on tombs, and planted in the cemetery's plots. Among many famous people, including Abelard and Heloise, Molière, Oscar Wilde, Marcel Proust and Edith Piaf, Jim Morrison, lead singer from the band The Doors, is also buried here. When I visited, fans had left red roses and cigarettes at his grave.[10] In another monumental cemetery in Milan, Italy, which was established in 1866 and covers 25 hectares, roses are especially in evidence. Many are planted beside graves. They look as though they have been growing for decades, and may well be varieties that are now impossible to find elsewhere, certainly not at one's local garden centre.[11] There are also plenty of roses in the cemetery's own well-maintained flowerbeds. When I visited, on fresh sunny day in spring, I was able to experience six manifestations of the rose in one go: stone, metal, plastic, cut, climbing and bush – and also roses in all the stages of the flower's life cycle. An especially moving tomb is that of Isabella Casarti, who died in 1889 aged twenty-four. She is sculpted in a hyper-realistic style as a beautiful young woman lying asleep in bed, with a crucifix on her chest. Her breasts are exposed, adding an erotic dimension – Eros and Thanatos share custody. Isabella's arms lie limply by her side, and a real red rose had been placed in her right hand – not too long ago, on the evidence of the state of the bloom. The juxtaposition was poignant. The hyper-realism of this genre of tomb sculpture briefly cheats death by producing an image so lifelike that we half believe the subject really

is just sleeping. But the organic rose betrays the truth, and sends the sculpture back into the realm of trickery and illusion.

An especially moving place to see roses in the company of the dead is the Somme in northwest France. Another flower, the poppy, is of course most famously associated with the First World War, but the rose also played an important role. In fact, the war gave birth to a brand-new rose-woman symbol: the Red Cross nurse. Here are the last two verses of a popular song from 1916:

> There's a rose that grows in no-man's land
> And it's wonderful to see
> Though it's sprayed with tears,
> it will live for years
> In my garden of memory
>
> It's the one red rose the soldier knows
> It's the work of the Master's hand
> 'Neath the War's great curse stands a Red Cross nurse
> She's the rose of no-man's land.[12]

The region of the Somme is still today predominantly rural, but in many places you can see the traces of trench-lines, and shell and mine craters. On the first day of what became known as the Battle of the Somme, 1 July 1916, the British sustained an appalling 57,470 casualties, with 19,240 killed. It was agreed by the combatants that the fallen should be buried as near as possible to where they died, so the area around the former front line in France and Belgium is marked with small and sometimes large cemeteries. The British, French and Germans each adopted their own style for interring the 'glorious' dead. To read the names carved on the cemetery headstones, or the simple phrase in Commonwealth cemeteries 'A Soldier Known Unto God', as the remains were beyond identification, is very moving. Among the immaculately maintained lines of headstones in the British Somme cemeteries, as elsewhere, bunches of roses in various stages of

decomposition are usually in evidence, as well as plastic ones, resting upon the graves or next to them. But roses also grow in the cemeteries' own flowerbeds. My visit was during the winter so there were no flowers, and the severely pruned specimens looked like miniature versions of No Man's Land. Whichever nation we are from, the convention is to leave roses for our war dead, and even though the ones on the British graves on the Somme were almost certainly purchased in French florists (and not even grown in Britain or France, as they were no doubt shipped in from the Netherlands or even Kenya) in this context they are somehow quintessentially *British* roses.

During and after the war, back home, there was also a great demand for memorial roses. Every village and town in Britain, France and Germany had a War Memorial built. London had the Cenotaph. One poem of the period, written by the nurse Charlotte Mew, called 'On the Cenotaph (September 1919)', includes the following sorrowful lines: 'And over the stairway, at the foot—oh! here, leave desolate, passionate hands to spread / Violets, roses, and laurel with the small sweet twinkling country things / Speaking so wistfully of other Springs / From the little gardens of little places where son or sweetheart was born and bred.'[13]

Two contrasting developments in recent times have worked to undermine the rose's significance as a symbol of death. On the one hand, the success of the modern breeders in prolonging the rose's period of inflorescence – which allowed me to admire roses in late November London – has inadvertently diminished the poignancy of the living plant as a *memento mori*. We no longer look at our garden roses and think with quite such finality 'Blown in the morning, thou shalt fade ere noon'. Instead, we can be assured that, while each bloom may be brief, our rose's total period of flowering will be spread over months, not a mere two weeks. But in stark contrast to this development, the typical shop-purchased cut roses, which have been transported to somewhere near

you from far away courtesy of cold-chain production, storage and distribution, will certainly decay much faster than any blossom you might have cut yourself from a living plant.

But today many of the roses and other flowers we see in cemeteries are likely to be plastic. These will not wither and die within days. My informal research reveals that some of these plastic flowers are designed to be planted in plastic pots filled with fake soil. Perhaps the Roman citizen mentioned earlier, who in his epitaph requested floral offerings so people think of 'unending spring', would have been satisfied with plastic roses if they had existed. They are cheap unproblematic proxies for the unreliably fugitive organic varieties. As people tend not to look too closely, such surrogates provide enough of the consoling effect of the real thing to suffice. So, it seems the vegetal original is no longer required; enough of the meaning of the symbol survives the transformation of the source into a representation, a simulacrum or low-resolution copy. This still manages to trigger the necessary positive associations. It is memory and tradition that furnish the grounds for the cathartic practice of presenting flowers in remembrance of dead loved ones, rather than the actual organic flowers themselves. But then again, surely much of the subtle underlying value implicitly encoded in the tradition cannot possibly be fully carried over once the connection to the source is severed. One could even say that a memorial offering of plastic roses feeds the dangerous illusion that we have placated, dominated and domesticated death, and so can continue to enjoy the fruits of life in blissful ignorance of our inevitable fate.

For me, the most poignant remembrance roses are the three white plastic ones that someone attached to the base of the lamppost outside our house in central France. They marked the spot near where a young man, late one icy night, skidded on the road, lost control of his car, crashed through our front wall and landed in our garden, where he died. We weren't staying in the house at the time, and the people who were had the terrible ordeal of discovering what happened. This was several years ago, and for three or four years the plastic roses stayed loosely tethered to the lamp post, getting grimier and grimier, and

constantly flopping over. I would regularly prop them up again. But whoever put them there seemed to have forgotten about their tribute, and they never tried to replace the roses. So, in the summer of 2016, and after quite a bit of deliberation, I decided they had been there long enough, and quietly threw them away. Dust had gathered, the colour faded, the plastic decomposed. People forget. And time leaves its trace even on a plastic rose.

Rose plants can themselves be dangerous, even killers. A few years ago, I woke up one morning to find a worrying lump in my right armpit, and knowing that this could be a sign that my lymph node was swollen, and was potentially a sign of a cancerous growth, I hastened to the doctor. After a short examination, he asked if recently I had been gardening. I replied that I had. Any roses involved? Certainly. In that case, said the doctor, in his opinion I had been pricked by a rose thorn, and the incision this created allowed bacteria from the soil or dust to get into my body. This can be very dangerous, as it may cause tetanus or worse. According to a British coroner's report from 2002, for example, a 61-year-old woman died due to septicaemia and necrotizing fasciitis, almost certainly as a result of being pricked by a thorn on a rose bush in her garden in Cirencester.[14]

My doctor was right. I was indeed in the bad habit of sometimes gardening without wearing gloves, and so my lymph node had swelled up in order to block the entry of the fungal or parasitic infection rising up my arm, which entered via the soil I had been working. He prescribed antibiotics, and I quickly recovered. But I inevitably began wondering which particular rose in my garden was responsible for the potentially lethal prick. After some reflection, and no doubt with a certain deliberate irony, I decided it was a rose I had been especially busy pruning: 'Peace'.

Later, I learned I am in exalted company. It seems in 1926 that the greatest poet of the rose in modern times, Rainer Maria Rilke (more on

him later), may have been killed by a rose. The story goes that on the occasion of a visit from a beautiful woman, Rilke, who was suffering from leukaemia, went to gather roses from his garden, and pricked his hand on a thorn. This small wound failed to heal, grew rapidly worse, and eventually both his arms became infected. The epitaph he chose for his grave is famously enigmatic:

Rose, oh reiner Widerspruch, Lust,
niemandes Schlaf zu sein unter soviel Lidern.

(Rose, oh pure contradiction,
desire to be nobody's sleep under so many lids.)

SEVEN

'Dat Rosa Mel Apibus'

MYSTICAL ROSES

These days, one is unlikely to think of the rose in relation to mystical experience. But as we saw in Chapter 4, one of the Virgin Mary's titles is *Rosa Mystica* – 'Mystic Rose'. As Cardinal Newman wrote, connecting the *Rosa Mystica* to the theme of the *hortus conclusus*: 'How did Mary become the Rosa Mystica, the choice, delicate, perfect flower of God's spiritual creation? It was by being born, nurtured and sheltered in the mystical garden or paradise of God.'[1] We also saw how the relationship of the rose to the immaterial realm of the spirit was important within Sufism. The mystical insights of Sufism, which emphasize the importance of seeking a direct and uncluttered embrace of the divine principle, involved the rose as a material representation of this goal.

But the spiritual vision central to Sufism also found marginal expression within Christianity. In *The Cherubinic Wanderer*, the seventeenth-century Catholic mystic poet Angelus Silesius evokes the rose as a striking metaphor for living 'without why'. Humanity, Silesius pointed out, is always *doing* things. We are aware of our doing, and are often concerned about what others make of our actions, and this, Silesius declared, is precisely the root of our unhappiness. By contrast, he wrote: 'The Rose because she is Rose / Doth blossom, never asketh

Why; / She eyeth not herself, nor cares / If she is seen of other eye.'² Silesius was employing the image of the rose to give beautiful concrete form to the observation that all too often we contract into ourselves in attachment to our own desires, and so we become 'closed', cut off by too much self-love. But when we are willing to 'open' ourself to God's gift, we will be truly with God. But this means letting go, or 'abandoning' oneself, as only then can the divine rush in, like a rose bloom opening to absorb the sunlight.

Silesius, in his turn, was inspired by the medieval Catholic theologian and mystic Meister Eckhart who believed that the truly spiritual life must be lived without any reason or purpose extraneous to the love of God. Eckhart was specifically protesting against the Catholic moral doctrine of the period that seemed to trade ethical behaviour for the divine favour of the Beatific Vision. Instead, Eckhart suggested that '[The just person] wants and seeks nothing, for he knows no why. He acts without a why *just in the same way as God does*; and just as life lives for its own sake and seeks no why for the sake of which, it lives, so too the just person knows no why for the sake of which he would do something.' Eckhart therefore counselled that we should strive to exist out of the plenitude of our own being alone. 'I live because I live,' he declared. 'God's ground is my ground and my ground is God's ground . . . You should work all your works out of this innermost ground without why.'³

Such refined uses of the rose as spiritual metaphor were also matched by its presence in much more arcane traditions in which its potential as a means of allegorizing the ascent of the seeker who is after enlightenment was imaginatively exploited, with often bizarre results. For the initiate, everything about the rose can take on spiritual meaning. Because the rose naturally reaches towards the sunlight it signifies the desire for transcendence of the body. As a rose blossom forms a circle, it symbolizes spiritual completion and perfection, the goal of the mystical work. As the petals are often folded in on each other and its roots

lie out of sight, it symbolizes the essential hiddenness of spiritual truth which must be revealed through magical ritual. The rose's elusive and impalpable scent alludes to the ineffability of the divine essence. As the rose is pollinated by the honey bee, it symbolizes the soul's impregnation with the 'gold' of higher spiritual truth. As it possesses prickles, it reminds the initiate of the necessity of suffering in the attainment of the priceless 'flower' of secret wisdom, but also that the wounds are noble, because they are the result of an uncompromising passion for divine love. When the rose is concealed in a closed rose garden for which one must seek a key to gain entry, it symbolizes the longing for secret knowledge which is revealed through love of wisdom, and which is only attainable through purity of heart.

Such analogies reveal that above the levels of symbolism accessible to ordinary people there also lie more rarefied dimensions of potential meaning which are hidden. There is the topological or moral meaning of the rose, wherein the rose speaks of attainments which can only be grasped if one is on the same journey towards enlightenment. And above this there also lies an even more refined level – the anagogical meaning of the rose. At this moment the rose becomes a symptom rather than a symbol. Deep meditation has prepared the mystic for the direct, unmediated experience of the divine principal, and at this ultimate stage the unreal and symbolic character of the rose falls away and only the form of the experience itself remains in pure consciousness. This deeply mystical experience has a 'noetic' quality, that is, it imparts special knowledge only to the one who is having the experience, and when one has arrived at this exalted level, one exists in an essential reality lying beyond both the senses and thought. So what is evoked cannot be described through normal language.[4] This is the archetypal meaning of the rose, which encapsulates the pure essence of divine wisdom as it is embedded in an intangible universal process or dynamic pattern. Within this exalted rose lies the secret 'mystery of the whole'.

The profane and sacred meanings associated with the rose also describe a hierarchy and opposition, one in which the values of the sacred dimension are always in danger of being polluted by the

compulsions and necessities of the profane. This stark opposition became particularly explicit in relation to the use of the rose within the Gnostic, Occult and Alchemical traditions. Gnosticism (*gnosis* means 'knowledge' in Greek) is a loosely connected set of beliefs that grew up alongside Christianity in the period of the Roman Empire and lingered on into the Middle Ages until extinguished by the Catholic Church as heresy. In Gnosticism the Greco-Roman myth of how the rose became red was re-envisioned in arcane allegorical spiritual terms as referring to *Theo-Sophia* – the secret knowledge of things divine. In Gnostic cosmology Sophia (Wisdom) emanates a flawed consciousness called the *Demiurgos* or 'half-maker' which becomes the creator of the material and psychic cosmos, and which is also therefore flawed. But opposed to this reality there exists the true deific component within Sophia which has created the true eternal cosmos. But this is not recognized by the demiurge, and there is therefore perpetual conflict in which humanity exists torn between the true and the false creators, and so must struggle to find its way towards authentic being. A text from the end of the third or beginning of the fourth century AD declares:

> But the first Psyche (Soul) loved Eros who was with her, and poured her blood upon him and upon the earth. Then from that blood the rose first sprouted upon the earth out of the thorn bush, for a joy in the light which was to appear in the bramble. After this the beautiful flowers sprouted up on the earth according to (their) kin from (the blood of) each of the virgins of the daughters of Pronia. When they had become enamored of Eros, they poured out their blood upon him and upon the earth.[5]

The erotic symbolism of the rose, which stems from its association with Aphrodite, is here conjoined with a powerful allegory of spiritual ecstasy dramatized within the Gnostic vision of a starkly dualistic cosmos in which an evil demiurge is pitted against a benevolent God. 'Pronia' is forethought or providence, and the allegory sees Eros, the uniting power of love, bringing order and harmony in the form of the rose among the conflicting elements of which the primordial Chaos consists.

The rose would also feature in the esoteric traditions of occult mysticism which permeate the Middle Ages. Arab philosophers were at the forefront of retrieving and disseminating what became known as the Hermetic occult doctrines from Greek texts ('hermetic' is from the Greek for 'hidden'), and these ideas gradually spread north and westwards into Europe. In the second century AD, Plato's concept of the immaterial essences had been refined within Neoplatonic mysticism into a doctrine that emphasized the absolute otherness of the One, the essence of the real. Then, in the early Renaissance this was joined by the mystical writings of Judaism embodied in the Cabala, as well as by alchemy, which explored the transformation of base matter through magic. Especially at the Medici court in Florence, and later in Elizabethan England, Hermeticism flourished secretly alongside Christian and humanist studies, and evolved a culture suffused by an undercurrent of interest in magic, the occult, alchemy and astrology. Here too the rose would come to play a significant allegorical and symbolic role.

Such occult traditions shared a fundamental concept: the macrocosm-microcosm. Close but hidden harmonies were understood to exist between the 'large-scale' (macro) cosmos and the small-scale, 'little' (micro) world of humanity, which when brought into correct alignment by an initiate who was inspired by true love of *Theo-Sophia*, made possible not only psychic but also seemingly 'miraculous' physical transformations. Belief in a correspondence between the macro- and microcosmic dimensions were therefore more than simply symbolic; they had transformational potential for those who knew how to bring them into alignment. For example, the planets were believed to be in correspondence with specific animals and plants, and the human psyche. Therefore, assessing the alignment of the planets was important for spiritual and physical well-being.

In the tradition of alchemy, it was believed that when the alchemist successfully established the correct inner- and outer-alignments it was possible to transmute base metal into gold. Important alchemical treatises included works with titles such as *The Rosary of the Philosophers* and the *Rosarium*. These drew on the well-established convention of

describing a treatise in floral terms, as well as the tradition of describing Mary as the *Rosa Mystica*, and prayers as roses or rosaries, envisaging the alchemical art as a rose garden, a metaphor borrowed from the Catholic tradition of likening Mary to a rose garden. Only those in possession of the 'key' could enter this secret realm. An important alchemical symbol was that of the pollination of the rose by the bee which, allegorically speaking, stood for the lovers of *Theo-Sophia* streaming by from all directions to gather the truth. The frontispiece of the Elizabethan magus Robert Fludd's *Summum Bonum* (1629), shows a single seven-petalled rose, designed like a medieval heraldic emblem, being pollinated by bees. Above, is written the Latin text: *Dat Rosa Mel Apibus* – 'The Rose Gives the Bees Honey'. The stem of the rose is also cruciform in shape. The seven-petalled rose bloom symbolizes the solar wheel, the *Rosa Mundi*, and the number seven is sacred to alchemy, representing the path taken by the seeker after gnostic wisdom. The journey can be dangerous – thorny – but the final goal is sweet, like honey to the bee.[6] An etching from the alchemical treatise called the *Rosarium* is a visual allegory of the vital moment in the 'Great Work', and also employs the symbol of the rose. The masculine spiritual energy is symbolized by the king standing on the sun, and the feminine soul energy of the bride stands atop the moon. They are brought into correspondence through the intertwining of rose branches, assisted by a dove, symbolizing the Holy Ghost, who reconciles the two opposing elements by adding a third rose branch. The union between *sol* and *luna*, male and female, is known as the *coniunctio* or *The Chymical Wedding*, and signals the transcending of the physical world and entrance into the spiritual.[7]

In some alchemical treatises, the red and white rose symbolize the male and female polarities, or the solar and lunar influences over the animal and vegetal world. The conjunction of a red rose and a wooden cross was understood in alchemical terms as the 'female' rose being attached to the 'male' cross. On another level of alchemical allegory, however, the rose and cross represent intellectual, spiritual and eternal beauty being 'crucified' upon the cross of the suffering world, the fallen

state the initiate hopes to transcend and purify. This alchemical symbol of the rose and the cross was especially important for the secret society known as Rosicrucianism, which was founded in the seventeenth century to study Hermeticism, alchemy, Cabala and Christian mysticism, merging them with the proto-scientific and humanist quest for deeper knowledge of the workings of the cosmos and advocacy of radical political reform of society. But even today, no one seems entirely sure why the Rosicrucians chose the title 'rose' and 'cross', but it probably derives from Christian Rosencreutz ('Rose Cross') the legendary figure at the centre of the so-called 'Rosicrucian manifestos' published in the second decade of the seventeenth century.[8]

In the eighteenth century the mystical Hermetic and alchemical tradition came under increasingly devastating attack from the nascent scientific thinking that became fundamental to the Enlightenment – the Age of Reason – and subsequently to the entire modern age. Now, there was no place for the arcane pretentions of Hermeticism, alchemy or Rosicrucianism. The scientific method rejected the macrocosm-microcosm principle, replacing it by the system upon which today's chemistry, physics and biology are founded. This was a new worldview that proceeded on the basis of the very different analogy in which the secrets of nature are understood according to the model of mechanism, and whose workings were reduced to mathematics. The seventeenth-century philosopher René Descartes argued that the only valid truth was that revealed through 'clear and distinct thought', which proceeds in a logical manner. This effectively overturned the pre-modern belief that if human reason is properly exercised, it grants spiritual or otherworldly illumination, and magical powers to transform reality. While the 'magician' sought domination through drawing the world into the darkness of his own subjectivity, the scientist externalized their subjectivity within the illumined world, dominating it through distancing and depersonalization. The mystical-occult insight into the macrocosm-microcosm was superseded by the abstract logical system of the modern scientist, which quickly reaped many benefits, especially in relation to medicine and technological innovation.

But the seemingly soulless society the scientific worldview brought into existence under the sign of the mechanical analogy, quickly provoked a reaction, and as the nineteenth century unfolded, visionaries, thinkers and artists emerged who hoped to strengthen the deep currents in Western mysticism and spirituality through the absorption of eastern philosophical and religious traditions which were becoming increasingly known through the translation into Western languages of Buddhist and Hindu texts. And once again the mystical rose would play its part. In France there was a briefly influential revival of Rosicrucianism, and in the final decades of the century the *Ordre Kabbalistique de la Rose Cross* was founded by Joséphin Péladin and his fellow initiates. Péladin was a well-known literary figure and dandy, who promenaded around Montmartre dressed as a monk. He was also a fervent Roman Catholic, and soon broke with his colleagues to found *l'Ordre de la Rose Croix Catholique, du Temple et du Graal*, in which he aimed to connect occult beliefs with the Church and also with the arts. Péladin organized several art exhibitions called *Salons de la Rose-Croix*, declaring: 'The artist should be a knight in armour, eagerly engaged in the symbolic quest for the Holy Grail, a crusader waging perpetual war on the bourgeoisie!'[9]

In Britain, the Hermetic Order of Golden Dawn was founded around the same time. This too proved briefly influential beyond the confines of those uniquely interested in occult philosophy, and included the poet Swinburne and the writer Oscar Wilde. The Anglo-Irish poet W. B. Yeats was an especially committed member of the Golden Dawn, who wore a rose on a 'rood' – or cross – as a pendant to symbolize the 'female' rose of intellectual, spiritual, eternal beauty united with the 'male' cross of worldly suffering. The symbol was intended to be a talisman to remind initiates to strive to overcome the material world in their quest for spiritual transcendence. In 'The Rose upon the Rood of Time', Yeats wrote: 'Red Rose, proud Rose, sad Rose of all my days! / Come near me, while I sing the ancient ways.'[10]

In the early twentieth century, the German philosopher Rudolf Steiner broke with the Theosophical Society, whose followers expressed

discontent with the materialism of the modern world and embraced both Western and eastern mystical and occult traditions, believing that they had identified the universal religion, and founded Anthroposophy. As Steiner described it, initiation into secret mystical knowledge must be as rigorous as any scientific experiment, and in his teachings he described what he called the 'Rose Cross Meditation', which drew on the Hermetic and alchemical tradition. An initiate is invited to consider the red petals of the rose as analogous to human blood in a purified state, that is, after the destructive aspects of the human passions have died away. Next, the initiate meditates on a wooden cross symbolizing what is left behind when the passions die. Following that, the initiate visualizes seven red roses of purified, transformed blood forming a wreath around the wooden cross. This is now a composite image of a rose cross, representing the victory of the higher, purified nature of the self over the lower animal dimension.[11]

Around the same time that Steiner was trying to organize Anthroposophy, the psychologist Carl Jung endeavored to comprehend the often bizarre-seeming allegories of the esoteric mystical tradition in terms that were understandable to the modern mind. For Jung, alchemy was above all a way of visualizing the quest for physical, emotional and cognitive individuation. He saw its bizarre symbolism not simply as illusions or fantasies but as mental projections corresponding to the modern psychology of the unconscious. Alchemists, Jung believed, had projected onto the realm of chemical change the same life processes evident in the dream worlds of his patients, and he saw their allegories as premodern attempts to describe the perennial struggle of the psyche to achieve total integration of the unconscious background to existence, which Jung called the process of 'individuation'.[12] Jung specifically studied the alchemical treatise the *Rosarium* from the perspective of his analytical psychology, and argued that this work symbolized the archetype of 'relationship'. He pointed out that there is an inherent affinity between opposites, and that if they can be synthesized, they become more than just a bolted-on combination of parts. The image I discussed earlier of the marriage of *sol* and *luna*,

with its intertwined rose branches, represented for Jung the integration of the animus and anima, the male and female aspects of the human psyche which, if achieved, permits the psyche to achieve a deeper, more holistic, level of experience.

While Jung was grappling with the arcane rose symbolism of alchemy, the German philosopher Martin Heidegger became fascinated by Angelus Silesius's rose that knows no 'why', and sought to free what he saw as a profound existential insight from the limits of a metaphysical Christian context and to place it within a modern secular worldview in which the goal was seen to be self-realization. Heidegger noted that in modern culture people value above all mental control, and crave clarity of communication, which is achieved through unambiguous, exact, graspable, objective and concrete information. There is nothing that is without some reason or ground. In other words, we excessively value the head over the heart.

Heidegger argued that the contemporary importance of the spiritual metaphorical rose envisaged by Silesius was that it is telling humanity to strive to live for the sake of life, not in relation to some external purpose. As Heidegger wrote: 'But blooming happens to the rose inasmuch as it is absorbed in blooming and pays no attention to what, as some other thing – namely, as cause and condition of the blooming – could first bring about this blooming. It does not first need the ground of its blooming to be expressly rendered to it. It is another matter when it comes to humans.'[13] Heidegger used the word *gelassenheit*, or 'releasement', to describe a state of unselfish surrender, letting-be or will-less existence. Such 'release', Heidegger declared, was what it means to live like a rose – 'without why'.

EIGHT

'Oh Rose! Who dares to name thee?'

POETIC ROSES OF THE NINETEENTH CENTURY

About one hundred years before Heidegger began musing on Silesius's rose, the American essayist Ralph Waldo Emerson looked out of his window on a spring morning in 1840 in Concord, Massachusetts. He saw roses in bloom, and wondered why people immediately turn them into symbols instead of just appreciating their joyful presence. The problem, Emerson concluded, lay with the character of a society which inevitably alienates its members:

> Man is timid and apologetic; he is no longer upright; he dares not say 'I think', 'I am', but quotes some saint or sage. He is ashamed before the blade of grass or the blowing rose. These roses under my window make no reference to former roses or to better ones; they are for what they are; they exist with God today. There is no time for them. There is simply the rose; it is perfect in every moment of its existence. Before a leaf-bud has burst, its whole life acts; in the full-blown flower there is no more; in the leafless root there is no less. Its nature is satisfied and it satisfies nature in all moments alike. But man postpones or remembers; he does not live in the present, but with reverted eye laments the past, or, heedless of the riches

that surround him, stands on tiptoe to foresee the future. He cannot be happy and strong until he too lives with nature in the present above time.[1]

Emerson was searching for new kinds of relationship to nature. He emphasized sensory experience, the oneness of the human and non-human in the present moment, and to this end drew on the mystical traditions discussed in the previous chapter. Natural forms should gain meaning and be enjoyed through being simply themselves, just as human life should simply be lived. This was an ideal that saw nature as no longer bound to an attitude that reduced it to utility, but was also freed from traditional symbolism. Central to this new pantheistic sensibility, which we now call the Romantic worldview, was the desire to praise the human only when it was deemed to be in harmony with nature. Humanity should be mostly silent before nature's majesty, and flora and fauna, geology and climate, should be our mentors or teachers. William Wordsworth wrote: 'For nature then ... / To me was all in all. – I cannot paint / What then I saw.'[2] Freed from the accretions that were imposed by tradition, people will learn to 'see into the life of things', and then even 'the meanest flower that blows can give / Thoughts that do often lie too deep for tears.'[3] Language should therefore be unshackled from reliance on over-familiar symbols. Wordsworth's friend Samuel Taylor Coleridge declared that he had no more need of roses (or lilies) to give poetic substance to the experience of being in love: "Tis not the lily brow I prize, / Nor roseate cheeks, no sunny eyes, / Enough of lilies and of roses! / A thousand fold more dear to me / The gentle look that love discloses, / The look that love alone can see.'[4] The overcrowded tradition in which a poet routinely compared the beloved to a rose was rejected so Coleridge could once again express directly, authentically, 'The look that love alone can see.'

The Romantics were greatly inspired by the eighteenth-century French philosopher Jean-Jacques Rousseau, the first influential voice promoting a counterculture which argued that the so-called 'Age of Reason' heralded by the Enlightenment was not characterized by progress and freedom but

by domination, appropriation and exploitation. The society coming into existence was inherently selfish and violent. 'God makes all things good; man meddles with them and they become evil,' Rousseau declared. 'He forces one soul to yield the products of another, one tree to bear another's fruit. He confuses and confounds time, place, and natural conditions. He mutilates his dog, his horse, and his slave. He destroys and defaces all things; he loves all that is deformed and monstrous; he will have nothing as nature made it.'[5] While people may be inherently good by nature, once they become enslaved in society they will be neither happy nor genuinely active citizens. 'Civilized man, is born and dies a slave,' Rousseau wrote in *Emile* (1762), and human society reduced all possible relationships to the world to only two: war and property.[6]

It was to oppose what they saw as the false and dangerous assumptions of science that the Romantics argued it was necessary to begin from the recognition that there was an intimate correspondence binding the human world to nature. Standing back and observing the world as if from the outside, 'objectively', inevitably leads to a loss of the fundamental and life-affirming truth of interconnectedness, and the human heart – the seat of the soul, intuition, imagination – is that part of the individual which instinctively recognizes the primacy of becoming and the inevitability of transformations. Certain ordered relations in the natural world correspond to significant aspects of being, but these affinities are all too often hidden by social convention. Therefore, announced the Romantics, it is the heart rather than the head that must be the basis for any true awareness of oneness within nature, and for all insights into the meaning of existence. As a result, the Romantic's rose will be a decidedly different kind of symbol to those encountered so far.

A poem by Emily Brontë, for example, describes a rose capable of capturing our attention through all four of the senses, and she also anthropomorphizes it in a new and more intimate way:

> It was a little budding rose,
> Round like a fairy globe,
> And shyly did its leaves unclose

> Hid in their mossy robe,
> But sweet was the slight and spicy smell
> It breathed from its heart invisible.⁷

Brontë mentions sight ('Round like a fairy globe'), smell ('sweet was the slight and spicy smell'), touch ('their mossy robe' is tangible) and taste. When a rose is used for medicinal or culinary purposes it involves the sense of taste. But here, smell is described metaphorically using a vocabulary of taste. We could say that Brontë's poem is also engaging sound. 'It breathed from its heart invisible' suggests audible respiration as well as movement. In fact, a rose plant does have an auditory dimension, as for instance, when it is agitated by the wind. Brontë has accounted for all five senses in describing her experience of a rose, and we should also probably add the 'sixth' sense; the 'soul', the intangible and emotionally engaging dimension to our experience. Brontë's various figures of speech also make original use of the fact that we often deploy one of the senses in order to better describe another, that on the level of metaphor synaesthesia is commonplace.

Two radically different ways of perceiving nature established themselves within Romanticism: the objective and subjective – the standpoint of the head and the heart. The tools of measurement-driven empiricism allow humanity to look at a rose with the detached, disinterested and objective eye of reason. But from the subjective standpoint, it is obvious that science's specialized and abstract language actually conceals the rose rather than truly reveals it, hiding the fact that the rose's essence as part of nature is reciprocity, and that there is the interpenetration of the non-human with the human. The rose as experienced by the Romantic is therefore inward and passionate, fundamentally mysterious, dark and chthonic. It cannot be analysed away. The characteristic state of mind for the Romantic is one of

yearning, of dreaming of a more complete reality, a superior order of being which is presently absent. In *Hymns to the Night*, the German poet Novalis wrote of the wonders of the daylight world, but then turned away and inward to consider 'the holy, unspeakable, mysterious Night'. It was only there, far removed from the safety of daytime, and within the dark shadow of death, that true enlightenment comes. The symbol of the 'blue flower' became for Novalis a metaphor of the unobtainable and impossible after which the true poet must quest, even at the risk of self-destruction.[8]

Within this heart-centred subjective vision, nature is defined under two aspects: the 'beautiful' and the 'sublime'. The beautiful evokes positive, pleasurable emotions of love that are socially beneficial, while the sublime is about fear, and engages emotions of self-preservation in the face of the awesome and overwhelming. Something deemed to be beautiful, in this sense, tends to be small, smooth, delicate, clear and bright. By contrast, the sublime is altogether more bracing as it is experienced in the presence of great size, unbroken uniformity, the powerful, the terrifying, the obscure, the gloomy.[9] Exploring the sublime means contemplating the chaotic and violent side of nature, and dwelling on the inability to fully escape its thrall, which is revealed most fully in the powerful emotional reactions we have to sex and death – Eros and Thanatos. Beauty is comforting and prone to provide easy satisfaction, and therefore far less challenging and invigorating than the sublime. The epitome of beauty could therefore be a rosebud or flower. The sublime, by contrast, is effectively cast as the 'anti-rose', and so for poets and artists inclined to pursue the sublime, the rose ceases to be a compelling image unless it can be made to reveal its sublime aspects. In Johann Wolfgang Goethe's deceptively childlike poem 'Heidenröslein' ('Heather Rose'), for example, which would be put to music by Franz Schubert, the thorns of the wild rose, the plant's defences against predatory animals, become a metaphor for a young girl's struggle and failure to protect her 'rosebud' – her virginity – from the unwelcome advances of a young man: 'Heathrose fair and tender! / Now the cruel boy must pick / Heathrose fair and tender.'[10]

The shadow cast by the darkness of the sublime also falls across William Blake's famous poem 'The Sick Rose':

> O Rose, thou art sick!
> The invisible worm
> That flies in the night,
> In the howling storm,
>
> Has found out thy bed
> Of crimson joy:
> And his dark secret love
> Does thy life destroy.[11]

Instead of the more common and consoling characteristics associated with 'beauty' Blake brings out the dark dimensions of sexual desire, and dwells on how the rose embodies the erotically charged violence of nature: 'The invisible worm / That flies in the night, / In the howling storm'. In fact, in both the poem and the picture Blake made to accompany it, there is a disturbing suggestion of auto-eroticism or masturbatory pleasure. The 'bed of crimson joy' has been interpreted by scholars as a metaphor for a woman's vagina being self-stimulated, but also, from a different but equally unsettling interpretative angle, these same words indicate an aggressive act of penetration by a male 'worm', or penis.[12] But perhaps the rose symbolizes the illicit and dangerous seductiveness of the temptress, and the 'invisible worm' is actually syphilis, a venereal disease which could be contracted or congenital. In Blake's time, doctors couldn't see the syphilis bacteria, which, being a sexually transmitted disease, 'flies in the night'.[13] But, in yet another reading of the same few lines, Blake might be understood to be alluding to something quite different: the inhibitions imposed by religious upbringing on young people as they start to explore their sexuality.

This is quite a heavy interpretative load for a poem of just eight lines, and Blake's poem shows just how flexible, how polysemic, the rose as a metaphor had become by this period. He also reminds us that

we fail to do full justice to the rose if we don't also pursue it into the chthonic depths, where it is sometimes employed to reveal complex and contradictory psychosexual dimensions.

The ambiguity associated with the rose as a symbol of love mirrors the ambiguity of the emotion itself, and the complexities of the relationship between the sexes. The male traditionally defines himself as the embodiment of reason and by removal from concern with the bodily sphere, which is then assigned to woman, along with the emotional, the irrational and the reproductive functions. Consequently, the idea became engrained within patriarchal culture that two opposing kinds of love, the sacred and the profane, struggled for supremacy within each human heart. True yearning and desire, true love of beauty, and true happiness is not for another's body but rather for their immortal dimension. As such, the beloved is loved only insofar as they provide a finite form for the permanent and changeless realm of ideas that lie beyond the ever-changing world of the senses. This idealization inevitably brought with it considerable anxiety concerning the male's ability to remain securely in a masterly position while simultaneously feeling the biological force of sexual attraction and responding to the necessity of procreation, and fulfilling his yearning for intimate connectedness with another human being.

In fact, the analogy linking the rose, the desirable woman and sexual intercourse had been given renewed vigour in the eighteenth century thanks to Linnaean botany, which effectively reversed the traditional direction of the sexual analogy linking human and plant. For Linnaeus interpreted flora according to the metaphor of the human bridal bed, where the consummation of stamens and pistils take place. The English physician and natural philosopher, Erasmus Darwin (Charles' grandfather) popularized such a sexual analogy through poetry, as in the following less than subtle lines: 'the wakeful Anther in his silken bed / O'er the pleas'd Stigma bows his waxen head'.[14] Through the common ground provided by sex, plants were humanized or anthropomorphized, and through the impact of the Linnaean system, the symbolic rose-woman-sex connection was re-cemented. A dominant metaphor

emerged within literature of the desirable female whose social and sexual maturation is expressed in terms of a woman's 'bloom' – she is a blooming flower and, most commonly, a blooming rose flower. But this was often cast in terms of a conflict between a botanical process and the constraints imposed by society.[15]

But darker implications concerning chthonic nature and human experience would also be read into the theory of evolution as it was interpreted from the mid-nineteenth century onwards, and this resulted in a challenge to the essentially pantheistic optimism of the early Romantics. In particular, Darwin's theory was understood to demonstrate that in the struggle for life the strong dominate the weak, and that the state of nature is the primitive stage of development that humanity must overcome. Nature must therefore be bested in order to move out of the wasteful and unpredictable swamp of the natural order. As the sociologist William Graham Sumner declared in 1881, applying Darwin's theory directly to human society: 'life on earth must be maintained by a struggle against nature'.[16]

As the nineteenth century unfolded, Rousseau and the Romantics' affirmative idyll of a pure and benevolent nature, from which humanity had been expelled through the corrupting influence of society and towards which it yearned to return, was to be increasingly challenged by a darkly eroticized vision in which the rose is often closely allied with the sublime, violence, danger and moral corruption. The complex, ambiguous and illicit dimensions of sexual desire and sexual transactions are no longer smoothed out within the pleasurable space of the beautiful, and unsettling, sordid, but nevertheless strangely alluring, realities are rendered visible. Within this 'decadent' worldview, the rose was often cast as a dangerously flowery plant with prickles, or as a dangerously prickly plant with flowers.

Fleurs du Mal (*Flowers of Evil*), the title of the French poet Charles Baudelaire's collection, published in 1857, plays on the well-established convention of describing a collection of poems as a posy of flowers, but Baudelaire presents us with a deliberate paradox – a juxtaposition of two apparent opposites. The beauty associated with flowers is joined

with the ugliness of evil. In French, the word *mal* can mean both 'evil' and 'disease' or 'sickness', opening up a richly metaphorical, but also a physically tangible, level of meaning. Purity, youth, sex, the life force and goodness, Baudelaire declares, coexist with impurity, decay, darkness, night, death and evil. As he wrote in the Preface to the collection: 'Since time immemorial the best poets have shared the most flowered spaces of the poetic realm. To me it seemed pleasing, and more agreeable than difficult, to extract the beauty of Evil.[17]

One target for Baudelaire was the fashionable but usually shallow vogue for floriography. In 1819, Madame Charlotte de la Tour had published a book entitled *Le Langage des Fleurs* (*The Language of Flowers*) in which she outlined the hidden meanings behind specific flowers, thereby launching a fashion that extended well into the twentieth century, and seems to be having a revival today, as the number of books on the subject testify.[18] Floriography weights flowers with precise symbolic meanings that are intentionally non-verbal, and as such provides a means of communicating without the formal and also ethical constraints imposed by words. Through plants one is able to speak a language of a different kind, often in ways that are deliberately secretive and illicit. In the 'language of flowers', when a woman gives the sweet-scented lily to a man, for example, it means 'This is my loved one'. The poppy signifies peace and sleep. The rose, it will come as no surprise to learn, symbolizes love. But the floral signals are nuanced. A red rose is passionate love and respect, a single rose in full bloom is an outright declaration of love. Pink roses are admiration, gratitude and joy. If they are light pink, this means sweetness and innocence, deeper pink is gratitude and appreciation. Yellow is joy and friendship. White is innocence and secrecy. Dark crimson is mourning. And so on.

During a period when more and more people were living in towns and cities, flowers were also promoted as a way to reconnect the urban dweller with the natural world in a pleasing and harmless way. 'A really well-made buttonhole is the only link between Art and Nature', declared Oscar Wilde. But when seen in a less genteel light, the 'language of flowers' could have darker implications. Within the Victorian demi-monde,

the poppy was associated with opium, a popular narcotic which was made from its seeds. As Baudelaire set out to demonstrate, seemingly innocent and lovely flowers can mask darker intentions. Flowers – and the rose in particular – were frequent symbolic props for the pornographer, who knew how useful it could be as part of a familiar vocabulary through which to encode illicit talk about women and sex. Here are some lines from an anonymous Victorian pornographic poem: 'Now my wanton fingers rove / O'er the beauteous mounds of love! / Now my eager lips I close. / On each blooming blushing rose!'[19] In the aroused male imagination of the nineteenth century, the rose as a metaphor for the female genitals would also sometimes signify a wound or snare. The fact that a rose's flower is so close to its prickle suggests the toothed vagina (the *vagina dentata*), the terror of castration, or venereal disease. The prickles could also speak of aggressive male sexual advances, the violent 'deflowering' of a virgin or, as in Goethe's poem, the opposite, the defence of the young virgin against male aggression.

Roses of vice weave their way through late-nineteenth-century literary and pictorial culture, signalling not just man's generalized fear of woman's sexuality, but also, indirectly, the very real danger of sexually transmitted disease, a serious problem in a society in which it is estimated that in this period there were as many as 80,000 women in prostitution in London alone. Within the Victorian Gothic imagination these strands blend and give birth to a crop of erotically transgressive and morbidly decadent roses. In the imagination of poets and artists, the innocent rose is recast as dangerously seductive, and wedded to carnal and psychological intoxication. The rose plays its role as a part in a drama in which beauty and love are placed alongside prostitution, venereal disease, adultery, deviance, violence and death.

In the French writer J. K. Huysmans' 1884 novel, *A Rebours* (Against Nature), the anti-hero, des Esseintes, is a collector of artificial flowers and abhors real ones. He wishes that nature's flowers could imitate his artificial ones, and examines hothouse specimens, describing them luridly as wounds and weapons, rotting and diseased. These flowers are the antithesis of the pleasingly beautiful. Some flowers seem to him to

be 'ravaged by syphilis or leprosy' and, so des Esseintes concludes, 'It all comes down to syphilis in the end.'[20] Huysmans expresses the deep-seated male terror in which the vegetative is equated with 'the swamp of female nature', as the scholar Camilla Paglia calls it. 'The female, with her dark, dank inwardness, is visually unintelligible. Medusa's pubic head is the plant world's writhing stems and vines; she is artistic disorder, the breakdown of form.'[21]

Woman, conventionally symbolized in terms of pure and compliant beauty, her eroticism carefully controlled, was transformed into a dangerously seductive force of nature. Innocence and sexual predation merge, with the rose blossoming firmly on the side of predation. A dangerous, but at the same time endlessly alluring rose-woman becomes a favoured preoccupation of several writers and artists, and the rose is frequently her consort. In *Abbé Mouret's Transgression*, Émile Zola uses a garden, and roses in particular, to express the overwhelming allure of the beautiful Albine:

> Above her head drooped an enormous cluster which brushed against her hair, set roses on her twisted locks, her ears, her neck, and even threw a mantle of the fragrant flowers across her shoulders. Higher up, under her fingers, other roses rained down with large and tender petals exquisitely formed, which in hue suggested the faintly flushing purity of a maiden's bosom. Like a living snowfall these roses already hid her feet in the grass. And they climbed her knees, covered her skirt, and smothered her to her waist; while three stray petals, which had fluttered on to her bodice, just above her bosom, there looked like three glimpses of her bewitching skin.[22]

Woman was also cast as a wild and emasculating temptress – a *femme fatale*. In the poem *Dolores* (1866), Algernon Swinburne transforms the symbolism of the Virgin Mary into 'Our Lady of Pain', and juxtaposes the lily and the rose, but puts them in opposition, so that the rose is very far from being a symbol of ideal beauty: 'Could you hurt me, sweet lips, though I hurt you? / Men touch them, and change in a trice / The lilies and languors of virtue / For the raptures and roses of vice.'[23] In

Swinburne, moments of pleasure are also moments of fear, violence and pain. Physical and mental boundaries are deliberately threatened, fractured and dissolved. The last verse of his 'The Year of the Rose' ends: 'A rain and ruin of roses / Over the red-rose land.'[24]

Alfred Lord Tennyson was also lured into the vice-ridden rose garden, exploring it as an ambiguous symbol of the pleasure and pain of sexual desire, and the conflict between idealism and the bitter realities of existence. In the long poem 'Maud' (1855), the rose undergoes metamorphosis from a symbol of life to one of decay, vice, violence and death. Tennyson begins by invoking the rose in characteristically romantic fashion – 'Roses are her cheeks, / And a rose her mouth.'[25] But he gradually introduces an uncanny note:

> Come into the garden, Maud,
> For the black bat, night, has flown,
> Come into the garden, Maud,
> I am here at the gate alone;
> And the woodbine spices are wafted abroad,
> And the musk of the roses blown.[26]

Eventually, nothing is what at first it seemed – 'And I almost fear they are not roses, but blood' – until we encounter a rose that has become synonymous with conflict, and 'Maud' has charted the metamorphosis of the narrator from enamoured lover to embittered nihilist who can evoke the 'Blood-red blossom of war with a heart of fire' – an image that Ernst Jünger's 'blood and roses' – mentioned in the Introduction – consciously echoes, in his attempt to evoke the heady atmosphere of the erotized death wish which set Europe on the path to war in 1914.

So within the poetry of the second half of the nineteenth century, the rose as female sexual symbol often reveals beneath its beautiful appearance the lies of deceit, vice and cruelty. As we will see in Chapter 12, the disgust experienced in relation to sexual depravity and deception will also sometimes be transferred to human life in general,

whereupon the rose becomes a symbol of the deception and disappointment of life in general, and of ideal at risk or cruelly betrayed by life's vulgarity and violence.

In this chapter we have encountered some rather overheated uses of rose symbolism. But I end with some examples of very different nineteenth-century poetic roses, as envisaged by two English women writers. Around the same time Emerson was pondering the disheartening message conveyed by the roses blooming outside his window, the poet Elizabeth Barrett Browning found a dried hedgerow rose flower in a drawer, perhaps a Dog Rose, and she too felt disheartened. She proceeded to write a guilty love poem directed to the natural rather than the human order, which Browning believed was ignorantly disregarding nature, and with fateful consequences. 'O Rose! who dares to name thee? / No longer roseate now, nor soft, nor sweet; / But pale, and hard, and dry, as stubble-wheat ... / Kept seven years in a drawer ... thy titles shame thee.'[27] For Browning, it was precisely the wildness of the humble hedgerow rose, its resistance to anthropocentric selfishness – its 'unofficial' status, as Rupert Brooke would write fifty years later – its status as something of outstanding natural beauty, that made it so valuable.

For Christina Rossetti, the rose also remained above all a tangible aspect of the natural world, one to be enlisted for more personal ends which were not shackled to the typically male exploration of the disjunction between ideals and bitter reality. In one poem Rosetti compares the rose to its traditional symbolic companion, the lily, and notes that while the lily 'has a smooth stalk' and the rose is a 'briar' with thorns, it is the rose that 'sets the world on fire'. The traditional link between the rose and love is cast by Rossetti in terms of the inevitability of inherent risk, and, as she writes in another poem, compared to the harebell of Hope and the lily of Faith, the rose of Love 'with all its thorns excels them both'. In the end, so Rossetti suggests in yet another poem that begins, 'O Rose, thou flower of flowers, thou fragrant wonder', humanity's 'weight of woe' has been definitively lightened by a benevolent God who decreed that the rose will 'gladden earth and cheer all hearts below'.[28]

NINE

'A Basket of Roses'

PAINTED ROSES

There is no better way to get a sense of the rose's status within visual art than to pay a visit to a municipal art gallery or museum. Here, of course, one will see roses in floral still-life paintings, but one may be unaware of just how many different kinds of painting contain the 'Queen of Flowers' until one dedicates oneself to a rose-hunt. I chose the National Gallery, London, for mine, and although I know the collection well, I was surprised that by the end of my hunt I had garnered a grand total of 50 paintings that included roses!

I followed a more or less chronological route, and so almost immediately on entering the Sainsbury Wing encountered a wonderfully explicit painting with roses. In the first of the four predella panels of Giovanni di Paolo's altarpiece of *Scenes from the Life of Saint John the Baptist* (1454), on either side of the central scene, which shows the saint retiring to the desert, there is painted a single upright stem of a rose, displaying a bud, an opening blossom, an open flower and several leaves. The level of realism is such that I recognized the rose on the right as (probably) *Rosa gallica officialis*, and on the left as a *Rosa alba*. This is a Christian painting, and so these roses are there to symbolize or allegorize something. In this case, martyrdom (deep pink/red) and purity (white).

Not surprisingly, the National Gallery contains several paintings featuring Christian roses, especially in works related to the Virgin Mary. A painting hanging not far away from the Giovanni di Paolo in its own special anteroom is often referred in relation to the rose: the *Wilton Diptych* (1395–1399). This contains two kinds of roses, which have two different iconographical functions. Rose-crowns of rosette-like roses, probably Alba Roses, adorn the heads of the angels who attend the Virgin Mary and Child; while lying on the verdant grass, among violets and daisies, are cut rose blooms that look like Gallicas. There was also another example of Marian roses hanging not far away from the *Wilton Diptych*: Carlo Crivelli's *Immaculate Conception* (1492). Here, located to the Virgin's right, is a very realistic still life of Gallica and Alba Roses arranged in a pottery decanter, which are in this context presented as symbols of charity and purity. On the Virgin's left-hand side, is an equally lovely depiction of lilies in a crystal vase.

As I proceeded chronologically, roses began to blossom in paintings with other themes. The hedge of pink and white roses behind the combatants in Paolo Uccello's famous *Battle of San Romano* was a complete surprise. I had never noticed them before. More prominent were the roses in the numerous paintings evoking pagan myths, especially those to do with Venus, such as Bronzino's *An Allegory with Venus and Cupid*. A few rooms farther on, and coming from geographically farther north, in the Low Countries, was Peter-Paul Rubens' *Judgement of Paris* (1632–1635), in which Venus, the winner of the beauty contest, is recognizable because she has a single pink rose pinned in her hair, although Ruben's bold brushwork makes it impossible to accurately identify which rose – is it a Damask?

Also to be found in the National Gallery are numerous floral still life paintings featuring roses. These are especially from seventeenth-century Holland, and often feature the Centifolia or Cabbage Rose. Particularly interesting is Ambrosius Bosschaert the Elder's *A Still Life of Flowers in a Wan-Li Vase* (1609–1610). From towards the end of the historical period covered by the Gallery is the Impressionist painter Henri Fantin-Latour's still life *A Basket of Roses* (1890). By the period

of Fantin-Latour, roses have been largely divested of overt symbolism, and their natural beauty now served as the pretext for the exploration of colour harmonies and textures.

Another pictorial context that soon emerged in the National Gallery was one in which roses are used as decorative and symbolic motifs within portraiture. In this category it was definitely a work by the Flemish painter Quinten Massys entitled *An Old Woman* (c.1513) also known as *The Ugly Duchess*, that was the most unexpected and memorable. A grotesque old temptress is holding a tiny pink rosebud – symbol of feminine beauty and sexual ripeness – in her ageing hand, up against her bulging and overripe décolletage. In contrast to this work, there was Jean-Marc Nattier's Rococo period portrait of Manon Balletti (1757), which provides evidence of how cut roses, in this case a Centifolia Rose (or Rose of Provence), were used in eighteenth-century France as fashionable floral jewellery for a low neckline. One or more fragrant roses, called 'bosom flowers' or 'bosom bottles', were often worn at the centre of the corsage or bodice, while for men the rose was popular as a buttonhole. In William Hogarth's *The Graham Children* (1742) the Graham girls have flower garlands that include Damask and Alba Roses, which was also a common practice at the time. Nosegays (small bouquets of flowers) and other floral crowns, flowers, artificial and real, attached to hats and elsewhere, were other mainstays of fashion. Flower patterns were also a popular motif in garment design and jewellery. During the nineteenth century, roses, daisies, tulips and carnations became especially popular motifs on silk brocades, as thanks to industrialization, textile production increased, and printing-dying techniques improved. In Jean Auguste Dominique Ingres' *Madame Moitessier* (1856), for example, the imposing sitter is clothed in a dress with a magnificent floral pattern that includes roses.[1]

When roses appear in Roman Catholic paintings the emphasis is first and foremost on their symbolic value, and only second on aesthetic

qualities. But in relation to the latter function, rose motifs associated with curvaceous foliage designs, sometimes interlaced between architectural elements, were a common feature of church architecture and wall paintings from the Middle Ages onwards. In illuminated manuscripts, floral motifs, including forms recognizably derived from the rose, frame pious liturgical texts. Bibles, breviaries, and Books of Hours, and initial letters ornately detailed with plant and floral embellishments, enlivened the faithful's devotion with colourful ornamentation, adding a beguiling aesthetic dimension to what were otherwise monotonous blocks of written didacticism. Sometimes, the level of botanical verisimilitude in such works is sufficient for one to be able to identify a specific species of rose.[2]

As it is an especially delightful part of God's creation, the rose could symbolize within painting heavenly joy, as in the *Wilton Diptych*, for example, where the angels have garlands around their heads. But more significantly, as we have seen, the rose could, allegorically speaking, serve to give pleasing visual form to aspects of Christian teaching which are inherently abstract and difficult to grasp, or impossible to express in words; the resurrection, the immaculate conception of Mary, damnation, salvation, eternal life. Bedecking the word of God in the visually attractive and familiar décor of the natural world was therefore a poignant way of consolidating via a pleasingly material form the arcane and abstract dogmas of the Church, so as to teach and inspire the faithful. A religious image's capacity to compel devout attention and be sacramentally useful rested on an appeal to the spirit made through the senses, but as the majority of the faithful were illiterate, images of the natural world were especially useful aids to correct worship.

Not surprisingly, the most prolific context for the rose as a Catholic visual symbol was in relation to the Virgin Mary. In a polychrome stone sculpture from about 1320 by an unknown Ratisbon master, Mary holds the infant Christ, who is perched in a rose-tree, thereby alluding to the symbolic association of the red rose with sacrifice on the cross, and the white rose of Mary's purity. In the Master of the Legend of St Lucy's *Virgin of the Rose Garden* (between 1475 and 1480),

Mary is shown seated with the infant Jesus on her lap, with a rose bush nearby – a tidy hedge of Gallica Roses that hides the new mother and her son from the outside world. Artists also often depicted Mary seated in a more formal rose arbor in the company of thornless roses and angels and saints, as in Stephan Lochner's *Madonna in a Rose Arbor* (4510) and Martin Schongauer's *The Madonna of the Rose Garden* (1473). But in Sandro Botticelli's beautiful *The Virgin Adoring the Sleeping Christ Child'* (c.1485), the 'enclosed garden' becomes a more informal setting in which thornless Gallica Roses enclose and protect mother and child.

By the time of the Baroque, the rose had become a standard iconographical feature of depictions not only of the Virgin Mary but also of female saints. In the Spanish artist Bartolomé Esteban Murillo's painting *Saint Rose [or Rosa] of Lima* (c.1670), for example, roses are especially prominent because of their overt relationship with the newly canonized saint whose name directly evoked the flower. Rose was born Isabel Flores de Oliva in Peru in 1586 in the Spanish Viceroy of Peru, where she died in 1617.[3] She became known as 'Rosa' because of her beauty, but as a nun she was renowned for her intense devotion to Jesus Christ, and is famous for her physically brutal acts of penance. On one occasion it is said that she failed to mortify herself on a social visit with her mother, and when she put on her perfumed gloves, they burned her hands with an unseen flame. She also took to wearing a crown made of silver with small spikes on the inside to emulate the crown of thorns.[4] In Murillo's painting, St Rose is depicted dressed in a Dominican habit, kneeling before the naked infant Jesus. She looks adoringly down at Jesus, and appears to be about to pick him up. In her left hand, Rose holds a pink Rose of Castile (the Damask Rose), towards which Jesus reaches out. Other roses are strewn on the ground, and behind, in the gloom, there is a Damask Rose bush.

In Islam, as we saw, the rose provided an acceptable natural form in which to represent the sacred. An illumination from an album of a *hilya* – a verbal poetic description of the Prophet Muhammad – from the eighteenth century, for example, shows the Prophet embodied as a

pink Damask Rose. The album draws on the long-standing tradition that compares Muhammad to a rose, as discussed in Chapter 4. In one example, a magnificent Damask Rose bloom stands erectly in a tiny blue vase. Placed within the geometric and diagrammatic structure of the *hilya*, it is the visual equivalent for what must, by necessity, remain beyond representation. Texts in gold written on the leaves and the rose petals describe Muhammad's exemplary characteristics. At the top, calligraphy in Arabic declares: '[This is] what the nightingale sings above the rose.'[5] Such images aided the faithful to recall of the beauty of the Prophet, while at the same time giving expression to his exceptional status.

Images of roses – five-petal species roses, semi- and double, like the Damask – also appear in Persian and Mughal miniature paintings. The natural world is usually depicted as a delightful garden, but the intention was also to visualize paradise. As such, a typical painted miniature depicts a space that is both real and other-worldly. Colour is vivid and decorative, and space flattened and geometric. It is not uncommon to have roses and other plants that blossom in the springtime alongside autumnal trees. Works in this genre were often intended as illuminations for texts, and a popular one was Sa-di's *Gulistan*, 'The Rose-Garden'.

In his religious works Sandro Botticelli painted Christian roses, but in his most famous painting of all, *The Birth of Venus* (mid-1480s), the roses we see have a wholly different symbolic meaning. They are bound on the level of the symbol to the pagan subject through an accumulation of visual references from literary sources derived from Homer and Ovid. Venus is carried on a conch shell blown by Zephyr, the west wind, and Chloris, the goddess of flowers, towards a Horai, goddess of spring, who is about to dress Venus in a flowered mantle. The famous painting also includes a lovely shower of Gallica Roses. Fifty years later, the Venetian artist Titian painted the equally celebrated *Venus of Urbino* (1538). By this period the theme of the goddess of love was

well-established and fully relegitimated in Western art. The woman cast as Venus in Titian's work is in fact the wife of the Duke of Urbino, who commissioned it as a wedding gift, and the work was intended as an allegory of marriage which taught the virtuous aspects of the Venus prototype – Venus as Urania. The Duchess of Urbino clasps a posy of pink roses, one bloom of which has fallen, a sign of 'deflowering' by her husband.

In floral still-life paintings, by contrast, symbolism is usually trumped by aesthetic value. The first known image of a rose is a kind of still life, where species roses appear as part of a bucolic garden fresco in Knossos, painted in the Bronze Age period of Minoan or Cretan culture, about 3,500 years ago. But due to the overzealous and botanically ignorant restorers hired by Sir Arthur Evans, the archaeologist who discovered the fresco, some of the painted roses got turned into six-petalled flowers and were recoloured yellowish-pink. As a result, they have been variously named as *Rosa persica*, *Rosa ricardii* or *Rosa canina*. Fortunately, towards the lower left-hand side the restorers left one area unmodified, and in a faded area of the design there is the vague form of a rose with five overlapping petals in pale pink, which has been more convincingly named a *Rosa pulverulenta*, a wild rose that is still growing in west and central Crete. In the Roman era, as noted, roses were sometimes painted in idealized depictions of nature on villa walls, and at times it is possible to identify which rose has been chosen, as is the case with semi-double Gallica Roses in the House of the Gold Bracelet in Pompeii. Roses were also common in tomb paintings, where the painted flora outlives the organic flora left as offering to the dead, mimicking an eternal springtime.

The greatest period of still-life painting was during the golden age of Dutch and Flemish painting of the seventeenth century. Ambrosius Bosschaert the Elder's *A Still Life* very prominently contains four yellow- and red-streaked tulips, and was painted in the period of tulip mania, when a single bulb changed hands for large sums of money. But the painting also includes Centifolia and Damask Roses in the vase, while on the tabletop lies a more humble species Dog Rose. In fact, the whole

painting is not simply an aesthetic tour de force, because it also has a practical purpose, being intended as a kind of boast, celebrating through flowers the wealth of the Dutch Republic, and in particular, the Dutch East India Company, who imported the Ming Dynasty blue-and-white porcelain vase, and several of the exotic flowers.

It would be wrong, therefore, to consider all such still-life paintings as necessarily devoid of a symbolic dimension. Indeed, in Protestant countries the ban on religious imagery obliged artists and their audience to develop other genres with an overtly moralizing content, and in such cases the beauty of the rose was often intended to remind the faithful that the pleasures of this life are transitory and fickle, a theme that derives from Ecclesiastes 1.2, which declares: 'Vanity of vanities, all is vanity.' A *vanitas* theme typically places wilting roses as a symbol of death in the company of, for example, a skull, butterflies (symbolizing transformation) or ruined parapets. In Jan Davidsz. de Heem's *Vanitas Still-Life with a Skull, a Book and Roses* (c.1630), two cut Centifolia Rose flowers lie to the side of the book, skull and a glass of water, adding a warm and beguiling note to the otherwise morbid composition, but only to drive home the sobering lesson. A vanitas painting was meant to remind the prosperous patron who purchased it that the pleasure, money, beauty and power they were enjoying in this world were not everlasting, and that it was the essence of earthly life to be fleeting and therefore fundamentally lacking in enduring value. But the message was one of hope, and one could enjoy the painting in the meantime, while on the other side of death for the faithful lay eternal life.

Images of roses in still-life paintings range from the highly detailed to the radically vague, but for detailed accuracy we must look to the pictorial genre whose main purpose is neither aesthetic nor symbolic, but essentially utilitarian: botanical drawing. The purpose of this special genre of visual image is to convey usefully precise technical information, thereby serving as a visual reference tool, and an objectively accurate

inventory. In a sense, a botanical drawing is a detailed portrait of a plant, and before the invention of photography was the only way to make such a visual record. To this end, a botanical drawing also always carries a textual caption whose function is to aid the identification of the depicted subject. Such works are usually made on paper using pen, pencil or watercolours, and are often etched for printing in books. Outlines are sharp, contrasts of lights and darks are moderated, and shadows are completely suppressed, except on the plant itself, while, in order to reduce ambiguity and aid clear observation, the plant is usually isolated against a blank background. Different stages of growth are sometimes shown simultaneously to present a composite of the plant's life cycle. But whereas the plant itself is accurately rendered in fine detail there is usually no additional information concerning the wider ecological environment, and the plant exists in splendid isolation upon the pure whiteness of the page.

As botanical drawings are not primarily produced to be works of art, symbolism is of no significance and the aesthetic value of the work is less important than its usefulness as a visual aid to study, but sometimes the genre transcends its limited technical function. This is certainly the case with P. J. Redouté, the 'Raphael of flowers', who remains to this day unsurpassed as a painter of flowers that combine botanical accuracy and high aesthetic value. Redouté was master draughtsman to the court of Marie-Antoinette before the French Revolution, and seems to have been of a harmlessly apolitical disposition, because he soon found himself similarly employed by Napoleon Bonaparte's wife, Empress Joséphine, whose love of roses, as we will see in more detail in Chapter 13, was largely responsible for launching the nineteenth-century's vogue for growing roses. After Napoleon's defeat and the Restoration in 1815, Redouté quickly found gainful employment again with the crème de la crème, which was now Marie-Amelie de Bourbon, the queen of King Louis-Philippe. Between 1817 and 1824, using mostly the roses in the gardens of Joséphine's former Château at Malmaison as his models, Redouté embarked on *Les Roses*, which was eventually published in 30 fascicles of usually six plates,

each with a commentary by the naturalist Claude-Antoine Thory. Regrettably, the originals were destroyed in a fire in the library of the Louvre in 1837, but numerous printed first editions have survived.

One very useful consequence of Redouté's labours is that posterity is provided with a snapshot of the world of roses in the early nineteenth century. Many of the most familiar species and sports are there, but also more obscure and now extinct or difficult to accurately identify roses. Concerning, *Rosa gallica officialis*, for example, Thory remarks: 'No species of rose has produced more numerous decedents than the French or Provins Rose; this group alone comprising almost half of all cultivated roses.'[6] This was no doubt true in 1820, but fifty years later, the Gallica had been largely superseded in this role by new arrivals, especially from China. In fact, Redouté paints several specimens of China Roses, harbingers of things to come, but they are all classified within the family *Rosa indica* – Latin for 'India'. At the time, these eastern roses were associated with India, and especially Bengal, because it was via India that the new roses travelled onwards to Europe.[7]

While botanical artists were dedicating themselves with increasing success to empirical accuracy, several fine artists moved in the opposite direction, eschewing the precise rendering of plants through clear outline in favour of more 'impressionistic' effects. In the only surviving floral still life by the eighteenth-century French painter Jean-Baptise Siméon Chardin, *A Vase of Flowers*' (1760–1765), we see a blue and white Delftware vase, of the kind inspired by the Chinese original in Bosschaert the Elder's painting, isolated on a table against an empty background. Among the rich variety of flowers in the bouquet, there are pink and white roses. But Chardin paints with swiftly applied brushstrokes, making it difficult to identify any botanical detail. Perhaps there is a Damask Rose and a couple of Albas. Instead of linear clarity, the flowers in Chardin's still-life painting seem invested with an

emotional presence and individual elegance that until then had been conferred only on human subjects. In other words, Chardin painted flowers so they seem to take on the anthropomorphic characteristics made familiar from floral poetry, but which had not yet been fully explored in pictures. The result is that the movements of human feeling are recorded in the process of recording the floral phenomena. What to all intents and purposes is a motionless or 'lifeless' study of flowers has thereby been imbued with lively potential.

The desire to convey a sense of the animated presence of flowers continues to be a preoccupation of artists into the nineteenth century. In the floral still-life paintings of Henri Fantin-Latour, for example, the linear precision of artists of the Dutch Golden Age has been left far behind, and like Chardin, Fantin-Latour imbues his rose still lifes with an animation that makes them seem like personal beings, invested with life. As a result, however, on a practical level it becomes more difficult to identify which specific roses the artist has depicted, although it is certainly still possible to make a conjecture. In *A Basket of Roses*, for example, I can with some confidence identify Centifolias, Tea Roses, Noisette, and what looks like a Hybrid Perpetual or Hybrid Tea.[8]

The roses of the Impressionist Auguste Renoir, which are an especially prominent aspect of his late work, are above all exercises in generating aesthetic pleasure, and they are motivated less by the artist's desire to represent something realistically, or by an interest in anthropomorphizing his subject, than in the aesthetic potential of displaying a dynamic relationship between coloured marks on canvas and the mind and body of the artist who made the marks. Traditional symbolism is buried under a luscious surface of paint. In a letter from May 1888, Vincent van Gogh, who had recently arrived in Arles, wrote about Renoir to his brother Theo: 'You will remember that we saw a magnificent garden of roses by Renoir. I was expecting to find subjects like that here ... You would probably have to go to Nice to find Renoir's garden again. I have seen very few roses here, though there are some, among them the big red roses called Rose de Provence.'[9] Van Gogh is referring to *Rosa centifolia*, the Centifolia or Cabbage Rose, which was

especially grown in Provence in the region around Grasse as a cash-crop. As a Dutchman, van Gogh would no doubt have been delighted to learn that the Rose of Provence is actually a sport first nurtured in Europe by Dutch breeders.

One year after this letter, and now a voluntarily resident of the mental asylum in Saint-Rémy, van Gogh was more successful at finding roses to paint. Referring to the painting entitled *Roses* (1890), he wrote to Theo in May 1890: 'I've just finished this canvas of pink roses against a yellow-green background in a green vase', and he concludes the letter by announcing: 'I feel absolutely serene, and the brushstrokes come to me and follow each other very logically.'[10] Unfortunately, today the bold colours van Gogh applied have faded considerably, so that, for example, the bright red of the Damask Rose buds have become flesh-like, and the overall visual impact of seeing the 'complementary colour' contrast of red against the green background has been greatly reduced.

In London at around the same time as van Gogh was painting roses in the garden of the asylum in Saint-Rémy, the Royal Academician Lawrence Alma-Tadema was using huge numbers of the same Rose of Provence for his painting *The Roses of Heliogabalus* (1888). He had them shipped specially from near to where Renoir lived, the French Riviera, in order to depict the Syrian-born Roman Emperor and psychopath Heliogabalus in the act of smothering to death his guests in an ocean of rose petals dropped from above. But, as a pedantic observation, I note that *Rosa centifolia* is a sport that did not exist at the time of the Roman Empire, so it would have been more accurate to use Gallica or Damask Roses.[11]

While Alma-Tadema's theme might ostensibly be the decadence of the classical world, the blandly academic style and the illustrational nature of his theme were really intended to gratify a Victorian public that was enamoured by such evocations of charming and easy escapism. As an image of real life, it could not be further in intention from

Édouard Manet's *Olympia* (1863), in which a huge floral bouquet, including the inevitable roses, is being delivered from a client to a reclining courtesan by her black maid. Manet draws subliminally on the whole history of classicism and paintings of a reclining Venus, and most especially those by Giorgione and Titian, and plays on the familiar connection between flowers, Venus, a woman's beauty and sexual promise, which in this case is given at an agreed-upon price. It is worth noting that in the slang of the period in France a prostitute was called *une rose*. The pagan goddess of love is still there, but subsumed now under a new, modern, abrasive and deliberately unsettling surface of realism.

The overtly erotic ambiance associated with the rose during the second half of the nineteenth century, which was discussed in the previous chapter, plays a central role in the Pre-Raphaelite painter and poet Dante Gabriel Rossetti's *Venus Verticordia* (1864–1868). Verticordia means 'who changes hearts', and the theme of the redemptive power of sexual love is given an explicit pictorial treatment. A lustrous, red-headed woman is shown bare-breasted and surrounded by flowers – Centifolia Roses behind her and honeysuckle in front. She holds Cupid's arrow in her right hand, and an apple – symbol of temptation, but also of the Judgement of Paris – in the other. Yellow butterflies, symbol of hope and guidance and of the soul, perch on the apple and arrow, and bedeck her halo. But it is the powerful reds of the flowers that make the biggest impression. In the popular 'language of flowers' of the period, the honeysuckle usually symbolized devoted love. Apparently, Rossetti spent a large amount of money to get his Centifolia Roses, refreshing his collection regularly with new blossoms, as he painstakingly painted them. The air must have been extremely fragrant, as honeysuckle and Centifolia are both especially noted for their powerful scents, which also adds an invisible dimension of sensual allure to the painting. Venus is a woman of considerable and threatening power.

In Rossetti's painting *Lady Lilith* (1864–1868) the Babylonian goddess, the first wife of Adam, and a manifestation of the ancient

fertility goddess – the Great Mother – is depicted in her more dangerous form. In Judaism, Lilith is cast as a powerful, seductive and wild woman, who uses all her wiles to get what she desires, thereby incurring God's wrath. As such, Lilith is often deemed a terrible, destructive vision of female character, but she can also be cast as an affirmative model for women, representing defiance of male dominance. Rossetti depicts Lilith as a radiant red-haired woman in languorous semi-dishabille combing her hair beside a mirror and a vanity table, on which lie some foxgloves, which in the 'language of flowers' are associated with insincerity. Behind Lilith is a bush of blush-pink roses, that seem to be rising up to invade her room, and which look very like the fragrant 'Mme Hardy', a Damask Rose in commerce since 1832, and that was extremely popular with the Victorians. As a commentary on the painting, Rossetti wrote a poem entitled 'Body's Beauty': 'The rose and poppy are her flowers; for where / Is he not found, O Lilith, whom shed scent / And soft-shed kisses and soft sleep shall snare?'[12] As a poet and a painter, Rossetti brings together in word and image several of the preoccupations of the nineteenth century, using the rose to explore the struggle between carnal and spiritual love.

Perhaps the greatest paintings of seductively dangerous roses from the Victorian period were created by another Pre-Raphaelite, Edward Burne-Jones, in his series called *The Legend of the Briar Rose* (1885–1890). This has been carefully integrated into the décor of the Salon in Buscot House, Oxfordshire, through the extension of the frames and the filling of the intervals with joining panels that continue the rose motif. Under each of the paintings there is written a verse from a poem by William Morris. The first in the series, called *The Briar Wood*, shows the prince standing on the far left, and the sleeping retinue sprawled among the briars. Morris' poem is as follows: 'The fateful slumber floats and flows / About the tangle of the rose; / But lo! the fated hand and heart / To rend the slumberous curse apart!'

We know the story of the Briar Rose best as *Sleeping Beauty*. A curse means the princess will prick her finger on a rose, and then she and everyone around her will immediately fall into a deep sleep for a

hundred years, until she is kissed by a prince. The original Sleeping Beauty story is by Charles Perrault, and makes no mention of roses, just "brambles and thorns". But in the Brothers Grimm retelling of the story, called *Briar-Rose*, the princess herself is called the 'Beautiful Briar-Rose' or the rose on the thorny briar. It seems likely that the Brothers Grimm chose to develop the theme in relation to the medieval allegory of the *Roman de la Rose*, discussed in Chapter 5. But in fact the story of Sleeping Beauty goes all the way back to *The Book of the 1001 Nights*, where it is more obviously about the relationship between sexual desire, violence and death. This theme is still subliminally there in Perrault's story, in which the prince must 'penetrate' the enclosing thicket. After 'awakening', the princess has two children, and is then tormented by any angry mother-in-law. In the Grimm's narrative the emphasis is also on the necessity of penetration, but the tale ends when the prince weds 'Beautiful Briar-Rose'.[13]

There is, in fact, a very personal dimension to Burne-Jones' painting. The model for the beautiful sleeping princess is the artist's own eighteen-year-old daughter, Margaret. Her father, evidently feeling ambivalent about her awakening sexuality, made sure the Briar was especially thick and impenetrable so as to prevent any suitor from coming to steal her 'innocence' – her 'rosebud' – or to 'deflower' her. Tellingly, Burne-Jones doesn't depict the moment when the prince achieves his goal, and Briar-Rose is awakened. Instead, he has delayed the moment of 'surrender' indefinitely. As long as his daughter/Sleeping Beauty remains asleep, protected by the wildness of the Briar rose, she will never be fully alive, but as soon as she moves she will inevitably be 'pricked' and feel pain. The rose symbolizes here the wounding danger of sexuality, particularly young female sexuality, and the social prohibitions that hem it in like the Briar surrounding Sleeping Beauty's castle. In this sense, one could say the rose in this painting is playing the role of chastity belt.[14] There is no evidence of penetration, nor any likelihood of it, in Burne-Jones' paintings, and an overwhelming soporific, death-like air pervades all of the works. Everybody except the prince is fast asleep, and he looks no more than decorous.

Burne-Jones also includes other references to the rose – petals painted on a knight's shield, and four heraldic Tudor roses on a tapestry in Sleeping Beauty's bower. The star of the suite is definitely the Briar itself – a real rambler. But which species rose is it? Definitely *Rosa canina*. Burne-Jones shows it with pink buds, then whitish-pink fading to white blooms. His specimens are extremely sinuous, and have very aggressive-looking prickles. Although certainly painted from life, this is like no rose one is ever likely to see in reality. It seems to be enveloping the whole world, a primeval rose from the time of the dinosaurs, a huge spiky serpent, although bedecked everywhere with lovely small, delicate five-petal pink flowers. One could describe it as the evil twin of the Hildesheim Cathedral Dog Rose mentioned in Chapter 2.

TEN

'Parks' Yellow Tea-Scented China'

EASTERN ROSES GO WEST

I have discussed Bronzino's *An Allegory with Venus and Cupid* already, but not yet mentioned that the roses held by the gleeful boy symbolizing Folly look very similar to a variety of China Rose, *Rosa chinensis*. This supposition is based on the fact that the roses are clearly semi-double blooms rather than single or double; that is, the flowers have more petals than a Gallica but less than, say, a Damask or Cabbage Rose. Also, the flowers have high-centred forms, so the petals in the middle stand above the ones towards the outside, like inverted cups. In other words, both the number of petals and the shape of the flowers are unlike familiar Western roses of the period, which were on the whole open in form exposing the sepals at the centre. However, today, we are unlikely to notice anything very surprising about the shape of the rose flowers in the painting for the simple reason that they look so familiar – like a typical rose. Why? Because we have become used to looking at roses shaped like this, which are now known as Hybrid Tea and Floribunda Roses. That is to say, we are used to living with roses that are the descendants of deliberate crosses between Western roses and Chinese roses, and whose flowers are usually shaped like the Chinese parent. For, as I mentioned, a major transformation in the appearance

and characteristics of the rose took place in the West during the nineteenth century, one that is so far reaching that most of the roses grown today, and pretty much all the roses we give as cut roses, are significantly different in appearance from all European roses in existence prior to this period.

But the presence of China Roses (if that is what they are) in Bronzino's painting is very surprising, for the simple reason that such roses are not documented as arriving in Europe until the eighteenth century. If they are indeed Chinas, then this painting can claim to be the very first known depiction of a rose from East Asia in Western art, and is evidence that, at least in Italy, such 'aliens' were already being cultivated.

However, after the setting up of East India Companies by the Dutch and British in the seventeenth century, and the establishment of trading posts along the Indian coast, contact greatly increased between East and West, and part of the trade was also botanical. In his *Species Plantarum* (1753), Linnaeus includes one rose from East Asia, *Rosa indica*, the Tea Rose, a dark red variety that was known locally as the Rouge Butterfly. I already noted that the Linnaeun name means 'Indian Rose', an indication that at that time this species rose was associated not with China but with India, from where it had more immediately come. Especially important for the British was Calcutta in West Bengal, which became the capital of India under the British Raj and served as a horticultural way station where plants could be planted before some specimens were transported on the long voyage to Europe via the Cape. In the mid-eighteenth century, the scientist Nikolaus Joseph von Jacquin described and illustrated a variety of *Rosa chinensis* in one of his books, and this is probably what a couple of decades later became known as Slater's Crimson, of which more shortly.

But Chinese rose immigration to the West begins in earnest in the late eighteenth and early nineteenth centuries. In 1793 *Rosa bracteata*, the Macartney Rose, a white single rose, was brought to England by Lord Macartney on his return from a diplomatic mission to China (the botanical name is on account of its prominent leafy bracts and the blunted ends of its leaves). But the rose didn't take easily to the change

in climate.[1] Then, in 1807, seeds were sent to England of *Rosa banksiae alba-plena*, named in honour of the most important collector and botanist of the age, Sir Joseph Banks, a gentleman who also made many natural history expeditions. In fact, it is thanks to Banks that the Royal Botanical Gardens at Kew became a leading botanical centre.[2] Two 'Lady Banks' *Rosa banksiae* were planted in Sir Joseph Banks' garden outside London, and were pruned and trained like espaliered fruit trees against a wall. By 1819 one had reached 14 feet high and 17 feet long, covering the wall with flowers from April to June.[3]

Between 1792 and 1824 four so-called 'stud' China Roses were picked with the specific intention of crossing them with Western homegrown varieties. Together, the resulting mutations caused the enormous changes in the range and characteristics of the rose's gene pool. These studs were: 'Parsons' Pink Rose', 'Slater's Crimson', 'Hume's Blush Tea-Scented China' and 'Parks' Yellow Tea-Scented China'. Along with a few other native roses, these China and Tea Roses made possible most of the transformations that characterize the rose plant we know today: a bush-like, robust garden plant with a wide variety of coloured flowers that are large, semi-double, high-centred and which bloom continuously from May to late autumn.

'Parsons' Pink Rose', aka 'Old Blush', was brought to Europe as part of the cargo of a merchant ship in 1752, and was recorded as growing in England by 1793. The flowers are of medium size and semi-double, and are a light silvery-pink colour that darkens as the flower ages. We now know that this rose owes its characteristic repeat-blooming habit to the fact that it is probably a cross between *Rosa chinensis* and *Rosa gigantea*. Soon, 'Parson's Pink Rose' had replaced the Autumn Damask, the only already existing remontant rose, as everyone's favourite rose. By 1823, it was said to be in every English cottage garden. Eventually, when it was crossed with the Musk and Dog roses, 'Parsons' Pink Rose' would give rise to numerous very popular descendants – the Noisette, Hybrid Perpetual and Hybrid Teas families.

'Slater's Crimson', named in honour of a merchant shipowner, is also known as 'Old Crimson China', and is technically *Rosa chinensis*

semperflorens. It was known to the Chinese as the Monthly Rose because it was a repeat-flowerer. 'Slater's Crimson' is dark red with white streaks running along the inner petals. The double flowers are borne singly or in clusters of generally three. This, the second important China stud rose, was imported to England in 1792 specifically for the repeat-flowering habit. The first specimen had been found growing in the Botanic Gardens in Calcutta, not in China, which is why in France the rose is named 'La Bengale'. 'Slater's Crimson' is, in fact, the oldest known garden rose – that is, domesticated rose.

The third stud, 'Hume's Blush Tea-Scented China', named in honour of Hume's wife, is also a repeat bloomer, and has large well-proportioned pale pink flowers. But while this rose served initially as an important stud, by the early twentieth century the original plant appeared to have gone extinct in Europe. However, it was then rediscovered in far-away Bermuda, where it was going under the alias 'Spice'. Today, it can be purchased from specialist rose nurseries.

The fourth stud, *Rosa odorata* var. *pseudindica*, 'Parks' Yellow Tea-Scented China', was discovered in China by John Damper Parks in 1824. It is a repeat bloomer, has a vigorous growth habit, bright green leaves and very large double or semi-double flowers with an average diameter of 4 inches, which have the unusual characteristic of being straw- or sulphur-yellow in colour. The petals are thick and mildly 'tea scented'. But the consensus is that although this rose is officially still commercially available, it actually disappeared 100 years ago.

Amateur and professional botanists fanned out across the world alongside soldiers, missionaries, merchants and administrators, infected by the botanical counterpart to the contagious hunger that led to the colonization and exploitation by Europeans of the rest of the world during the nineteenth and early twentieth centuries. They were bent on enriching their homelands' plant kingdom not only out of a zeal to introduce non-Western specimens but also because of their awareness of the

potential the Chinese specimens offered for the planned creation of desirable mutants – of new hybrids. This was a pan-European venture that often went hand-in-hand with others in China, such as the tea and opium trade, which both became highly lucrative businesses in the second half of the nineteenth century, as China struggled to resist the incursions of the Western powers.

Horticulturally, China was historically much more advanced than Europe, but there were also strong undercurrents within its Confucian culture, derived from Taoism, which advocated the ideal of the unworked and untouched, of 'flowing' with nature. Humanity, so it was taught, exists in a holistic unity with earth and heaven united by *ch'i* energy, the life force permeating everything. Therefore, every precaution must be taken not to upset the delicate balance. In relation to nature, this meant the human role was strictly custodial. Such ideals inevitably mitigated against efforts to actively intervene to change anything within nature by conscious design, but did not prevent it.

John Barrow, writing in his *Travels in China* (1804), described what was available in the early nineteenth century in China: 'In the neighbourhood of this village [Fa Tee, near Canton] are extensive gardens for the supply of the city with vegetables. In some we observed nurseries for propagating the rare, the beautiful, the curious, or the useful plants of the country, which are sent to Canton for sale.'[4] Roses were among the plants Barrow saw laid out in rows of pots.

In their travels around China, Western traders, botanists and horticulturalists often relied on Chinese gardeners, especially around Canton, because travel restrictions were placed on foreigners. They found that by the late eighteenth century, the gardens around Canton in particular were a hub of experimentation and the development of new gardening techniques. But there were also basic practical obstacles in the way of the Europeans: they were severely hobbled by the travel restrictions imposed by the Chinese rulers, and the collectors were often disappointed by the narrow range of local supply to which they had access.[5]

A vital role in the accumulation of scientific knowledge about Chinese plants was played by botanical painting, discussed in the

previous chapter. As an integral part of the scientific-imperial impulse that led botanists to roam China alongside traders, soldiers and missionaries in search of the most extraordinary or beautiful plants, as yet unknown to Westerners, large numbers of paintings were commissioned as visual references that could be perused in the comfort of the Horticultural Society, and other such institutions in Europe and the United States, prior to launching any attempt to purchase or otherwise acquire a real specimen.

One of the most interesting collections of botanical art from China was amassed in the early nineteenth century by the Englishman John Reeves, an East India Company tea inspector and amateur botanist. Reeves was stationed in China with the Company prior to the First Opium War (1839–1842) and collected plants in and around Canton in his spare time.[6] He too was often frustrated by having to use Chinese gardeners as go-betweens due to the restrictions imposed on foreigners, and he had the capital idea of hiring Chinese artists to paint what he did get his hands on. In all, Reeves amassed over 800 pictures. Only sixteen are roses, but they include a wonderful representation of one of the studs discussed earlier – 'Parks' Yellow Tea-Scented Rose', which also graces this book's cover. Interestingly, the painting shows a specimen entirely without prickles. The rigours of botanical art must have appealed to the anonymous Chinese artist-artisans who were already accustomed to working in water-based paints on paper, and so could adapt easily to accurate linear outline and the suppression of a plausibly three-dimensional contextual location. Such characteristics, unusual outside botanical painting in the West, were already an inherent part of the rich flower painting genre within the Chinese tradition. An interesting feature of the paintings made for Reeves is that they often show decomposition as well as juvenescence and maturity; for example, decayed and broken leaves. Such features are absent from Redouté's work. Perhaps the Chinese artists, taking to heart Reeves' requirement of empirical accuracy, considered it useful to show a greater part of the plant's life cycle.[7] Anyway, it was on the strength of the painting that the Horticultural Society of London sent John

Danvers Parks to China to chaperone the rose (and other plant specimens) westwards.

Perhaps the most colourful of the British botanist-imperialists in China is Robert Fortune, who was appointed by the Horticultural Society of London in 1842 to hunt specifically for interesting plants in China. A Scot, Fortune seems to have been a rough diamond, having worked his way up the career ladder by sheer tenacity. When he agreed to go plant hunting in China he insisted on the Society supplying him with a firearm, in fact a reasonable request as China was severely restricting foreign interactions of all kinds, and experiencing a widespread breakdown in law and order – actively encouraged by the Western powers. In short, China was a very different prospect to bucolic England, and on his expeditions Fortune was dogged not only by fever, mobs, beatings and robbery, but also by the Chinese plantsmen's reluctance to show him any specimens.

Fortune's instructions from the Horticultural Society were to search for 'seed and plants of an ornamental or useful kind, not already cultivated in Great Britain'.[8] But the Society was after specific plants, including 'the Double Yellow Rose of which two sorts are said to occur in Chinese gardens'. After several years, Fortune finally succeeded. He wrote the following concerning his discovery at Ningpo in 1842:

> On entering one of the gardens on a fine morning in May, I was struck with a mass of yellow flowers which completely covered a distant part of the wall. The colour was not a common yellow, but has something of buff in it, which gave the flowers a striking uncommon appearance, I immediately ran up to the place and, to my surprise and delight, found that it was a most beautiful yellow climbing rose.[9]

In 1846 the Horticultural Society announced the arrival of 'Fortune's Double Yellow'. Alas, it did not take to the English climate, and in a report of 1851 the Society's Journal described it as 'A straggling plant', with 'little claim to English notice.'[10] But while 'Fortune's Double Yellow' may not have immediately satisfied, it was certainly a fine indication

of the way forward for the rose. It was necessary not only to introduce non-Western roses to the West, but to cross them with Western specimens.

In the 1880s, another Scotsman, Dr Augustine Henry, began hunting for species roses. Officially, Henry was employed by the Imperial Maritime Customs Service in China, but in his free time he dedicated himself to supplying Kew Gardens with tens of thousands of pressed specimens of various plants from China. Between late 1884 and early 1889, for example, Henry discovered 500 species that were new to Westerners, and 25 new genera. But as a typical Victorian, he seems to have had a soft spot for roses, writing to a friend: 'I like plants with beautiful foliage and neat little flowers. I don't care for colour much, I think chrysanthemums are positively ugly on account of their wretched leaves. The Rose is an exception: it is wonderfully beautiful in every way. As for Geraniums, I really can't understand any one liking them.'[11]

In 1883, Henry sailed up the Yangtze River and made an important discovery growing in a narrow ravine near the cave and temple of Three Pilgrims at the Ichang gorges in western Hubei province: the pure ancestor China Rose, *Rosa chinensis spontanea*. This species rose is especially important from a botanical perspective because it is the parent of many of the China Roses which began to reach Europe by way of India from the beginning of the eighteenth century. *Rosa chinensis spontanea* is a climber with solitary flowers that sometimes are pink but more usually deep red, and Henry dutifully reported his find, and then eventually, in 1902, a drawing was published in the *Gardener's Chronicle*. But Henry only reported the rose, supported by the illustration, and the plant itself wasn't formally collected until 1916 by another notable amateur botanist and important collector for Kew Gardens and other institutions of the period, E. H. Wilson.[12]

But Wilson's specimen was never seen in the West and then, because of the crisis in China and the Communist victory in 1948, no foreign botanist got to set eyes on the rose again in order to corroborate its existence. But in the 1980s the political situation thawed enough for a Japanese botanist to find many *Rosa chinensis spontanea* flowering in

southwest Sichuan province in 1983. He collected specimens, and made a full report. What he saw were large shrubs with arching and scrambling branches growing up to 25 feet tall. The flowers, however, had more petals than Henry's specimen, and furthermore they were pale pink when first open, but became darker red as they aged, a colour change that is almost unique among roses. But the botanist went on to discover that in other regions the species displayed somewhat different characteristics, and the flowers didn't change colour.[13]

To conclude this section on Chinese roses, it is worth considering how the act of renaming is an intrinsic if rarely consciously acknowledged part of any imperialist agenda, and plants are no exception. With more or less total disregard for their original Chinese names, all roses identified and imported were 'rechristened' as Westerners as if they had never existed before. To the Chinaman who painted 'Parks' Yellow Tea-Scented China' for John Reeves, this particular rose would have been known as '*Dan Huang Xian Shui*', 'Light Yellow Sweet Water Rose'. *Rosa chinensis* is known as '*Yue Ji*' or Four Season Rose, the Tea Rose is '*Hsiang Shu Yuen Chi*' or Scented Monthly Rose, *Rosa banksaie* is '*Mu Hsiang*' or 'Grove of Fragrance', and 'Old Blush' is '*Yue Yue Fen*' or 'Old Pink Daily Rose'. Here are some other varieties which have especially evocative translations: '*Jin Ou Fan Lu*', 'a golden bird splashing in water'; '*Kuo Guo Dan Zhuang*', 'reminiscent of the Queen of Kuo Guo, charmingly dressed'; '*Yu Shi Zhuang*', 'colourful robes of a Taoist priest'; '*Chi Long Han Zhu*', 'a flying, flame-breathing red dragon of Chinese mythology'; '*Lui Zhao Jin Fen*', a pink rose that is 'as tender and delicate as a beautiful girl in an ancient palace'; and '*Chun Shui Lu Bo*', a pale green rose which 'gains its name from water gently disturbed by rain and breezes in spring'.[14]

During the period when botanists were bringing Chinese roses to the West, and European breeders were setting out to deliberately coax them to interbreed with Western roses, several new natural sports were also making themselves known in the West, and these too would

contribute crucially to the emergence of the quintessentially modern rose. They were appealing in their own right, while also revealing what new possibilities there were for the rose family. These hybrids are principally the Portlands, Noisettes and Bourbons.

As is always the case with natural crossings there is a great deal of uncertainty about the origins of the Portland Rose. It used to be thought that it was a cross between the Autumn Damask and 'Slater's Crimson', thus making it a natural hybridization of an Occidental and Oriental rose. This thesis was premised on the Portland's repeat-flowering characteristics. However, recent DNA analysis has demonstrated that the original Portland rose has no direct Chinese ancestry whatsoever, and that it is a cross between the Autumn Damask and *Rosa gallica officinalis*.

The first recorded plant in the Portland class came from Italy at the end of the eighteenth century, and was known then by the Latin, *Rosa paestana* or 'Scarlet Four Seasons' Rose', which indicates its special attractions. The flower's form is close clustered or rosette, and they come on short stems. The fragrance is sweet, like the Damask. As an early repeat-flowering European rose, it proved a huge success across Europe, and roses in this group eventually ranged from white through pale to deep fuchsia pink, and could be double or semi-double. By 1848 there were eighty-four varieties growing in Kew Gardens alone.

The Noisette is North America's very own natural hybrid and transcultural rose from the nineteenth century. Or is it? There remains some controversy over whether to call it a natural or man-made hybrid. At the beginning of the nineteenth century John Champney, a rice plantation owner in Charleston, South Carolina, either did or didn't deliberately cross a *Rosa moschata* with 'Parsons' Pink China'. Whatever the case, the result was a rose with small pink flowers blooming in clusters, which was a vigorous climber. But as is the case when a one-time bloomer is crossed with a repeat bloomer, the remontancy did not carry over into the first generation. But a successful second generation was then masterminded by Champney's neighbour, a French

nurseryman named Philippe Noisette. The result, in 1816 or 1817, was a repeat bloomer with clustered small white, blushed pink, semi-double flowers, 'The Blush Noisette', which quickly spawned many more varieties, augmented with more crossings involving Chinas.

The Bourbon Rose family probably originally came into being from an informal liaison among several species of rose in a hedgerow on a small island in the Indian Ocean – the French colony named Île Bourbon, renamed Réunion by the Revolutionary government in 1793. The Bourbon's flowers are very large, the petals often making an almost perfect globe. They also have an intense fragrance. Eventually, seeds found their way from Réunion to Paris, where Bourbons were introduced to commerce in the 1820s with great success. By mid-century there were dozens of varieties. But, as usual, no one knows for sure who 'bedded down' with whom. The consensus is that 'Parsons' Pink China' crossed with a Damask while growing in a hedge. This, it seems, really *is* the first natural cross between an eastern and Western rose. But it occurred on 'neutral' territory, far from both.

The British did the donkey-work in bringing Chinese roses to the West and studying them, but it was to be the French who first applied their know-how and commercial acumen to become the pre-eminent rose breeders and marketers of the nineteenth century. This was largely thanks to one person: Empress Joséphine. For her garden at Malmaison, near Paris, she organized the collecting of many rare plants from around the world, an activity that was abetted by her husband's imperial ambitions. War was no obstacle, and one of her gardeners, the Irishman John Kennedy, had a passport permitting him to travel freely through French- and British-controlled territories. Between 1803 and 1804, it is recorded that 200 plants previously unknown in Europe were being grown at Malmaison. But roses were Joséphine's favourites – perhaps because her middle name was Rose. A garden dedicated to roses was therefore laid out at Malmaison for which she aimed to collect all known rose varieties.[15]

For, by 1798, and despite the war going on between Britain and France, the French had received specimens of the first studs from

England and begun the systematic hybridization experiments that would put them at the forefront of rose cultivation. It seems the Teas and the Chinas bred more effectively under French hands, and 'Parks' Yellow Tea-Scented China', for example, was to become the parent of many of the yellow Hybrid Tea and Noisette Roses that quickly began to spread across the world from the greenhouses of French breeders. More than 300 different roses – including 89 Hybrid Chinas, 60 Chinas, 51 tea-scented Chinas, 16 miniature Chinas, 66 Noisettes and 38 Bourbons are recorded in J. C. Loudon's *Arboretum*, published in 1838, and most of them were the sires of French breeders.[16] As the Englishman T. Rivers wrote in *The Rose Amateur's Guide* (1837), of the 'tea-scented' China Roses that were all the rage at the time:

> In France, this rise is exceedingly popular, and in the summer and autumn months, hundreds of plants are sold in the flower markets of Paris, principally on little stems or 'mi tiges'. They are brought to market in pots, with their heads partially enveloped in coloured paper in such an elegant and effective manner, that it is scarcely possible to avoid being tempted to give two or three francs for such a pretty object.[17]

ELEVEN

'Pedigree Hybrids of the Tea Rose'

MODERN ROSES

It is the summer of 1867 in the city of Lyon, France, and the breeder Jean-Baptiste André Guillot, known as Guillot *fils*, has just presented the world with a new variety of rose, the glorious culmination of the collective efforts of European botanists and breeders over the previous fifty years to marry the best of the East with the best of the West. Somewhat immodestly, Guillot *fils* proudly named the new rose 'La France'. It is pale silvery pink in colour, has globular double blooms, and grows to around 4–5 feet tall in a tight shrub-like structure. For us, unlike Guillot *fils*' contemporaries, looking at a specimen of 'La France' will seem a familiar and not especially extraordinary experience because 'La France' possesses most of the characteristics we routinely associate with the typical garden roses of today. But at the time it was a sensation; it was in the vanguard of the modern rose revolution which would soon give the world the Hybrid Tea family – the modern rose.

Guillot *fils* had conscientiously built on the success of a family of recent rose mutations called Hybrid Perpetuals. These were crosses with Portland, Chinas and Bourbon Roses, and are upright plants about 6 feet tall, quite fragrant, and mostly pink or red. Between 1850

and 1900 they were considered the characteristically new or modern roses. As the name suggests, Hybrid Perpetuals inherited the remontancy characteristic from being crossed with a Chinese parent. This longer blooming period became a hugely appealing new feature for European rose growers. But the Hybrid Perpetuals would soon be overshadowed by the Hybrid Teas, which possess the general habit of the Hybrid Perpetuals but have the more elegantly shaped buds and free-flowering character of their parent, the Chinese Tea Rose.

But Guillot *fils* did not so much breed 'La France' as ensure favourable ambient conditions so he could 'discover' it. He himself described coming across the new variety in one of his beds of chance seedlings from Tea Roses, and admitted that he didn't know for sure who the parents were.[1] Such vagueness wasn't at all unusual at the time, however. But in the course of the nineteenth century, Western botanists and horticulturalists overcame the two obstacles that had stood in the way of actively cross-breeding plants and animals: religion and ignorance. Until the Enlightenment philosophers challenged the pervasive belief that seeking to deliberately change nature was considered playing at God and therefore a sin, those who attempted it were understood to risk divine retribution, meted out via God's representatives on earth. A sport, a naturally occurring mutation, could be taken in hand, but to actively strive to engineer such changes meant inviting moral censure. The wind or the bee did God's handiwork, not humanity. Furthermore, until the seventeenth century and the dawning of the scientific spirit of enquiry in the West, the general assumption had also been that everything there was to know was already known, that humanity had inherited this storehouse of knowledge from the past through their ancestors, supported by the messengers of the divine on earth.

But in the eighteenth century these deep-rooted beliefs were increasingly challenged by a new attitude, one based on the awareness of how much humanity *didn't* know, along with the unquenchable desire to reduce this weight of ignorance by all means possible. Meanwhile, on the basis of sound empirical evidence, science was revealing that God's 'creation' was reducible to chemistry and physics,

and could be successfully understood without invoking divine intention and design. Thus, what came to increasingly set the West apart from the rest of the world was a fervent new spirit of enquiry that became central to the ethos of the modern age. The ideal of a timeless natural order gave way to one of progress, of continued improvement in the direction of greater perfection in all domains, cultural and natural, engineered by science. The waning of the controlling power of religion, and the emergence of this new and confident spirit of enquiry, began to challenge the culture of humility. Armed with empirical and theoretical know-how, and now less intimidated by God or his earthly representatives, scientist-explorers such as Alexander von Humboldt and Charles Darwin set out to discover a natural world that seemed immense and mysterious, but which they were sure would eventually offer up its secrets.

In all the capitals of Europe, botanists proceeded to describe and catalogue new species of plants in ever-increasing numbers, an undertaking greatly aided at first by explorative trade and then by the colonization by the European powers of the Americas, Africa and Asia. In relation to the propagation of plants, however, there still remained a major practical problem. No one yet knew just *how* to successfully tackle and control hybridization. The efforts of botanists and horticulturalists to deliberately hybridize roses were based on nothing more than speculative notions, and success was largely down to skilled observation, which involved the committing to memory of much experience, and the keeping of meticulous records. A breeder didn't know exactly what was happening, empirically speaking, even when a successful cross was achieved.

Until the late nineteenth century, a rose was cultivated from hip seed or by striking a cutting from late autumn hard wood. But at first, many of the resulting hybrids cultivated by Europeans were unable to produce viable seed. The Law of Heredity was discovered by the Abbé Gregor Johann Mendel two years before 'La France' was introduced, but Mendel's work on genetics did not become widely known until after 1900. In the period during which Guillot *fils* was at work, the

norm was to plant rows of different rose varieties next to each other, and hope for the best. It was a very inexact science. Rose breeders relied on experience, and waited for pollination to occur. As we have seen, sports from time to time occurred, as in the case of the Bourbon Rose, for example, and probably the Noisette, and what these breeders were doing was upping the chances of a new and interesting mutation happening. When ripe, seeds were harvested and sown in the open, remaining in beds for two years until transplanted. After that, any viable mutations were consolidated, with the expectation that they might become a reliable and appealing new rose.

The goal of a breeder of roses, so Guillot *fils* suggested through the success of 'La France', and many other roses, should be to find ways to produce hardy and repeat-flowering plants with flowers that had large semi-double or double petals, and hopefully, but by no means essentially, a delightful fragrance. The focus at first was above all on the perfection of the flower rather than the value of the rose as a hardy shrub. But gradually, the latter also became an important consideration, as breeders responded to the need for tightly packed blossoms on short stems and tidy bush-like growth that could be accommodated in suburban and cottage gardens and, of course, be relatively trouble free.

But it wouldn't be until the 1880s that the number of roses with similar hybrid ancestry and characteristics were numerous enough to warrant the naming of a whole new class, and it was an Englishman who was to see the real potential of roses like 'La France'. In the 1870s Henry Bennett began to breed what he termed 'Pedigree Hybrids of the Tea Rose', and in 1879 put in commerce ten of them at the same time. The rose would never be the same again. As the authors of the *Encyclopedia of Roses* write succinctly: 'Henry Bennett invented modern roses, the Hybrid Teas that flowered repeatedly, not as delicate glasshouse treasures, but as hardy garden plants. There is scarcely a rose in our gardens today that does not descend from Hybrid Teas of the Wiltshire "wizard".'[2]

The typical Hybrid Tea has long, slender, high-centred buds, carried singly on long, slender, upright stems producing an erect plant form. Its

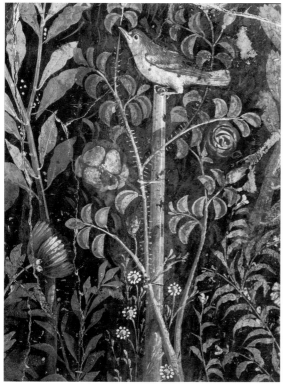

Left: *A nightingale on a cane holding a rose*, AD 30–50. A detail from a fresco discovered at Pompeii offers an intriguing insight into how the Romans planted roses in their gardens, in this case Gallica Roses.

Below right: Illustration from *Le Roman de la Rose*, c.1490–1500. In this Flemish work, the lover is shown approaching to pluck his 'prize', a Gallica Rose represented many times its normal size.

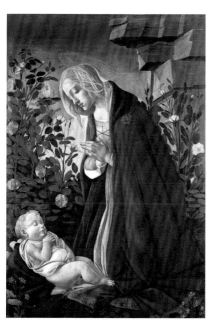

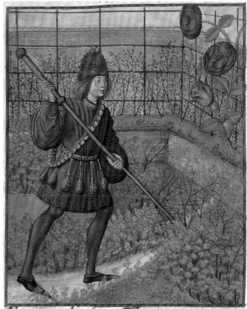

Above left: Sandro Botticelli, *The Virgin Adoring the Sleeping Christ Child*, c.1485. The *Rosa gallica officinalis* is very realistically depicted but, in keeping with its role as a symbol of the Virgin Mary, it has no thorns.

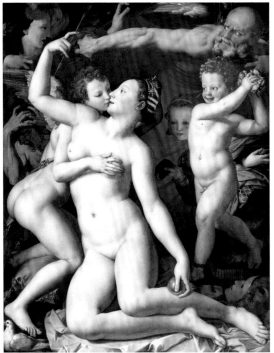

Agnelo Bronzino, *Allegory with Venus and Cupid*, 1545. In Classical mythology the rose is closely associated with Venus – hence its popularity on St. Valentine's Day. The bunch of blossoms held by the boy symbolizing Folly could be a variety of *Rosa chinensis*. If so, it is the earliest known depiction of a Chinese species rose in Western art.

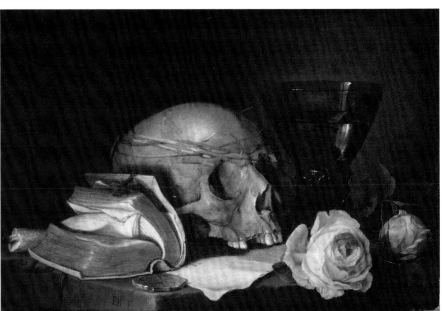

Jan Davidz. de Heem, *A Vanitas Still-Life with a Skull, a Book and Roses*, c.1630. This still-life painting by a Dutch artist is intended to remind viewers of the transience of life, that 'all is vanity'. The Centifolia roses serve as an uplifting counterpart to the austere gloom of the skull and book, but they too 'shalt fade ere noon'. Although one can also argue that because they are *painted* roses, they will in a sense never fade.

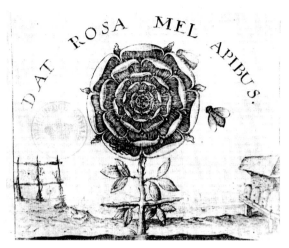

Dat Rosa Mel Apibus. An illustration from Robert Fludd's *Summum Bonum*, 1626, which carries a Latin text that translates as 'The Rose gives the bees honey'. Here, the rose features as part of an elaborate allegory for the 'Great Work' of alchemy.

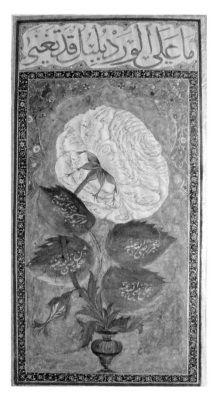
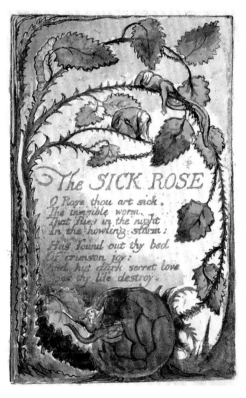

Above left: *Prophet Muhammad as a Rose.* Persian. Eighteenth century. The gold writing on the leaves and petals of the *gol mohammadi* (Muhammad's Rose) – aka the Damask Rose – describes the Prophet's exemplary characteristics, and the text at the top in blue declares: '[This is] what the nightingale sings above the rose.'

Above right: William Blake, *The Sick Rose.* A hand-coloured print by Blake issued c.1826. Note the worm, top left.

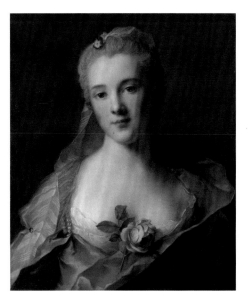

Jean-Marc Nattier, *Manon Balletti*, 1757. The sitter was one of Casanova's love interests, and in this portrait the Centifolia Rose is a symbol of love, while the violas in her hair symbolise thoughts of the beloved.

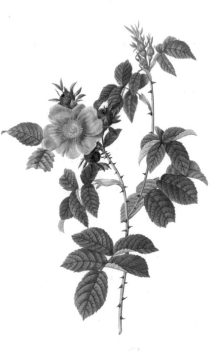

Above right: Pierre-Joseph Redouté, *Rosa canina*. A painting of the Dog Rose by the 'Raphael of Flowers', from his magisterial *Les Roses*, 1817–24.

Left: *Rosa odorata 'Ochroleuca'* (Parks' Yellow Tea-Scented China), c.1824–31. Painted by an anonymous Chinese artist for the Englishman John Reeves and the Horticultural Society of London.

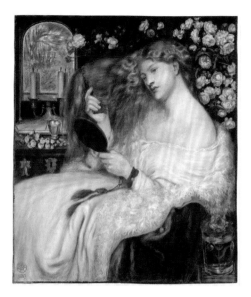 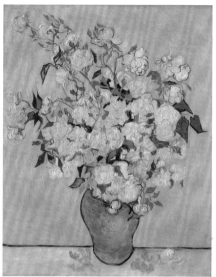

Above left: Dante Gabriel Rossetti, *Lady Lilith*, 1864–68. Rossetti's depiction of the first wife of Adam is an example of how the rose within Victorian culture was often associated with the dangerous allure of woman.

Above right: Vincent van Gogh, *Roses*, 1890. Painted when the artist was recuperating in the asylum at Saint-Rémy, near Arles.

Below: One panel from a series that adorn a room at Buscot Park in Oxfordshire, England, telling a story best known as Sleeping Beauty. It shows the prince flanked by the princess' sleeping retinue engulfed by monstrous Dog Roses.

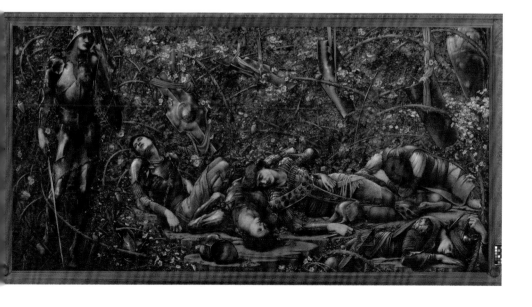

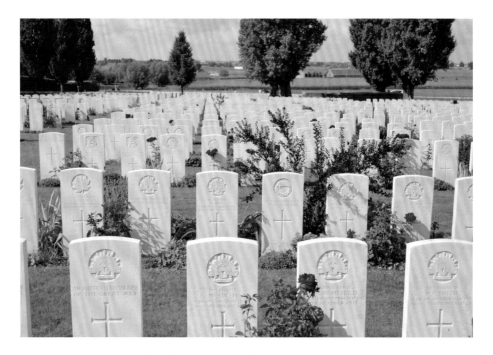

Above: Tyne Cot British and Commonwealth Cemetery, Belgium. While the poppy is the flower most closely associated with the First World War, commemorative roses are a beautiful presence in cemeteries.

Below: The rose garden at Mottisfont Abbey, Hampshire, in glorious bloom. As photographed by its head gardener Jonny Norton.

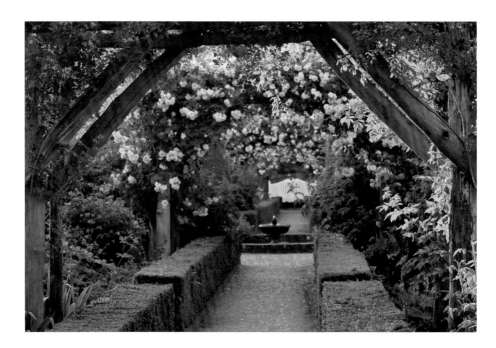

'Gertrude Jekyll'. Named after the renowned English horticulturalist and garden designer, this rose has been gracing gardens since 1986, and is one of David Austin's 'English Roses', which aim to blend the best characteristics of old and new roses.

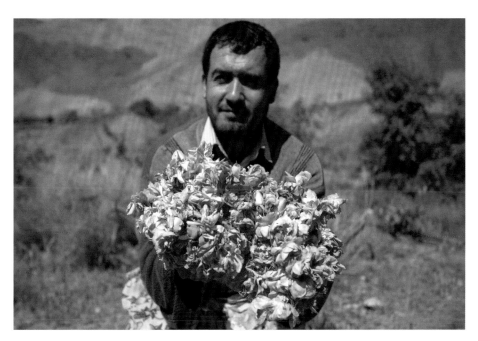

Present-day heir of a thousand years' old business, a farmer in Kashan, Iran, shows off a huge armful of recently harvested Damask Roses.

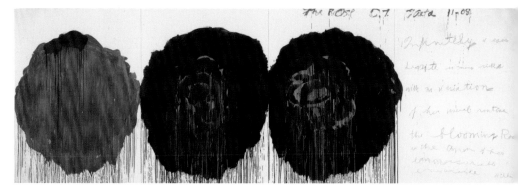

Cy Twombly, *Roses V*, 2008. The American artist includes a quotation from one of the Austrian poet Rainer Maria Rilke's French language rose poems (translated into English).

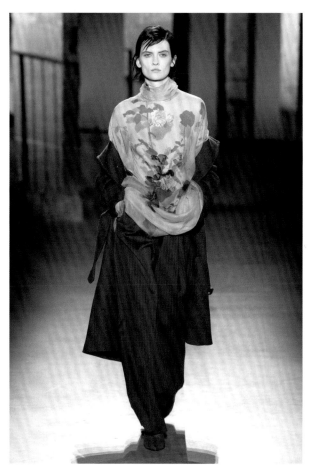

A rose-themed design by the Belgian fashion designer Dries van Noten for his Autumn/Winter 2019 collection.

flowers are large but not too full, having larger outer and smaller inner petals which unfurl without losing their cup-like form. These flowers can vary considerably in colour, are vigorous and borne over long periods. Sound familiar? It should, because these still remain today the dominant characteristics of the roses in our gardens, parks and bouquets.

The next important stage in the modern rose revolution occurred over sixty years later, in 1945, and although it again begins in France, this time it will come to fruition in the United States. Between 1936 and 1939 in the south of France, the nurseryman Francis Meilland produced a stunning yellow-tinged-with-pale-red Hybrid Tea Rose, which he catalogued as No. 3-35-40. At the time, yellow was still a rare hue. As we saw, yellow was characteristic of some China Roses, and in the West before the nineteenth century there was only the five-petalled *Rosa foetida*, the Persian Yellow or Austrian Briar, a native of the Caucasus mountains in Georgia, that came to Europe via Persia. Joseph Pernet-Ducher, the 'Wizard of Lyon', was especially adept at breeding yellow roses, using the *Rosa foetida* as parent.

Pernet-Ducher was a third generation rose breeder, the son of Jean-Claude Pernet, and he inherited the rose business from his father-in-law Claude Ducher, who was also a rose breeder of note. Such was Pernet-Ducher's success in breeding new roses, that a whole class known as Pernetianas was officially designated, and remained in use through the 1920s, whereupon Pernetianas were absorbed into the Hybrid Tea family. In 1900, Pernet-Ducher introduced the first yellow Hybrid Tea, 'Soleil d'Or', which he crossed not with a China or Tea Rose, but rather with *Rosa foetida*, resulting in 'Antoine Ducher', a Hybrid Perpetual that had been introduced in 1866.

I am especially fond of Pernet-Ducher, as the rose that is so amply covering our garden arbour in France is one of his creations: 'Cécile Brünner', a pink Noisette introduced in 1881 by the daughter of Claude Ducher, Marie, and Joseph, her soon-to-be husband. This prodigious

climber also goes by the names 'Cécile Brunner', 'Mademoiselle Cécile Brünner', 'Malteser Rose', 'Mignon' and 'Sweetheart Rose' (on account of the fact that it makes a perfect buttonhole rose). I was also pleased to discover that a descendant of Pernet-Ducher today runs a rosary not far from Lyon, from whom I purchased several classic rose – more of which in a later chapter.

It was from another of Pernet-Ducher's yellow roses, 'Souvenir de Claudius Pernet' – named (as I mentioned in the Introduction) after Joseph's son, who died in the First World War – that Meilland would use as the yellow-pigmented grandparent of the rose No. 3-35-40.[3] To be precise, this rose was the result of the hybridizing of an unnamed seedling parent originating from crosses between four roses – 'Souvenir de Claudius Pernet', 'George Dickson', 'Joanna Hill' and 'Charles P. Kilham', whose offspring was then crossed with the other parent, 'Margaret McGreedy'. Once he could see its potential, Meilland decided to name the new rose 'Madame Antoine Meilland', after his mother, who had died young. Just before the outbreak of the Second World War, Meilland sent cuttings to a nursery in Italy, where, unknown to him, it was to be named 'Gioia', and to Germany, where it became 'Gloria Dei'. Another cutting was flown to America, and once safely there it was taken in hand by a well-established nursery, Conrad Pyle Co. in Pennsylvania, who named it 'Peace'. Then, in a stroke of promotional genius, the nursery arranged to have cuttings given to all delegates at an inaugural session of the United Nations in San Francisco in 1945.

'Peace' was an immediate and huge sensation. It made the Meillands very rich, not only because of prodigious sales to the public, but also because during the 1950s and 1960s 'Peace' went on to become one of the most widely used roses for breeding other Hybrid Teas, which by this period were the dominant commercially available roses.[4] I have 'Peace' growing in my French garden, although I should, strictly speaking, be calling it 'Madame A. Meilland'. My specimen is a tidy bushy shrub, and is indeed impressive when in bloom. The flowers are almost the archetypal shape of the modern rose – large, not too compact, with not too many

petals, which are a delicate yellow colour fringed with pink. But these blooms have almost no scent, and the very glossy, deep green leaves suffer terribly from various unsightly blemishes (at least, mine do).

The next stage of the modern rose revolution this time actually begins in the United States. In 1954 the pink rose 'Queen Elizabeth', opportunistically named to celebrate the ascendency of Elizabeth II of Great Britain in 1952, was introduced by the Californian breeder Walter E. Lammerts. It is a very tall (up to 8 feet) upright shrub and bears tight clusters of flowers – hence the designation it was soon to receive – Floribunda – thereby inaugurating a new class of roses. 'Queen Elizabeth' now ranks as one of the most popular modern roses. In 1979 it was named the 'World's Favourite Rose', and forty years later, in 2019, won the 'Award for Excellence for Best Established Rose'. 'Queen Elizabeth's' parentage is the Hybrid Tea 'Charlotte Armstrong', bred by Lammerts in 1940, crossed with 'Floradora', which was bred in Germany in 1944 by Matthias Tantau, another important pioneer of modern roses. My specimens of 'Queen Elizabeth' are extremely lanky and upright, and have very glossy leaves, like 'Peace'. This rose is indeed very floriferous, but it has no fragrance. I also have a white variety of 'Queen Elizabeth', which is the same in every way except colour. It is somewhat ironic that this iconic rose, named after the Queen of Great Britain, is actually the scion of an American breeder, and is also in fact half German. (But, come to think of it, so are the Windsors.)

Central to the success of the European and American breeders of the later nineteenth and early twentieth century was their ability to assimilate and profit from the work done on inheritance, from which modern genetics derives. After Mendel's pioneering work was widely disseminated, it was understood that the desired characteristics of a new

cultivar would appear after the first generation, and so a structured breeding plan could be put in place. Consciously planning a cross was a complex undertaking, but once the Law of Heredity was known it became more rigorously scientific.

The starting point of hybridizing is the choice of seed and pollen parent, and genetics has shown that a rose will inherit its qualities from both parents. The seed parent is a rose that from experience is known to give a good harvest of seeds. From there, as Gerd Krüssmann writes, the hybridizer has two strategies available:

> a) He can cross two wild species which have some of all of the desired characteristics. The offspring will show these in the first generation. The grower must now cross these back on themselves (selfing), and will undoubtedly get closer to his goal in the F2 and F3 generations; it may take longer if some of the seeds prove sterile. If everything goes well at this stage then he can build upon it with infinite patience, liberal investment and unlimited time until finally the ultimate goal is reached.
>
> b) Alternatively, he can cross two hybrids which appeal to him and wait and see what comes up. In this case there is a vast number of possibilities of something new, but no one can tell whether the seedlings will be better than their parents; usually they are not. It was in this way, without real planning, that the roses of the last century [the nineteenth] were obtained, as well as a considerable number of our modern roses.[5]

Millions of different seedlings are born from the same two parents, so the chances of a breeder being able to combine the qualities he wants are very slim, and this is when honed skills of observation grounded in experience still help choose a 'winner', that is, a popular and enduring variety. The celebrated British nurseryman Jack Harkness provides a description of the technique:

> Rose breeders perform their task by growing their plants in an environment which will ripen the seed ... The mechanics are simple. The plant chosen to be the seed is brought to flower, and before its stamens are ready

to shed pollen, they are removed. Its stigma, as soon as they are receptive, are covered with pollen brought from the chosen father. Thus a planned mating occurs, and much of the rose breeder's art lies in his vision in choosing which cross to marry ... The seedlings grow quickly, and are normally flowering three months after the spring time of germination, given good growing conditions. They prove to be all different, identical twins being as rare as in the human race.[6]

Eventually, a standard way of mass propagating a new hybridized rose developed. They are grafted onto the roots of another, which is chosen for its ease of propagation, hardiness and vigour. It was discovered that a few varieties of rose were the most suited to serve as rootstock species roses, such as *Rosa canina*, and later the native East Asian roses *Rosa multiflora* and *Rosa rugosa* became widely used for this purpose, because they are very robust wild roses (as we saw, Rugged Rugosa is one of this species' nicknames). Many more new plants could be produced by grafting each bud of a new variety to the roots of an established plant. Grafted roses will also often form more and larger blooms. These days, *Rosa laxa* is commonly used in the United Kingdom, a species rose indigenous to the dry steppes of central Siberia, while in the United States 'Dr Huey' or 'Fortuniana' are preferred. *Rosa multiflora* is also popular rootstock, especially in colder climates. Traditionally, grafting was carried out in the field on open beds. But nurserymen have found quicker methods, such as bench grafting and grafting direct into pots. More recently, however, there has been a reaction against grafting, and a return to growing roses on their own roots. But grafting still remains the preferred commercial method, as hardwood cuttings take longer to make a saleable plant.

What are breeders looking for in their new rose? They want variations on the existing forms of the roses that are familiar, so they test these variations against the natural and cultural environment, thereby generating further variations in an ongoing process that continues ad infinitum, as more 'successful' roses progressively nudge suddenly less 'successful' ones aside. This drive to introduce new 'improved' roses

reflects a major transformation in Western culture. Until the eighteenth century it was customary to look backwards for guidance on how to move forward. There was a cyclic view of time in which the golden age declined into the decadence of the present. The search for truth was, thus, a search for the early, the ancient, the pure and original forms of life from which the present and immediate past were degenerations. The past was always better than the present. But in the modern era, this attitude changed. The past was an impediment to moving into the future, which under the correct guidance would be even better than the present. This basic realignment in the relative value of past, present and future unconsciously informed the assumptions of the nineteenth-century rose breeders. The rose inherited from the past needed to be improved or bettered. It required adjustment to reflect the progressive standards of the present. The new roses existed within a socio-economic system that had made a cult out of innovation.

The shift in the preferred colour intensity and range in roses, for example, mirrors a much broader transformation in the culture of colour in the modern age. The developed world in general became more colourful in the twentieth century, and the majority of surfaces that surrounded people were far more chromatically vivid compared to those that surrounded the people of the past. For as a result of the widescale development of chemically synthesized tints in the nineteenth century, buildings, walls and shop windows have progressively became more colourful, while product packaging, clothing, paintings, photographs and films were increasingly suffused with all the hues of the rainbow. This transformation amounts to a significant modification of the world, a shift from the paleness of the past to a technicolour present. And under careful human tutelage, roses followed suit. They were bred to accommodate the taste for brighter and novel colours, which are now such familiar characteristics of the modern age in general.

Another key factor was the introduction in the first half of the twentieth century of copyright and patent laws. In fact, the first patent ever registered for a plant was for a hybridized rose, and was issued by the United States Patent and Trademark Office on 18 August 1931 to Henry

F. Bosenberg, of New Brunswick, New Jersey, for his 'Climbing or Trailing Rose', 'New Dawn'. Since then, the patent of a rose name has become fiercely guarded, and the naming of roses is another lucrative aspect of the rose business. In 2016, the United States Patent and Trademark Office granted eighty plant patents for new and distinct roses. Patents impose strict legal constraints on naming, forcing on a rose a single and uniform name within the region of the patent, although, as we have seen, these can vary from country to country, as nurserymen take out their own patents. As a result, as in the case of 'Peace', things can become somewhat confusing. Nowadays, in addition to having a patent in order to register a new rose it is necessary to apply to the International Cultivar Registration Authority of the country of origin, which imposes the rules of the International Code of Nomenclature for Cultivated Plants. Each ICRA checks that the name is not already in use, and ensures that a new name is formally established through publication in hard copy, including a description and date of introduction, as only then does the new name have legal precedence. As the example of 'Peace' demonstrates, the right name at the right time and place can make all the difference.

In fact, much can be learned about the profound social changes that have occurred in Western society over the past one hundred and fifty years through examining the changing conventions behind the naming of roses. Here are some examples of varieties bred between the mid-nineteenth century and around 1920: 'Commandant Beaurepaire', 'Cramoisie Picotée', 'Cuisse de Nymphe Emue', 'Duc d'Orleans', 'Duchesse de Verneuil', 'Frau Karl Druschki', 'Königin von Dänemark', 'La Reine Victoria', 'Lady Penzance', 'Madame Caroline Testout', 'Mademoiselle Cécile Brünner', 'Madame Isaac Periere', 'Madame Pierre Oger', 'Manette', 'Princess Adelaide', 'Reine d'Anjou', 'Rose of Comte de Chambord', 'Zéphirine Drouhin'. And now here are some of the names of 'new' roses from the post-1945 period: 'Absolutely Fabulous', 'All My Love', 'Best Friend', 'Blue Moon', 'Dear One', 'Diamonds Forever', 'Doris Day', 'Freddie Mercury', 'Fragrant Cloud', 'Hot Chocolate', 'Iceberg', 'Love Me Do', 'Masquerade', 'Moody Blue',

'Moonlight', 'Orangeade', 'Peace', 'Sexy Rexy', 'Superhero', 'Super Star', 'Tina Turner', 'White Romance'.

Before the mid-nineteenth century, the customers of the rose trade in the West were primarily the nobility and the *haute bourgeoisie*, and the names of newly introduced commercial roses reflected their tastes, and often appropriated their family names. Over time, like Western society in general, the rose trade became more democratic. But at first the names remained mostly patrician, as befits a hierarchical society in which everyone knows their place. The fashion until the mid-twentieth century remained to name a newly bred rose after a person, and often, but not always, they were female. The act of naming was meant to flatter someone famous or influential – a male aristocrat, statesman or general – through honouring their wife. Sometimes, nurserymen were proud enough to name roses after themselves or their own wives, but more often the honour of the name went to their patron or his wife. The goal was to make the right kind of association. The rose's name had to conjure up something agreeable that would flatter the one who had been named and those associated with them, but also impress potential buyers. The name had to invite benign comparisons, and was intended to help the rose associated with the name become a success. It must add glamour to the rose, magic and enchantment, and the reliable cultural connection between female beauty and the rose made the strategy of giving a rose a woman's name obvious and very successful.

What produces this glamour is largely culturally determined, and depends on taste, which is acquired through upbringing and education, class and aspiration. What was once considered 'glamorous' can later seem pretentious or merely dull. Today, the names of the older roses have their own special nostalgic enchantment, but at the time they were designed for a specific social context. This is also true of the newer roses. The transition to the more populist names which now attach themselves to roses occurred after the Second World War. As we saw, in the early twentieth century the western European and American middle and lower-middle classes fell in love with roses, and the names

of roses reflected this shift. The two world wars helped fuel the vogue, as many memorial rose gardens were built, and war graves and war memorials needed commemorative roses. Furthermore, we have seen how the rose itself was undergoing major morphological changes, as it became tailored to the tastes and capacities of the new clientele, with their small suburban or cottage gardens that didn't want climbers and ground coverers, but needed neat, shrubby bushes that weren't much trouble to maintain.

During the second half of the nineteenth century the naming of roses became more overtly commercialized. 'Madame Caroline Testout', a pink Pernetiana introduced in 1890 by Joseph Pernet-Ducher, got its name because the real flesh-and-blood Caroline Testout worked in a London showroom selling the latest Parisian fashions, and purchased the name of the new rose as an advertisement for herself. Madame Testout was 'not only wise in her generation, but considerably in advance of it', as Jack Harkness comments:

> It is usually hinted or assumed that Pernet-Ducher was quite taken in by the sharp lady, and sold her a rose he had little expectation from . . . In fact it is difficult to evaluate a rose until it has been on the market for three of four years, and most breeders are content to share the risks with those who buy varieties or names from them. How many of 'Caroline Testout' were grown, nobody knows; it used to be said that an astronomic number were planted in Portland, Oregon, where the municipality used roses along the roadways, to the great benefit of that place.[7]

Gradually, rose naming became more solidly bourgeois. Here, for example, are some of the names of roses from the National Rose Society of Britain's *Rose Annual* of 1924: 'Phyllis Bide', 'Betty Hulton', 'F. J. Harrison', 'Allen Chandler', 'Mrs Beckwith'. The latter was named after the wife of the breeder of the rose itself, G. Beckwith & Son, and is yellow, with typical Hybrid Tea characteristics, but at the time it was classified as a Pernetiana. 'Mrs Beckwith' won the Gold Medal at the Spring Show of 1923. Another new rose in the *Rose Annual* of 1924 is

called 'Lady Roundway', which honoured the wife of Brigadier-General Edward Murray Colston, 2nd Baron Roundway. It is also classed as a Pernetiana, and was the creation of the most important rose breeder of the period in Britain, B. R. Cant & Sons.

In my garden in central France I have floral memorials to, for example, the following Victorian women: 'Madame Isaac Perière', 'Madame Alfred Carrière', 'Zéphirine Drouhin', 'Madame Caroline Testout' and 'Cécile Brünner'. I also have memorials to more recent women – 'Mme A. Meilland' (aka 'Peace'), 'Ena Harkness', and one that is retro-named to bring a modern rose the cache or glamour of an earlier age, 'Gertrude Jekyll'. 'Ena Harkness', which was introduced in 1946, made the Harkness nursery famous, but was bred by the amateur breeder, and subsequent president of the National Rose Society of Great Britain, Albert Norman. It has beautiful big crimson-coloured flowers, and in 2006 I planted a climbing form of this rose about 10 feet away from the Noisette climber 'Cécile Brünner'. The plan was to have them both ascend our pergola in a sort of rosy *Entente Cordiale* (one rose is a French rose, the other British). Yet 'Cécile Brünner' is now a veritable monster. The gnarled trunk twists and turns like something truly ancient, and not altogether benign. 'Ena Harkness', meanwhile, is a mere 3 feet tall, and consists (at the time of writing) of two spindly, sparsely leaved canes. I have on several occasions thought to give up on it, but never have because it still graces us with a few wonderful velvety crimson and scented flowers each summer, which tend to nod downwards rather than stand erect. The extreme contrast between my two specimens' respective growth certainly gives me pause for thought, and is a reflection of this gardener's amateurism when it comes to growing roses, so the fact that it is 'Cécile Brünner', a French rose, which has become the giant, and the British one that seems to perpetually struggle on the verge of extinction, should not be taken as any kind of cultural metaphor. Jack Harkness, the son of the man who introduced the rose, William Ernest Harkness (he agreed to distribute it for Albert Norman), writes: 'My firm has reason to be grateful to this rose, for our name became famous through it; at least to rosarians.' To rub

salt in the wound regarding the lacklustre state of my specimen, I read the following in one of the indispensable guides from the 1960s to the practical side of roses, Roy Genders' *The Rose: A Complete Handbook* (1965): "'Ena Harkness', in all her glory, grew close by. What a magnificent rose it is. In my own garden it was a mass of colour throughout the dull, cold June and July of 1962 and until the end of November with never a spoilt bloom."[8]

Having a rose named after you can be a fairly good way to achieve immortality, hence the continued appeal of buying a rose name. As long as the rose remains in commerce and there are customers keeping you alive by buying and planting your avatar, a rose with your name can bring symbolic life after death. But the terrible truth is that the whole business of rose naming and patenting is a lottery. There's absolutely no guarantee that a rose whose name has been purchased, and is then put in commerce by a professional breeder, will be around in five years. The rose you paid good money to have named after yourself or a loved one may only survive in your garden and those of other family members, perhaps on a loved one's grave. When I checked the roses in the *Rose Annual* of 1924, I was struck by just how many roses marketed that year are no longer with us, or at least, not knowingly. Neither 'Lady Roundway' nor 'Mrs Beckwith' are in commerce today, which makes the commentary in the *Rose Annual* of 1924 on the latter rose all the more poignant:

> A fine Rose of good habit. The blooms, which are well formed, are a bright lemon colour, shaded with white. Fragrant. The foliage is a dark green, glossy and free of mildew. An ideal bedding Rose. We are getting a number of yellow Roses now, almost too many, but there is plenty of room for this one. In commerce.[9]

One of the roses illustrated in the *Annual* which still is 'in commerce' is the yellow rose 'Souvenir de Claudius Pernet', which I have mentioned already. Through a rose named in his memory, Claudius lives on. But Pernet-Ducher named a pink rose after his other son, who was also

killed in action – 'Souvenir de Georges Pernet'. Alas, as far as I know, this rose is no longer with us.

The modern rose breeders had a basic testing mechanism when they marketed a new rose: will it sustain attention? But habituation is two-sided. It provides established forms that reduce costs through the guarantee of secured interest, but it eventually leads to loss of attention through being overly persistent and repetitive. So, to counter habituation, the breeder knows that innovation is necessary. There is therefore a constant pressure for novelty. Sometimes this novelty overshadows garden worthiness. And, of course, how can one ever know if the novel rose will grab the public's attention, and then hold it long enough to metamorphose into a lucrative habit?

In 1906, L. Simon and P. Cochot set out to list all roses introduced by that date, and concluded that between 1810 and 1904, 11,016 varieties were marketed. In 1899 alone, 150 new roses were introduced. In this period, the French were the most prolific. Jean-Pierre Vibert, for example, the leading rose breeder of the first half of the nineteenth century, introduced 600 new roses. His specialty was striped and spotted varieties. William Paul's firm in the United Kingdom, the biggest across the Channel in the second half of the nineteenth century, only mustered a modest 107. Most of the new roses only lasted a few years, and were quickly superseded. Only a select few achieve genuine longevity, and as the competition increased, so did the chances of failure.

CHAPTER TWELVE

'The perfect rose is only a running flame'

MODERNIST ROSES

In the period during which the newfangled Hybrid Teas were taking Europe, America and the colonies by storm, the Anglo-Irish writer Oscar Wilde published a short story entitled 'The Nightingale and the Rose' (1888), in which he certainly didn't have those kinds of modern roses in mind. Wilde retells the old Persian story of how the first red rose came into existence, but in his version the poor nightingale sacrifices itself for the sake of a lovelorn but overly intellectual student who is pinning for the delightful but superficial daughter of his professor. All she needs to make her happy, the student overhears the young lady say, is one red rose. But as there are only white ones available, the student feels he cannot court her. The nightingale listens and sees him weeping, and filled with compassion decides to help by piercing its own heart with the thorn of a white rose, thereby willingly sacrificing its own life. The red rose is created. The student plucks it, and then hastens to give it to his love interest. But she just laughs at him, and scoffs that the chamberlain's nephew has already given her something much more to her taste: real jewels. 'Why, I don't believe you have even got silver buckles to your shoes as the Chamberlain's nephew has,' she mocks. As a result of this rebuff Wilde's student is led to lament:

> What a silly thing Love is... It is not half as useful as Logic, for it does not prove anything, and it is always telling one of things that are not going to happen, and making one believe things that are not true. In fact, it is quite unpractical, and, as in this age to be practical is everything, I shall go back to Philosophy and study Metaphysics.[1]

The purpose of Wilde's story is to stress that the nightingale has risen above the young people's sentimental failings through useless sacrifice. Wilde casts it as an allegory of the struggle between crass materialism and the transcendent power of art for art's sake, equating beauty with a higher universal truth lying above a material world soiled by petty dreams and selfish vices. But, more broadly, Wilde's story is an indication that progressive artists of the late nineteenth and twentieth century were experiencing a crisis concerning the purpose of art. Against the lure of the overly entertaining kind of culture which was being increasingly produced for the industrialized masses, the imaginations of some artists moved steadily upwards towards more and more refined modes of existence, sometimes taking the rose with them.

In fact, by the time Wilde wrote his story, the rose had achieved a uniquely dominant status as a poetic floral image. Through being a human symbol drawn from nature and rooted deeply in numerous traditions, the rose had become a seemingly archetypal symbol with timeless value. It was perhaps the most recognized metaphor through which to address the shifting ground between feeling and thought, love, beauty, temptation and loss, passion and idealism, the material and the abstract, the profane and the sacred. The problem, however, was that this symbolic rose had also become so familiar that it was easily co-opted for mass enjoyment, and so risked losing any authentic transformational force.

W. B. Yeats, another Anglo-Irishman, showed great interest in the rose as a way of symbolizing the relationship between idealism and the fallen reality of modern mass society. The ugliness of the human world, mired in tragic history, was juxtaposed in his poetry with the timeless and ideal, symbolized by the rose. In 'The Secret Rose', Yeats

alludes to Dante's visionary rose in the *Divine Comedy*, and writes: 'Far off, most secret, and inviolate Rose, / Enfold me in my hour of hours.'[2] In a love poem from 1899, Yeats drew on the familiar analogy between the rose and the human heart, but gives it renewed transcendental implications:

> The wrong of unshapely things is a wrong too great to be told;
> I hunger to build them anew and sit on a green knoll apart,
> With the earth and the sky and the water, re-made like a casket of gold
> For my dream of your image that blossoms a rose in the deeps of my heart.[3]

Yeats effectively marries two metaphoric 'containers' of emotion – the heart and the rose – thereby extending the rose's relationship with love so that it decisively gravitates away from carnality towards the more noble emotions with which the heart is linked. As a result, for Yeats, the rose carries associations with kindness, sincerity and affection, but also with concern, sadness, vulnerability and pity. Above all, perhaps, the rose-heart symbolizes incorruptible spiritual courage. But this fragile rose in the heart must also be protected from the ravages of time and public life. In sum, the rose for Yeats symbolizes the heart when it has been purified, leading the spirit upwards towards the Truth. He tacitly accepted the fundamental duality of heart and head and, against the grain of a society which he perceived as overly dedicated to the 'head', emphasized the importance of the heart. But this means that head and heart are strictly compartmentalized; the head engages with the reason and science that govern public life, and the heart speaks of feeling, emotion and personal commitments, which belong in the private realm of religious faith and art. However, as his thinking developed, Yeats increasingly strove to bring his vision of the ideal rose-in-the-heart into closer alignment with the senses, a convergence evoked, for example, by the fusion of the images of wine and roses: 'And one has seen in the redness of wine / The Incorruptible Rose.'[4] But despite his efforts to conjoin the rose with the 'wine-vat' of the senses, the

overwhelming impression we have is that, for Yeats, the rose is thoroughly abstract and ideal. The organic rose has been wholly lost from sight. For instance, we have no idea which particular rose Yeats might have been inspired by. His rose only seems to exist in poetry. It is, as Barbara Seward elegantly puts it in *The Symbolic Rose*, 'The inconsolable rose of human longing for what cannot be attained in time.'[5]

The same rarefied and generalized symbolism suffuses the roses in the work of the Anglo-American poet T. S. Eliot, for whom it is also a primary symbol of the ideal, a vision of the eternal in the midst of a fallen world. In 'The Hollow Men' (1925), Eliot also invokes Dante's rose, describing a modern human being who is 'Sightless, unless / The eyes reappear / As the perpetual star / Multifoliate rose / Of death's twilight kingdom / The hope only / Of empty men.'[6] There is no longer hope, Eliot declares, except for those capable of holding onto the timeless spiritual vision of redemption held out by the 'multifoliate rose'. In the later cycle of poems, *Four Quartets* (1945), Eliot draws even more centrally on the rose as a poignant, but wholly abstract, symbol of redemption. In the 'Burnt Norton' section, he writes of a 'rose-garden': 'Footfalls echo in the memory / Down the passage which we did not take / Towards the door we never opened / Into the rose-garden.'[7] This garden, a resonant metaphor established through long tradition, symbolizes for Eliot the moment when language breaks down before the experience of perfection and the infinite, and represents the escape from the heavy weight of history into timelessness. He emphasizes that there is a fundamental paradox in the fact that history-bound and material symbols like the rose and the rose garden are needed in order to imagine the escape from history into the eternal: 'But only in time can the moment in the rose garden, / . . . Be remembered.'[8] In other words, perfection can only be glimpsed through the material world of existence, and because of this, it is never possible to actually enter the eternal 'rose garden'. It is forever closed to finite beings.

In the final lines the 'Little Gidding' section of *Four Quartets*, published in 1942, Eliot writes: And all shall be well and / All manner of thing shall be well / When the tongues of flames are in-folded / Into

the crowned knot of fire / And the fire and the rose are one.'[9] He is quoting the medieval mystic Julian of Norwich ('All shall be well, and all manner of things shall be well'), and again alluding to Dante's *Divine Comedy*. The line, 'And the fire and the rose are one', suggests Tennyson's 'Maud', from whose pessimism Eliot sought to swerve upwards away into religious transcendence. But again, one is inclined to ask what rose is this that can be 'one' with fire? Like Yeats' rose, Eliot's seems to exist only in the rarefied air of the mystic-artist. So, perhaps it is worth briefly glancing downwards towards the earth to remind ourselves that in the same year that *Four Quartets* was published – 1945 – a Hybrid Tea Rose called 'Madame A. Meilland', known as 'Peace' in both Eliot's homeland and adopted homeland, had just been introduced to very lucrative commerce.

The Austrian poet Rainer Maria Rilke was also drawn to the rose as a metaphor that could speak of the ideal. In the posthumously published collection of poems written in French, entitled *Les Roses* (1926), Rilke writes beautifully of how the rose has been used throughout history to communicate the unsayable truths of our inner life. Here is one example, translated by David Need:

> A single rose, it's every rose
> and this one—the irreplaceable one,
> the perfect one—a supple spoken word
> framed by the text of things.
>
> How could we ever speak without her
> of what our hopes were,
> and of the tender moments
> in the continual departure.[10]

In 'A Bowl of Roses', Rilke refers to the rose's capacity to transform human life through being the promise of another, better, mode of being: 'You've witnessed anger flaring; seen two boys / who've balled their bodies up, / . . . But now you know how that may be forgotten: /

before you stands a bowl that's filled with roses.'[11] But Rilke was more concerned than Eliot to link metaphysical aspiration to the material world, and to employ the rose as a way of exploring the mind and the body, and their often conflictual but indivisible relationship. In his poetry we never feel that we have lost sight of real roses growing in a real garden or real roses gathered into real bouquets.

Rilke was acutely sensitive to the mystery and obscurity of the rose's vegetal being, and for him it was not so much a definite, fixed symbol but a special part of nature with the capacity to remind humanity to keep a passage open to the unknown, to the non-human. Rilke noted that petals are a powerful spatial and kinetic metaphor for the shifting polarities of inner and outer. When we encounter a rose we are faced with an object existing in the humanly perceived world but also something closed to, or independent of, this humanly meaningful world. Rilke therefore saw the opening of the rose's petals as a metaphor for openness of being that necessarily involves constant transformations. The translucency of the petals filters the light, and as such, a rose is a metaphor for inwardness that is neither closed to the outside nor entirely open to it. It is precisely the rose's semi-opacity to human thought that Rilke saw as making it potentially a channel for our most subtle thoughts and unnamed desires, those that cannot find a place within a world framed by the limiting parameters of human intelligence, with its obsession with reasoning and quantifying. For Rilke, the rose calls forth something in us, and we call forth something in the rose.

But Rilke shares with Wilde, Yeats and Eliot a commitment to the rose as a metaphor for the creative act itself, and these modern poets envisage a kind of 'poem-rose' whose intrinsic properties serve as a model for the mystery of the formative artistic process. The contrast between outer appearance or meaning and inner hidden meaning parallels the necessary duality of a good poem. For Rilke, especially, the rose is therefore also a model for what is essential in the art of poetry, but also, by extension, for the fulfilled life. The American novelist William Gass noted that, for Rilke ''The rose is a distilling eye. It gathers light and filters it until the concentration is powerful and pure,

until its stamens become erect. If the rose is not a poem, the poem is surely a rose.'[12]

The Englishman D. H. Lawrence also explicitly employed the rose as a metaphor for the creative act, and not only within art but within life as a whole. He envisaged a literature arising from what he called 'that which is at hand: the immediate present', writing:

> The perfect rose is only a running flame, merging and flowing off, and never in any sense at rest, static. Don't give me the infinite or the eternal: nothing of infinity, nothing of eternity. Give me the still, white seething, the incandescence and the coldness of the incarnate moment: the moment, the quick of all change and hate and opposition: the moment, the immediate present, the Now.[13]

Flowers are a potent presence in Lawrence's novels and short stories, where they often serve to express his belief that passionate love is like a fire in which death and regeneration struggle for domination, an emotionally complex and longed for sensation that is closely bound up with the rare and marvellous experience of existing in a state in which another person shares the centre of one's own being. In *Lady Chatterley's Lover* the gamekeeper Mellors says: 'We fucked a flame into being. Even the flowers are fucked into being, between sun and earth. But it's a delicate thing, and takes patience and the long pause.'[14] But it is in his poetry that Lawrence engaged with the rose most directly, casting it as a beautiful goad that encourages us to break free of the social conventions holding us back from finding true sensual and spiritual fulfilment.

For Lawrence, then, the rose demonstrates that any true understanding of spirituality must incorporate the role of the carnal. He rejects the ideal rose of Symbolism, and of Yeats and Eliot – the rose of the 'infinite' and the 'eternal'. Instead, Lawrence sees the rose as a metaphor for the 'incarnate moment'. As such, he employs the rose to describe the mind and the senses brought into harmony, seeing the special beauty and magic of the rose as a mirror for the human desire for the ecstatic experience of continuous metamorphosis. Seemingly

echoing the maxim of Angelus Silesius in the poem 'Rose of all the World', Lawrence invokes the rose to deepen the theme of fulfilled sexual relations: 'Blossom, my darling, be a rose / Of roses unchidden and purposeless; a rose / For rosiness only, without an ulterior motive.'[15] But this very lack of any 'ulterior motive' is what makes the rose a fine role model for uninhibited human behaviour. In another poem in the same collection called 'I am Like a Rose', Lawrence writes: 'Here I am all myself. / No rose-bush heaving / Its limpid sap to culmination had brought / Itself more sheer and naked out of the green.'

In his greatest rose-poem, 'Gloire de Dijon' (1917), Lawrence directly takes on the overcrowded poetic convention in which a beautiful woman is compared with a rose, and manages to rescue the cliché from the clutches of popular sentimentality on the one hand and idealism on the other:

> When she rises in the morning
> I linger to watch her;
> She spreads the bath-cloth underneath the window
> And the sunbeams catch her
> Glistening white on the shoulders,
> While down her sides the mellow
> Golden shadow glows as
> She stoops to the sponge, and her swung breasts
> Sway like full-blown yellow
> Gloire de Dijon roses.
>
> She drips herself with water, and her shoulders
> Glisten as silver, they crumple up
> Like wet and falling roses, and I listen
> For the sluicing of their rain-dishevelled petals.
> In the window full of sunlight
> Concentrates her golden shadow
> Fold on fold, until it glows as
> Mellow as the glory roses.[16]

Through the colour gold, and the act of spying on a woman as she bathes, Lawrence assimilates his experience of the beauty of his lover to history via invoking the goddess of love, 'Golden Aphrodite', and to Artemis, goddess of wild animals and the hunt.[17] But by the simple act of naming a specific rose Lawrence also succeeds in making his vision credible, tangible, of making contact with the real. The rose named 'Gloire de Dijon', also known as the 'Glory Rose', is classed as a Tea Rose, although it often goes with the Noisettes. In the period Lawrence wrote this poem, 'Gloire de Dijon' was much admired for its looks and delicate fragrance. As Lawrence indicates, it is golden yellow, although he doesn't mention that it also has salmon highlights, and that it is a climber.[18]

The Irish writer James Joyce's novel *A Portrait of the Artist as a Young Man* (1916) is useful in the present context as it amounts to a roll-call of all the accumulated symbolic meanings the rose had come to embody by this period, and it is also an acknowledgement that it was now necessary for the modern writer not so much to abandon outright the rich legacy but to knowingly assimilate it in a critical and creative manner. A sequence of different symbolic roses present themselves to Joyce's alter ego, the young emerging writer Stephen Dedalus, as slippery tokens that need to be confronted on the road to true self-awareness. The youthful and naive Stephen starts out by seeking to conform to the time-honoured tradition in which the rose and the idealized beauty of woman are closely equated. But his early aspirations are also entwined with a non-existent 'green rose', an impossible ideal that is a sign of his attachment to illusory ideas about art and the role of the artist: 'You could not have a green rose. But perhaps somewhere in the world you can,' Stephen muses.[19] Later, as Stephen tries to be a pious Catholic, Joyce writes that 'his prayers ascended to heaven like perfume streaming upwards from a heart of white rose'. This is the white rose of the Virgin Mary, the 'rose without thorns', symbol of chaste beauty and purity. Subsequently, as Stephen seeks to enter deeper into the mysteries of aesthetic transformation, he borrows Dante's mystical 'multifoliate rose', and W. B. Yeats' 'inviolate rose': 'A word, a glimmer, or

a flower? . . . breaking in full crimson and unfolding and fading to palest rose.' But while Stephen's upbringing has compelled him to always reach upwards, towards the noble, intangible and transcendent, in the manner of the 'art for art's sake' aesthetics of Wilde or the symbolism of Yeats, Joyce emphasizes that Stephen also finds himself being pulled downwards by his instincts towards the earth. The delicately refined perfumes of the imaginary green rose, the Marian white rose, and the Dantean mystical rose are increasingly challenged by a compulsive fascination with 'a certain fishy stink like that of longstanding urine'.[20]

After *A Portrait*, Joyce continued the battle between perfume and stench, idealization and fact, in *Ulysses* (1922). The final lines of the soliloquy by Molly Bloom, and the last lines of the book, decisively win the rose back for pleasure, and from all forces intent on idealizing it out of earthly existence:

> Gibraltar as a girl where I was a Flower of the mountain yes when I put the rose in my hair like the Andalusian girls used *or shall I wear a red* yes and how he kissed me under the Moorish wall and I thought well as well him as another and then I asked him with my eyes to ask again yes and then he asked me would I yes to say yes my mountain flower and first I put my arms around him yes and drew him down to me so he could feel my breasts all perfume yes and his heart was going like mad and yes I said yes I will Yes.[21]

But the optimism expressed in Joyce's work was gravely challenged by the horrors of the First World War, which were sometimes experienced at first hand by poets and artists. In 'Conscious', a poem written early in 1918 by the Englishman Wilfred Owen, who soon after perished fighting in the war, a wounded soldier lies semi-conscious in hospital, and within the confusion of his traumatized mind the rose has lost its inspirational power: 'And everywhere / Music and roses burnt through crimson slaughter.' What once upon a time could be kept safely apart in the imagination has come crashing down into uncomfortable proximity, as the spiritual and refined beauty are sullied by violence. In the searing light of the mechanized carnage of No Man's Land, Romantic

sentimentality, Symbolist transcendence, the Decadent's cult of vice, and the dream of a rose showing the way to sensual fulfilment, seemed no longer credible. With 'June, 1915', the English poet Charlotte Mew caught the disenchantment of the time in a poem in which she begins by casting the rose as a naive symbol of beauty and hope: 'Who thinks of June's first rose today? / Only some child, perhaps.' The horrors of war have robbed adults of such innocence: 'What's little June to a great broken world with eyes gone dim?' In such a tragic time the image of the rose, its associations with erotic and idealized love, hope and joy, must be abandoned, or somehow re-envisioned. Pleasure itself seemed an indulgence in a world of pain and social crisis, and irony takes hold of the Western imagination, and is probably the most significant cultural legacy of the Great War.[22]

One way forward seemed to be for writers to drop the idea of metaphor and symbol altogether and to return to the obdurate materiality of the world, the wonder of things in themselves. The American poet William Carlos Williams described the fundamental problem facing the artist and writer as an overuse of 'crude symbolism', and in this context the rose was, of course, a prime suspect. 'The rose carried weight of love / but love is at an end – of roses', wrote Williams in a poem that begins with the manifesto-like declaration: 'The rose is obsolete.'[23] Williams argued that a symbol acts as a barrier to the real, and so 'crude symbolism' had to be challenged by the invigorating experience of 'contact', or 'sense'.

The American writer Gertrude Stein's famously enigmatic declaration: 'Rose is a rose is a rose is a rose', can also be understood as a rejection of the serial symbolic abuse inflicted on the rose. As Stein later explained:

When I said.
A rose is a rose is a rose is a rose.
And then later made that into a ring I made poetry and what did I do I caressed completely caressed and addressed a noun.
Now let us think of poetry any poetry all poetry and let us see if this is not so.[24]

But while Williams may have begun his poem 'The Rose' with a pessimistic declaration of obsolescence, he does not in fact claim it is necessary to abandon the rose altogether. Rather, there must be a return to the rose itself, a pruning away of the suffocating associations that have attached themselves over time. The rose could still be poetically valuable, but it would have to be in a very different form to that inherited from the past. 'It is at the edge of the / petal that love waits . . .', Williams wrote, enigmatically. 'The fragility of the flower / unbruised / penetrates space.'

Another American poet, H. D. (Hilda Doolittle), in the poem 'The Sea Rose', published in 1916, pays homage to the tangible natural beauty of the humble 'rugged Rugosa' which, in effect, becomes in her eyes the new anti-idealist floral icon. She rejects the elegant garden roses that have been nurtured in the imagination to symbolize idealized, perfect beauty – religious or artistic – in favour of the wild ones which simply *are*. Employing adjectives that deliberately negate the idealized values usually in poetry associated with the rose – 'harsh', 'meager', 'thin', 'stunted' – H. D. also implies that the old ideals of feminine perfection must be rejected. In this, she echoed the sentiments of all women who were tired of being compared to pretty flowers and treated as merchandise in the love transaction. The rose-woman hybrid, from this perspective, links the female to vegetal rather than animal nature, and was a symbol designed to limit woman's status to that of an object of desire for men, placing her automatically in an inferior and powerless social position in which she is cast as a reproductive body, in possession of lesser reasoning capacity. When Robert Burns wrote, 'Oh my Luve is like a red, red rose', he meant it as a compliment, but it had become increasingly evident that the tacit use of a mode of symbolism created in the male imagination to render woman unthreateningly accommodating to male desire had to be challenged. A poem by the American writer Dorothy Parker, published in 1926, amusingly exposes the hackneyed symbolism of the rose in relation to love, and its hypocritical ties to commerce, as seen from the perspective of a modern woman. Parker describes receiving a 'perfect rose', but wonders

why she never receives a 'perfect limousine'.[25] Her poem stands as a resounding rebuff to the whole history of courtship as seen through male idealizing eyes, drawing attention to the radical transformations in male-female relations that were being caused by the emergence of technology-driven consumer society.

All these modern writers were deeply conscious of the debasement of language within commercialized mass culture. A metaphor is like a living thing, and a newly invented one has the capacity to unsettle entrenched mental habits and push thought in unexpected directions. But soon, any metaphor will die and become wholly conventional, and then it is no longer really a metaphor. But in between the new and the moribund there lie what the English writer George Orwell, writing in the 1940s, called 'a huge dump of worn-out metaphors', in other words, those 'which have lost all evocative power and are merely used because they save people the trouble of inventing phrases for themselves'. When metaphors are so totally familiar but still in use, it is possible to be almost unconscious when employing them, and then, so Orwell warned, people are in a 'reduced state of consciousness' – one in which 'if not indispensable, is at any rate favorable to political conformity'.[26]

The problem of sentimentality and its relationship to power was therefore especially pressing. It was evident that Western society was evolving a culture in which habits, pieties, sentiments and affections were given new prominence, and in which the organizing and directing of these dimensions of life was a principal source of social cohesion and control. Power, in a sense, was aestheticized. Sentiments were colonized by commerce and the empty platitudes of the powerful, and expressions of feeling in language had become increasingly shallow, lazy, self-deluding and self-serving. It therefore seemed to many intellectuals and artists that modern culture was succumbing to pernicious and novel kinds of abuse of thought and emotion.

Another avant-garde strategy was to draw attention to the hidden, repressed, obscene, illicit and shameful, everything that social decorum sought to conceal. In an essay ironically entitled 'The Language of

Flowers' (1927), the French Surrealist George Bataille discussed what he called 'baseness', 'excess' and 'formlessness' of flowers, as opposed to the 'miserable evasions' of the beautiful, the elevated, the noble and sacred. His goal was to demonstrate the extent to which culture rests upon a false division; on one side is the 'flower' – ideal beauty, truth, the eternal – while on the other is 'manure' – the ugly, carnal and transient. Bataille mentions approvingly the universal equation of the rose with the beauty of woman and erotic love, but argued that when the rose becomes a symbol of *ideal* beauty, then the rot has set in. We should remember, Bataille advised, that this glorious flower we praise so effusively has actually '[r]isen from the stench of the manure pile – even though it seemed for a moment to have escaped it in a flight of angelic and lyrical purity'. He noted that once the rose has had its petals removed, it is no longer the image of the rose we have fixed in our minds. The corolla conceals the 'dirty traces of pollen' and a 'satanically elegant' stamen. A meditation on the rose blossom's beauty means ignoring these 'hairy sexual organs'. As a parting gesture, Bataille invites us to contemplate 'the disconcerting gesture of the Marquis de Sade, locked up with madmen, who had the most beautiful roses brought to him only to pluck off their petals and toss them into a ditch filled with liquid manure'.[27]

The visual arts of the early twentieth century are also characterized by a rejection of time-honoured symbols and styles. But at the turn of the century it must have seemed to most artists and designers that floral motifs and floral patterns would always remain in one way or another a fundamental part of the language of visual art. Writing in 1878 of the need for a radical reform of the arts, the English designer, writer, and socialist reformer William Morris argued that 'everything made by man's hand has a form, which must be either beautiful or ugly; beautiful if it is in accord with Nature, and helps her; ugly if it is discordant with Nature, and thwarts her'.[28] For Morris, decorative ornamentation

based on natural forms was an intrinsic and essential part of the visual arts, and in his own designs for wallpapers and tapestries for Morris & Co., Morris frequently created patterns based on the organization of vegetal forms into harmonious patterns – sometimes using the characteristic petal structure of roses and their sinewy, prickly stems as, for example, in his 'Sweet Briar' design of 1917. To be 'modern' for Morris meant returning to traditions that were already in his time threatened by mass-production, through restoring 'those wonders of intricate patterns interwoven' which, while not slavishly based on the imitation of natural forms, were nevertheless inspired by them, in order that 'the craftsman is guided to work in the way that he does, till the web, the cup, or the knife, look as natural, nay as lovely, as the green field, the river bank, or the mountain flint'.[29]

But a younger generation was coming to the conclusion that Morris himself was not radical enough. He was mired in outmoded aesthetic ideals that gave uncritical value to the organic forms of nature. In 1910 the Austrian architect Alfred Loos wrote an influential manifesto called 'Ornament and Crime' in which he implicitly condemned Morris and the whole British Arts and Crafts movement and similar manifestations in Europe, such as Art Nouveau and Jugendstil. Writing in italics to make his point, Loos declares: *'cultural evolution is equivalent to the removal of Ornament from articles in daily use'*. As a result of this animus, the rose fell suddenly from decorative paragon to anathema, and a new model was called for: the neutral and rationally geometric, which would permit the plastic arts to follow a model based on simplicity, 'truth to materials', rationalism, innovation, social revolution, the modern, the future. Within the architecture of the new 'machine aesthetic', there was to be little place for the organic forms of the rose.

The rejection of 'ornament' and the embrace of the rationalism of techno-science, on the one hand, and the quest to create an abstract 'spiritual art' on the other, were part and parcel of the much wider revolt among modernists against the past and tradition, which were deemed oppressive and outdated, and obstacles to both societal and personal development. The future must be very different from the past.

The 'golden age' was no longer in times gone by, it was in the future – perhaps the near future. Thus, symbols inherited from the past were associated with inequality, ignorance, prejudice, oppression, conformity and the moribund – the 'obsolete'.

As was the case with the spoken and written word, there was also much evidence that traditional visual symbols were all too easily manipulated by the ruthlessly powerful. Adolf Hitler, for example, systematically abused the traditionally benign message carried by roses, and many propaganda photographs show women and children offering him roses and other flowers – a photograph of the opening day of the Berlin Olympics of 1936 shows Hitler receiving a bouquet of roses from the five-year-old daughter of the organizer of the event. 'Thanks to Beloved Stalin for Our Happy Childhood' runs a caption to a poster from 1950 showing a girl presenting Josef Stalin with a bouquet of red roses. In 1949, the year the USSR conducted its first nuclear test, the artist Boris Vladimirksi painted 'Roses for Stalin', which depicts a half dozen smiling Soviet children handing 'Uncle Stalin' a big bunch of white and red roses. The artist has painted the red of the roses in exactly the same hue as the boys' Communist Party bandanas. The painting was also part of a Stalinist 'cult of children' which began in the 1930s, and sought to cast Stalin as a benign leader with the future of Soviet children at heart.[30]

But just as the rose did not wither completely within the works of modernist writers, so too can it still be sometimes found on the canvases of some modernist artists. But these would be different kinds of roses. The poem cited earlier in which William Carlos Williams announced that 'the rose is obsolete' was actually directly inspired by a Cubist collage including pasted-on photographs of roses by the Spanish artist Juan Gris, which Williams found to be an exemplary model of the modern work of art because, like Cubism in general, it so obviously departed from traditional models through its reductively geometric structure and the breaking-up of forms into interlocking fragments: 'the start is begun / so that to engage roses / becomes a geometry . . .' Williams wrote. By a radical rejection of naturalism and realism,

painting was renewing itself, and becoming a truly modern art.[31] The American Georgia O'Keeffe painted numerous pictures of flowers, and several of roses, such as *Abstraction White Rose* (1927). But in these works O'Keeffe explored the borderline between figuration and the kind of abstraction, pushing the rose towards the realm of pure shape and colour. Furthermore, she was loath to attribute to her paintings any of the familiar symbolism.[32]

The rival to abstraction in the modernist art was Surrealism, with which O'Keeffe's work also at times has affinities. Here, the rose found a new and subversive lease of symbolic life in the hands of the Belgian artist René Magritte. In the latter part of his career Magritte was especially interested in the rose's compelling cultural significance, writing in a letter from late 1951: 'My present research, at the beginning of the winter, is concerned with the rose. I must find something precious and worthy to say about it.'[33] In *The Blow to the Heart* (1952), Magritte seems to have painted what he discovered. A single red rose of the modern Hybrid Tea variety is shown growing on bare ground next to the ocean. Instead of prickles, it sports a large golden dagger. In a letter to the poet Paul Eluard, Magritte wrote:

> for about two months I have been looking for a solution to what I call 'the problem of the rose'. My research now having been completed, I realize that I had probably known the answer to my question for a long time, but in an obscure fashion, and not only I myself but any other man likewise. This kind of knowledge, which seems to be organic and doesn't rise to the level of consciousness, was always present, at the beginning of every effort of research I made ... After completion of the research, it can be 'easily' explained that the rose is scented air, but it is also cruel.[34]

Magritte's insight is not entirely original, but his painting certainly makes something that is always latently present strikingly manifest. The image reminds us that the special power of the rose as a metaphor and symbol emanates from its ambivalence and duality which, however, makes it a fitting metaphor for the truth that pleasure and pain, life and

death, exist in the same one and only world, and that we tend to exist in a state of knowing and not knowing simultaneously concerning this reality. We turn a blind eye, so to speak. Magritte's insertion into his painting of a very visible dagger was obviously intended to make us apprehend what we usually don't consciously see for a very simple reason: we prefer not to acknowledge its disconcerting implications.

THIRTEEN

'What is the heart's goal when looking at the garden World?'

ROSE-GARDENS AND GARDENING

I began writing this chapter on 5 May 2020, the day on which the first *Rosa rugosa* flower opened in our garden in South Korea. We planted several bare-rooted Rugged Rugosas two years ago, and this is the first time they have rewarded us with their wonderfully large, open-cupped blooms, which are cerise, five petalled, with bold yellow stamens – its prickles are a plentiful and formidable deterrent. While enjoying a Rugosa's 'scented air', it is very hard to ignore its 'violence', as Magritte put it. This species rose is a native of these parts, so it is more than able to cope with sometimes -15 degrees centigrade temperatures in winter, and the monsoon season in July. The Rugosas would also be blossoming in my garden in France, alongside some of the other early bloomers.

Having a garden is a luxury, one cherished since humanity abandoned nomadic life for cultivating the land and settlements. Over time, ornamental or aesthetic plantings became progressively more organized and ambitious, turning into gardens and parks, which were designed to be places where nature could be admired in safety, and adapted to suit human taste. As Robert Pogue Harrison writes in *Gardens: An Essay on the Human Condition*: 'gardens exist to re-enchant

the present'.[1] But as such, they are as much connected to the deep-seated impulse to actively tend and nurture as to any desire to retreat into a verdant realm of contemplation. Gardens are useful, they are sanctuaries in a world of calamities, but they also require work.

The oldest recorded mention of a garden is in the Sumerian *Epic of Gilgamesh*, written about 1800 BC. Famously, the book of Genesis in the Bible places the first human couple in an idyllic garden: 'Now the Lord God had planted a garden in the east, in Eden: and there he put the man he had formed. And the Lord God made all kinds of trees grow out of the ground – trees that were pleasing to the eye and good for food. In the middle of the garden were the tree of life and the tree of the knowledge of good and evil.'[2] In such mythical gardens, nature is remodelled to represent what is in fact the elite's ideal of human happiness. As I already mentioned, according to the medieval Catholic Church, there were roses growing in Eden, but they had no thorns, which only started to appear on the plant after the Fall, and Adam and Eve were cast out from the garden into the wilderness.

Today, we take for granted the pre-eminence of roses and the dominance of colourful flowers in general in gardens, but it wasn't always so in the West. Under the influence of Greek cultural models the idea of bringing the countryside into the city was gradually established in ancient Rome as a motive for the creation of gardens. This meant they were not only decorative but useful, a cross between a farm and what we now consider to be a garden. As time went by, however, this designated space became increasingly the physical and emotional centre of the house. Flowers, such as roses, oleander, oriental poppies and stocks were planted for purely or mainly ornamental purposes. Areas of garden dedicated to roses were usually composed of hedges, with divisions into beds where individual rose bushes were planted. The fact that roses have thorns also meant as hedges they served the practical function of keeping unwanted animals out.

Some sense of what the Romans enjoyed can be gleaned from the surviving garden paintings in Pompeii, such as in the House of the Gold Bracelet and the House of Venus Marina, where red Gallica Roses

are depicted, while in the House of the Fruit Orchard, a rose is shown growing behind a low fence.[3] These gardens were evidently meant to be places of delight and respite, and were dedicated largely to pleasure. Longus, a Greek author from about the second century AD, wrote:

> the garden he trimmed with great care and diligence, that all might be pleasant, fresh and fair ... The roses, hyacinths, and lilies were set and planted by hand, the violet, the daffodil, and pimpernel the earth gave up of her own good will. In the summer there was shade, in the spring the beauty and fragrance of flowers, in the autumn the pleasantness of the fruits.[4]

For people who were becoming increasingly habituated to urban life, the ideal of rustic simplicity grew in importance. The cultivation of a garden was associated with escape from the distractions and vices of the town. In bucolic terms that still speak to our yearnings today, Virgil in the *Georgics* describes an old bee-keeper's humble garden:

> For I remember an old Corycian, who had a few acres of forsaken ground; nor was his land rich enough for the plough, nor good for pasture, nor proper for vines. Yet the planting of a few potherbs among the bushes, and white lilies around about, and vervain, and esculent poppies, equaled in his mind the wealth of kings; and returning home late at night, loaded his table with unbought dainties. He was the first to gather roses in the spring, and fruits in the autumn: and when sad winter even split the rocks with cold and with ice retrained the course of the rivers, in that very season he could crop the soft acanthus, accusing the slow summer, and the loitering zephyrs.[5]

The gardener is cast as a guardian, custodian of a bordered space, a formalized world within which matter is mastered, and where the gardener is tasked to ward off potential intruders. Aesthetic horticultural considerations were often coupled with a theoretical component, and the selection and arrangement of plants were determined by the

botanical theory of the period, which in its turn reflected the way the world was perceived to be ordered. A garden was to some extent a microcosm, reflecting within its boundaries the macrocosm of Rome as a political power. Plants were used to give physical form to a specific worldview in which the inhabitants of the known universe were assigned to a place within a geographical space, social organizations and an economic system.[6]

But as we saw, between the fall of the Roman Empire and the beginning of the nineteenth century, flowers as a whole were of less importance in European gardens than they were in ancient Rome, or are again today. The plants in the monastic gardens of the Middle Ages were cultivated above all for their utility as foodstuffs or medicine, not because they were lovely to regard. Charlemagne, King of the Franks, who became Holy Roman Emperor by uniting much of western and central Europe, introduced agricultural regulations around 794 AD that stipulated that gardens should be encouraged, and stated that within them there should in particular be lilies and roses. Probably, the roses were Gallicas and Albas, floral legacies of the Roman Empire. The species rose, *Rosa canina*, would also have been commonly planted as prickly hedges to keep out cattle, and for the medicinal value of its hips. Roses were encouraged because of their utility value rather than for aesthetic reasons.

In fact, before the eighteenth century in Europe, a garden was mostly a place to grow edible plants, such as vegetables and fruit, and herbs to treat illnesses. A few flowers would have also been planted to ward off insects. But while utility may have been the primary concern, this did not discount the enjoyment of the aesthetic dimension, nor preclude engagement with the symbolic meanings of the plants being grown. A Benedictine monk working in his garden could meditate upon Christ's suffering while picking deep pink Gallica Roses with medicinal value, and on the Virgin Mary's purity when pruning a hedge of Dog Roses. But he could also find simple happiness in admiring their natural beauty, bestowed by God. In fact, the Benedictine monastic order took a recognizably modern idea of the

garden north from Italy, and by the eighth century, roses were certainly growing in monastic gardens throughout Europe in the form of hedges.⁷

In Persia, the rose as an ornamental garden plant had long been especially highly cherished flower for aesthetic reasons, alongside practical medicinal, cosmetic and culinary applications. The typical Persian garden was a sophisticated architectural form that depended on an elaborate system of irrigation. Gardens were constructed around a watercourse, divided into four areas by channels, and these could be subdivided into innumerable sunken beds with geometrical patterns and have smaller water channels, fountains and pavilions.

The *Gulistan* – the rose-garden – was a tangible reality, but also a powerful symbol that suffused Persian poetry and art. Hafiz compares his love to a *Gulistan*: 'What is the heart's goal when looking at the garden World? / To pluck roses from your cheek with the hands of the [eye's] pupil!'⁸ In *The Rubaiyat* (written c.1120), the poet Omar Khayyam expresses the beauty which the garden rose shares spontaneously with humanity: 'Look to the Rose that blows about us—"Lo, / Laughing," she says, "into the World I blow: / At once the silken Tassel of my Purse / Tear, and its Treasure on the Garden throw."'⁹ The favorable religious context provided by Islam, discussed in Chapter 4, in which paradise is envisaged as a real garden, supported the expansion of Persian-style gardens across all the lands practising Islam, which eventually extended from North Africa into southern Spain, and as far east as India. In the early sixteenth century, the Mughal ruler Babur took a love of the rose eastwards from his homeland in Uzbekistan, and planted it deeply in India.¹⁰

A seventeenth-century French traveller in Persia, Jean Chardin, wrote of how enchanting he found the gardens and of the great variety of flowers he saw, and was especially moved by the many roses:

> The Rose, which is so common among them, is of five sorts of Colours, beside its natural one [he probably meant 'rose' coloured, that is, dark pink like a Gallica Rose], *White, Yellow, Red*, which we call the *Spanish Rose* [the Damask Rose] and others of two Colours viz. Red on one Side, and White or Yellow on the other. The Persians call these Roses *Dou Rouye*, or Two Places. I have seen a *Rose-tree*, which bore upon one and the same Branch, *Roses* of three Colours, some *Yellow*, others *Yellow* and *White*, and others *Yellow* and *Red*.[11]

The Scottish artist, author, diplomat and traveller Robert Ker Porter, writing in the first half of the nineteenth century, reported from Persia:

> I was struck with the appearance of two rose trees, full fourteen feet high, laden with thousands of flowers, in every degree of expansion, and of a bloom and delicacy of scent that imbued the whole atmosphere with exquisite perfume. Indeed, I believe that in no country in the world does the rose grow in such perfection as in Persia; in no country is it so cultivated and prized by the natives. Their gardens and courts are crowded by its plants, their rooms ornamented with roses, filled with its gathered branches, and every bath strewed with the full-blown flowers, plucked with the ever-replenished stems.[12]

It was largely thanks to the high status of the rose within Islamic culture that the rose and the rose garden were to receive a new lease of life in the late Middle Ages in western Europe. As a result of the Crusades, and increased trade with the Near East and beyond, the European nobility were introduced to the idea of the walled garden, fountains and pavilions, which they then imported to western Europe. The defeat of the Moors from southern Spain in the late fifteenth century, and their expulsion in the early seventeenth century, left many elaborate Muslim gardens for the Christians to appropriate, and within them they found that the Damask Rose had pride of place. The vision of paradise as literally an earthly garden was alien to the Christian worldview, in which the life to come after death is never made so overtly tangible as it is in

Islam, but the rose garden would nevertheless be absorbed into Christian culture – as the *Roman de la Rose* clearly demonstrates. As we also saw, the *hortus conclusus*, or walled garden, became a prominent material and symbolic feature from the twelfth century in western Europe, and was depicted in countless paintings of the Virgin Mary.

In China, which became known as 'the mother of gardens', the transformations of the paradisal dream garden into an actual, real garden took place long ago. One Chinese myth tells of the fabled Mount Penglai, a mystical land where the Eight Immortals abide. In this paradise, there is no suffering or pain, and no winter. The rice bowls and wine glasses are never empty. Magical fruit grow with the ability to heal all diseases, grant eternal youth and even raise the dead. King Qin, the first emperor of unified China, believed that Penglai really existed somewhere in the East Sea, and so he sent expeditions to discover it, and when they failed, he was obliged to satisfy himself with the creation of a miniature version, which he had built in his garden. This, in its turn, founded the tradition of scholars, poets, artists and aristocrats building gardens, writing poems and painting pictures, inviting escape from the chaos of the outside world, and the enjoyment of the peace and security of an idyllic little 'paradise'. Visitors to these gardens could enjoy bridges and streams, paths through cultivated beds of exotic plants and flowers, gazebos and pavilions to sit in and ponder the beauty of nature, the full moon, and recollect for a while the sense of perfection in the mind.

By the Six Dynasties period (220–281 AD) in China, the ideal of the secluded garden was well-established. As places of peace, harmony and beauty, the garden was also cast as a tangible critique of the decadence of the emperor's court, the administrative elite and society in general. For the ruling elite, the garden was a quiet retreat from the world of public affairs. These spaces aimed to idealize natural scenery, to import the fundamental features of mountains and lakes and rivers into the

courtyard through an arrangement of rocks and trees, and bodies of water. A garden was intended to imitate paintings and poems, and at the same time, paintings and poems strove to imitate the real garden.

But flowers were not of primary importance in these gardens. The Chinese ideal reflected the cardinal concept of 'mountain-water' as the two essential and interacting poles of nature. This meant the emphasis was always on the artful organization of rocks and the channelling of water. Nevertheless, flowers were assiduously cultivated in the open fields, and grown in nurseries in pots and planters, and roses were certainly a feature of a typical Chinese garden. In the fifth century AD Hsieh Lun-yui writes: 'I have banished all world care from my garden. I have damned up the stream and made a pond . . . I have planted roses in front of the windows and beyond them appear the hills.'[13] But as I already noted, the rose never caught the imagination of East Asia as it did the peoples of the Near East and Europe. Pre-eminent among cultivated varieties of plants were tree flowers such as the peach, plum, magnolia, camellia and tree peony. Chrysanthemum, gardenia and rhododendron were also much loved. For the scholarly elite, the 'three friends of winter' were the bamboo, pine and plum (which blossoms in late winter), and all these plants were frequent subjects of painting and poetry.

During the seventeenth century in Europe it was another family of flowers, the tulip, that proved to be the preference when it came to the creation of the terrestrial garden 'paradise', decorating interiors, and for a brief period the financial madness of 'tulip mania' took hold in Holland.[14] But by the early nineteenth century the rose had usurped all rivals to become firmly established as the 'queen of the garden', to a large extent thanks to the influence of Napoleon Bonaparte's wife, Joséphine. By the time of the empress' death in 1814, at her country estate, Malmaison, it is recorded that 250 varieties of rose were growing: 167 *Rosa gallica*, 27 *Rosa centifolia*, 22 Chinas, 9 *Rosa Damascena*, 8 *Rosa Alba*, 4 *Rosa pimpinellifolia*, 3 Moss Roses, 3 *Rosa foetida*, and

the species, *Rosa moschata, alpina, banksiae, laevigata, rubriflora, rugosa, sempervirens* and *setigera*.[15] Subsequently, Restoration France fell head over heels in love with the rose, and by 1829 one of the most important French nurserymen of the period, Desportes, could list in his catalogue 2,562 roses, of which 1,212 were *Rosa gallica*, 120 *Rosa centifolia*, 112 *Rosa alba*, and 18 Moss Roses. Many of these designations are probably dubious, however, and Gallic pre-eminence did not go uncriticized. I already quoted the English nurseryman T. River's comments about the love of the French of the period for China roses, but he also cautioned: 'In forming a collection of roses from the French gardeners, great difficulty is often experienced by their incorrectness in the names of their plants: this inattention, to call it by no worse name, has long been the bane of commercial gardening. In this country almost every nurseryman is now aware of the great responsibility he is under as to correct nomenclature.'[16] In 1848, William Paul, another important British nurseryman, and the author of a bestselling book on roses, wrote jingoistically: 'the English cultivators produce far handsomer plants than the French. Although I may be ranked among the former, I state this boldly; not from prejudice, nor from interest, but from a thorough conviction of its truth.'[17]

While the practical applications of the rose for cosmetics, food and medicine had once been important incentives for cultivating roses, and I return to them in the next chapter, by far the most compelling motives in the nineteenth century were aesthetic and decorative. Western people wanted to be surrounded by the beauty of roses. They wore them as floral jewellery, adorned their houses with them, brought paintings of them and were becoming increasingly enamoured of gardening. European gardens large and small were filling to bursting point with roses: 'We can scarcely enter any garden, however humble, which does not contain a Rose-tree', wrote William Paul concerning his homeland. '[A]nd many of the noted establishments in England have, like in Rome of old, places set apart expressly for their cultivation. And it is not a slavish obedience to fashion that has led to this.

Although cherished alike by peer and peasanty, the popularity of the Rose rests on a surer foundation – its intrinsic merit.[18]

A couple of decades later, another Englishman, Samuel Reynolds Hole noted in his influential *A Book About Roses* (1868): 'Suffice it to say, that where Roses were grown twenty years ago by the dozen they are grown by the thousand, and where by the thousand now by the acre.'[19] In 1877, Hole became the first president of the National Rose Society in the United Kingdom, and he proved a major catalyst for the burgeoning romance with the rose in his homeland, and beyond. Hole began his bestselling book on roses by boldly asserting: 'He who would have beautiful Roses in his garden must have beautiful Roses *in his heart*. He must love them well and always.'[20] Hole was also the Anglican Dean of Rochester, and evidently believed that the cultivation and love of the rose would benignly unite society under the true Protestant Christian faith. He declared that three key qualities explained the deep affection he and his fellow Victorians had for the rose: *'semper, ubique, ab omnibus'*. Roses are always, everywhere, and for all.[21] Of his aims in writing his book, Hole wrote confidently:

> I will essay, therefore, while I enumerate and extol the special charms of the Rose, to convince all florists why, before I proceed to demonstrate how, they should admire and honour pre-eminently the Queen of Flowers.
> First of all, because she is Queen. There is not in her realm a single Fenian, but her monarchy is the most absolute, and her throne the most ancient and the most secure of all because founded in her people's hearts.[22]

Hole was keen on encouraging rose breeding for competition, a popular activity at flower shows, which he saw as an exercise in Christian democracy. 'I will tell what may be done in a very small garden, by a very poor man, who *really* loves the Rose', he wrote, going on to recount what one working man told him about how he came to afford roses: '"I'll tell you," he said, "how I managed to buy 'em – by *keeping away from the beershops!*"'[23]

For the people of Britain and its huge Empire, Dean Hole managed to amalgamate the whole cultural history of the rose, fusing the legacies of the goddess of love, the *Roman de la Rose*, Papist Mariology and a Romantic ecology of benign nature with a solidly practical Anglican attitude. In adopting such a fervently pious stance vis-à-vis gardening, and towards the 'Queen of Flowers' in particular, Hole also neutralized the potential sensual pleasure involved with the calming balm of solidly Protestant ethics. A Freudian would no doubt make short shrift of the Dean's displaced or sublimated passion, but perhaps we should not be too quick to dismiss his conviction, as all rose-lovers probably agree with him on some level.

One reason for the success of the rose as a garden plant was the exponential extension of flowering period from a few weeks to months thanks to the introduction of Chinese rose genes. Another was pragmatic. Unlike many other flowers, the rose proved to be a robust garden plant that could 'thrive on neglect'. 'What other genus of plant embraces so great a variety of character, or gives forth such a number of delicious blossoms for so long a period?' wrote William Paul. 'Moreover, it is easy of culture; suited to a great variety of soils; lives and blooms even when neglected; yet yields an abundant return for whatever labour may be bestowed upon it.'[24] Fifty odd years later, Gertrude Jekyll in her book *Roses for English Gardens* (1902) opined: 'Roses are so comparatively modest, they are so accommodating and so little fastidious, that with very moderate preparation and encouragement they can be made to succeed.'[25] As practical advice to her many readers, Jekyll advocated that in a rose garden there should always be a dark background – a band of trees, for example – to show up the growth and the delicate colours of the roses.

If we fast-forward to the 1950s and 1960s, we find that while the world was falling increasingly for the Hybrid Tea and Floribunda, some rosarians were making a stand against their brazenly modern attributes, and

the kind of garden aesthetic they encouraged. Between the wars, the British rose breeder Edward Bunyard had inspired the influential member of the Bloomsbury Group and keen gardener Vita Sackville-West to introduce old roses into her garden at Sissinghurst Castle in Kent.[26] These early advocates were soon joined by Graham Stuart Thomas, whose *The Old Shrub Roses*, published in 1955, launched a post-war rose sub-culture dedicated to the 'classic' or garden roses, that is, to roses that existed before the first Hybrid Teas. In his book Thomas wrote with characteristic good sense but undaunting conviction: 'We all desire as much beauty, colour, fragrance, longevity, and annual goodwill as possible from our plants, and it is the purpose of this book to try to show how a great group of neglected roses can add to the list of shrubs available for general garden use.'[27] Thomas would go on to write profusely on the merits of the 'old shrub roses', and to put words into action by designing and planting gardens of old roses, such as Mottisfont Abbey, to which I will return later. Subsequently, two other British rose lovers took up the challenge, and they have done much to reinstate the 'neglected roses' in the gardens of the world: the rose expert, grower and author Peter Beales and the rose breeder David Austin.[28] In *The Heritage of the Rose* (1988), Austin writes that, for him, Graham Thomas 'did more than just preserve these roses, he changed the way we looked at them. He pinpointed the advantages and disadvantages of the moderns: the ideal lies in the bud with its high-pointed centre, but the mature flower tends to be muddled and almost completely lacking in form.'[29] What, according to Austin, is the special charm of the old roses? 'Their buds, though often charming, are likely to open as small cups, with little petals developing within, but it is as the flower gradually expands into the full bloom that its true beauty is revealed.'[30] The old garden roses also have many more variations in their open forms of blooming than the modern roses, and while their colours are limited to whites, pinks, and maroon-crimsons, these are subtle vegetable dyes when compared with the harsher 'chemical' colours of modern roses. Their perfumes are also stronger, richer and more varied. They are also often more garden worthy and hardy than the modern roses, and live longer.

The vogue for old roses quickly spread to the United States, where it gained many enthusiasts. The extraordinary efforts made to rescue old roses, often from the brink of extinction, is charted with special gusto in Thomas Christopher's *In Search of Lost Roses* (1989). Christopher describes how the fans of old roses gathered plant material from old gardens and small nurseries, abandoned homesteads and old cemeteries, and does a fine job evoking what they saw as their special allure: 'As idiosyncratic as their creators, no two of the old roses are alike. Whereas modern roses almost invariably aim at the tight, high-centered blossom of the Hybrid Tea, the old roses may be flattened like architectural rosettes, or cupped, with the petals wrapped tightly round the centre, or even as huge, fluffy and overblown as a crinoline petticoat.'[31] Even the most obvious difference between the oldies and the moderns – the fact that the former bear the bulk of their blossoms for only a few weeks, in late spring/early summer – could seem a positive attribute to the admirers of the old roses, adding to their poignancy. The old roses are also steeped in history, of course. In fact, this is one of their primary attractions. As one collector told Christopher, old roses are the most 'people' flowers, in that they have been loved the longest.[32] This seems to be what Vita Sackville-West meant when she wrote in 1937 about why the old garden roses were for her very far from passé: 'A sentimental association: they recall everything that we have ever read in poetry, or seen in paintings, in connexion with roses. A more personal association, possibly: we may have met them, neglected and ignored in the gardens we knew in childhood. Then, they usually smell better than their modern successors.'[33]

Since the 1980s, there has been a growing trend among rose lovers for 'new' roses which still possess some of the endearing characteristics of the old 'vintage' garden varieties. The breeders who nurtured and responded to this demand were effectively creating thoroughly historicized roses, and were aware of the rich cultural resonances the rose possesses. They created roses to appeal to people who no longer identified 'contemporality' with the rejection of the past. In fact, the new hybrids might be called 'postmodern' roses, as they are an indication of

a much wider cultural swerve away from an uncompromising cult of the new towards more nuanced relationships with the past. For, in the rush to make the rose the *modern* rose, the *rose of today*, much got lost along the way. The aim of the postmodern rose breeders was to use contemporary scientific knowledge to create a new race of roses that could unite the best of the old with the best of the new.

The most successful of the breed of the new-old roses are those produced by David Austin, which are known as 'English Roses'. As Austin writes:

> An English Rose is, or should be, a Shrub Rose. According to variety, it may be considerably larger or even smaller than a Hybrid Tea. But whether large or small, the aim is that it should have a natural, shrubby growth. The flowers themselves are in the various forms of the Old Roses: deep or shallow cup shapes; rosette shapes; semi-double or single, or in any of the unlimited variations between these. They nearly always have a strong fragrance, no less than that of the Old Roses, and their colours often tend towards pastel shades, although there are deep pinks, crimsons, purples and rich yellows. The aim has been to develop in them a delicacy of appearance that is too often lacking in so many of the roses of our time; to catch something of that unique charm which we associate with Old Roses. Furthermore, English Roses nearly all repeat flower well under suitable conditions.[34]

The breakthrough for Austin was a rose called 'Constance Spry', released in 1961. As his nursery website puts it: 'The original English Rose. Large, glowing pure rose pink, deeply cupped blooms. Strong myrrh fragrance. Summer flowering only.'[35] Since 1961, Austin and his team (Austin died in 2018) have produced over 200 English Roses, and revolutionized how, today, we think about the roses of the present. We can therefore say that 1961 stands as another important date in the revolutionary rose calendar. And this time it happened in England.[36]

Broadly speaking, four models for a rose garden exist today. First, is the carpet-garden style, the geometric model of the formal garden, which is often preferred for public displays. This foregrounds the ordered massing of colours, and is designed to give an overall impression of control and unity. Second, there is the cottage garden, originally modelled by the well-to-do on the gardens planted by labourers, and much promoted in Great Britain by Gertrude Jekyll. This is intended to encourage an informal and carefree planting of flowers, such as peonies, foxgloves, snapdragon, pansies, columbine, hollyhock and, of course, roses. The prominent gardener and rosarian Hazel le Rougetel, in her book *A Heritage of Roses* (1988), called this kind of garden 'associative planting', in which various plants are generously juxtaposed in an embroidered style. Third, is the private suburban rose-garden style, with a neatly clipped lawn bounded by tidy beds of well pruned shrub roses – this is the kind of garden I grew up with. Fourth, there is the *hortus conclusus* style rose garden which, as we saw, owes much to Islamic models, and involves water, with roses sited within the confines of some kind of enclosure.

Dean Hole described the formal rose gardens of the wealthy of his time as often nothing better than 'dismal slaughter-houses'. This impulse to control, embodied in the imposition upon the organic profligacy of flora of a geometric structure that unconsciously materialize the social ideals of the ruling elite of the period, became one of the prominent features of many ambitious large-scale rose gardens, such as those laid out in the second half of the nineteenth and beginning of the twentieth century at Parc de Bagatelle in the Bois de Boulogne in Paris, and the Rosariae de L'Haÿ, just south of Paris, but also of the less ambitious ones that proliferated in the gardens of private residences on both sides of the Atlantic, in India and the colonies. Rosariae de L'Haÿ, laid out in 1899, is the first modern formal garden uniquely for the rose as an ornamental plant. It was created in order to grow every known rose, and by 1914 housed 7,000 different cultivars. Today, over an area of around 4 acres grow 16,000 roses – species and cultivars. The focus is on the older roses, and 85 per cent date from before 1950, organized around a strict geometric ground plan.

Formal rose gardens dedicated to world peace, or serving a commemorative function, are an especially significant development of the twentieth century, and they usually follow the geometric model. The use of flowers as symbols of commemoration and remembrance of the dead, a longstanding historical and cultural tradition, had its legacy further entrenched after the First World War, when numerous 'gardens of remembrance' were built. At the end of the war, the Irish created a National Memorial Rose Garden in Dublin designed by Sir Edwin Lutyens, who had already dedicated himself to several of the Great War memorials in France and Belgium. His spare, classical building in granite serves as the perfect counterpoint to the colourful beds of roses. But roses, as we have seen, can be unwitting victims of ideological change, and in the 1950s the National Memorial Rose Garden suffered two IRA bomb attacks, and then fell into neglect and disrepair. Today, thankfully, it has been returned to its former nobility.

As I noted, the Hybrid Tea Rose called 'Peace' (at least in the English-speaking world) is now one of the world's favourite roses. Its christening in 1945 built on a history, but also created the foundations for a new narrative, encouraged by the fact that in the period after the Second World War the rose became a truly global 'meme'. As it did so, it also sought to culturally de-territorialize. Until then, much of the rose's symbolic value lay within a specifically Western cultural narrative, one that often made little sense outside the West. Historically, symbolizing peace was never a function to which the rose was consciously dedicated, although the condition of peace is certainly implied wherever love and beauty are invoked.

But all too often a formal rose garden, commemorative or just decorative, seems to be little more than a sequence of uniformly coloured rectangles distributed in orderly geometric fashion within a characterless flat area of gravel or grass. There is a photograph on the United Nations' website showing the Memorial Rose Garden in New York in the 1950s, in which the photographer had artfully composed the picture to include an attractive woman wearing yellow leaning over to look at an area of the garden with identically yellow coloured roses

– probably 'Peace.'[37] This serendipity, combined with the layout of the garden itself – very flat, open and organized into rectangular plots – suggests the model for this rose garden was the ideal of a united gathering of nations. But the result is very dull, despite the colour.

Mottisfont Abbey in Hampshire is an excellent example of a formally laid out rose garden that manages not to seem excessively formalized. The garden dates from the early 1970s when Graham Stuart Thomas was invited to use part of the land near the abbey to create a garden dedicated to old roses – those bred before 1900. It is a living memorial to the old European shrub roses, and is helping to ensure their continued survival. I describe the garden as 'formal', because it is arranged around straight paths and lawns, and has box edging the beds of roses which are usually planted together in the same classes. But as the head gardener Jonny Norton explained to me: 'Actually the lawn shapes are convex due to the irregular outer walls of the garden. A view from Google earth will confirm this. The impression on the ground, as you say, impresses formality.'[38] So, the garden certainly doesn't seem like other formal rose gardens. One area radiates at an angle from a fountain at the centre of a circular pond. The garden is also walled with red brick, which gives it the air of a secluded 'secret garden'.

Many of the roses I have discussed are there at Mottisfont: Gallicas, Damasks, Moss Roses, Bourbons, Noisettes, Chinas, Teas, Hybrid Perpetuals. Thus the rose garden is also an organic history lesson, revealing – at least in June, because these are almost all once-blooming roses – the subtle beauty of the old style rose. The rest of the year, however, one can enjoy the perennials, the companion plantings, which extend the pleasure beyond the roses' time. As Norton says: 'The uniqueness of this rose garden is indeed the companion garden that enhances the romance of the roses yet allows their dominance . . . But the celebration of the garden is the rose. The rose dominates from early spring through to autumn. During the month of June, for about a week when almost all are in bloom, the rose garden at Mottisfont is absolutely a garden of paradise.'

Of course, taste in gardens is mostly subjective, and my own personal favourite is far from formal. Sissinghurst Castle in Kent more or less combines all four styles of rose garden within its acreage through the concept of axial walks opening onto enclosed gardens, or 'garden rooms'. One of the creators of the garden, Vita Sackville-West (the other was her husband, Harold Nicolson), in the Foreword to her *Some Flowers* (1937), throws down a challenge, which at the time must have stung many gardeners:

> This country is a country of garden-lovers, and it contains many who, getting perhaps a little bored with growing exactly the same things as their neighbours year after year, look round for a few extras which shall come well within the scope of their purse, time, and knowledge. We can all grow wallflowers, lupins, delphiniums or snapdragons. Far be it from me to run down any of these valuable allies, but the moment always comes when the taste of every true flower-lover turns also towards something less usual and obvious.[39]

Sissinghurst's garden is deliberately crammed to bursting point with plants, but it never quite collapses into chaos. Roses – especially old garden roses – were central to Sackville-West and Nicolson's vision, and there is also a dedicated area for them. They believed the garden's setting, beside a medieval castle, 'lent itself kindly to their [roses'] untidy, lavish habit; there was space a plenty, with the walls to frame their exuberance'. The intention was therefore to arrange things so that 'roses may be found growing in a jungle, sprawling, intertwining, barely tamed and foaming in an unorthodox way'.[40] As I mentioned, Sackville-West was a pioneer in celebrating the old and species roses, and at the time she and her husband were planting the garden, the roses were distinctly out of fashion. By 1953, there were almost 200 different old garden roses at Sissinghurst, including 'Cardinal de Richelieu', 'Complicata', 'Camaieux', 'Charles de Mills', 'Belle de Crécy', 'Variegata di Bologna' and 'Paul Ricault'.

In *Some Flowers*, Sackville-West discusses four roses, all 'old': *Rosa moyesii* (a native of China that at that time was rare in England), *Rosa*

centifolia muscosa (the Moss Rose), *Rosa mundi* and 'Tuscany', a very dark red Gallica Rose, which is also known as the Velvet Rose. Sackville-West writes:

> What combination of words! One almost suffocates in their soft depths, as though one sank into a bed of rose-petals, all thorns ideally stripped away. We cannot actually lie on a bed of roses, unless we are decadent and also very rich, but metaphorically we can imagine ourselves doing so when we hold a single rose close to our eyes and absorb it in an intimate way into our private heart. This sounds a fanciful way of writing, the sort of way which makes me shut up most gardening books with a bang, but in this case I am trying to get as close to my true meaning as possible. It really does teach one something, to look long and closely at a rose, especially such a rose as Tuscany, which opens flat (being semi-double) thus revealing the quivering and dusty gold of its central perfection.[41]

Sackville-West doesn't mention Sissinghurst's most famous feature, the White Garden, in *Some Flowers* for the simple reason that it wasn't until the 1950s that she began to plant it into existence. The idea was that only white, green, grey and silver were to grow there. By choosing a pale palette, Sackville-West was uniting flora that usually do not find themselves neighbours, and pride of place is a white species rose, the climber *Rosa mulliganii*. But the rose I remember best at Sissinghurst is the one growing on the south face of South Cottage – the Noisette climber 'Mme Alfred Carriére' – which, I later discovered, is the very first rose Sackville-West planted in the garden after she purchased the property. Inspired by this encounter, I planted my own 'Mme Alfred Carriére', which climbs up the east facing wall of our house in France. We've nicknamed it the 'Curious Rose', because it is so prolific it keeps reaching high enough to conceal the view out of our back window, obliging us to prune it back regularly.[42]

The gardener's little bit of paradise is rarely a place only of repose, as it requires constant care. Indeed, all gardens establish a relationship between the human urge to dominate nature and the willingness to let it be, and as Robert Pogue Harrison writes, 'no one embodies the care-dominated nature of human beings more than a gardener.'[43] But the gardener finds that special attention to a small parcel of carved-out nature is more than adequately rewarded. As Pogue Harrison continues:

> Gardening is an opening of worlds – of worlds within worlds – beginning with the world at one's feet. To become conscious of what one is treading on requires that one delve into the ground's organic underworld, so as to appreciate, in an engaged way, the soil's potential for fostering life. No one knows better than the gardener that in order to realize that potential, the soil needs an external agent, a husbandman, as it were, to undertake the labour of domestication and fertilization.[44]

But what are the conditions that optimally serve the rose plant in order that it will prosper in our gardens? The horticulturalist William Paul, writing in the 1840s, observed:

> If we were called upon to select the spot as best suited for the cultivation of Roses, we should seek one at a distance from large towns, that we might secure the advantages of pure air. It should lie open to the south, and be so far removed from trees of very description, that their roots could not reach the soil of our Rose-beds, or their tops overpower us with shade, and prevent free circulation of air. If, in addition to this, we could choose our soil, that preferred would be strong loam: if rich, so much the better; if poor, we would enrich it by the addition of manures.[45]

Sound advice in 1848, and sound advice today, although seeking distance from large towns is now much more difficult (while, paradoxically, inner-city pollution isn't as noxious today as it was in 1848, thanks to Clean Air Acts). Avoiding trees is one rationale for indulging in the carpet garden style rose garden, which is founded on strict horizontal

geometric organization. Gertrude Jekyll designed several formal rose gardens, but she was also a strong advocate of a more relaxed cottage garden plan.[46] She wrote: 'The English Rose garden that I delight to dream of is also embowered in native woodland, that shall approach it nearly enough to afford a passing shade in some of the sunny hours, though not so closely as to rob the Roses at the root.'[47] Jekyll stressed that the purpose of roses in a garden is not simply to show off the size and quality of blooms, but to display their beauty through free and luxurious growth. This is also sound advice today as it was in 1902. From the other side of the rose 'revolution', Hazel le Rougetel, writing in 1988, had the following advice: 'When starting to make a garden of roses from scratch, there should be three prime considerations: how they are to be arranged, what is to be planted with them, and, applying to both – a factor often overlooked – scale.'[48]

Future promise and potential are what motivate a gardener to work hard in the present moment. But roses are deceptive, in that they often seem too refined to be tough and adaptable. Luckily for us amateurs, however, they are very robust on the whole. You soon learn that the more you prune roses, the faster they grow, and the stronger they become. But on consulting the rose experts you often discover that major questions, such as when, how and if to prune, often receive different and conflicting answers.

Furthermore, in the course of caring for one's 'special' rose, unexpected things inevitably sometimes happen. For example, early on in my life as a rose gardener I was surprised to find a rose growing some canes whose wood and leaves looked different, and whose blossoms then turned out to be quite unlike the rest of the rose. I learned that this was the suckers of the rootstock sprouting from below a portion of the stem and root system onto which a bud eye had been grafted. If you don't cut these back, they may very well take over, reverting the rose to the rootstock, such as *Rosa laxa*, 'Dr. Huey' or *Rosa multiflora*. Furthermore, one can uproot a rose and replant it, and then find its rootstock suckers pushing their way through where the now relocated rose once grew. As a result, I have a vigorous *Rosa multiflora* growing in

my French garden, which is just like the one I transplanted from a nearby hillside in South Korea and is growing in my garden there. These mishaps have helped me realize that beneath even the most sophisticatedly hybridized rose there is a species rose struggling to get out.

A gardener must guard against the intrusion of all they consider does not belong in their garden. Intrusions are both internal and external, and the overwhelming desire to care-take can be short-sighted. Resorting to herbicides, insecticides and other poisons, a gardener sometimes achieves security and purity for his or her charges at the expense of unleashing a lethal toxic rain. But the trouble is that despite its robustness, the rose has many enemies. 'O Rose, thou art sick', writes William Blake, and the gardener will probably reply 'yes!' – with Anthracnose, Black Spot, Botrytis blight, Brand Canker, Brown Canker, Dewy Mildew, Powdery Mildew, Rust, Rose Mosaic Virus, Rose Rosette . . .

A major scourge is the fungus *Diplocarpon rosae* – Black Spot. Dark brown to black spots develop on the upper leaves, which eventually become yellow and drop off. Black Spot is extremely unsightly – it makes looking at a rose like looking at someone with the pox – and this effect is made more jarring by the close juxtaposition of infected leaves to beautiful blossoms. But it's more than an aesthetic problem. When the leaves fall off, the plant cannot convert the energy in sunlight into the chemical energy it can use as food. Furthermore, the upper buds expand before their time. And winter doesn't kill Black Spot, as it hides on fallen leaves and diseased stems, and then, as soon as spring is in the air, it spreads onto the healthy new leaves. The problem is worst in humid, damp weather, followed by cool nights – which sounds very much like the normal English spring and summer, or the spring and summer where I live in France – although global warming is transforming all that. There is no cure for Black Spot, only prevention.

It is interesting to consider that the rose's ascension to the position of 'Queen of Flowers' coincides exactly with the massive spread of sulphur into the atmosphere caused by the Industrial Revolution. But the Clean Air Act, and equivalent legislation in other countries, meant

that from the 1960s onwards fungi had a freer reign, which also signalled the end of an Age of Innocence for the rose trade. Rosarians had never seen any need to spray their roses, but now everything changed. Before the various pieces of clean air legislation, the average rose grower felt competent enough to buy and plant them, and it was as easy as, well, growing roses. In response, the chemical companies turned their attention to curing the disease, and with considerable success. But cure is not prevention. Furthermore, it was natural that in order to sell their products these companies advertised them, and because they were selling to rosarians, they chiefly featured gruesome pictures of diseased roses. This, of course, was a self-defeating manoeuvre, because it discouraged the public from planting roses. In this way, suburbia discovered that the plant it hoped would give more than a lifetime of trouble-free pleasure now required the expense and labour of spraying. Indeed, nowadays, as one gardening website puts it stoically, 'Black Spot and roses go hand in hand.'

Today, however, perhaps the greatest enemy of the rose as a garden plant isn't Black Spot but changing fashion. Since the 1990s, a revolutionary gardening movement dubbed 'new wave planting' or the 'New Perennialism' has uprooted roses, private and public. Key words for the most well-known exponent of the style, the Dutch landscape gardener Piet Oudolf, are 'natural', 'wildness', 'wildscaping', 'symbiosis' and 'ecological sustainability'. He talks of the emotional experience of a garden as more important than the aesthetics, and the plants of choice in an Oudolf garden are wild grasses and other herbaceous perennials which die down to the ground over winter and re-emerge in spring. The ornamental cedes to the wild look, as simple blocks of single-species planting are replaced by drifts, producing more open and rhythmic patterns. The dominant impression is of a field or meadow untouched by human hands.

As the supporters of this style of gardening point out, a garden centred on flowers tends to be interesting only in spring and summer,

while the goal of their plantings is to be visually interesting all the year round. In Oudolf's matrix style, a garden is comprised of 70 per cent 'structure plants' and only 30 per cent flowery ones. As a result, the Gardens of Remembrance at The Battery, New York City, for example, which opened in 2003 and were designed by Oudolf, contain no roses whatsoever.[49] Not surprisingly, the dominance of the 'New Perennial' style has led to a backlash. In some quarters in the United Kingdom the Brexit impulse has found a horticultural parallel among those seeking to 'defend' English gardens from what they deem 'foreign' contamination. There are calls for a return to the cottage garden style and, of course, to the central role of the rose in garden plantings.

A garden overly dedicated to spring and summer flowers will certainly be a very dull place for the rest of the year. In relation to the rose, the drawback of limited inflorescence has been partly countered by the much longer period of flowering typical of the newer roses. But while roses amount to much more than simply a brief or more prolonged show of colourful and (sometimes) fragrant blossoms, one has to admit that in winter a rose bush is not an especially attractive sight. Few have a beautiful leaf colour in autumn, and most lose their leaves, and once they have fallen, we become much more aware of the prickles, which can look unpleasantly dangerous. Pruning roses back, as is usually required for Hybrid Teas and Floribundas so as to maintain the neat suburban garden style and to encourage maximum inflorescence, makes a winter rose bush or shrub look a sadly apt metaphor for brutal discipline (even if it is, obviously, for the rose's own good – or rather, for our greater satisfaction in spring and summer).

But I hope that I have made it abundantly clear that roses are much more than just over-hybridized garden mutants. There are many wild species roses, and natural sports which, while often taken in hand and developed by artificial selection, are also 'wild', in the usual sense of the word. Not all roses are shrubby Hybrid Teas or Floribundas. Roses have a richly evocative pre- and post-blossom life, and very varied growth habits and structures. They attract a wide variety of wildlife, which is an important consideration for the New Perennialism. But

these caveats are of course missing the deeper significance of the trend. 'Every garden is a replica, a representation, an attempt to recapture something', writes the architectural historian Robert Harbison. If this is true, then the New Perennialists are hoping to 'recapture something' that is significantly different to the gardeners of the past.[50]

But there is no real cause for alarm. Roses are not going to disappear. Today, the most important rose garden in the world is the Europa-Rosarium in Sangerhausen, Germany. It contains more than 7,800 different varieties of cultivated hybrids, 500 species wild roses and 75,000 individual rose bushes.[51] As a reference collection, which tells the history of rose cultivation through the living evidence, it is unrivalled. The largest private rose garden in the world is the Roseto Botanico Gianfranco and Carla Fineschi in Tuscany, Italy, boasting an extravagant 6,500 different specimens. The most poignant rose garden today is certainly the one in Futaba, near Fukushima, Japan, which had to be abandoned in 2011 because it lies dangerously close to the leaking nuclear power station.[52]

CHAPTER FOURTEEN

'Rose N'Roses'

THE ROSE BUSINESS

If you want to test the rose's pervasiveness within today's consumer society, a department store is a good place to start. I chose John Lewis on Oxford Street, and walked there directly after my rose-hunt in the National Gallery. Once at the store, I made straight for the cosmetics' hall on the ground floor. At Dior, I tried the new Eau de Toilette 'Rose N'Roses', which had been recently launched to coincide with Valentine's Day 2020, joining the six other Miss Dior rose-based perfumes (the first appeared in 1947). I asked the two sales assistants what specific type of rose was used for the perfume, and one of them replied, 'the Grass Rose', which threw me for a moment, until I realized she was referring to the Grasse Rose, that is, *Rosa centifolia*, the Cabbage Rose or the Rose of Provence (the roses in van Gogh's painting). In the twelfth century, returning Crusaders may have carried knowledge of rose distillation back with them to western Europe, although such knowledge could have arisen independently in Europe. Eventually, the rose became an important ingredient for the Western perfume industry, and in the sixteenth century, around the town of Grasse in southern France, rose cultivation developed for this purpose. *Rosa centifolia* was the species of choice, and remains today at the

heart of a thriving business. Dior, Chanel and Hermès all source their roses in Grasse.

I discovered that 'Rose N'Roses' is a lively and sparkling fragrance and wasn't too sweetly floral. I then went directly over to Lancôme, and tried their 'La Vie est Belle en Rose', launched a year earlier for Valentine's Day 2019 as a further iteration of their successful 'La Vie est Belle' perfume. But as I am wholly ignorant of, and seemingly rather insensitive to, perfume, I couldn't really tell the difference between the two. Feeling somewhat light-headed, I proceeded to explore the rest of the store, and found roses adorning scarves, blouses, skirts, dresses, hats, lingerie, crockery, china, cushions, furniture and lampshades. There were also artificial rose flowers, including a lovely red polyester *Rosa centifolia*, retailing at a very reasonable £8. Valentine's Day had recently passed, but Mother's Day was looming, so there were also rose-themed promotions for this important event.

We tend to think of roses mostly in relation to their symbolic or ornamental value, but as we have seen, historically, and also today, the rose business takes many forms. There are not just roses for planting, or cut roses for bunches, bouquets and wreaths but also, as the cosmetics hall at John Lewis reminds us, roses for perfume. In some parts of the world, as we have seen, there are roses for both culinary and medicinal purposes. Roses have been lucrative for more than 5,000 years, which makes their cultivation one of the longest running commercial enterprises in the world.

If an Ancient Roman could afford it, he or she arranged for thousands of fragrant and soft rose petals to be dropped from above onto the banqueting guests. In a previous chapter, I mentioned Alma-Tadema's painting *The Roses of Heliogabalus* (1888), in which the Victorian artist sought to evoke the decadence of ancient Rome through a scene of excessively extravagant floral display. In the painting, one can also see that the languorous guests are wearing rose

chaplets – garlands for their heads. Such sartorial accessories were common in many social situations, sacred and profane.

The Romans set a day aside annually in May or June called *Dies Rosalia* or *Rosaria* (Feast of Roses), which required the assiduous cultivation and marketing of roses to satisfy demand. Flower sellers abounded, and it was sometimes deemed a morally dubious profession, as a poem attributed to Dionysius the Sophist suggests: "You with the roses, rosy in your charm; but what do you sell, yourself or the roses, or both?"[1] In the region around Pompeii, Paestum and Capua, the products of local rose cultivation were intended for a large market, spreading beyond the Italian peninsula. Roses were grown in greenhouses and under glass, so that they were available all year round. But such was the demand that Italy could not grow enough of them, and they had to be imported from Syria and Egypt.

But after the fall of Rome the flower business went into steep decline, and one can imagine the Dark Ages as metaphorically 'dark' because of the absence of colourful, aromatic flowers. As we saw, rose chaplets, garlands and offerings were condemned by the Church, as was the use of flowers in commemoration of the dead. But by the fourteenth century, flowers worn as ornamental and sacramental chaplets were again commonplace. Conventions of floral body decoration also evolved in secular contexts, as several works in the National Gallery showed, and until the mid-twentieth century roses were a standard fashion accessory, not only for ladies but also for gentlemen, who wore them as buttonholes. The high demand ensured a lively business in cut roses.

Another practical and profitable use for the rose, although not so much in western Europe, is the production of rose water and the perfumed attar of roses. The latter involves distilling volatile oils from the flowers, and knowledge of this process dates from at least the first century AD. By the ninth century attar of roses was being exported from, especially, the Fars region in Persia to places as far afield as Spain, India and China. From the tenth to the seventeenth century, Persia was the acknowledged centre of the industry, and the Damask rose was

cultivated for this purpose especially around Shiraz in the Fars province, and still is to this day. *Rosa centifolia* is also used for this purpose in the Near East. The Moors brought the technology of rose-water production to southern Spain, and the Moghuls to India, and a tradition says that it was actually Queen Noor Jehan in sixteenth-century India who discovered rose oil or attar when she collected droplets of the oil from a canal flowing with rose petals. Today, roses for oil is a significant cash-crop in regions of India such as Kashmir and Uttar Pradesh.

As an enduring legacy of the Turkish Ottoman Empire, cultivation of roses for rose water and rose oil also continues today in Turkey and Bulgaria. Over the centuries not much has changed in how roses are cultivated and processed to make oil. In the spring the pickers still work quickly from the early morning, as the harvesting period is short and dependent on the weather. During a cool, cloudy day in spring harvesting can last for a month, while in hotter seasons, for only 16–20 days. The flowers are then brought to sills (copper or iron), mixed with water and the distillate collected in metal tubing. The primary distillate is then further processed to obtain the desired properties. To produce just one kilogram of rose essence in a still, takes about 12 tonnes of fresh roses. Industrialization of the time-honoured practices began in the early twentieth century, especially in Bulgaria, where steam stills and volatile extraction systems were developed. Under communism, copper stills were abandoned and the rose farms were collectivized and nationalized. Today, Bulgaria remains a world leader in the production and export of attar. There is even a Valley of the Rose dedicated to the cultivation of the Alba, and especially the Damask Rose, *Rosa damascena trigintipetala*, aka the Kazanlik Rose.

In general, the emission of rose scent is greatly influenced by ambient conditions, such as the moisture of the soil, the time of day and weather conditions. Gloomy, cold weather reduces scent, while warm sunshine can shift the quality of a fragrance between morning and evening. This is why roses cultivated for their scent are always picked in the early morning, when the odour is strongest. Technically

speaking, the rose flower's aroma comes from tiny cells on the undersides of petals, and is produced by an amalgam of chemicals called monoterpenes. Enzymes speed up a chemical reaction and modify the monoterpenes to produce a scent. Recently, scientists discovered that the enzyme Nudix hydrolase (RhNUX1) is active in sweet-smelling roses and dormant in odourless blooms.[2]

Traditionally, rose water has also been credited with significant medicinal value. Pliny the Elder recorded thirty-two different applications. After the foundation of the monastic orders, Christian monks and nuns grew roses in their gardens as an ingredient for herbal remedies, medicines, and also for their cooking. In herbals and illuminated health handbooks the rose is often referred to. In her twelfth-century treatise *Physica*, Hildegard von Bingen writes:

> Rose [*rosa*] is cold, and this coldness contains moderation which is useful. In the morning, or at daybreak, pluck a rose petal and place it on your eyes. It draws out the humor and makes them clear. One with small ulcers on his body should place rose petals over them. This pulls the mucus from them. One who is inclined to wrath should take rose and less sage and pulverize them. The sage lessens the wrath, and the rose makes him happy. Rose, and half as much sage, may be cooked with fresh, melted lard, in water, and an ointment made from this. The place where a person is troubled by a cramp or paralysis should be rubbed with it, and he will be better. Rose is also good to add to potions, unguents, and all medications. If even a little rose is added, they are so much better, because of the good virtues of the rose.[3]

I have already mentioned a rose that was especially associated in Europe with medicinal benefit: *Rosa gallica offinalis*, the Apothecary's Rose or Provins Rose. Right up to the nineteenth century in the town of Provins in France there were more apothecaries on the main street than any

other type of shop. They dispensed remedies derived from the Apothecary's Rose, which were said to aid digestion, sore throats, skin rashes and eye maladies.[4] In the *Tacuinum of Vienna* (c.1407), a medical handbook, the rose is listed as useful in the treatment of 'inflamed brains'. But it warns: 'In some persons they cause a feeling of heaviness and constriction, or blockage of the sense of smell.' The positive effects of the rose are described as follows: 'They are good for warm temperaments, for the young, in warm seasons, and in warm regions.' The compilers of the various *Tacuinum Sanitatis* had absorbed medical knowledge inherited from Greece and Rome, but much was culled from Arabic botanical and medical treatises. The *Tacuinum of Vienna* refers specifically not to the Apothecary's Rose but to the Damask Rose, and is clearly repeating verbatim the advice of Arab treatises. But the Arabs, in their turn, drew on ancient Greek texts. The Persian Ibn-Sînâ, or Avicenna as he is known in the West, stated in *The Canon of Medicine* (1025) that distilled rose water was beneficial in cases of fainting and rapid heartbeats, and can strengthen the brain by enhancing memory. Boiling rose water and exposing the rose bud to its steam, he wrote, is especially beneficial for eye diseases. Influenced by the Arabs, the *Tacuinum of Vienna* states that the best roses come from Suri in Persia, and trade along the Silk Road and via ports such as Venice made Syrian and Persian rose water and rose oil available in western Europe – at a price. One illumination in the *Tacuinum of Vienna* shows red and white flowers being plucked by two handmaids from the same rose tree, and handing them to their lady who is seated on the left, who cradles several blooms in her lap, and wears a rose garland on her head.[5]

As we saw, John Gerard also discussed the rose in relation to several useful medicinal applications for Elizabethan England. But in Western medicine today, the rose is not generally credited with many health benefits, apart from the use of hips for their vitamin C content, which aids in the prevention and treatment of colds, flu and vitamin deficiencies. The calyx also contains vitamins A, B, C, E, K and P, with C in the highest concentration. But in contrast to the decline in medicinal value in the West, the rose remains important in the Middle Eastern medical

tradition, where the properties noted by Ibn-Sînâ – its usefulness as a mild sedative and antidepressant, the anti-inflammatory properties of rose petals and rose water for inflamed eyes, as a diarrhoea remedy, helping to reduce thirst and to ease gastric inflammation – remain part of medical practice. These days, however, such traditional applications are again being explored in the West by some herbalist and medical practitioners, bolstered increasingly by credible modern scientific research.

But it is as a cash-crop for the cut rose and gardening businesses that the rose is most commonly grown globally today. In 2018 the market for cut flowers and ornamental plants in general the UK was worth £1.3 billion. Thanks to Valentine's, Mother's Day, and all the other celebratory or commemoratory occasions, the fate of many rose plants is to be continuously interfered with by humans as an agricultural commodity. In huge warehouses shoots are bent, flower canes harvested, pruned and pinched (that is, flower-bearing branches are removed), and treated with chemicals. Each of these interferences are intended to manipulate the functioning of the plant so as to optimize profit. Then the results are packed for refrigerated transportation so you can purchase them at your local supermarket.

For over 200 years the centre of the global cut-flower trade was the Netherlands, but now increasing numbers of flowers in Europe come from Kenya and Ethiopia, and those purchased in the United States, from Ecuador and Colombia. Kenya is an especially prolific exporter of roses – it supplies one-third of all roses sold in the European Union, and flowers are the nation's second largest export after tea. Many fragrant David Austin's English Roses are grown on Kenyan farms. Today, the rose is the most commonly grown flower in China, where there is a thriving international rose trade centred on Henan and Yunnan provinces. In 2013, Yunnan had 67,400 hectares dedicated to rose cultivation, and this accounted for about a third of China's rose exports.

Thanks to globalization, and the development of cold-chain transportation, cut flowers travel prodigious distances to arrive in time for Valentine's Day. The fact that 14 February is not the time of year when roses naturally bloom – in both the northern and southern hemispheres – should give us pause for thought. While they were growing in huge, temperature-controlled greenhouses, they would likely have been sprayed with a toxic cocktail of chemicals, some of which are restricted or banned outright where you live. As a result, prenatal exposure to chemicals sometimes leads the women employed to pick the roses to have children with abnormalities. Once the roses are on their way to somewhere nearer to you, they need to be preserved in energy-hungry refrigerated warehouses, then flown by refrigerated cargo plane to another refrigerated warehouse prior to their distribution by refrigerated truck to the florist or supermarket, and then to your loved one.[6] This is a very considerable carbon footprint.

What can one honestly say about cut roses? They are certainly useful. A birth, birthday, courtship, Valentine's Day, Mother's Day, marriage, anniversary, celebration, convalescence, funeral or memorial day is incomplete without them. But here is a character (who happens to own a rose nursery) contemplating cut roses in the British novelist Iris Murdoch's novel *An Unofficial Rose* (1962):

> There was a flower stall outside St. Thomas's hospital, and he paused there. Roses. The long-stemmed neatly rolled and elongated buds affected him sadly. They were more like City umbrellas than flowers. They were scarcely roses, those skinny degenerate objects, meanly and hastily produced by a coerced and cynical Nature for a quickly turning market, and made to perish unnoticed by bed-sides or to be twisted in the nervous hands of girls in long dresses.[7]

Supplying living rose plants for growing in our gardens is also a very lucrative global enterprise, involving a network of family run or corporate garden centres and nurseries, who together provide us with specimens in a bewildering variety of shapes, colours and sizes:

thornless roses, perfectly formed cut roses, giant climbing roses, dense ground-cover roses, miniature roses suitable for the city apartment's veranda.

The next big thing in the 'quickly turning market' that 'a coerced and cynical Nature' will be required to produce is the first truly *blue* rose: the Holy Grail of rose breeding. The association of the colour blue with dreaming, sadness, melancholy, and concepts like the impossible, transcendence, infinity and the soul, suggests that a blue-coloured rose would certainly evoke some interesting reactions. Meilland's 'Charles de Gaulle' and Tantau's 'Mainzer Fastnacht' (which is known in Britain as 'Blue Moon') both claim to be blue, but they are not. Nor is a more recent Japanese effort, 'Suntory Blue Rose Applause', marketed in 2005 after twenty years of research. All these roses are lilac. Although the ingredients necessary to form blue pigmentation have almost certainly not been part of the rose's chemistry for the past few thousand years, it is, however, possible that there used to exist a blue rose that went extinct. Ibn-el-'Awwam in his twelfth-century treatise on agriculture and gardening, declares that 'the colours of Roses are very many, red, white, yellow, the colour of zulite (celestial blue) and another which is blue outside and yellow within'. But writing in the 1930s in a classic study of the rose, Edward Bunyard, who mentions this surprising description, is sceptical:

> The 'blue rose' has puzzled commentators, but the use of colour terms in ancient days is a subject of great complexity, witness the 'purpurea' of the Romans as applied to human hair and also snow. The only link here seems to be the sheen which might be seen on both. The most likely candidate for the rose 'blue' without and yellow within is the Copper Austrian Briar.[8]

A more likely possibility, also mentioned by Bunyard, is that the roses Ibn-el-'Awwam describes were hand dyed to look blue.

A truly blue pigmented rose is an especially tantalizing prospect because the colour is certainly no stranger to the world of plants. A petunia can synthesize blue pigments and produce pure blue. The

higher the pH in the cellular vacuoles – the closed sacs, made of membranes with organic molecules inside – in which blue pigment is accumulated, the more pure blue the colour will be. However, it is not simply a case of inserting a blue gene from a petunia into the rose's DNA. If this were attempted, it would form a pink pigment. In fact, if we try to change the genes that determine cell pH there is the risk of changing a whole range of other cell functions as well. But, at least in theory, a very small interior change can cause a revolutionary outward one. Recently, an Indian-Chinese team of biochemists attempted to manipulate bacterial enzymes in the petals of a white rose to convert L-glutamine in the blue pigment indogoidine. The bacteria transferred the pigment-producing genes to the rose genome and as a result a blue colour spread from the injection site. But there was one big problem: the colour (which certainly looks blue in the photographs I have seen), is short-lived and patchy, and requires each time the injection of the enzyme.[9]

Today, the most impressive commercial rose nursery anywhere must be David Austin Roses Ltd near Wolverhampton in the English Midlands, not least for his highly successful English Roses. At the nursery there is not only a plant centre, tea room and gift shop, but also six linked rose gardens, with over 700 different varieties of roses, whose free-sprawling growth is contained by carefully maintained hedge borders. Each garden has a specific theme, from a formal Victorian Walled Garden to an informal Species Garden. Austin's own English Roses are displayed in the Renaissance Garden. David Austin Roses Ltd provides, one could say, the 'total' rose experience, and Austin, and the others who have followed his lead, have recognized that the modern is only better than the ancient if it is proven to be so in recognizable ways.

My own personal favourite rose nursery is in France, southwest of Lyon, and it is very different from the ambitious statement-making

David Austin Roses Ltd, or the French rose giants Delbard, which happens to be located not far from my house in the Allier department in central France, or Meilland International, farther south in Provence, the present-day descendant of the rose nursery that brought the world 'Madame A. Meilland', aka 'Peace'. Roseraie Ducher is a small and unassuming place in the middle of gently rolling, sparsely populated countryside, with green hills in the distance. It is run by a sixth generation descendant of the rose-breeding dynasty of Ducher, creators of classics like 'Gloire de Ducher', 'Cécile Brünner' and 'Soleil d'Or' – the yellow rose bred by the legendary 'Wizard of Lyon' Joseph Pernet-Ducher.[10] Along with Peter Beales and David Austin nurseries, Rosairie Ducher was honoured in 2019 to be one of the three breeders invited to create a 'Rose Romance' theme at the Gardens by the Bay in faraway Singapore, a project which aimed to recreate a traditional European-style garden setting.

Roseraie Ducher is dedicated to the old garden or heritage roses, and for my garden I have acquired from them such historical roses as the Four Seasons' Damask, *Rosa damascena* 'Kanzanlik', the Provins Rose and *Rosa gallica versicolor* (known as 'Rosa Mundi', and which is a very old striped pink and white rose, like raspberry ripple). Based on the hybridization techniques of Pernet-Ducher, and using *Rosa canina* for grafting, Fabien Ducher has also been creating his own roses for almost two decades, roses that seek to blend the best of the old and the new – as in the light pink and highly fragrant 'Florence Ducher', a climbing Bourbon with a very old garden rose appearance, which is named after Fabien Ducher's wife and partner in the business. The firm also produces rose water distilled from *Rosa centifolia* and *Rosa damascena*, in the time-honoured tradition. But as Fabien Ducher admitted when I talked with him and his wife, one of the practical problems facing a rose breeder dedicated to the old roses is that it isn't very profitable. So, theirs is very much a labour of love, which Fabien admits has been inspired primarily by English rosarians like Beales and Austin, who have done so much to reintroduce the charm of old roses to the modern-day public.

All the various breeders who specialize in producing the 'heritage' style roses make a point of naming their new roses according to the old manner, with great discretion and very good taste, such as these from David Austin: 'Emily Brontë', 'Gertrude Jekyll', 'Lady of Shallot' and 'The Lark Ascending'. In the twentieth century the glamour moved to Hollywood, and downmarket towards mass or popular culture, which is why today there are roses named for movie stars, like 'Ingrid Bergman', 'Bing Crosby', 'Elizabeth Taylor' and 'Betty Boop', and pop stars, such as 'Neil Diamond' and 'Freddie Mercury', which is a bright orange with pink tints Hybrid Tea, and lightly scented. 'This rose is full of character, pizzazz and style,' says one hopeful online vendor. It cost the Freddie Mercury fan club £2,000 to name and register, and the first bushes, available in 1994, were sent to Mercury's mother and other family members.

But even today, aristocrats are still sometimes involved in the naming of roses in general, and royalty is always a good bet. There were several varieties of rose whose patent owners wished to be claimants to the glamour of Princess Diana, and which did well for a while, but are of doubtful interest now. However, the glamour can be of a more spiritually purifying kind. 'Pope John-Paul II', for example, is a pure white Hybrid Tea launched in 2008, marketed as 'one of the most fragrant white roses of all time'. The breeder had to get permission from the papal nuncio before patenting the name. The same protocol was involved in 2015 when Pope Francis was also honoured with a white rose – 'Pope Franciscus'. In fact, as we saw, the current pope has a special devotion to the roses of St Thérèse of Lisieux. In passing, I should note that there is also a rose called 'St. Patrick' – the yellow flowers are supposed to be tinged with green. But truth be told, the name has less to do with religion than targeting the Irish on St Patrick's Day.

On occasion, artists can be privileged with a rose named in their memory. There is one called 'Pablo Picasso' (1966), whose flowers give the impression of each having been individually hand coloured. This has become part of the burgeoning and lucrative Picasso franchise that also includes a brand of car. Picasso was not an artist especially noted

for painting flowers of any kind, although he did have his Rose Period, during which he produced rose-coloured paintings, several of which also have rose-coloured roses in them. 'Pablo Picasso' is indeed a pink rose, but rather too deep a shade to evoke his Rose Period. The idea of hand-painted petals has been fully exploited by the French nursery Delbard, who market a line called Roses des Peintres – 'painters' roses' – including a creamy white and pink bi-colour rose called 'Claude Monet' (1992), and another called 'Henri Matisse' (1995), whose petals suggest they have been painted with crimson and pink splashes.

Nowadays, some of the most strikingly titled roses are associated with Valentine's Day. In the advertising business it is well known that sex sells everything and anything, but when it is Valentine's Day, the connection is obligatory. Here, chosen at random, are some roses targeted at this event: 'Lovestruck', 'Erotica', 'Playboy', 'Sexy Rexy', 'Dark Desire'. But as soon as Valentine's Day is over, people seem to prefer roses with names that aim to reassure them that the rose in question will sit politely in a vase on a table in some genteel café or hotel lounge, next to tea and scones. Here, to give the general idea, are some rose names that are all currently in commerce in the UK: 'Anniversary', 'Fragrant Cloud', 'Sceptre'd Isle', 'Hope for Humanity', 'Wise Woman'.[11]

As the success of the Hybrid Tea named 'Peace' demonstrates, and as a look at the names of more recent remembrance, memorial and tribute roses confirms, roses today are often titled to evoke beneficial or hoped for existential conditions, or positive feelings, moods and relationships. 'Sweet Memories', 'Scent from Heaven', 'Missing You', 'One in a Million' and 'Perfect Pet', are a sampling. The benefit of choosing a name that evokes a positive emotional condition, or that is a mood name rather than a proper name, is that a closer association can then be made between the tangible beauty of the rose and aspects of human experience that are inherently intangible. A 'mood' is the way we feel at particular time, and the mood name of a rose is meant to signal in unambiguous terms the fact that the flower is a proxy for our feelings towards the person (or the pet) that is being remembered. But of course, this act of remembrance need not involve an organic rose, one

that will soon enough become, in some circumstances, a strikingly overt symbol of the loved one's corporeal putrefaction.

If you are wondering how you go about having a rose named in someone's, or even your own, honour, below is Brad Jalbert, a nurseryman in British Columbia, Canada, with an explanation from the website to his rosary, 'Select Roses':[12]

> To Commission a Rose
>
> Visit our gallery of roses available for naming to view some of the seedlings available, and the prices at which they are offered. We will offer just a few roses for commissioned naming each year, and their prices are based not on the superiority or inferiority of a given variety, but rather upon the difficulty in breeding the colour, fragrance, or specific type of rose.
>
> All commissioned roses will be registered with the International Cultivar Registration Authority – Roses . . . The client receives the first 10 rose bushes when they are ready, during the proper planting season. The rose is then propagated at Select Roses and sold to customers with the commissioned name.
>
> And how much will it cost? For a miniature rose, CDN $5,000 (about £4,000), and for roses that are difficult to produce, up to $15,000 (or over £9,000).

The modern rose business is primarily founded on our insatiable appetite for beauty, which we gratify primarily via two physical senses: vision and smell. Recall that the Greek word *rhódon* and the Latin *rosa* are used to describe both a plant and a colour, and that modern languages which derive from Greek or Latin mostly also use the same word for the plant as for a colour – except the English language, where the word for the colour is 'pink'. When used to designate a colour, the word 'pink' embraces everything from pale blush pink to a fairly chromatically saturated fuchsia or cerise. 'Rose', on the other hand, is light red, the historically dominant colour of the rose, which today is usually

associated with innocence and naivety, and in some circumstances, connotes a lack of seriousness. Rose as a colour also correlates closely with youth, especially feminine youth, and we tend to think of the colour as intimately aligned with tender and caring feelings of love, and the passionate variety is more likely to be associated with bright or deep red, hence these colours' prominence on Valentine's Day. But as we saw, the stronger hues were in fact rare in roses in Europe until nineteenth-century breeders introduced them via hybridization.

Colour associations are not, however, hard-wired, that is to say, instinctual. They are historical through and through. In the contemporary West, the colour rose (or pink) is considered primarily a feminine colour, but until the late 1950s it was gendered as a *boy's* colour, and girls were supposed to be associated with blue. In Japan, pink still has masculine association. The shift in gender assignment of pink in the West was in part a consequence of women's empowerment during the Second World War, but it also reminds us that the range of associations we now make in relation to the pinkness typical of a rose may not have been made in the past.

Then again, there does seem to be a sound physiological and chemical basis for feeling better, or at least, calmer, from looking at a moderately pink colour. Tests have shown that staring at an 18- x 24-inch card printed with a pale whitish pink, especially after active and intentional exercise, produces what the experimenters report to be lowered heart rate, pulse and respiration, as compared to viewing other colours. The hue acts as a calmative through chemically affecting our hormones. Subsequently, the potential social benefits of this tranquillizing pink which, most unappetizingly, was labelled P-618, or 'Drunk-Tank Pink', or 'Baker-Miller Pink', were tested in prisons and psychiatric hospitals in the United States with some success. So pink brings about a mood-shift towards feelings of tranquillity, warmth of emotion, nurturing love and sustenance, and is soothing rather than stimulating. This means that the cultural association of pink with innocence, levity and a romantic kind of attachment may be grounded in a chemical process that reduces hostile, violent and aggressive behaviour. Pink is, in other

words, a chemical pacifier, and paves the way for tender feelings. P-618 has less warm red in it than the typically 'pink' roses, such as the Gallica or Damask. But nevertheless, its efficacy leads one to speculate about what is happening when we look at a classic pink rose. Is our nervousness, desire, voraciousness and aggressiveness being physiologically lulled through contemplating it? Could this be one of the subliminal reasons why we choose roses over other plants?

The visual sense is of paramount importance when it comes to being grabbed and held by the spectacle of a rose, and in delivering the emotional and intellectual frisson we call 'beauty'. But as the perfume industry attests, so too is the sense of smell. In periods when people rarely bathed, much of the appeal of rose chaplets, crowns and bouquets, and rose water and rose oil, must have lain in their agreeably fragrant properties. In fact, it is often the olfactory sense that in the past seems to have been the most powerful modality through which roses caught the attention of people and affected them. Shakespeare's Juliet doesn't say, 'A rose by any other name would *look* as *fair*.' Rather, she draws attention to the rose's sweet scent. In Sonnet 54, Shakespeare declares: 'The rose looks fair, but fairer we it deem / For that sweet odour which doth in it live'.

On the whole, darker coloured roses tend to be more highly scented than ones with a lighter shade. Red and pink roses give off the more typical scents associated with the rose, while yellow and white roses often have scents which can be reminiscent of orris, nasturtium, violet, lemon or even bananas. Roses of orange shades are considered to have scents comparable to fruit, orris, nasturtium, violet or clover. Of the fragrances of the old garden roses, Thomas Christopher writes: 'There were roses that smelled of exotic spices, myrrh, cinnamon and cloves. Some were said to smell of apples, others of mangoes, oranges, pineapples and bananas ... In the heyday of the old roses ... it was said that a blindfolded expert could identify different varieties by fragrance alone.'[13]

But when we refer to 'strongly scented' roses, which do we mean? Prior to 1500, the most powerful fragranced rose was probably *Rosa*

moschata, the Musk Rose. But it is *Rosa damescena*, the Damask Rose, which has a sweeter aroma, and was most cherished. By 1500, the variety of Damask Rose known nowadays as 'Kanzanlik' was universally admired and cultivated for its especially strong scent, which as we saw was used in the production of rose water and oil. This was also complemented by another sweetly scented rose, *Rosa centifolia*. From the sixteenth century, a pale pink Alba Rose, *Rosa alba incarnata* named 'Cuisse de Nymphe Emue' or 'Great Maiden's Blush' was much admired for its strong and delectable fragrance, and by the nineteenth century cultivated roses such as Guillot *fils*' 'La France', 'Duchesse de Brabant' 'Ulrich Brunner' and 'Madame Alfred Carrière' were especially prized olfactorily.

Sight produces the indispensable mental properties of continuity, uniformity and connectedness, thereby creating the impression that we are firmly located in time and space. Smell, by contrast, brings more intimate awareness. Through smell our body remembers who we are, and where we are physically located in the world. It is vital in infant-mother bonding, and later in life, during intimate social bonding of many kinds. Smell enmeshes us in the world through immaterial attraction (or repulsion) in ways that are far more immediate than visual inspection. One can say that smell happens in a kind of 'darkness', but it nevertheless verifies and brings conviction through tangible directness. Sight is a physical sense, but responding to the scent of a rose involves a *chemical* reaction in our bodies, and while smell may be the most intangible of the senses, it is also the most powerful trigger of memory and imagination, inducing vivid recollections of scenes and episodes from the past, or fantasies of the future. Smell is a particularly strong stimulant to reminiscence and reverie, creating bridges to the past and future that the other senses and the reasoning mind cannot construct. Pleasant smells are especially recalled, because humanity lives on a daily basis with maleficent or indifferent odours more than pleasant ones. Thus it is that the odour of a specific rose can launch vivid memories, perhaps nostalgic feelings about childhood, of the time when a particular rose was first encountered. Smell suppresses the rational,

analytical brain, and encourages more inward, imaginative and dreamy dimensions of consciousness. It induces reverie, even an awareness of other-worldly powers.[14]

The capacity of scent to generate a powerful ambiance and to encourage spontaneous recall is central to the perfume industry. In particular, as all parfumiers know, odour is closely bound to Eros. 'What slender youth sprinkled with fragrant perfumes / now makes love to you, Pyrrha, on a bed of roses / in some pleasant cave?' wrote Horace in the first century BC.[15] Two thousand years after Horace, the French writer Edmond de Goncourt observed: 'certain odours seem to have been composed to deepen the enchantment of amorous embraces'.[16] 'Without perfume, the skin is silent', declared a series of French perfume advertisements from the 1980s. 'One must smell a woman before having even seen her', announces the perfumer Marcel Rochas.[17] And it seems the potency of a rose's scent is more than merely associative: the pheromones released really do excite sexual attraction.

FIFTEEN

'Silronzem Rosea'

THE ROSE, TODAY AND TOMORROW

There are many websites for commercial rose nurseries or dedicated to the care of the rose. Some are managed by international and national rose societies, or by groups of specialized enthusiasts interested, for example, in classic heritage roses.[1] And the more one surfs, the more one finds. In fact, there are websites catering for all manner of rosy 'niches' in human consciousness. I discovered, for example, that the rose is successfully hybridizing in new imaginary worlds, like the one invented for James Cameron's sci-fi movie *Avatar* (2009), where there is a 'Healing Rose' identified within the taxonomy *Silronzem rosea*. The *Avatar Wiki* website informs us that this species is

> a gigantic plant found predominantly in wooded areas. It has a similar shape and size to the poisonous and deadly Pseudocenia Rosea, with the exception of the hook-like petal on the latter. Measuring nearly six meters tall, it produces nectar with various regeneration and healing powers, both spiritual and physical . . . Since its discovery, the healing flower has been used to create various soothing potions and cures. This particular plant plays a large role in the lives of the Tawkami. This clan of spiritual alchemists draws high-power wisdom from inside the Silronzem Rosea. They

climb inside the plant to practice a form of meditation that can last up to four full days.²

But the internet is 'history's largest sewer', as the historian and commentator Timothy Garton Ash put it, which means delightful pictures of roses, fascinating historical and practical information, and so on, must compete with all manner of trivia, misinformation, deception and perversion. But thankfully, roses are rarely if ever implicated in terrorist incitements, physical threats, cyber-stalking, harassment or phishing. Trolls, haters and extortionists tend not to think about roses. Sometimes, it's good to be a flower. Although, as we have seen, historically speaking, roses have sometimes been used to distract from many kinds of exploitation and abuse.

On the other hand, roses are certainly victims of the lies and disinformation that is rampant on the Web. Here is one tall story I came across. It was reported on more than one website that Eleanor Roosevelt said: 'I once had a rose named after me and I was very flattered. But I was not pleased to read the description in the catalogue: no good in a bed, but fine up against a wall.'³ Eleanor Roosevelt definitely did *not* say such a thing. But as I discovered in the course of researching this book, lies and disinformation, or at least misinterpretation and historically erroneous information, have dogged the rose from time immemorial. I have, no doubt, inadvertently added to the confusing corpus.

My special field is modern art, so I am particularly interested in how the rose is faring among contemporary artists. It doesn't take long to discover that things are definitely not what they once were for the rose in art. Religious and mythological themes are rarely deemed viable themes in contemporary culture, so all the roses associated with these subjects have gone. Still-life painting is considered far too bland. In fact, so much of the credibility of the rose as a symbol has been lost. In some intellectual quarters, the very concept of *beauty* has become

difficult to take seriously. It is tainted, especially when connected with cultural representations of woman. As Naomi Wolf wrote in *The Beauty Myth* (1991):

> 'Beauty' is a currency system like the gold standard. Like any economy it is determined by politics, and in the modern age in the West it is the last, best belief system that keeps male dominance intact. In assigning value to woman in a vertical hierarchy according to a culturally imposed physical standard it is an expression of power relations in which women must unnaturally compete for resources that men have appropriated for themselves, 'Beauty' is not universal or changeless, though the West pretends that all ideals of female beauty stem from one Platonic ideal woman.[4]

So, a rose hunt in London's Tate Modern, for example, will not garner many works containing roses. But this is not to say that contemporary art is wholly rose free. Perhaps the most significant recent paintings of roses are those made by the American artist Cy Twombly, who died in 2011. In a cycle called *Analysis of the Rose as Sentimental Despair* (1985), Twombly confronted head on the status of the 'Queen of Flowers' as an aesthetic and symbolic phenomenon with a rich but compromised history. Blurred and smeared pink and red rose-like forms are coupled with scrawled written pendants citing poetic references to the rose attached to the top horizontal of the canvases. Roses also featured prominently in a later cycle, a suite of massive paintings called simply *The Rose* (2008), which consist of huge red, yellow, orange, and purple rose-bloom shapes suspended on pale blue grounds. These also include scrawled quotations. In *The Rose V*, for example, Twombly quotes one of Rilke's French language rose poems. In yet another series of rose-themed paintings, Twombly quotes Eliot's lines from 'Little Gidding' about fire and roses. Rumi is cited, too.[5] Twombly effectively lassoes some of the most important rose poets into his painting in his quest to embrace all that the rose embodies as both a resonant cultural symbol of the transcendent and an example of natural beauty, acknowledging and even celebrating the impossibility of

finding a language – verbal or visual – that can adequately encompass the numinous beauty the rose evokes. While he places a good deal of the value on the rose as rich in cultural associations, as especially evoked through poetry, at the same time his dynamically gestural painting style is effective at suggesting that the rose is in constant metamorphosis, going through its life cycle.

The roses of the celebrated German artist Anselm Kiefer (b.1945) seem to consciously look back to the dark and chthonic blooms of nineteenth-century Symbolism. Some of Kiefer's works also contain *real* roses – desiccated ones attached to a work's surface. A series entitled *Let a Thousand Flowers Bloom*, which was inspired by the artist's trip to China, uses Mao Zedong's famous declaration of 1956: 'The policy of letting a hundred flowers bloom and a hundred schools of thought contend is designed to promote the flourishing of the arts and the progress of science.' As we have seen, roses were not a very resonant flowers in China before red ones became a communist symbol, and Mao didn't especially have roses in mind. An exhibition in 2015 by Kiefer was called *In the Storm of Roses*, and featured works in which stark and morbid-looking dry rose stalks and blooms jostle with other plants in darkened fields under brooding and stormy skies.

Real roses were also used by the British artist Anya Gallaccio (b.1963) in her exploration of ephemerality entitled *Red on Green* (2012), for which she amassed 10,000 fresh deep red roses, laying them out in a rectangle on the gallery floor; Conceptual Art's answer to Alma-Tadema's *Roses of Heliogabalus*. 'I like the mixture of celebration with death or decay,' Gallaccio noted. Real roses associated with death also feature in a work by the Colombian artist Doris Salcedo (b.1958), entitled *A Flor de Piel* (2014). Salcedo and her team stitched together hundreds of deep red rose petals, each of which had been chemically treated to preserve their dark hue and pliant texture, within a huge canopy which is intended to lie creased and pleated on the floor. *A flor de piel* is a Spanish idiomatic expression meaning 'on the surface of the skin', used to describe extreme emotions that are beyond words, and the work was inspired by a Colombian nurse who, after providing care

to injured parties on both sides of Colombia's protracted civil war, was kidnapped and tortured to death. Salcedo has found a powerful analogy for the eruption of pain onto the skin's surface, but also of the transfiguring of the suffering through the ethereal beauty of the rose petal cloak. By linking the blood-red rose petals to the human skin and to a contemporary context of political anarchy and systemic violence, Salcedo has also succeeded in instilling new and unsettling life into the age-old comparison that likens a woman's skin to a rose petal.

At the opposite aesthetic extreme are contemporary artists inspired by the Pop Art of the 1960s who do not try to quarantine their art from the encroachments of mass culture, and instead embrace the overtly kitsch value of roses and other flowers. Jeff Koons' (b.1955) *Large Vase of Flowers* (1991), for example, is a garish, larger-than-life-size work in polychromed wood of blousy roses matched with a host of other technicolour blooms.[6] Koons celebrates the smooth, commodified kind of beauty that is so pervasive in our culture. An easy-going populist vision of the rose also seems to inform the work of the American artist Will Ryman (b.1969), who sited giant roses along the length of ten blocks on Park Avenue in early 2011. Some of them were as tall as 25 feet. On a literally lighter note, roses featured in 2016 in a rooftop installation called *Light Rose Garden*, in Chengdu, China. This was a work produced by the Hong Kong-based creative agency AllRightsReserved, and was made up of 25,000 LED roses. Each evening, the work lit up at 6 pm for a period of time. The rose has gone electric, and has only a symbolic relationship with any real-life examples. The goal, the creators announced, was to celebrate love and romance.

The rose's continuing and lucrative association with the themes of love and romance is amply attested in today's popular and romance fiction. One website I visited lists 100 books with the word 'rose' in the title: *Roses and Rodeo, A Rose for Maggie, Moonlight and Roses, The Seduction of the Crimson Rose, Deadly Texan Rose, Of Swine and Roses, A Rose is*

a Rose, for example. Pop songs with the word 'rose' in the title currently exceed 100. A ranking website puts Linda Ronstadt's 'Love is A Rose' at No.1, 'La Vie en Rose' at No. 2, but not Edith Piaf's original, rather, a cover by Madeleine Peyroux, and at No. 3 is 'Kiss from a Rose' by Seal.[7] My personal favourite is ranked No. 4: Grace Jones' disco bosso nova version of 'La Vie en Rose', from 1977. In the video, Grace Jones has a pink rose tucked behind her left ear, and although she starts off singing quite demurely, wearing a coat adorned with a pink rose pattern, she inevitably removes this outer layer to reveal a gold mini dress. The rose behind the ear remains in place throughout. Her rendition is, in a sense, a throwback to the seedy origins of the original song, a bordello and nightclub in Paris called La Vie en Rose where Piaf performed in 1943.

The rose also remains an inspiring motif in contemporary haute couture fashion – D&G and Erdem use roses every season – and it may even be having something of a comeback.[8] Dries van Noten, the Belgian designer (and avid rose gardener), featured numerous rose designs in his catwalk fashion show from the autumn/winter 2019–2020 collection. In his garden in Antwerp, van Noten grows more than fifty varieties of roses, and used photographs of rose cuttings and other flowers to create a series of print designs for the collection, which also include signs of vegetal decay. 'The flowers couldn't be romantic,' van Noten declared. 'I didn't want to have sweet flowers. At the end of the season you have mildew, blackspots, so that within the flowers you have all the imperfections.'[9]

Roses are an especially interesting presence in cinema. In the Oscar-winning film *American Beauty* (1999) red roses are everywhere, and serve as an especially important symbol.[10] We see cut roses, rose bushes in immaculately kept suburban gardens, rose patterns on clothes, and most memorably, roses in fantasy sequences in which the lead character, played by Kevin Spacey, is lusting after the schoolfriend of his own daughter, and fantasizes rose petals cascading down on her naked and floating out as she opens her shirt.

But all these roses, the movie implies, are false. They are facile and banal symbols of beauty, desire and truth because they have become so

over-familiar and lacking in originality. The rose is an empty surrogate for beauty, whose function it is to mimic the real thing in ways that are wholly conformist and manageable. By being conditioned to identify with such a commonly recognized and commodified image, people are actually prevented from any possibility of experiencing *real* beauty, which is not fabricated or easy, and is available to everyone, free of charge. In the movie, the few individuals who have self-motivated and spontaneous experiences of beauty – with a plastic bag wafting in the air, for example (but never with roses) – are self-confessed 'freaks'. *American Beauty* reminds us that authentic symbols come from active, open and original engagements with the world, and always involve something new and spontaneously experienced. If everyone wasn't so conditioned by the sterile values of society they too would see that a plastic bag floating in the breeze, a bit of ugly garbage of no apparent worth, can be where beauty is found. In modern American society, and by implication, Western society as a whole, or so the movie suggests, genuine experiences, the movements of the heart with which beauty is associated, have become increasingly impossible. The suburban rose bush and the vases of cut roses are the real 'garbage', because they conceal the capacity to truly express from the heart.

In a more recent film, *Paradise Hills* (2019), roses are also abundantly present.[11] Here, they serve as a central prop within an environment that aims to reinforce, or as it turns out, enforce, feminine stereotypes. Roses bedeck the cloying décor of what at first seems to be a luxurious finishing school located on a lovely island, but is in fact a nasty reform school for troublesome young women. The rose is there as an obvious, clichéd symbol of the traditional feminine virtues – beauty, desirability, purity, perfection, obedience – virtues that are exposed in the film as insidiously imprisoning those who have been bold enough to resist embodying them and are now being secretly eliminated and replaced by more compliant clones. The school and the roses are far from inoffensively benign, and in one memorable scene, as the heroine makes her escape, a monstrous rose plant ends up literally devouring the evil headmistress. What *Paradise Hills* demonstrates

in melodramatic form is the extent to which the rose's association with a compromised vision of the 'feminine' renders it ripe for critique and parody in the age of MeToo.

Films like *American Beauty* and *Paradise Hills* graphically show that over time a culture's images of beauty lose their dynamic capacity to embody real joy and hope, and actually become obstacles to positive social change. The roses in *American Beauty* are 'ersatz roses' saving people the trouble of thinking too deeply or for too long, making expression of the emotional life simpler and reassuringly similar to everyone else's. The roses in *Paradise Hills* are proxies for patriarchal power, dubious surrogates to be used to lull women into conformity with the acceptable stereotypes.

Such questioning of the value of the traditional symbolic role of the rose in the arts is also taking place from the midst of a much wider paradigm shift involving our attitude and behaviour towards nature, which is being driven largely by the many signs of deepening ecological crisis. Humans make up a mere 1/10,000 of Earth's biomass, while plants constitute 80 per cent, and it is estimated that in the past 10,000 years human action has reduced Earth's biomass by half, which means the destruction rate of other living species is now tens to hundreds of times higher than the average over the past 10 million years. Our massive impact on the environment over the last 200 years is unique only in scale and rapidity. Already by about 14,000 years ago in Europe, there was what Tim Flannery calls a 'human-maintained ecosystem'.[12] But today the technologies designed to ensure humanity has enough to feed itself, and which have led to the wholesale industrialization of agriculture, are obviously having a major and often deleterious effect on the plants that are cultivated, and everything else on planet Earth.

The sad fate of many rose plants today is to be mass-produced agricultural commodities, and this manipulation is aimed at controlling and deforming their growth solely in order that profits are optimized

for their cultivators. But industrialized agriculture has also impacted on 'wild' species roses. Hedgerows have been removed to facilitate the creation of larger fields enclosed by wire fencing, and their loss affects the species roses that grew there. But the demands of advanced capitalist societies inevitably makes small-scale traditional husbandry impractical. 'The loss of the spinnery and hedgerow is a great blow to many Europeans, for it is the loss of a dreaming tied to the potent themes of childhood idylls and freedom', notes Tim Flannery. But he adds: 'if we wish to maintain them, someone must be willing to work the small fields and hedgerows of a Beatrix Potter world, with the skills and willingness to live as characters in a Thomas Hardy novel'.[13]

But today, as a result of our heightened awareness of ecological crisis, and as the prerequisite for the future survival of life on Earth, more and more of humanity in the 'developed' world is currently struggling to reimagine its relationship with the non-human world, fundamentally rethinking basic assumptions, and aiming for what the contemporary philosopher Michel Serres calls an attitude to nature characterized by 'admiring attention, reciprocity, contemplation, and respect'.[14]

As far as plants are concerned, a practical place to begin this transformation in consciousness is to recognize that many of the basic distinctions that separate flora from fauna are spurious and self-serving. For example, it may not look as if a rose can move, but in fact it is indeed in motion, only comparatively slowly. While we humans move through space like all animals, a rose, like all plants, occupies space to the maximum extent possible using a branching structure with tip growth, that propels it upwards in the competition for light. A rose's changes of state, growth and decay in time and space are relatively imperceptible, and not obvious and visible to us, but with the aid of time-lapse film, for example, which permits us to step outside the limits of our spatio-temporal tunnel, it becomes possible to see just how much movement is actually involved in being a plant. Then, as a consequence, we may start to bridge the profoundest gap between us and the plant, which is how we live in space and time. By speeding time up, we can also see that a rose has intentions and agency which are not

simply metaphorical, a recognition that is potentially subversive of much of what we think is true about the human compared to plants.

The biggest assumption that has traditionally permitted humanity to judge itself superior to plants, and also allowing it to have the ethically untroubled right to exploit plants, is their apparent absence of intelligence. In considering interactions between a human agent and a plant the traditional assumption, at least in the West, is that the former is in total control and has full permission to engage with the latter without any consideration for its well-being. In fact, we are likely to think of someone who believes a plant is a sentient being and can exert influence on us as being out of touch with reality or in thrall to a form of magical thinking in which the plant has been transformed into a fetish. But now biologists are showing that plants do indeed possess a form of 'intelligence', and not just in the poetic or figurative sense. They mean intelligence in a specifically Darwinian context, linked to the struggle for survival, which is more than simply reflex behaviour.

We now know that the rose, like all plants, has the capacity to store and access memories, and has a sophisticated communication network. Plants measure time, and possess a chemical signalling system which is effectively a wireless communication network enabling them, for example, to draw animals – including humans – into assisting them in functions that require mobility, such as the dispersal of seeds. Trees in a forest share information and aid other trees that are struggling due to insect infestation, water shortages and changes in soil quality. They can 'talk' via airborne chemicals, soluble compounds exchanged by roots and networks of fungi, and through ultrasonic sound – skills that have been dubbed the 'wood-wide web'. Trees also warn neighbours of herbivore attacks, alert each other to threatening pathogens and impending droughts, and can even recognize kin, continually adapting to the information they receive from plants growing nearby. Communication between plants of the same species and to other plants can induce a natural pest control mechanism. Roses can detect their neighbours by stimuli senses through their root exudates – the substances secreted in the rhizosphere, that is, the soil area around the roots of the rose – but they can also do it via their leaves.

But if we acknowledge that a rose is intelligent, then where is its brain? This question, as the pioneer of studies in plant intelligence, the botanist Anthony Trewavas, puts it, reflects our basic 'brain chauvinism', the tacit assumption that behaviour and intelligence need a nervous system.[15] We believe a plant cannot truly be called 'intelligent' because it lacks a clearly articulated nervous system and has no nerve cells like animals. But, like all plants, a rose is thinking without a brain. It is using electrical signals, and has millions of cells, each of which is capable of problem-solving. As a result, whereas humans must use specific organs for specific tasks, and will likely die if the brain malfunctions or there is the loss of the use of a vital organ, in a plant tasks are spread throughout its entire organism and it can sustain considerable damage without dying. But a narrowly zoo-centric (animal-centred) understanding of what a 'mind' is leads to the limiting of the possession of mind-like qualities in the animal world, making it difficult to credit anything that is not an animal as an agent, as an originator of intentions. This, in turn, allows us to ignore the implications of treating the plant world as anything more than exploitable resources.

In *The Revolutionary Genius of Plants* (2018), plant neurobiologist Stefano Mancuso argues there is a fundamental human–plant asymmetry woven into the fabric of human thinking that is blinding us to the potential for change because this thinking is grounded in a basic misperception of the character of animal-plant biological difference. This distinction takes the form of a structural contrast between the animal-centric principle of 'concentration' and the vegetal principle of 'diffusion'.[16] 'Concentration' is so basic to a human animal's survival that it long ago became the very essence of what it means to be 'human', serving as the underlying guiding concept around which human societies are built. For example, throughout history, human societies have been highly centralized and hierarchically structured because they mimic how an animal's body is assembled. 'Everything that man designs tends to have, in a more or less overt way, a similar structure', Mancuso writes: '[A] central brain that governs the organs that perform its commands.'[17] This principle is in radical contrast to the principle of

'diffusion', which describes the process through which plants survive and evolve without a centralized brain to control decision-making. If we can break free of such fundamental prejudices, Mancuso argues, it could be possible that plants, including perhaps the rose family, will provide solutions to the environmental challenges the ecosystem faces.

In 2015, Swedish researchers reported that they had 'rewired' a living rose plant by 'growing' fully functioning electronic circuits within it. The result is described as a plant cyborg, an 'e-plant' or 'electronic plant' that can change the hue of its leaves when an electrical current is passed through it.[18] Perhaps a rose cyborg is the inevitable next step in the story I have been telling of the human-rose relationship. But this news also reminds us that scientists often seem to remain systemically trapped within the wider problem which they, no doubt, hope their innovations will remedy. They still adhere to the fundamentally modern Western idea that nature is there as a passive resource to be manipulated and used. But Mancuso, for one, is optimistic. He believes we can overcome these systemic limitations and recognize that 'when it comes to robustness and innovation nothing competes with plants. Their way of functioning is a useful model, especially in an age when the ability to perceive change and find innovative solutions has become a requirement for success. We would do well to bear this in mind when planning for our future as a species.'[19]

We've known for some time that humanity has much to learn from plants. But the philosopher Michael Marder argues that we should be going further by striving to accommodate into our consciousness what he terms 'plant-thinking'. This involves the non-cognitive, non-ideational and non-imagistic intelligence of the vegetal. We can learn vital lessons from 'the living tending of plants toward their other, the tending expressed in growth, the acquisition of nutrients, and procreation, [which] amounts to the non-conscious intentionality of vegetal life, the cornerstone of its "sagacity"'.[20] Plants can, indeed, help us nurture love rather than hate, and sharing instead of hoarding and dominating.[21]

Such profound changes in how we see plants mean we are now obliged to recognize that the roses growing in our gardens are actively solving major problems coming from many directions, profiting in relation to specific goals and objectives, and adapting to different objectives and environments by interacting with their environment in ways that use learning, memory and communication. We should also recognize that we are joined to them in a co-evolutionary process in which roses *and* humans gain mutual benefits, and that we participate in their life cycle in ways the rose has invited. Roses need bees for pollination, but they have been actively attracting our attention too because we aid their survival.

Roses have indeed been massively profiting from contact with us. Since the development of agriculture, many species roses have gained advantages from our need for hedgerows dividing cultivated fields, and especially thorny hedgerows to keep out animals. Would the Dog Rose that is growing up the wall of the cathedral in Hildesheim, which I mentioned at the beginning of this book, have survived this long without human assistance, an assistance which we can argue it also invited? As I noted, a sport, which involves, say, a species rose mutating dozens of petals instead of the usual five, is often eliminated by natural forces because too many petals waste limited growth potential, making the plant less hardy. But because of their perceived beauty, some of these vulnerable mutations have been carefully protected and propagated by human hands, thereby ensuring their survival.

In the mindset we inherit from the past, roses are thought to be totally available for remaking as we see fit, and without any moral qualms. They can be manipulated to suit our needs, bred into a more rational, better, improved, more marketable form. But can we still blithely justify the lucrative business of breeding countless roses in industrialized conditions that are a direct threat to the ecosystem, simply because we are educated by our culture to see them as symbolically freighted, aesthetically pleasing and useful gifts? What if we instead entertain the unsettling thought – 'unsettling' to our conventional anthropocentric minds – that rather than simply being used by us, a rose is an autonomous, intelligent organic entity that has been manipulating *us* in order to

improve its evolutionary chances? And this manipulation is also manifestly present on an intellectual level, within a cultural legacy strewn with vast numbers of symbolic roses composed of words and images. However, we might also reflect on the fact that when considered on the level of the meme, in relation to cultural information, the rose's ubiquity as a symbol has less to do with any intrinsic value to humanity than with the goal of the meme's replication.

Seen in relation to these various cultural changes, the New Perennialism movement in gardening, for example, belongs to a general 'rewilding' or 'naturalizing' impulse, in which the liberation of vegetation from the human compulsion to select, limit, shape and generally impose mastery is replaced by the idea of nature as something permitted to grow, unfold and develop freely. 'Domesticated' is a dirty word among progressives, as it implies enslavement. To this 'negative' they oppose the 'positive' of 'wildness', which signifies freedom. The New Perennialist gardener is more interested in mood, atmosphere and dreaming, which are mental not sensory states. The focus on colour in a garden, which is likely to foreground roses and is directed towards aesthetic gratification, cedes to a more emotional experience.[22]

But there are other dimensions to this implicit critique of the rose to consider. The rose, as we have seen, is a pre-eminently people plant. Its vegetal being is inextricably interwoven with us – with the traces of our history and culture. We have seen how this is the case not only in relation to the rose's use as a cultural sign but also how, botanically speaking, the garden rose is the product of artificial selection, of concerted human intervention. As such, the rose is as much a product of culture as it is of nature. This means our relationship with the rose is also a relationship with our past, and as this past is no longer judged with rose-tinted anthropocentric sunglasses, the rose finds itself once again growing on the wrong side of the ideological fence. It is now sullied by an intimate association with a human history too often characterized by prejudice, violence and oppression. In this context, 'wildscaping' can be seen as aiming to depose a concept of the garden based on a proprietary vigilance in which the rose is an exemplary form of

chattel. So, in this sense, the New Perennialism reflects a more general turn within contemporary culture which is motivated by a desire to exit from the nightmare of history. Through rejecting plants like the rose that resonate deeply with a compromised history, the New Perennialists are deliberately abandoning a sense of continuity with the past, and seeing this state as an emancipation.

But while this celebration of rewilding is ultimately an offshoot of the important and potentially transformational resurgence of a Romantic, pantheistic ecology, it risks losing sight of the fact that plant and human interests are obviously distinct. In aiming to replicate a floral world untouched by humanity, and to deprive the garden of its cultural-historical depth and density, Oudolf and his followers perhaps only shift the territory on which the old human sense of supremacy operated. Referring to a 'natural' or 'wild garden' is only a different way of exerting the controlling role which defines the human world in opposition to something called 'nature'. The environment is only natural or wild *for us*. In other words, we must still *plant* the perennials beloved of the New Perennialists. They won't grow for our delectation in these places without human custodianship. As Michael Marder notes of the general tendency to embrace rewilding, we should be wary of assuming that all it takes to jump free of the history of human oppression is to replace formal rose gardens by drifts of perennials or miniature forests: 'For one, it guards an illusion that we are powerful enough, in our conscious rejection of mastery and dominance, to bring back the past of wilderness and to erase a long history of human-plant interactions that have profoundly influenced the two parties to the relation. For another, it preserves a form that has been sundered from matter, just in a softer, more porous and malleable version.'[23]

At least for some, the rose is judged to be too closely associated not only with an outmoded concept of the garden and a compromised version of humanity's relationship to nature but also, more deeply, with the whole human past. In this sweeping critique, the conventional notion of the gardener's guardianship is recast as a form of caring that

is only judged in relation to perverted human interests. But, surely, we shouldn't be too quick to abandon the models presented by historical gardens, private and public, which have a vital conservatory role, and should remain a source of continuous inspiration and a point of reference to future garden designers.

Meanwhile, of course, the cut rose business is buoyant and increasingly global in scale. My informal survey of people's gardens in England, France and South Korea suggests that roses are in no immediate danger of being uprooted. However, the statistics are still somewhat worrying for rose-lovers, and those in the rose business. In 2002 the rose market in the United States had a total sale value of more than US $58.8 million. Since then, the value has slumped by more than half, and in 2018 was only slightly over $19 million, although this was a little up on the five preceding years.[24]

It seems certain that at least in the near future, and barring immediate catastrophe, people will still go on loving roses. Formal peace rose gardens continue to proliferate, for example. There is even an organization called International World Peace Rose Gardens, based in the United States. It has initiated projects at the Lake-Shrine-Gandhi World Peace Rose Garden in Pacific Palisades, California, located within the Self-Realization Fellowship Lake Shrine, the Basilica of Our Lady of Guadalupe World Peace Rose Garden, and the Basilica of St Francis of Assisi World Peace Rose Garden.[25] The organization's website says: 'International World Peace Rose Gardens (IWPRG) is a catalyst for peace in diverse communities around the world. The nonprofit organization was incorporated in 1988 for the purpose of creating beautiful rose gardens for peace on public, accessible sites. The gardens become magnetic centers where people gather, enjoy beauty and are inspired to be better persons and world citizens.'[26]

This bold statement led me to wonder whether the rose has actually made human beings, or some of them, 'better persons and world

citizens'. In his Introduction to *The Gulistan* (The Rose Garden), the Sufi Sa'di certainly seemed in no doubt about the benign influence exerted by the rose's close presence on himself: 'I was a worthless piece of clay; but for awhile associated with the rose', he wrote. 'Thence I partook of the sweetness of my companion; otherwise I am that vile piece of earth I seem.' And in his poem 'The Bowl of Roses', Rainer Maria Rilke also suggests there is profound benefit to be accrued from intimacy with roses: 'You've witnessed anger flaring; seen two boys / who've balled their bodies up, becoming something / that was hatred / . . . But now you know how that may be forgotten: / before you stands a bowl that's filled with roses.'[27]

Roses look certain to remain a feature of gardens and parks worldwide. The rose as a symbol and metaphor clearly remains a stalwart of romantic fiction and pop music, and is also a reliably convivial subject for the 'Sunday painter' and for popular and decorative art. But more challenging writers, musicians and artists will surely also continue to breathe new life into what is, indeed, so often a tired old cliché.

CONCLUSION

'Flower Power'

I have a particularly strong memory of a visit made one warm June morning to Queen Mary's Garden in Regent's Park.[1] The garden is the largest collection of roses in London, and the massed flower beds offered my weary eyes a pleasingly stimulating, concentric, multi-coloured pattern in three dimensions, while in some areas the scent of the blooms seemed to hang in the air like a perfumed canopy. It was enchanting. But now, some years later, I realize I wasn't just experiencing the garden through my senses. I was also subliminally taking it in through my sensibility. And that means I wasn't alone. Others were standing in the garden beside me. All the mythological and religious personages, mystics, artists, poets, explorers, breeders and gardeners encountered in this book were there too. The Victorian apostle of the rose Dean S. Reynolds Hole was beckoning: 'Enter, then, the rose garden when the first sunshine sparkles in the dew, and enjoy with thankful happiness one of the loveliest scenes on earth.'[2]

As metaphor and symbol, a powerful meme, and as a much-loved garden plant, the rose has often amounted to an image of a hopeful future. It promises happiness. Such images of hope are part of a shared

ancestral language which is loaded with meaning that is difficult or impossible to formalize but helps us cope with conflict and trauma.

But the pleasure and feeling of connectedness I experience as I think about that day in Queen Mary's Rose Garden are also coloured by an awareness of the troubling realities described in the last chapter. All the 'companions' from the past gathered around me bring with them beliefs and attitudes which we of the present increasingly see as prejudices that must be challenged and corrected. For example, a history that is full of religious and secular piety tells an unsettling story of how the beauty of the rose is understood to 'ensnare' us directly in the carnal world and so must be purified, idealized. While the rose continues to be employed to celebrate feminine beauty, we can now not so easily ignore the fact that there is a stark asymmetry in routinely comparing women to pretty ornamental plants and men to animals like the lion, bear or wolf. We recognize that Valentine's Day may conventionally represent a festival celebrating love for someone special, but that it is also a debased and commercialized ritual. The rose has been dramatically transformed by its adoption into consumer culture: 'Say it with flowers'. This catchy slogan, the brainwave of an American adman at the beginning of the twentieth century, looks backwards towards the nineteenth-century's 'language of flowers' but also forwards to a society increasingly mass-producing modes of pleasure and stimulation, and working to separate 'head' from 'heart' to better exploit the latter. Money has been successfully infiltrated deep into our emotional lives, transforming heartfelt moments into bankable trickery. The rose has not only been packaged, commodified and trivialized, it has been exploited in illegal and cruel money-making rackets.[3] Its mass production within an economy that is dependent on industrialized agriculture is contributing directly to global warming. Even the idea of a rose garden can be criticized as embodying values that are no longer ethically sound.

'The rose is obsolete,' as William Carlos Williams put it one hundred years ago. But many of the traditional images embodying hope and happiness have been similarly compromised. Today, most positive

visions of the not so distant future are drawn from the domain of science and technology rather than nature. I began the last chapter by referring to the internet, and over the past thirty years it has been above all the digital realm that has offered the most appealing and socially replicable futuristic images of optimism. At the click of the mouse I can create a digital blue rose, instantly overcoming the refusal of the botanical world to oblige. Today, people are increasingly isolated from the sights and rhythms of the natural world. Even the nostalgic and reassuring emotional triggers that can occur later in life in relation to the smells that suffuse childhood are shifting from odours derived from natural sources to ones emanating from human-made environments. Today's society seems to envisage the promise of happiness as lying within a virtual reality rather than an organic one, and the collective transfer of images of the future from nature to culture represents a profound shift in the sources of our conviction. These nurture the consoling, but surely deluded, fantasy that humanity can survive without the burden of belonging to a world shared with the animals, vegetables and minerals.

But consider the term 'Flower Power'. It is suffused with the sweet aura of the hippy Age of Aquarius, and in a way is the counterculture's foil to the adman's cynical 'Say it with flowers'. One of the iconic images of the period is a photograph of Jane Rose Kasmir, aged seventeen, holding up a chrysanthemum as she confronts a phalanx of National Guardsmen's bayonets during a protest against the Vietnam War in Washington in 1967. 'Flower power' is 'soft' power, the power of what is traditionally called 'femininity', of love and the heart rather than the historically dominant 'male' values associate with the power of the head that coerces and directs, and uses the hand to punish rather than caress. From the perspective of our disenchanted times, the aspirations of the counterculture probably seem far-fetched, and to some extent we are right to see the hippies as naive. The world they and the political radicals dreamed of making real is very far from the one we live in now. It is easy to be cynical about flower power. But nevertheless, I like to think that this book has been a history of the awesome cultural 'power' of one particular flower.

The rose has given arrestingly tangible form to our most important and tender emotions and experiences. It has helped us to communicate the ineffable, all that cannot be observed with the naked eye, or comprehended with the head through rational analysis.

In a poem published in 2005 entitled 'Walking Past a Rose This June Morning', the contemporary British poet Alice Oswald meditates on an encounter with a rose that launches many profound associations. The poem takes the form of a series of unanswerable questions, and evoking W. B. Yeats' vision of a rose within the human heart, Oswald considers the deep sense of absolute otherness she feels in the rose's *unspeakable*, ineffable presence. Clearly her encounter does not call forth the tame emotions associated with an appreciation of the rose's domesticated beauty. On the contrary, this rose seems to have the capacity to put the poet in a fluid, intimately entangled and inevitably vulnerable relationship to the world. During an interview, Oswald (who used to be a professional gardener) explained that her poem came 'from the way I always feel when I meet a rose: it's a point of metaphor, and it's so unbelievable that it throws you into a sort of metaphorical and remembered world'. And then, in what could be a fitting coda to *By Any Other Name*, she added: 'I'm wary of roses because they are used so much as symbols, and yet the actual rose still remains. It's somehow a hinge between the spiritual and the tangible world.'[4]

In late April 2020, while I was writing *By Any Other Name*, a local municipal authority in Japan announced that it would be snipping off thousands of rosebuds in a public park in an attempt to stop people congregating to admire the flowers when they bloomed in early May, thereby discouraging the spread of Covid-19.[5] Thoughts of a team of Japanese gardeners frantically decapitating rosebuds brought to mind Morticia (played by Angelica Huston) in the movie *The Addams Family* (1991), snipping off the blood-red blooms of a climbing rose with

ghoulish and gleeful diligence. It also made me think of the English stationmaster and amateur rose breeder in the film *Mrs Miniver* (1942) who, when faced with the wrath of the Luftwaffe, defiantly declares: 'There will always be roses.'[6] While the safety measures in Japan were newsworthy because of their extreme and perverse nature, writing about the 'Queen of Flowers' hasn't been easy while the world as we know it convulses in collective trauma, pain and uncertainty. Presumably, if you are reading this, our society hasn't yet expired. And, hopefully, roses will be there in gardens and our imaginations for our children, and their children, and their children's children. Roses will be there to simply enjoy, but also to potentially be, as Robert Hunter of Grateful Dead put it, an 'allegory for, dare I say it, life'.

Notes

PREFACE

1 Larkin, P., 'This Be the Verse', *High Windows* (London: Faber and Faber, 1974), 30.
2 Keats, J., 'To a Friend who sent me some Roses' [1816], in P. Wright, ed., *The Works of John Keats: With an Introduction and Bibliography* (Ware, Hertsfordshire: Wordsworth Poetry Library, 1994), 40.
3 Quoted in J. Harkness, *Roses* (London: J. M. Dent & Sons, 1978), 27. There is also a National Rose Garden in Washington D.C.
4 The Grateful Dead's lyrics often include references to the rose, most famously in the song 'It Must Have Been the Roses'. One of the Dead's albums is called *American Beauty*, and features cover art of the eponymous red rose (of which, more later on). Their 1991 compilation live album is called *Infrared Roses*. There's a Grateful Dead poster of a blue rose (which you can buy online). The album cover I mentioned featuring the roses and skull was going to be called 'Skull Fuck', but for obvious reasons the band's record company vetoed the title, so the album went title-less. 'Skull fucking', by the way, was hippy slang for 'blowing your mind'. But as Bob Dylan sang in the early 1960s, 'The times they are a-changin'', and the online Urban Dictionary informs me that nowadays 'skull fuck' means, 'the act of grabbing a partner's skull and putting your dick in their mouth, grabbing their skull and holding it still, therefore having sex with their skull', www.urbandictionary.com/define.php?term=skull%20fuck (accessed 02.03.21).
5 Quoted in D. Robb, 'The Rose: A thematic essay for the Annotated Grateful Dead Lyrics', http://artsites.ucsc.edu/GDead/AGDL/rose.html (accessed 02.03.21).

INTRODUCTION

1 Shakespeare, W., *Romeo and Juliet*, Act II, Scene II. The title of my book, *By Any Other Name*, is shared with the newsletter of the World Federation of Rose Societies, a rich source of information about rose conservation and heritage on a truly international scale: www.worldrose.org/conservation-and-heritage.html (accessed 24.05.21).

2 When Brooke writes 'blows' he is using archaic poetic phrasing to describe the *blooming* of a rose, as when Tennyson, for example, writes 'And the musk of the rose is blown.' A residue of this meaning remains in common speech with the term 'full-blown'.

3 It is also worth noting that the Socialist International had adopted the red rose as its emblem. In fact, however, it seems the story about the strike is a legend, as no such signs with this slogan are in evidence in any of the photographs of the strike, or recorded in eyewitness accounts. See: *The American Magazine*, 1911, 619. Cited in R. J. S. Ross, 'Bread and Roses: Women Workers and the Struggle for Dignity and Respect', *WorkingUSA*, Vol. 16, No. 1 (March 2013), 59–68, www.researchgate.net/publication/264493015_Bread_and_Roses_Women_Workers_and_the_Struggle_for_Dignity_and_Respect (accessed 02.03.21).

4 Jünger, E., *Storm of Steel*, trans. M. Hofmann (London and New York: Penguin, 2016), 1.

5 Goody, J., *The Culture of Flowers* (Cambridge and London: Cambridge University Press, 1993).

6 In a song in his novel *Les Miserables* (1862), Victor Hugo writes: '*Les bleuets sont bleus, les roses sont roses, / Les bleuets sont bleus, j'aime mes amours*', which translates as: 'Violets are blue, roses are pink, / Violets are blue, I love my loves.' Hugo's contemporary, the poet Charles Baudelaire, also profits from the colour–plant correlation when responding in verse to a painting by Edouard Manet of the raunchy dancer Lola of Valence. He describes her as '*un bijou rose et noir*' – 'a pink and black jewel' – which evokes the erotic allure of the dancer, the actual dominant colours of the painting itself, a jewel, and a flower (the latter of which can be seen in the pattern on the shirt of Lola in Manet's painting). But Baudelaire also plays on the fact that the rose flower is a well-established metaphor for the female genitals; Lola's are composed of pink flesh and black pubic hair; also, the slang of the time for a prostitute was '*une rose*'.

7 Price, M. W., 'Wild Roses and Native Americans,' in F. Hutton, ed., *Rose Law: Essays in Cultural History and Semiotics* (Frankfurt am Main: Uncut/Voices Press, 2012), 25–44; 30–31.

8 de Saint-Exupéry, A., *The Little Prince* [1943], trans. I. Testot-Ferry (Ware, Hertsfordshire: Wordsworth Classics, 2018), 82.

9 Eco, U., *The Name of the Rose*, trans. W. Weaver (London: Harvest Books, 1980), Postscript, 3.

10 Sappho, 'Song of the Rose: Attributed to Sappho', trans. E. B. Browning, in *A Selection from the Poetry of Elizabeth Barrett Browning* (Leipzig, Germany: Tauchnitz, 1872), 195. The consensus now is that this eulogy to the rose is definitely not by Sappho, but by Achilles Tatius, writing in the second century AD. It was very indirectly from him that Browning made her version. See: Håkan Kjellin, 'The Myth of Sappho and the Queen of Flowers', *By Any Other*

Name: Newsletter of the World Federation of Rose Societies, No. 20 (September 2019), 2–3, www.worldrose.org/assets/wfrs-heritage-no-20-september-2019.pdf (accessed 24.05.21).

11 In 1911, the very first poem by the Scottish poet Robert Burns to be translated into Chinese was his famous 'A Red, Red Rose' (see Chapter 5). In an essay that surveyed the numerous translations into Chinese made of Burns' poem since that date, the literary historian Li Zheng-shuan observes that it

> appeals to all people whatever their nationality is. The rose is no longer merely a plant. It has become a symbol of love, an embodiment of feeling and an outlet of passion. Nobody but a genius could transform an ordinary flower among many more beautiful flowers into such a wonderful expression of human sentiment. The Chinese people, like people worldwide, appreciated this poem so fully that generation after generation of scholars have tried to present it to more people with more beauty and passion.

But, as we will see, while the rose was certainly celebrated as a symbol of beauty in China, and also, by association, was used as a metaphor for the beauty and love of woman, it is striking that it never achieved the same kudos commanded in the land from which Burns came. In China it was the peony that most obviously held a similar position to the rose. So, while Burns' poem may indeed have been appreciated in part because of the 'universality of thought and feeling' it expressed, Chinese interest in Burns' eulogy to love through the metaphor of the rose was also specifically informed by a desire among the educated Chinese elite to assimilate and emulate the values of Western culture, which were construed as representing social, economic and political 'progress', and which also involved a willingness to engage with the symbolism of Western culture, of which, in this case, the rose is representative. In this sense, the rose and its symbolic associations cannot be separated from wider issues of cultural imperialism, assimilation and emulation. See: Li, Z., 'A Survey of Translation of Robert Burns' "A Red, Red Rose" in China', *Journal of Literature and Art Studies*, Vol. 6, No. 4 (April 2016), 325–339, https://pdfs.semanticscholar.org/8763/c54ba2cb1d3f3973f40a01f17a920a419b9a.pdf (accessed 02.03.21).

12 Dawkins, R., *The Selfish Gene* (Oxford: Oxford University Press, 1976). See also: Blackmore, S., *The Meme Machine* (Oxford: Oxford University Press, new edition, 2000).

13 Harkness, J., *Roses*, 48.

CHAPTER ONE: MEETING THE FAMILY

1 Krüssmann, G., *Roses* (London: B. T. Batsford Ltd., 1982), 6–11.
2 I'm following here Peter Beales' taxonomy in *Classic Roses: An Illustrated*

Encyclopedia and Grower's Manual of Old Roses, Shrub Roses and Climbers* (London: Harvill Secker, 1985), 125–413.
3 Beales, P., *Classic Roses*, 125–413.
4 These are Peter Harkness's figures, *The Rose: A Colourful Heritage* (London: Scriptum Editions, 2003), 37.
5 This is the New York Botanical Garden's figure, for example.
6 Pollan, M., *The Botany of Desire* (New York: Random House, 2002), 109.

CHAPTER TWO: LIVING WITH THE SPECIES AND THE 'SPORTS'

1 Krüssmann, G., *Roses*, 33.
2 Pliny, *Natural History*, Book 21, Chapter 10. Cited in G. Krüssmann, *Roses*, 34–35.
3 Krüssmann, G., *Roses*, 74.
4 See, for example: Rollin, R., '*De Rosariis Paesti*: Roses of Paestum, Remontant or Not', *Rosegathering*, www.rosegathering.com/debiferi.html (accessed 02.03.21).
5 Mattock, R., 'The Silk Road Hybrids: Cultural linkage facilitated the transmigration of the remontant gene in Rosa x damascena, the Damask rose, in circa 3500 BCE from the river Amu Darya watershed in Central Asia, the river Oxus valley of the Classics, to Rome by 300 BCE', unpublished PhD dissertation, University of Bath, 2017, https://researchportal.bath.ac.uk/en/studentTheses/the-silk-road-hybrids (accessed 02.03.21). See also: De Carolis, E., Lagi. A., Di Pasquale, G., D'Auria, A. and Avvisati, C., *The Ancient Rose of Pompeii* (Rome: L'Erma di Breitschneider, 2017).
6 Bunyard, E. A., *Old Garden Roses* (London: Country Life Ltd, 1936), 95.
7 Gerard, J., *Leaves from Gerard's Herball: Arranged for Garden Lovers* [1931], ed. M. Woodward (Dover Publications Inc., 1969), 97–98.
8 Bunyard, E. A., *Old Garden Roses*, 96.
9 As I found out when I visited Provins, a town southeast of Paris, the legend is alive and well, as is the local rose industry, although much diminished.
10 Rivers, T., *The Rose Amateur's Guide* (London: Longman, Orme, Brown, Green, and Longmans, 1837), 1.
11 Rivers, T., *The Rose Amateur's Guide*, 101.
12 Shakespeare, W., *A Midsummer Night's Dream*, Act II, Scene I.
13 Krüssmann, G., *Roses*, 95.
14 Thomas, G. S., *Climbing Roses Old and New* (London: Weidenfeld & Nicolson, 1983).

 Two hundred years after Shakespeare, John Keats wrote in 'To a Friend who sent me some roses' (1817), from which I quoted in the Preface:

 > I saw the sweetest flower wild nature yields,
 > A fresh-blown musk-rose; 'twas the first that threw

> Its sweets upon the summer: graceful it grew
> As is the wand that Queen Titania wields.

But it seems we should also doubt John Keats' botanical acumen, as he writes that the Musk rose was '*the first* that threw / Its sweets upon the summer', which also cannot be the case, unless Keats means the Musk rose was the first 'sweets' that he himself happened to smell. More likely, he was deferring to the Shakespearian precedent.

15 Rivers, T., *The Rose Amateur's Guide*, 97.
16 Rivers, T., *The Rose Amateur's Guide*, 97.
17 Gerard, J., *Leaves from Gerard's Herball*, 97.
18 Gerard, J., *Leaves from Gerard's Herball*, 102.
19 Gerard, J., *Leaves from Gerard's Herball*, 99.
20 Jekyll, G. and Mawley, E., *Roses for English Gardens* (London: Country Life and George Newnes Ltd, 1902), 13.
21 Jekyll, G. and Mawley, E., *Roses for English Gardens*, 12.
22 Jekyll, G. and Mawley, E., *Roses for English Gardens*, 12.
23 Jekyll, G. and Mawley, E., *Roses for English Gardens*, 6.
24 A few years ago in Korea, I uprooted a specimen of *Rosa multiflora* from a nearby hillside, where it was growing bordering a road, and planted it in our garden. In Korea, this rose is commonly called *Jjillekkot*, Mountain Rose, and there is a popular song by Jang Sa-Ik about it. Here is a translation of the first verse: 'White flower, Mountain Rose, / Simple flower, Mountain Rose. / Sad like a star, Mountain Rose, / Doleful like the moon, Mountain Rose.' Since hearing this song, I can but see the Multiflora in our garden as sad, an impression that the sparseness, thinness and the arching trajectory of the canes tends to encourage. We made the mistake of pruning it back a couple of years ago, and it protested by barely blossoming last year. This year, however, as I write these lines (mid-May 2020), it put on a very multifloriferous show.
25 Thomas, G. S., *The Complete Flower Paintings and Drawings of Graham Stuart Thomas* (London and New York: Thames and Hudson, 1987), 144.
26 Beales, P., *Classic Roses*, 37.
27 'Tombstone's Shady Lady', *CBS News*, 2 July 2017, www.cbsnews.com/news/tombstones-shady-lady (accessed 02.03.21).
28 McCann, S., *The Rose: An Encyclopaedia of North American Roses, Rosarians, and Rose Lore* (Mechanicsburg, PA: Stackpole Books, 1993), 49–50.
29 It is historical fact that between 1405 and 1433, during the Ming dynasty, Admiral Zheng sailed seven technically advanced armadas of ships from China (one armada consisted of almost 300 ships), which visited regions far from the Chinese mainland, such as East Africa and the Red Sea. If they did make landfall in America – of which, unlike in relation to Africa and Arabia,

there is no existing documentary evidence – perhaps they brought rose seeds with them to plant as a floral memento of their visit for future generations to enjoy. Menzies' theory, while a wonderful example of non-orthodox history, lacks hard evidence to support it. See: Menzies, G., *1421: The Year China Discovered the World* (London: Bantam Press, 2002).

CHAPTER THREE: PAGAN ROSES

1 Baring, A. and Cashford, J., *The Myth of the Goddess: Evolution of an Image*, (New York: Viking, 1991), Chapter 9.
2 Scott, K. and Arscott, C., 'Introducing Venus', in K. Scott and C. Arscott, eds., *Manifestations of Venus: Art and Sexuality* (Manchester: Manchester University Press, 2000), 18.
3 Virgil, *Aeneid*, 8, quoted in M. Hall, *Plants as Persons: A Philosophical Botany* (Albany, New York: SUNY Press, 2011), 123.
4 Anacreon, *Ode XXXVIII*, *The Odes of Anacreon*, trans. T. Moore (London: John Camden Hotten, 1803), 193–197.
5 Homer, *The Iliad*, 23, trans. S. Butler (Pacific Publishing Studios, 2010), 338, www.literaturepage.com/read/theiliad-338.html (accessed 02.03.21).
6 Anacreon, *Ode V*, *The Odes of Anacreon*, 41.
7 Plato, 'Symposium', in E. Hamilton and H. Cairns, eds., *Plato: The Collected Dialogues*, (Princeton, New Jersey: Princeton University Press, 1963), 180.
8 Monaghan, P., *The Book of Goddesses & Heroines* (Chicago: Llewellyn Publications, 1981), 29.
9 Apuleius, *The Golden Ass*, trans. S. Ruden (New Haven, Connecticut: Yale University Press, 2013).
10 Neumann, E., *The Great Mother: An Analysis of the Archetype* (Princeton, New Jersey: Princeton University Press, second edition, 1963), 7.

CHAPTER FOUR: MONOTHEISTIC ROSES

1 Schauffler, R. H., *Romantic Germany* [1909], Chapter IV, 'Hildesheim and Fairyland', reprinted online by Lexikus, www.lexikus.de/bibliothek/Romantic-Germany/VI-Hildesheim-and-Fairyland (accessed 02.03.21).
2 Genesis 1.28. Authorized Version.
3 Herbert, G., 'The Rose', *The Temple* [1633], *The Poems of George Herbert* (Oxford: Oxford University Press, 1907), 184.
4 St Basil the Great, 'Fifth Homily', *The Haexemeron, Fish Eaters*, www.fisheaters.com/hexaemeron5.html (accessed 02.03.21).
5 Fisher, C., 'Plants and Flowers. The Living Iconography', in C. Hourihane, ed., *The Routledge Companion to Medieval Iconography* (London and New York: Routledge, 2017), 453–465.

6 Fuller Maitland, J. A. and Rockstro, W. S., *English Carols of the Fifteenth Century, from a MS. Roll in the Library of Trinity College, Cambridge* (London: The Leadenhall Press, E. C., ca. 1891), Carol No. XIII, 26–27, 54–55.
7 Quoted in M. R. Katz and R. A. Orsi, eds., *Divine Mirrors: The Virgin Mary in the Visual Arts*, exhibition catalogue, Davis Museum and Cultural Center (Oxford: Oxford University Press, 2001), frontispiece.
8 Pelikan, J., *Mary Through the Centuries: Her Place in the History of Culture* (New Haven, Connecticut, and London: Yale University Press, 1996), 7–21.
9 This is also the title of Marina Warner's classic study, *Alone of All Her Sex: The Myth and the Cult of the Virgin Mary* (London: Picador, 1976).
10 Pelikan, J., *Mary Through the Centuries*, 120.
11 Quoted in J. Pelikan, *Mary Through the Centuries*, 118.
12 Quoted in E. Wilkins, *The Rose-Garden Game: The Symbolic Background to the European Prayer Beads* (London: Victor Gollancz Ltd, 1969), 113.
13 Newman, J. H., 'Rosa Mystica', in *Meditations and Devotions* [1893], reprinted in *John Henry Newman On the Blessed Virgin Mary* (Fordham University, 2019), https://sourcebooks.fordham.edu/mod/newman-mary.asp (accessed 02.03.21).
14 www.ewtn.com/catholicism/devotions/litany-of-loreto-246 (accessed 02.03.21).
15 Dante Alighieri, *The Divine Comedy*, trans. A. Mandelbaum, 'Paradiso', Canto 30, lines 103–108 and 124–129, https://digitaldante.columbia.edu/dante/divine-comedy/paradiso/paradiso-30/ (accessed 02.03.21).
16 Wilkins, E., *The Rose-Garden Game*, 233.
17 Nevertheless, Martin Luther used a rose in his emblem, a reflection of the importance of the convention of the emblematic rose in heraldry. It became known as the 'Luther Rose', and comprises a black cross centred on a red heart in the middle of a five-petalled white rose on a sky-blue ground surrounded by a gold ring. The heart and cross are Christ, while the white rose symbolizes the heavenly spirits and angels, and the blue is heaven itself.
18 India has a number of wild roses that were there before the Mughals arrived in the sixteenth century, some of which had somehow migrated from China, perhaps via the Silk Road. In particular, the Mughals imported the Autumn Damask and the Musk Rose, the former being used to develop a thriving rose oil business (see Chapter 14 for more on rose oil).
19 Rumi, *Mathnawi* IV: 1020–1024 and *Divan-e Sham-e Tabrizi*, Quatrain 673, in *The Rumi Daybook: 365 Poems and Teachings*, selected and trans. K. Helminski and C. Helminski (Boston: Shambhala Publications, 2012), 238, 163.
20 Gruber, C., 'The Rose of the Prophet: Floral Metaphors in Late Ottoman Devotional Art', in D. J. Roxburgh, ed., *Envisioning Islamic Art and Architecture* (Leiden: E. J. Brill, 2014), 224.

21 Hafiz, *Poems from the Divan of Hafiz*, trans. G. L. Bell (London: William Heinemann, 1897), VIII, 75, https://archive.org/stream/poemsfromdivanof-00hafiiala/poemsfromdivanof00hafiiala_djvu.txt (accessed 02.03.21). For the nightingale and rose motif in Persian literature and art, see: Schimmel, A., *A Two-Colored Brocade: The Imagery of Persian Poetry* (Chapel Hill: University of North Carolina Press, 1992), 178.

22 Hafiz, *Poems from the Divan of Hafiz*, XXIX, 102, https://archive.org/stream/poemsfromdivanof00hafiiala/poemsfromdivanof00hafiiala_djvu.txt (accessed 02.03.21).

23 Hernán Cortéz invaded Mexico with a tiny army in 1511 and by 1521 had totally defeated the Aztec Empire and claimed Mexico for Spain.

24 Near the place where Juan Diego had his vision, there used to be a temple to the mother goddess. The elevation of the Virgin Mary to a significant position of veneration, one that seemed to the native population to have something in common with their own goddess, helped to guarantee allegiance to the new religion and the new colonial masters. The Spanish had destroyed a temple to the Aztec mother goddess outside Mexico City, and built a chapel dedicated to the Virgin on the same site. But many natives continued to worship the old gods and goddesses, and Juan Diego's vision was therefore very useful politically to the Spanish in helping to impose on a 'magical' level, involving the natural order, the transition to the religion of the colonizers.

Mexico is mostly too far south for species roses, and the only native rose that would have been growing there at the time of the Spanish conquest is *Rosa california*, which are limited to the north of the country, and is very similar to the Gallica Rose. The Spanish mistook the native *Rosa california* for the rose they knew from western Europe, *Rosa gallica*, and so named the Mexican species the Rose of Castile. This is all the more confusing because the Damask, which you will recall is a sport of the Gallica, is known in Europe as the Rose of Castile. See: Bowman, J. N., 'The Rose of Castile', *Western Folklore*, Vol. 6, No. 3 (July 1947), 204–210, www.jstor.org/stable/1497193?readnow=1&seq=7#page_scan_tab_contents (accessed 02.03.21).

It is also worth noting that unlike the Gallica, the California Rose has a very long inflorescence, which might have been stretched, in the imagination of the Spanish, to seem 'miraculous'.

25 See www.lourdes-france.org/en/roses-for-our-lady-of-lourdes (accessed 02.03.21). As we saw, yellow is a very rare colour for a Western rose. The species yellow rose of Europe is *Rosa foetida*, the Persian Yellow or Austrian Briar, which was certainly growing in Europe at the time of the apparition. The first hybridized yellow roses to make a big splash were bred just a few hundred kilometres from Lourdes, in Lyon, by Ducher and Pernet-Ducher, but this wasn't until 1900. On the other hand, yellow was a relatively common

colour in China and Tea Roses, and most yellow roses gain their colouration from them. More on this later.

26 Every 8 December, the Feast of the Immaculate Conception, roses are offered to Our Lady of Lourdes. In the weeks leading up to the day in 2019–2020, the faithful were invited to offer up a novena, and to order roses online to send to Lourdes. They arrived in their tens of thousands.

27 Annually a group of Catholic faithful in the United States named 'America Needs Fatima' makes it a special mission to deliver roses to the site. In 2019 the group arranged for 30,000 red and white roses to be sent. 'Pope in the Chapel of Apparitions: "I beg you for world harmony amongst the peoples"', *Rome Reports*, 5 December 2017, www.romereports.com/en/2017/05/12/pope-in-the-chapel-of-apparitions-i-beg-you-for-world-harmony-amongst-the-peoples (accessed 02.03.21).

28 Morgan, D., *The Sacred Gaze: Religious Visual Culture in Theory and Practice* (Berkeley: University of California Press, 2005), 55.

29 For records of intercessions by the saint, including many roses, see: www.littleflower.org/prayers-sharing/st-therese-intercessions (accessed 02.03.21).

30 Baring, A. and Cashford, J., *The Myth of the Goddess*, 553–554.

31 Baring, A. and Cashford, J., *The Myth of the Goddess*, 553.

CHAPTER FIVE: LOVE AND THE ROSE

1 In 2009 it was estimated that the 100 million roses given on Valentine's Day in the United States generate about 9,000 metric tons of carbon dioxide on the journey from field to florist. To put this in perspective, the average American has a carbon footprint of about 15 metric tons a year, which is the highest in the world (Wheelan, C., 'Blooms Away: The Real Price of Flowers', *Scientific American*, 12 February 2009, www.scientificamerican.com/article/environmental-price-of-flowers (accessed 02.03.21)). The carbon footprint of the cut rose trade will continue to increase, because the internet has made ordering so effortless, while simultaneously widening the chasm between our commendable intentions and any sense of the real world consequences of our actions, which have also been highjacked by social media in cahoots with commercial interests. All this means that rather than taking carbon dioxide from the atmosphere and giving out oxygen, like normal plants, cut roses are actually adding to the disastrous toxic payload: www.weforum.org/agenda/2019/01/chart-of-the-day-these-countries-have-the-largest-carbon-footprints (accessed 02.03.21). In 2019 the level for the UK was 5.65 cubic tons.

2 Howard, D. R., *Chaucer and the Medieval World* (London: Weidenfeld & Nicolson, 1987), 307–308.

3 Camille, M., *The Medieval Art of Love: Objects and Subjects of Desire* (London: Laurence King Publishing, 1998), 95.

4 *The Romance of the Rose* [1278], trans. F. Horgan (Oxford: Oxford University Press, 1994), 3.
5 *The Romance of the Rose*, 334, 335.
6 Huizinga, J., *The Waning of the Middle Ages* (New York: Doubleday Anchor Books, 1954), 108.
7 Chaucer, G., *The Romaunt of the Rose*, in L. D. Benson, ed., *The Riverside Chaucer* (Oxford: Oxford University Press, 1987), Fragment A, 687.
8 Huizinga, J., *The Waning of the Middle Ages*, 108–109.
9 Campion, T., 'Laura' and 'Cherry-Ripe' [1617], 16 and 6, www.poemhunter.com/i/ebooks/pdf/thomas_campion_2004_9.pdf (accessed 22.04.21).
10 Shakespeare, W., *Love Labour's Lost*, Act V, Scene II.
11 Shakespeare, W., *Twelfth Night*, Act V, Scene IV.
12 Quoted in D. Brenner and S. Scanniello, *A Rose by Any Name: The Little-Known Lore and Deep-Rooted History of Rose Names* (Chapel Hill, North Carolina: Algonquin Books, 2009), 181–182. Interestingly, in France the rose was given a much racier name: Cuisse de Nymphe Emue ('Thigh of an Aroused Nymph'). This association seems to have been rather too much for the staid British rose business, who rechristened it 'Maiden's Blush'.
13 Burns, R., 'A Red, Red Rose' [1794], in *The G. Ross Roy Collection of Robert Burns: An Illustrated Catalogue* (Columbia: University of South Carolina Press, 2009), 28, www.google.co.uk/books/edition/Poems_and_Ballads_by_Algernon_Charles_Sw/nphBV9FT-_UC?hl=en&gbpv=1 (accessed 28.2.2021).
14 Swinburne, A. C., 'Dolores: Notre-Dame Des Sept Douleurs', *Poems and Ballads* [1866] (London: John Camden Hotten, 1873), 180, www.google.co.uk/books/edition/Poems_and_Ballads_by_Algernon_Charles_Sw/nphB-V9FT-_UC?hl=en&gbpv=1 (accessed 28.2.2021).
15 See: Cook, C., 'An Allegory with Venus and Cupid: A story of syphilis', *Journal of the Royal Society of Medicine*, Vol. 103, No. 11 (November 2010), 458–460, www.ncbi.nlm.nih.gov/pmc/articles/PMC2966887 (accessed 02.03.21). Also, J. F. Conway, 'Syphilis and Bronzino's London Allegory', *Journal of the Warburg and Courtauld Institutes*, Vol. 49 (1986), 250–255.

CHAPTER SIX: DEATH AND THE ROSE

1 Nadel, D., Danin, A., Power, R. C., et al., 'Earliest floral grave lining from 13,700–11,700-yr-old Natufian burials at Raqefet Cave, Mt. Carmel, Israel', *Proceedings of the National Academy of Sciences of the United States*, Vol. 110, No. 29 (July 2013), 11774–11778, https://doi.org/10.1073/pnas.1302277110 (accessed 02.03.21).
2 This species rose is the only one growing wild in sub-Saharan Africa, Ethiopia and across the Red Sea. It is a shrub-like plant with large clustered flowers

with five white or pink petals which are pleasantly fragrant. But for centuries it seems to have vanished from Europe, and it was only reintroduced five years after the Hawarra tomb was opened, when some descendants were discovered alive and well and growing down south in Ethiopia, to where it may have been taken by Coptic Christians – hence one of the names for the rose (Ethiopia was then Abyssinia).

3 Spenser, E., *The Fairie Queene*, Book II, Canto XII [1590], in *The Complete Works in Verse and Prose of Edmund Spenser* (London: Grosart, 1882), www.luminarium.org/renascence-editions/queene2.html (accessed 02.03.21).

4 Fanshawe, R., 'A Rose' [1607], in A. Quiller-Couch, ed., *The Oxford Book of English Verse: 1250–1900* (Oxford: Clarendon, 1919), 350.

5 Spenser, E., *The Fairie Queene*, Book II, Canto XII, www.luminarium.org/renascence-editions/queene2.html (accessed 02.03.21).

6 Herrick, R., 'To the Virgins, to Make Much of Time' [1648], in F. W. Moorman, ed., *The Poetical Works of Robert Herrick* (London and New York: Oxford University Press, 1921), 84. Insofar as a 'rosebud' was slang for the female genitals, it seems plausible to read Herrick as saying to his male readers that they should 'get laid' as much as possible before marrying.

7 Quoted in J. M. C. Toynbee, *Death and Burial in the Roman World* (Baltimore, Maryland: Johns Hopkins University Press, 1971), 63.

8 1 Corinthians 15.55–57. Authorized Version.

9 Parsons, S. B., *The Rose: History, Poetry, Culture, and Classification* (New York: Wiley and Putnam, 1847), 25–26.

10 In the song 'The Severed Garden' on the album *An American Prayer*, released in 1978, Jim Morrison intones over the droning music that he is sick of the technological world of TV and wants to rest in a 'rose bower'. He died in 1971 of a drug overdose, so the album is definitely post-mortem, a voice from beyond the grave. I thank Fabien Ducher for pointing these lyrics out to me.

11 Thomas Christopher in *In Search of Lost Roses* recounts exploring with old rose enthusiasts out of the way and neglected cemeteries in the United States, and finding very rare roses.

12 'The Roses of No Man's Land', lyrics by J. Caddigan and J. A. Brennan, 1916.

13 Mew, C., 'On the Cenotaph (September 1919)', *Complete Poems* (London: Penguin, 2000), 61–62.

14 Morgan, H., 'Woman Died After Being Pricked by Rose Thorn', *Independent* online, 16 May 2002, www.independent.co.uk/life-style/health-and-families/health-news/woman-died-after-being-pricked-by-rose-thorn-9175388.html (accessed 02.03.21).

CHAPTER SEVEN: MYSTICAL ROSES

1 Newman, J. H., *Meditations and Devotions*, https://sourcebooks.fordham.edu/mod/newman-mary.asp (accessed 02.03.21).
2 Silesius, A., 'Without Why', *The Cherubinic Wanderer*, trans. J. E. Crawford Flitch [1932], compiled by M. Hughes (The Out-of-Body Travel Foundation, 2015), 88, www.academia.edu/36152177/The_Cherubinic_Wanderer (accessed 02.03.21).
3 Meister Eckhart quoted in J. Caputo, *The Mystical Element in Heidegger's Thought* (New York: Fordham University Press, 1986), 100.
4 James, W., *Varieties of Religious Experience: A Study in Human Nature* [1902] (Oxford: Oxford University Press, 2012).
5 'On the Origins of the World, II, 5', in J. M. Robinson, ed., *The Nag Hammadi Library in English*, trans. Members of the Coptic Gnostic Library Project of the Institute for Antiquity and Christianity (Leiden: E. J. Brill, 1984), 169.
6 Roob, A., *Alchemy & Mysticism* (Köln, Germany: Taschen, 1996), 690.
7 Fabricius, J., *Alchemy: The Medieval Alchemists and their Royal Art* (Wellingborough, Northamptonshire: The Aquarius Press, 1976), 24. After Jung, this study is the most developed 'Jungian' approach to alchemy. See: Jung, C., *The Psychology of the Transference* [1946] (London and New York: Routledge, 1983).
8 In fact, the 'Ros' in 'Rosicrucian' may not be referring to a plant at all. In alchemy, the Latin *ros* (dew) and *crux* (cross) were very significant symbols. See: Yates, F. A., *The Rosicrucian Enlightenment* (London: Ark Paperbacks, 1986), 221.
9 Quoted in C. McIntosh, *The Rosicrucians: The History and Mythology of an Occult Order* (Wellingborough, Northamptonshire: Crucible, 1987), 106.
10 Yeats, W. B., 'The Rose upon the Rood of Time' [1893], in R. J. Finneran, ed., *The Collected Poems of W. B. Yeats* (Ware, Hertsfordshire: Wordsworth Editions, 2000), 23.
11 Steiner, R., *The Rose Cross Meditation: An Archetype of Human Development* (Forest Row, UK: Rudolf Steiner Press, 2016).
12 See, for example: Jung, C., *The Practice of Psychotherapy*, Collected Works, Vol. 16 [1954] (Princeton, New Jersey: Princeton University Press, 2014).
13 Heidegger, M., *The Principle of Reason*, Lecture 5, trans. R. Lilly (Bloomington: Indiana University Press, 1996), 38.

CHAPTER EIGHT: POETIC ROSES OF THE NINETEENTH CENTURY

1 Emerson, R. W., 'Self-Reliance' [1841] (Mount Vernon, New York: The Peter Pauper Press, 1967), 32–33.
2 Wordsworth, W., 'Lines Written a Few Miles above Tintern Abbey, on Revisiting the Banks of the Wye during a Tour, July 13, 1798', *The Collected*

Poetry of William Wordsworth (Ware, Hertsfordshire: Wordsworth Editions, 1994), 205–207.

3 Wordsworth, W., 'Ode: Intimations of Immortality from Recollections of Early Childhood' [1807], *The Collected Poetry of William Wordsworth*, 587–590.

4 Coleridge, S. T., 'Song, Ex Improvisa on Hearing a Song in Praise of a Lady's Beauty' [1830], *The Works of Samuel Taylor Coleridge: Prose and Verse* (Philadelphia, Pennsylvania: Crissy & Markley, 1849), 228.

5 Rousseau, J.-J., *Emile* [1762] (Dover Publications, reprint edition, 2013), 5.

6 Rousseau, J.-J, *Emile*, 11.

7 Brontë, E., *Emily Brontë: The Complete Poems*, ed. C. Shorter (London: Hodder & Stoughton, 1929), XXI, 259.

8 Novalis, *Heinrich von Ofterdingen* [Henry Von Ofterdingen: A Romance] [1802] (Mineola, New York: Dover Publications, 2015).

9 See: Burke, E., *A Philosophical Enquiry into the Origins of Our Ideas of the Sublime and Beautiful* [second edition, 1757], Part I, Section VII, in A. Ashfield and P. de Bolla, eds., *The Sublime: A Reader in British Eighteenth-Century Aesthetic Theory* (Cambridge: Cambridge University Press, 1996), 131–143.

10 Goethe, J. W., 'Heidenröslein' [Heather Rose] [1779], trans. E. A. Bowring, 1853, https://germanstories.vcu.edu/goethe/heiden_dual.html (accessed 02.03.21).

11 Blake, W., 'The Sick Rose' [1794], in N. Shrimpton, ed., *William Blake: Selected Poems* (Oxford: Oxford University Press, 2019), 28.

12 Paglia, C., *Sexual Personae: Art and Decadence from Nefertiti to Emily Dickinson* (New York: Vintage, 1991), 276–278. See also: Srigley, M., 'The Sickness of Blake's Rose', *Blake: An Illustrated Quarterly*, Vol. 26, No. 1 (Summer 1992), 4–8.

13 A common metaphor for syphilis was 'Amor's poisoned arrow', thereby linking the disease to the rose via Venus's son. In *Hamlet*, Shakespeare juxtaposes the rose and disease in order to describe the calumny of Claudius's usurpation of the throne and the marriage to his mother. Hamlet says: 'Such an act / . . . Calls virtue a hypocrite, takes off the rose / From the fair forehead of an innocent love / And sets a blister there' (*Hamlet*, Act III, Scene IV, 42–45). Shakespeare also uses the metaphor of the serpent for syphilis in *Hamlet*, thereby linking the disease to Eve's temptation. Analysis has subsequently revealed that the syphilis virus, *Treponema pallidum*, a microscopic organism called a 'spirochete', really is worm-like in shape. See: http://bq.blakearchive.org/pdfs/issues/26.1.pdf (accessed 02.03.21).

14 Darwin, E., 'The Loves of Plants' [1789], quoted in A. Syme, *A Touch of Blossom: John Singer Sargent and the Queer Flora of Fin-de-siècle Art* (University Park, Pennsylvania: Penn State University Press, 2010), 26.

15 King, A. M., *Bloom: The Botanical Vernacular in the English Novel* (Oxford: Oxford University Press, 2003), 3.

16 Quoted in B. Dijkstra, *Idols of Perversity: Fantasies of Feminine Evil in Fin-de-Siècle Culture* (Oxford: Oxford University Press, 1986), 236.
17 Baudelaire, C., Preface to *Les Fleur du Mal* [1857]; Eng. trans. as *The Flowers of Evil*, trans. (with notes) J. McGowan (Oxford: Oxford University Press, 1993), 5–10.
18 See, for example: Gray, S., *The Secret Language of Flowers* (London and New York: CICO Books, 2011).
19 Part of a longer work entitled 'On Enjoyment' from the pornographic magazine *The Exquisite* (1842–1844), quoted in R. Pearsall, *The Worm in the Bud: The World of Victorian Sexuality* [1969] (London: Sutton Publishing, 2003), 59.
20 Huysmans, J. K., *Against Nature* [1884], trans. R. Baldick (Baltimore, Maryland: Penguin, 1959), 101. Quoted in Paglia C., *Sexual Personae*, 432.
21 Paglia, C., *Sexual Personae*, 434.
22 Zola, É., *Abbé Mouret's Transgression* [1875], ed. and with an introduction by E. A. Vizetelly (Paderborn, Germany: Outlook, 2017), 133.
23 Swinburne, A. C., 'Dolores (Notre-Dame des Sept Douleurs)' [1866], *Poems and Ballads*, 180, www.google.co.uk/books/edition/Poems_and_Ballads_by_Algernon_Charles_Sw/nphBV9FT-_UC?hl=en&gbpv=1 (accessed 28.2.2021).
24 Swinburne, A. C., 'The Year of the Rose' [c.1878], *Poems and Ballads*, 49, www.google.co.uk/books/edition/Poems_and_Ballads_by_Algernon_Charles_Sw/nphBV9FT-_UC?hl=en&gbpv=1 (accessed 28.2.2021).
25 Tennyson, A., 'Maud' [1855], Book One, XVII, *The Works of Alfred Lord Tennyson, Poet Laureate* (London: Macmillan and Co, 1889), 297.
26 Tennyson, A., 'Maud', Book One, XXII, *The Works of Alfred Lord Tennyson, Poet Laureate*, 300.
27 Browning, E. B., 'The Dead Rose', *Sonnets from the Portuguese and Other Love Poems* [1846], in S. Donaldson, ed., *The Works of Elizabeth Barrett Browning*, Vol. 2 (London: Pickering & Chatto, 2010), 307.
28 Rossetti, C., *The Complete Poems*, ed. B. S. Flowers (London and New York: Penguin Classics, 2001), 'Hope', 230; 'The Lily has a smooth stalk', 251; 'The Rose', 557.

CHAPTER NINE: PAINTED ROSES

1 For more on roses and fashion in the period, see: de la Haye, A., *The Rose in Fashion: Ravishing* (New Haven, Connecticut: Yale University Press, 2020), Chapters 3–6.
2 See, for example: Bologna, G., *Illuminated Manuscripts: The Book Before Gutenberg* (London and New York: Thames and Hudson, 1988).
3 Peru was invaded in 1532, and was firmly established as a Spanish colony after the defeat of the Incas in 1572.
4 St Rose was the first Catholic in the Americas to become a saint, and today she

is the patron saint of Latin America, and the patroness of florists. Her skull is preserved in the church of St Dominic in Lima in a glass reliquary surmounted by a crown of paper roses, while the rest of her body is nearby in the monastery basilica of St Domingo. Recently, St Rose has been given a makeover, and in popular devotional images she often looks like Julie Andrews in *The Sound of Music*, plus a nice crown of roses. In 2015 Peruvian scientists reconstructed her face from the data gathered from her skull. In conformity with the iconography of the saint, in the reconstruction she is dressed in a Dominican nun's habit with a garland of roses on her head. Here too, she looks like Julie Andrews.

5 Gruber, C., 'The Rose of the Prophet: Floral Metaphors in Late Ottoman Devotional Art', in *Envisioning Islamic Art and Architecture*, 223–249.

6 Redouté, P. J., *Redouté's Roses* (Ware, Hertsfordshire: Wordsworth Editions, 1998), 54. Illustrated, 55.

7 Botanical painting certainly did not die out with the advent of photography. Today, most countries can boast professionals whose work almost rivals Redouté's. One of the most talented and influential is a Scot, Rory McEwen, who also had a successful career early on in his life as folk singer. He died in 1982, aged fifty. See: Rix, M., *Rory McEwen: The Colours of Reality* (London: Royal Botanic Gardens, Kew, revised edition, 2015). For a survey of contemporary botanical art, see: Sherwood, S., *The Shirley Sherwood Collection: Botanical Art Over 30 Years* (London: Royal Botanic Gardens, Kew, 2019). A contemporary British painter of roses of note is Rosie Sanders; see: Sanders, R., *Rosie Sanders' Roses: A celebration in botanical art* (London: Batsford, 2019).

8 Interestingly, the celebrated graphic designer Pete Saville borrowed a reproduction of Fantin-Latour's painting for the album cover of *Power, Corruption and Lies* (1983) by the electronica band New Order. As he later explained, with what is surely an excess of cynicism: 'Flowers suggested the means by which power, corruption and lies infiltrate our lives.' There is a wonderful pink rose called 'Fantin-Latour', but it in fact has nothing directly to do with the artist, and turned up as a seedling in an English garden in the mid-twentieth century. As the *Encyclopedia of Roses* remarks: 'Although often classed among the Centifolias, it is clearly a modern hybrid, a prototype of David Austin's English Roses.' (Quest-Ritson, C. and Quest-Ritson, B., *The Royal Horticultural Society Encyclopedia of Roses* (London: Dorling-Kindersley, 2003), 146.) I have a specimen in my garden in France. It's a robust shrub, with blousy blush-pink and fragrant blooms and nice dark leaves, but it only blossoms once in the early summer. Peter Beales is very keen on it: 'When seen at its best, this rose will convince even the most ardent rejectors of non-remontant roses that it should be growing in their garden, for it is one of the most beautiful of

shrubs.' (Beales, P., *Visions of Roses* (New York: Little, Brown and Company, 1996), 202.)

9 Bumpus, J., *Van Gogh's Flowers* (London: Phaidon, 1989), unpaginated, quoted with Plate 23.

10 van Gogh, V., *Ever Yours: The Essential Letters*, eds. L. Jansen, H. Luijten, and N. Bakker (New Haven, Connecticut: Yale University Press, 2014), 735.

11 In fact, the idea of a shower of deadly rose petals is pure Victoriana. What the *Scriptores Historiae Augustae: Antoninus Heliogabalus* – a Roman equivalent to the 'gutter-press' – actually says is that Heliogabalus dropped 'violets and other flowers'. The rose is in no way directly named, although considering the Romans' love of the rose, and its widescale use at festivities, it is certainly very likely to have been heavily (literally) involved.

12 Rosetti, D. G., 'Body's Beauty' (Sonnet LXXVIII), *The House of Life* [1881], *The Collected Works of Dante Gabriel Rossetti*, Vol. 1, (London: Ellis and Elvey, 1890), 216.

13 Zipes, J., ed., *The Great Fairy Tale Tradition: From Straparola and Basile to the Brothers Grimm* (New York: Norton, 2001), 688–698.

14 The Briar also features in the Walt Disney animation of *Sleeping Beauty*, with music from Tchaikovsky's ballet, but is inevitably much less threatening. In the publicity stills, Sleeping Beauty is shown holding a meek little red Hybrid Tea Rose – nothing at all like a species rose. It is clearly one of those varieties which, as Rupert Brooke says, 'bloom as they are told', like a tulip.

CHAPTER TEN: EASTERN ROSES GO WEST

1 The United States, on the other hand, has been systematically invaded by this rampant rose. First planted by Thomas Jefferson at Monticello in 1799, it subsequently spread south and west, and is now deemed an invasive species, and planting is prohibited in Texas. But as Thomas Christopher writes: 'Not that the law has had any perceptible effect on the rose. Its thorny canes and suckering roots have defeated all attempts at eradication; mounds of its glossy foliage swell up along Texas roadsides to bloom white through the summer like drifts of unseasonable snow.' (*In Search of Lost Roses*, 143).

2 *Rosa banksiae alba-plena* is the largest species rose in the world, see page 39.

3 Kilpatrick, J., *Gifts from the Gardens of China: The Introduction of Traditional Chinese Garden Plants to Britain 1698–1862* (London: Frances Lincoln Ltd, 2007), 180.

4 Quoted in Y. L. W. Chan, 'Nineteenth Century Canton Gardens and the East–West Plant Trade', in P. Ten-Doesschate Chu and N. Ding, with L. J. Chu, *Qing Encounters: Artistic Exchanges Between China and the West* (Getty Research Institute, 2015), 111–123; 115.

5 Chan, Y. L. W., 'Nineteenth Century Canton Gardens and the East–West Plant Trade', in *Qing Encounters*, 111–123.
6 Bailey, K., *John Reeves: Pioneering Collector of Chinese Plants and Botanical Art* (London: Royal Horticultural Society/ACC Art Books, 2019).
7 The original paintings are in the Royal Horticultural Society, and when I examined them I was struck by the fact that they were made on two kinds of paper – the more prestigious were on specially prepared watercolour paper from England, the smaller ones on traditional Chinese paper. The former paper was intended to be robust enough to survive the humid climatic conditions in China, and a long ocean voyage, but today these papers are discoloured, foxed and showing signs of atmospheric pollution, while the local product has survived almost pristine into the twenty-first century.
8 Quoted in T. Christopher, *In Search of Lost Roses* (Chicago: Chicago University Press, 1989), 144.
9 Quoted in P. Harkness, *The Rose*, 151.
10 Christopher, T., *In Search of Lost Roses*, 151.
11 Letter to Evelyn Gleeson, November 1896, quoted in E. C. Nelson, 'Augustine Henry and the Exploration of the Chinese Flora', *Arnoldia*, Vol. 43, No. 1 (1983), 21–38, 25, http://arnoldia.arboretum.harvard.edu/pdf/articles/1983-43-1-augustine-henry-and-the-exploration-of-the-chinese-flora.pdf (accessed 02.03.21).
12 In 1913, Wilson described the scene on one of his botanical forays up Yangtse river:

> Rose bushes abound everywhere and in April perhaps afford the greatest show of any one kind of flower. *R. laevigata* and *R. microcarpa* are more common in fully exposed places. *R. multiflora*, *R. moschata*, and *R. banksiae* are particularly abundant on the cliffs and crags of the glens and gorges, though by no means confined thereto. The Musk and Banksian Roses often scale tall trees and a tree thus festooned with their branches laden with flowers is a sight to be remembered. To walk through a glen in the early morning or after a slight shower, when the air is laden with the soft delicious perfume from myriads of rose flowers, is truly a walk through an earthy paradise.

Wilson, E. H., *A Naturalist in Western China* [1913], quoted in H. Le Rougetel, *A Heritage of Roses* (Owings Mills, Maryland: Stemmer House Publishers, Inc., 1988), 40.
13 Rix, M., '*Rosa Chinensis f. spontanea*', *Curtis's Botanical Magazine*, Vol. 22, No. 4 (November 2005), 214–219.
14 As quoted in H. le Rougetel, *A Heritage of Roses*, 34.

15 The rose garden at Malmaison fell into neglect, but it has recently been restored. Today, 750 roses of the First and Second Empire period can be admired there.
16 Kilpatrick, J., *Gifts from the Gardens of China*, 208.
17 Rivers, T., *The Rose Amateur's Guide*, 73.

CHAPTER ELEVEN: MODERN ROSES

1 Krüssmann, G., *Roses*, 86.
2 Quest-Ritson, C. and Quest-Ritson, B., *The Royal Horticultural Society Encyclopedia of Roses*, 57.
3 To give some idea of how complex rose hybridization can be, here is the parentage of 'Souvenir de Claudius Pernet', with the date of the introduction of each parent:

> 1833 'Persian Yellow' – a wild rose, introduced from Persia to England
> 1900 'Soleil d'Or' ('Antoine Ducher' 1866 x Persian Yellow)
> 190? Unnamed Seedling ('Soleil d'Or' 1900 x unknown)
> 1910 'Rayon d'Or' ('Mme. Melanie Soupert' 1905 x 'Soleil d'Or' seedling)
> 1915 'Constance' ('Rayon d'Or' 1910 x unknown)
> 1920 'Souvenir de Claudius Pernet' ('Constance' 1915 x unknown)

4 See: Rudge, A., *For Love of a Rose: Story of the Creation of the Famous Peace Rose* (London: Faber and Faber, 1965).
5 Krüssmann, G., *Roses*, 168.
6 Harkness, J., *Roses*, 17.
7 Harkness, J., *Roses*, 72–74.
8 Harkness, J., *Roses*, 96; Genders, R., *The Rose: A Complete Handbook* (London: The Bobbs-Merrill Company, 1965), 69.
9 Page, C., ed., *The Rose Annual for 1924: National Rose Society* (Croydon, UK: Advertiser Printing Works, 1924), 136.

CHAPTER TWELVE: MODERNIST ROSES

1 Wilde, O., 'The Nightingale and the Rose' [1888], *Complete Works of Oscar Wilde* (Boston, Massachusetts: The Wyman-Fogg Company, 1921), 282.
2 Yeats, W. B., 'The Secret Rose' [1897], *The Collected Poems of W. B. Yeats*, 69.
3 Yeats, W. B., 'Aedh tells of the Rose in his Heart' [1899], *The Collected Poems of W. B. Yeats*, 44.
4 Yeats, W. B., 'The Blessed' [1899], *The Collected Poems of W. B. Yeats*, 69.
5 Seward, B., *The Symbolic Rose* (Dallas, Texas: Spring Publications, Inc., 1989), 79.
6 Eliot, T. S., 'The Hollow Men' [1925], *The Complete Poems and Plays* (New York: Harcourt Brace Jovanovich, 1971), 58.

7 Eliot, T. S., 'Burnt Norton' [1936], *The Complete Poems and Plays*, 117.
8 Eliot, T. S., 'Burnt Norton', *The Complete Poems and Plays*, 119–120.
9 Eliot, T. S., 'Little Gidding' [1942], *The Complete Poems and Plays*, 139.
10 Rilke, R. M., *Roses*, VI, *Roses: The Late French Poetry of Rainer Maria Rilke*, trans. D. Need (Durham, North Carolina: Horse & Buggy Press, 2014).
11 Rilke, R. M., 'The Bowl of Roses', *Neue Gedichte / New Poems*, Part 1, trans. L. Krisak (Cambridge, UK: Boydell & Brewer, 2015), 167–170.
12 Gass, W., *Reading Rilke: Reflections on the Problems of Translation* (New York: Basic Books, 1999), 6. I have drawn here on Gass's discussion.
13 Lawrence, D. H., *Poetry of the Present* [1922], in M. Herbert, ed., *Selected Critical Writings by D. H. Lawrence* (Oxford: Oxford University Press, 1998), 76.
14 Lawrence, D. H., *Lady Chatterley's Lover* (Cambridge, UK: Cambridge University Press, 2002), 301.
15 Lawrence, D. H., 'Rose of all the World' [1917], *The Complete Poems of D. H. Lawrence* (Ware, Hertsfordshire: Wordsworth Editions, 1994), 166.
16 Lawrence, D. H., 'Look! We Have Come Through!' [1917], *The Complete Poems of D. H. Lawrence*, 165.
17 In Ovid's *Metamorphosis* there is the story of how Actaeon while out hunting with his dogs comes across the goddess bathing, and she is so angered by his voyeuristic intrusion that she turns him into a stag, and his own dogs devour him. The story was most famously painted by Titian, and his *The Death of Actaeon* (1559–1575) is in the National Gallery, London. Another allusion is to the story of Susanna and the Elders from the Bible (Daniel. 13). This was also a popular theme in art and literature, and provided the opportunity to make the voyeurism, implicit in images of naked women, more explicit. Lawrence cast himself simultaneously as Actaeon and an elder, and without guilt. But then, he is in love, and the woman he describes was in love with him; the poem is about Frieda von Richthofen, a German woman who left her family for Lawrence.
18 As one of the first Western yellow-coloured and repeat-flowering roses, 'Gloire de Dijon' is of some significance for the future development of the modern rose. It was the first big success of the Guillot *fils*, and by the time Lawrence was acquainted with it, it had already been in commerce since 1853. For the rest of the century it was one of the most acclaimed of all the new varieties. Dean Hole wrote: 'and if ever, for some heinous crime, I was miserably sentenced, for the rest of my life, to possess but a single Rose-tree, I should desire to be supplied, on leaving the dock, with a strong plant of Gloire de Dijon.' More recently, Peter Beales wrote: 'This is a deservedly well-loved, old variety, made more famous by the writings of the Rev. Deans [*sic*] Hole, first President of the National Rose Society. This gentleman seems to have persuaded almost each new incumbent that the thing to do was plant one in

the garden of every rectory in the late Victorian era' (*Classic Roses*, 352). Perhaps it was in a Nottingham rectory's garden that Lawrence first made his acquaintance with 'Gloire de Dijon'.

19 In what follows I am drawing on Barbara Seward's discussion in *The Symbolic Rose* (Dallas, Texas: Spring Publications, 1989), 187–221. In fact, there really *is* a 'Green Rose', *Rosa chinensis viridiflora*, a sport of *Rosa chinensis*. Native of China, it was brought to the West in the late eighteenth century.

20 See: Frost, L., *The Problem with Pleasure: Modernism and Its Discontents* (New York: Columbia University Press, 2013), Chapter 2.

21 Joyce, J., *Ulysses* [1922] (Minneapolis, Minnesota: First Avenue Editions, 2016), 850.

22 Fussell, P., *The Great War and Modern Memory* (Oxford: Oxford University Press, 1977).

23 Williams, W. C., 'The Rose', in *Spring and All* [1923], reprinted in A. Walton Litz and C. J. MacGowan, eds., *The Collected Poems of William Carlos Williams*, Vol. 1 (New York: New Directions, 1991), 195.

24 Stein, G., 'Poetry and Grammar', *Lectures in America* (Boston, Massachusetts: Beacon Press, 1985), 231. The expression first appeared in the poem 'Sacred Emily' (1913).

25 Parker, D., 'One Perfect Rose' [1926], in B. Gill, ed., *The Portable Dorothy Parker* (New York: The Viking Press, 1973), 9–10.

26 Orwell, G., 'Politics and the English Language' [1946] (London and New York: Penguin Books, 2013), www.orwell.ru/library/essays/politics/english/e_polit (accessed 02.03.21).

27 Bataille, G., 'The Language of Flowers' [1927], *'Visions of Excess': Selected Writings, 1927–1939*, trans. A. Stoekl, with C. R. Lovitt and D. M. Leslie, Jr (Minneapolis: University of Minnesota Press, 1985), 10–14. André Breton, leader of the Surrealists, didn't agree with Bataille's prognosis. He wrote in the *Second Manifesto of Surrealism* that Bataille 'must surely not be well', because 'the rose, deprived of its petals, remains *the rose*'. In other words, he agrees with Juliet: 'A rose by any other name . . .' For Breton, ideal beauty was still something to be guarded, even if it was now related to the Surrealist fascination with the unconscious.

28 Morris, W., *Hopes and Fears for Art: The Lesser Arts* [1878], in A. H. R. Ball, ed., *Selections from the Prose Works of William Morris* [1931] (Cambridge, UK: Cambridge University Press, paperback reprint, 2014), 139.

29 Morris, W., 'Innate Socialism', from *The Lesser Arts* [1878], reprinted in A. Briggs, ed., *William Morris: Selected Writings and Designs* (London: Penguin Books, 1962), 85.

30 Ohnuki-Tierney, E., *Flowers That Kill: Communicative Opacity in Political Space* (Stanford, California: Stanford University Press, 2015), Chapter 2, 73.

After the Chinese Communist victory in 1949, in imitation of Soviet Russia, the red rose was also adopted as a political symbol. A Chinese poster from 1976 incorporated the more truly eastern symbolic flower – the peony – ancient symbol of sensuality, wealth and honour – now condemned as a class enemy associated with the pre-revolutionary upper class.

31 Williams, W. C., 'The Rose', *The Collected Poems of William Carlos Williams*, Vol. 1, 195. The work by Gris that Williams had in mind is a collage from 1914 called *Flowers*.

32 Not surprisingly, some critics and viewers were inclined to see the familiar sexual symbolism in her paintings, but in 1943 O'Keeffe responded angrily in a letter to one critic:

> A flower is relatively small. Everyone has many associations with a flower — the idea of flowers. You put out your hand to touch the flower — lean forward to smell it — maybe touch it with your lips almost without thinking — or give it to someone to please them. Still — in a way — nobody sees a flower — really — it is so small — we haven't time — and to see takes time, like to have a friend takes time. If I could paint the flower exactly as I see it no one would see what I see because I would paint it small like the flower is small.
>
> So I said to myself — I'll paint what I see — what the flower is to me but I'll paint it big and they will be surprised into taking time to look at it — I will make even busy New-Yorkers take time to see what I see of flowers.
>
> Well — I made you take time to look at what I saw and when you took time to really notice my flower, you hung all your own associations with flowers on my flower and you write about my flower as if I think and see what you think and see of the flower — and I don't.

O'Keeffe, G., *Georgia O'Keeffe Museum Collection*, ed. B. Buhler Lynes (New York: Harry N. Abrams, 2007), 139.

33 Quoted in D. Sylvester, S. Whitford and M. Raeburn, eds., *René Magritte: Oil paintings, objects and bronzes, 1949–1967*, Catalogue Raisonée, Vol. II (Houston, Texas: Menil Foundation, 1993), 196.

34 Quoted in *René Magritte: Oil paintings, objects and bronzes, 1949–1967*, Catalogue Raisonée, Vol. II, 197.

CHAPTER THIRTEEN: ROSE-GARDENS AND GARDENING

1 Harrison, R. P., *Gardens: An Essay on the Human Condition* (Chicago: University of Chicago Press, 2009), 39.
2 Genesis 2.8–9. Authorized Version.
3 See: Jashemski, W. F., Meyer, F. G. and Ricciardi, M., 'Plants: Evidence from

Wall Paintings, Mosaics, Sculpture, Plant Remains, Graffiti, Inscriptions, and Ancient Authors', in *The Natural History of Pompeii*, eds. W. F. Jashemski and F. G. Meyer (Cambridge, UK: Cambridge University Press, 2002), 158–160.

4 Touwaide, A., 'Art and Science: Private Gardens and Botany in the Early Roman Empire', in M. Conan and W. J. Kress, eds., *Botanical Progress, Horticultural Innovation and Cultural Change*, (Washington D.C.: Dumbarton Oaks Research Library and Collection, 2007), 37–50, 40.

5 Virgil, *Georgics*, Book IV, quoted in C. Thacker, *The History of Gardens* (Berkeley: California University Press, 1979), 15.

6 Touwaide, A., 'Art and Science: Private Gardens and Botany in the Early Roman Empire', *Botanical Progress, Horticultural Innovation and Cultural Change*, 37–50, 46.

7 See: Maclean, T., *Medieval English Gardens* (Mineola, New York: Dover Publications, 2014), Chapter 5; and Landsberg, S., *The Medieval Garden* (Toronto: University of Toronto Press, 2003).

8 Quoted in A. Schimmel, *A Two-Colored Brocade: The Imagery of Persian Poetry* (Chapel Hill: University of North Carolina Press, 2004), 171.

9 Khayyam, O., *Rubaiyat of Omar Khayyam*, trans. E. Fitzgerald, 1859. Quatrain XIII, http://classics.mit.edu//Khayyam/rubaiyat.html (accessed 02.03.21).

10 But while Badur may have admired the delicate beauty of the rose and its role in Islam, as a warrior he was also attuned to its more chthonic dimensions. 'My heart is steeped in blood like a rosebud,' he declared. 'Even if there were a hundred thousand springs, what possibility would there be of its opening?' Quoted in J. Potter, *The Rose: A True History* (London: Callisto and Atlantic Books, 2010), 248.

11 Quoted in J. Potter, *The Rose*, 250, 252.

12 Porter, R. K., *Travels in Georgia, Persia, Armenia, ancient Babylonia, &c. &c. during the years 1817, 1818, 1819, and 1820* [1821–1822], quoted in S. B. Parsons, *The Rose*, 140.

13 Quoted in J. Harkness, *Roses*, 139.

14 See: Pavord, A., *The Tulip: The Story of a Flower That Has Made Men Mad* (London: Bloomsbury, 2019); and Goldgar, A., *Tulipmania: Money, Honor, and Knowledge in the Dutch Golden Age* (Chicago: University of Chicago Press, 2008).

15 Krüssmann, G., *Roses*, 103.

16 Rivers, T., *The Rose Amateur's Guide*, v.

17 Paul, W., *The Rose Garden: In Two Divisions* (London: Sherwood, Gilbert & Piper, 1848), 16.

18 Paul, W., *The Rose Garden*, i–ii.

19 Hole, S. R., *A Book About Roses: How to Grow and Show Them* (Edinburgh and London: William Blackwood and Sons, 1868), 4.

20　Hole, S. R., *A Book About Roses*, 1.
21　Hole, S. R., *A Book About Roses*, 29.
22　Hole, S. R., *A Book About Roses*, 29.
23　Hole, S. R., *A Book About Roses*, 11, 21.
24　Paul, W., *The Rose Garden*, i–ii.
25　Jekyll, G. and Mawley, E., *Roses for English Gardens*, 4.
26　Bunyard, E., *Old Garden Roses*.
27　Thomas, G. S., *The Old Shrub Roses* [1955] (London: J. M. Dent & Sons Ltd, revised edition, 1979), 17.
28　The 'Bible' of old roses is Peter Beales' *Classic Roses* (1997), and his nursery is one of the best places to buy old roses: www.classicroses.co.uk. The nursery, near Norwich, also boasts a rose garden which includes Peter Beales' collection of many rare and almost extinct roses.
29　Austin, D., *The Heritage of the Rose* (London: Antique Collectors' Club, 1988), 30.
30　Austin, D., *The Heritage of the Rose*, 31.
31　Christopher, T., *In Search of Lost Roses*, 23.
32　Christopher, T., *In Search of Lost Roses*, 23. One of the most impressive efforts to rescue the old roses in the United States has been undertaken, beginning in the 1980s, by Gregg Lowery and Phillip Robinson. The collection is based near San Francisco. The Friends of Vintage Roses have also now documented inventories of 5,412 named cultivars – http://thefriendsofvintageroses.org/about-us/ (accessed 02.03.21). The quest by scholars and rosarians to identify and document species roses and old garden varieties is now truly global in scope. In China, for example, the country that has the most species roses and a rich history of cultivating garden varieties, there is Wang Guoliang. In India, Viru and Girija Viraraghavan. In Japan, Yuki Mikanagi, Katsuhiko Maebara and Yoshihiro Ueda.
33　Sackville-West, V., *Some Flowers* (London: Cobden-Sanderson, 1937), 36.
34　Austin, D., *The Heritage of the Rose*, 176.
35　www.davidaustinroses.com/us/constance-spry-english-climbing-rose (accessed 02.03.21).
36　Other rose breeders have also developed 'postmodern' lines, such as Meilland International's 'Romantica' in France, and 'Renaissance' roses by the Danish breeders Poulsen.
37　www.un.org/en/ccoi/rose-gardens (accessed 02.03.21).
38　Email correspondence with the author, September 2020.
39　Sackville-West, V., *Some Flowers*, 1.
40　Quoted in 'The History of Sissinghurst's Roses', *Country Life*, 28 June 2014, www.countrylife.co.uk/gardens/country-gardens-and-gardening-tips/the-history-of-sissinghursts-roses-58258 (accessed 02.03.21).

41 Sackville-West, V., *Some Flowers*, 40.
42 For more of Sackville-West's writings on gardens, see: Lane-Fox, R., ed., *Sackville-West: The Illustrated Garden Book* (London: Atheneum, 1986). As Hazel de Rougetel puts it: 'Through her writing we appreciate the romance in roses, find poetry on their petals', *A Heritage of Roses*, 133.
43 Harrison, R. P., *Gardens*, 25.
44 Harrison. R. P., *Gardens*, 31.
45 Paul, W., *The Rose Garden*, 23.
46 Bisgrove, R., *The Gardens of Gertrude Jekyll* (London: Frances Lincoln, 1992).
47 Jekyll, G. and Mawley, E., *Roses for English Gardens*, 68.
48 le Rougetel, H., *A Heritage of Roses*, 141.
49 The most renowned of Oudolf's public gardens is the High Line in Manhattan. See, for example: Oudolf, P. and Kingsbury, N., *Planting: A New Perspective* (Portland, Oregon: Timber Press, 2013).
50 Harbison, R., *Eccentric Places* (Boston and New York: The MIT Press, 2000), 3. The perfunctorily disciplinary convention of pruning back roses might in this context be seen as analogous to a much wider social phenomenon. In the period when Hybrid Perpetuals, Hybrid Teas and Floribundas were bred to be planted in neat suburban gardens or city parks, Western society was dominated by what the historian Michel Foucault terms a regime of discipline and punishment. It was organized around prohibitions, commandments and laws. The pruning of roses seems a fairly explicit vegetal enactment of this oppressive regime. But since the 1960s, Western society has undergone a major change, becoming more libertarian in its social practices and characterized by a focus on individual motivation, projects, and initiatives. A disciplinary society is governed by 'no!' while our achievement society is governed by 'yes, we can!' It may not be too much to suggest that the laissez-faireism of New Perennialism better reflects the underlying drives of this new kind of society. See: Foucault, M., *Discipline and Punish: The Birth of the Prison*, trans. A. Sheridan, (New York: Vintage Books, 1995). For the concept of the 'achievement society', see: Han, B.-C., *The Transparent Society* (Stanford, California: Stanford University Press, 2012).
51 For an account of a visit to this rosarium, see: Potter, J., *The Rose*, Chapter 20.
52 See: Moore, M., *The Rose Garden of Fukushima* (Tokyo: Sekai Bunka, 2014).

CHAPTER FOURTEEN: THE ROSE BUSINESS

1 From a poem attributed to Dionysius the Sophist in the *Greek Anthology* (v. 81). Quoted in J. Goody, *The Culture of Flowers*, 59–60.
2 See: Magnard, J.-L., Roccia, A., Caissard. J.-C., et al., 'Biosynthesis of monoterpene scent compounds in roses', *Science*, Vol. 349, No. 6243 (July 2015), 81–83, https://science.sciencemag.org/content/349/6243/81 (accessed 02.03.21).

3 von Bingen, H., 'Physica', *The Complete English Translation of Her Classic Work on Health and Healing* [1151–1158], trans. P. Throop (Rochester, Vermont: Healing Arts Press, 1998), 21.
4 Perks, E., 'Provins and the Provins Rose', *The Rosarian Library*, 1 July 2019, www.therosarianlibrary.co.uk/articles/4593059233/Provins-and-the-Provins-Rose./11389566 (accessed 02.03.21).
5 Arnano, L. C., *The Medieval Health Handbook:* Tacuinum Sanitatis (New York: George Braziller, 1976), illustration XXXIII. The compiler of the *Tacuinum of Vienna* was probably drawing heavily on an unillustrated eleventh-century Arab medical treatise, the *Taqwīm as-Siḥḥa*, which had been translated into Latin as the *Tacuinum Sanitatis*.
6 Grayson, J., 'Flowers may be nice for Mom, but they're terrible for Mother Earth', *The Washington Post*, 7 May 2015, www.washingtonpost.com/opinions/flowers-may-be-nice-for-mom-but-theyre-terrible-for-mother-earth/2015/05/07/fb69f9f4-f4d5-11e4-b2f3-af5479e6bbdd_story.html (accessed 02.03.21).
7 Murdoch, I., *An Unofficial Rose* (New York: The Viking Press, 1962), 199–200.
8 Bunyard, E. A., *Old Garden Roses*, 24.
9 Ankanahalli, N., Urs, N., Hu, Y., Li, P., et al., 'Cloning and Expression of a Nonribosomal Peptide Synthetase to Generate Blue Rose', *ACS Synthetic Biology*, Vol. 8, No. 8 (2019), 1698–1704, https://doi.org/10.1021/acssynbio.8b00187 (accessed 02.03.21).
10 https://roseraie-ducher.com (accessed 02.03.21).
11 In this vein, here are some of my own fictional well-mannered roses, aimed at the British market: 'The Accountant's Rose', 'The Archers', 'Brave Brexit', 'Terry Wogan', 'Beige' (guess what colour), 'Bridge Rubber', 'Hole in One'.
12 www.selectroses.ca/naming-avail/ (accessed 02.03.21).
13 Christopher, T., *In Search of Lost Roses*, 23.
14 Gary Paul Nabhan, ethnobiologist, Franciscan monk and author, recalls the impact of the rose aromas associated with his Middle Eastern ethnic background on his childhood in Gary, Indiana, in the 1950s:

> When I was four or five years old, I had the impression that my Lebanese and Syrian grandfathers, all of my uncles, and my father naturally smelled of roses. Whenever they called me *habibi* and kissed me on both cheeks, as Arab men are fond of doing to children in their clan, I became overwhelmed by the fragrance of the Damascus rose [the Damask Rose]. It was not until several years later when I went to a barber shop with one of my uncles that I witnessed how Rex the barber splashed an astringent mixed with rose water on my uncle's newly shaven skin and greased his hair with rose oil. Not too much later, I read the words *rose water* on a bottle my father kept in my parents'

bathroom. However naively these early olfactory memories arose in me, they have had staying power.

Nabhan, G. P., *Cumin, Camels, and Caravans: A Spice Odyssey* (Berkeley: University of California Press, 2014), 116.
15 Horace is also celebrating the softness of the petals, so he incorporates another of our senses – touch.
16 Quoted in R. H. Stamelman, 'The Eros – and Thanatos – of Scents', in J. Drobnick, ed., *The Smell Culture Reader* (London: Berg, 2006), 262–276, 268.
17 Quoted in R. H. Stamelman, 'The Eros – and Thanatos – of Scents', *The Smell Culture Reader*, 263.

CHAPTER FIFTEEN: THE ROSE, TODAY AND TOMORROW

1 Such as: The World Federation of Roses: www.worldrose.org/; the Historic Roses Group: www.historicroses.org; the American Rose Society: www.rose. org. But there are way too many websites to mention here, although I would like to recommend The Rosarian Library, a collection of books and other resources dedicated to the rose, and a blog: www.therosarianlibrary.co.uk.
2 Avatar Wiki, 'Healing Rose', https://james-camerons-avatar.fandom.com/wiki/Healing_Rose (accessed 02.03.21).
3 For example, see: www.brainyquote.com/quotes/eleanor_roosevelt_141732 (accessed 02.03.21).
4 Wolf, N., *The Beauty Myth: How Images of Beauty are Used Against Women* [1991] (New York: Harper Collins, new edition, 2002), 12.
5 See: Jacobus, M., *Reading Cy Twombly: Poetry in Paint* (Princeton, New Jersey: Princeton University Press, 2016), 220–231.
6 This work sold at Christie's in 2009 for $5,682,500, making these roses the most expensive in the world.
7 For the books, see: www.goodreads.com/list/show/86879.Romance_Novels_with_Rose_in_the_Title_ (accessed 02.03.21). For the songs, see: www.ranker.com/list/the-best-songs-about-roses/reference (accessed 02.03.21).
8 See: Finnegan, K., 'Roses – in full bloom', *Financial Times* online, August 2019, www.ft.com/content/9a85adf0-a23b-11e9-a282-2df48f366f7d (accessed 02.03.21). See also: de la Haye, A., *The Rose in Fashion*, Chapter 9.
9 See the video made by van Noten: 'The Making of Dries Van Noten Autumn/Winter 2019', https://www.youtube.com/watch?time_continue=20&v=px59tlfjW10&feature=emb_logo (accessed 02.03.21).
10 I draw here on: Renée, V., 'What Do Roses Represent In "American Beauty" (Hint: It Ain't Beauty)', *No Film School*, 30 September 2016, https://nofilm-school.com/2016/09/what-do-roses-represent-american-beauty-hint-aint-beauty (accessed 18.3.21); and the video 'American Beauty: Inside the

Rose,' *Screenprism*, www.youtube.com/watch?v=XvTwjusPAlM&t=1s (accessed 18.3.21). These in their turn draw heavily on: Anker, R. M., *Catching the Light: Looking for God in the Movie* (Grand Rapids, Michigan/Cambridge, UK: William B. Eerdmans Publishing Company, 2004), Chapter 12.

There is actually a rose called 'American Beauty' – a Hybrid Perpetual. It was a French creation from 1885, whose breeder, Henri Lédéchaux, named it 'Madame Ferdinand Jamin'. But it was astutely rechristened for the American market. 'American Beauty' has a strong, sweet scent, and repeat blooms a little. *The Encyclopedia of Roses* observes: 'It was a popular cut-flower rose in the late 19th-century ... Unfortunately, it is susceptible to all the fungal diseases that affect roses: blackspot, mildew, and rust' (p. 30). Another association no doubt triggered by the title of the movie is Frank Sinatra's shmaltzy song 'American Beauty Rose'. In fact, for a time, the 'American Beauty' rose was the most famous rose in America. As Douglas Brenner and Stephen Scanniello write in *A Rose By Any Name: The Little-Known Lore and Deep-Rooted History of Rose Names* (2009): 'The lasting fame of "American Beauty" made it the fail-safe cut flower for generations of nervous hostesses, bashful beaux, and penitent spouses – and an easy target for satire' (p. 8). But the roses seen in the movie are not *the* 'American Beauty' rose.

11 Directed by Alice Waddington, and starring Milla Jovovich as the nasty headmistress.
12 Flannery, T., *Europe: The First 100 Million Years* (London and New York: Penguin Books, 2018), 228.
13 Flannery, T., *Europe*, 293–294.
14 Serres, M., *The Natural Contract*, trans. E. MacArthur and W. Paulson (Ann Arbor: University of Michigan Press, 1995), 38.
15 See, for example: Trewavas, A., 'Foundations of Plant Intelligence', *Interface Focus*, Vol. 7, No. 3 (April 2017), 1. http://dx.doi.org/10.1098/rsfs.2016.0098 (accessed 02.03.21).
16 Mancuso, S., *The Revolutionary Genius of Plants: A New Understanding of Plant Intelligence and Behavior* (New York: Atria Books, 2017), xi.
17 Mancuso, S., *The Revolutionary Genius of Plants*, xi.
18 Stavrinidou, E., Gabrielsson, R., Gomez, E., et al., 'Electronic Plants', *Science Advances*, Vol. 1, No. 10 (November 2015), https://advances.sciencemag.org/content/1/10/e1501136 (accessed 02.03.21).
19 Mancuso, S., *The Revolutionary Genius of Plants*, xii.
20 Marder, M., *Plant-Thinking: A Philosophy of Vegetal Life* (New York: Columbia University Press, 2013), 12.
21 Irigaray, L. and Marder, M., *Through Vegetal Being* (New York: Columbia University Press, 2016).

22 It doesn't take long for a formal rose garden to become a New Perennialist garden. A nuclear disaster helps. I mentioned the rose garden of Fukushima, Japan, which has the misfortune of lying within the exclusion zone, set up after the accident of March 2011. Already in the spring of 2013, photographs of the now abandoned garden – which during its heyday was a splendid example of a European-style rose garden, with arbors, trellises, fountains, a farmer's cart laden with roses, and sculptures of rosy damsels – show it adrift with perennials, and very much looking like the kind of place Piet Oudolf would appreciate. See: Moore, M. *The Rose Garden of Fukushima*.

23 Marder, M., 'The Garden As Form', *The Learned Pig*, 21 November 2018, www.thelearnedpig.org/michael-marder-garden-as-form/5821 (accessed 02.03.21).

24 www.statista.com/statistics/257776/value-of-us-rose-sales-since-2002/ (accessed 02.03.21).

25 www.worldpeacerosegardens.org (accessed 02.03.21).

26 www.worldpeacerosegardens.org/who-we-are/ (accessed 02.03.21).

While I was writing this book, one particular rose garden was often in the news: The White House Rose Garden. Most of the roses there are moderns – for example, the first Floribunda Rose, 'Queen Elizabeth', and the creamy-white 'Pascali', a big favourite introduced by the Belgian rosarian Louis Lens in 1963, which has 'Queen Elizabeth' as a parent, and the ever-popular snowy white 'Nevada', introduced by the Spaniard Pedro Dot in 1927. The garden was created in 1913 as a contemplative retreat, and largely redesigned during the Kennedy presidency, apparently by Jacqueline herself, but most presidents or their wives have tinkered with it before and since. As I put the finishing touches to this book, there was news that Melania Trump had led yet another redesign. The garden is usually only used for major announcements and state visits, but during the Covid-19 crisis President Trump, displaying his typical eagerness to break with custom in the most egregious fashion, used it as a location less prone to spreading viral contagion, and gave there his rambling and disinformational Monday morning news conferences. The Rose Garden was very much a consoling background, making the President of the United States of America seem a little less the belligerent, chaos-spreading, narcissistic monomaniac he actually was. The news that Melania had redesigned the garden gave rise to a fine example of rose-centred, internet-borne misinformation. Here is Reuters' 'fact-check' team to set us straight:

> Tens of thousands of social media users have published posts claiming that in her redesign of the White House's Rose Garden, First Lady Melania Trump has removed roses from every First Lady since 1913, including Jaqueline Kennedy's crab apple trees . . . The posts, shared over 93,000 times, either consist of text saying 'Melania dug up the WH Rose Garden, removing roses from every First Lady since 1913' or

they are a screenshot of a Tweet which shows the new and old rose gardens and reads, 'Those were Jackie Kennedy's crabapple tree's [sic]. Many of those rose bushes were from ALL the First Ladies of America, going all the way back to Ellen Louise Wilson in 1913 . . .'

All this is false. The original roses from 1913 were removed before or during the Kennedy era redesign, a reflection of the general trend away from the old garden roses. Apparently, those roses growing in the garden today were often in a sorry state. Hybrid Teas and Floribundas struggle in the Washington D.C.'s humid climate. Many had died-off. The famous crab-apple trees are not from 1913. They have been replanted since, and although uprooted in Melania's 'redesign', this is only temporarily, as they too were in bad condition. I hesitate to draw any general moral from the fact that the Rose Garden of the White House seems to be in a bad way, or from the ease with which, thanks to the internet, a garden can be turned into a partisan arena in which to score cheap political points, but the news does serve to remind us that the rose has often been implicated in one form of ideological power-play or another.

See: Reuters, 'Fact check: Melania Trump's Rose Garden redesign did not remove rose bushes from all first ladies since 1913', 28 August 2020, www.reuters.com/article/uk-factcheck-melania-rosegarden/fact-check-melania-trumps-rose-garden-redesign-did-not-remove-rose-bushes-from-all-first-ladies-since-1913-idUSKBN25O225 (accessed 02.03.21).

27 Rilke, R. M., 'The Bowl of Roses', *Neue Gedichte / New Poems*, Part 1, 167–170. The possibility that roses may have actually contributed to making humans more peaceable and empathetic can be fruitfully considered in the light of Rutger Bregman's argument in his bestselling *Humankind: A Hopeful History*, trans. E. Manton and E. Moore (New York, Boston, London: Little, Brown and Company, 2019).

CONCLUSION

1 The garden opened in 1932, and has about 12,000 roses, many of them planted in the 85 single-variety beds.
2 Hole, S. R., *A Book About Roses*, 45.
3 Here is something depressing to think about. The next time you are on holiday and consider buying a cut rose from a cute-looking child while enjoying a meal al fresco in a restaurant or a refreshing drink in a bar or cafe with your loved one, consider the circumstances that may have brought the child before you. All along the length of the backpackers' haven of Bangkok's Khaosan Road, for example, children try to sell cut roses to tourists. They are mostly from Burma, and have been willingly given away by their parents to brokers

on the understanding that their child will be sending money home. But they rarely do, as the brokers pocket it. In 2018, a report estimated that around 500 children were being exploited in this way. Tourists who in good faith give money to these smiling children selling roses are actually helping to keep them enslaved. Mairs, S., 'The Exploited Kids Selling Roses to Tourists on Bangkok's Khaosan Road', *Vice*, 19 November 2018, www.vice.com/en_nz/article/7b7mdx/why-not-to-buy-roses-from-the-kids-on-khaosan-road (accessed 02.03.21).

4 'A leaf out of her book: Alice Oswald.' Janet Phillips talks to award-winning poet Alice Oswald, *The Poetry Society*, 2005, http://archive.poetrysociety.org.uk/content/publications/poetrynews/pn2005/asprofile (accessed 02.03.21). The poem was published in *Woods etc.* (London: Faber & Faber, 2005). It can be read in full (and listened to) at: https://voetica.com/voetica.php?collection=15&poet=798&poem=6595 (accessed 22.04.21).

5 'This week workers began severing the buds of about 3,000 rose bushes at Yono Park in Saitama, north of Tokyo, in an attempt to keep flower viewers away ... "It's very painful, but we decided to take action after looking at the situation in other cities," a local official told the Mainichi newspaper, adding that it would take about a week to remove all the buds.' McCurry, J. '"Very painful": Japan Covid-19 officials cut off thousands of roses to deter gatherings', *Guardian* online, 24 April 2020, www.theguardian.com/world/2020/apr/24/very-painful-japan-covid-19-officials-cut-off-thousands-of-roses-to-deter-gatherings (accessed 02.03.21).

6 In the film, the humble amateur rose breeder, Mr Ballard, asks Mrs Minever if he can name his new red Hybrid Tea after her, and she agrees. Later, Mr Ballard wins the local flower show prize for the best rose, thanks to the intervention of Mrs Minever, who persuades the local lady of the manor – who *always* wins the first prize for her roses – to award it to Mr Ballard, as even the lady recognizes it is the better one, despite the fact than the sycophantic judges have already awarded it to her. Full disclosure: one hour later, Mr Ballard is killed by a German bomb.

Acknowledgements

This book sits on the shoulders of many others – far too numerous to acknowledge here. But I would like to especially note my debt to the following books. For roses in general: *Classic Roses* by Peter Beales; *In Search of Lost Roses* by Thomas Christopher; *Roses* by Gerd Krüssmann; *The Rose* by Jennifer Potter; and *The Royal Horticultural Society Encyclopaedia of Roses* by Charles and Brigid Quest-Ritson. For the symbolism of the rose: *Culture of Flowers* by Jack Goody and *The Symbolic Rose* by Barbara Seward. For a thought-provoking background: *Plants as Persons* by Matthew Hall; *The Cabaret of Plants* by Richard Mabey; *The Revolutionary Genius of Plants* by Sefano Mancuso; *Plant Thinking* by Michael Marder; and *The Botany of Desire* by Michael Pollan.

For their expert knowledge of the rose as a plant and for fact-checking the relevant chapters in my book, I would like to thank: Jonny Norton, Head Gardener, Mottisfont Abbey Rose Garden, whom I also thank for allowing Oneworld to use one of his beautiful photographs of the rose garden; Kim Wook-Kyun, President, South Korea Rose Society, and Yuki Mikanagi, former Chairperson of the Conservation and Heritage Committee of the World Federation of Rose Societies, for excellent advice. Thanks also to Fabien and Florence Ducher of Roseraie Ducher for an insightful interview and for helping augment my rose garden. And thanks to Chang Eungbok for the wonderful design for the endpapers.

Also, thanks to: Roger Vlitos, Curator of the Farringdon Collection at Buscot Park; the staff at the Lindley Library, RHS, London, especially Charlotte Brooks, Art Curator. Also, thanks to the RHS for letting us use the wonderful watercolour in their collection for the cover; Elizabeth Perks of the Rosarian Library (www.therosarianlibrary.co.uk) for

helpful suggestions and encouragement; Lindy Usher who early on encouraged my interest in roses, and for research concerning Rumi.

A very big thank you to my agent, Clare Grist Taylor, whose clear-sighted expertise at the proposal stage made this book much more coherent, and who found a wonderful home for it. Huge thanks at Oneworld to my editor, Cecilia Stein, who knocked the manuscript into shape; Elizabeth Hinks, for eagle-eyed copyediting; Rida Vaquas, for picture and literary rights research; Paul Nash, Head of Production; Kate Bland, for publicity; and Matilda Warner, for press.

So far in these Acknowledgements I have managed to avoid rose-inspired metaphors, but here is one to end with: They say that in any relationship there is one partner who is the gardener and another who is the rose. My thanks to my partner, Chang Eungbok, for taking it in turns.

Index

Abelard, Peter 88
Addams Family, The (film) 246–7
Adonis 44, 46
adultery 114
agriculture 184, 232–3, 244
Alba Rose, *see* White Rose
Albertus Magnus, St 59
alchemy 99–101, 103–4
allegory 43, 58, 59, 119, 122
 and love 75–6, 80
 and mysticism 98, 100–1
Alma-Tadema, Lawrence: *The Roses of Heliogabalus* 130–1, 208, 228
Ambrose, St 61
American Beauty (film) 230–1, 232
Anacreon: *Odes* 47, 49
ancient Greece 4–5, 8, 25, 38, 45, 98, 212
anima (the soul) 52–3, 80
animals 14, 46–7, 49, 75, 99
Anthroposophy 103
Aphrodite 44–5, 46, 47, 48, 50, 51–2, 98
Apollo 46, 49
Apothecary's Rose (*Rosa gallica officinalis*) 7, 29, 211–12
apparitions 69–70, 71
Apuleius, Lucius: *The Golden Ass* 51
Aral Sea Basin 27
archetypes 52–3
art 38–9, 43–4, 80–1, 119–34, 140, 226–9
and death 86
and Islam 65
and modernism 164, 176–80
Artemis 45
artificial flowers 91–2, 114–15, 208
attar of roses, *see* rose oil
Attis 46
Austin, David 194, 213, 216–17, 218
 The Heritage of the Rose 192
Autumn Damask Rose 17, 25–7
Avatar (film) 225–6

Babur 185
Babylonia 45
Bacchus 46, 49
Bactrians 27
Bai Juyi 38
Balletti, Manon 121
Banks, Sir Joseph 137
Banks Rose (*Rosa banksiae*) 39, 137, 189
Baring, Anne 72
Barrett Browning, Elizabeth 8, 117
Barrow, John: *Travels in China* 139
Basil the Great, St 59
Bataille, Georges: 'The Language of Flowers' 175–6
Baudelaire, Charles: *Fleurs du Mal* (*Flowers of Evil*) 112–13, 114

Beach Rose (*Rosa rugosa*) 15, 26, 36, 155, 181
Beales, Peter 15–16, 38, 192
beauty 8, 19–20, 68, 176, 226–7, 230–1
 and poetry 109–10, 112–13
bees 14, 19, 20, 100
Bennett, Henry 150
Bernadette Soubiroux, St 70, 72
Bernard of Clairvaux, St 60, 63
Bible, the 57–8, 62, 182
Black Spot (*Diplocarpon rosae*) 202–3
Blake, William: 'The Sick Rose' 110–11, 202
blue roses 215–16
'Body's Beauty' (Rossetti) 132
Bosenberg, Henry F. 156–7
Bosschaert the Elder, Ambrosius: *A Still Life of Flowers in a Wan-Li Vase* 120, 125–6
botanical drawing 126–8, 139–41
Botticelli, Sandro:
 The Birth of Venus 124
 The Virgin Adoring the Sleeping Christ Child 123
Bourbon roses 15, 144, 145, 150
'Bread and Roses strike' 1, 2
breeding 11, 90, 154–7, 190, 218
 and France 145–6, 147–8
 and modern roses 149–50, 151–2, 162
Briar Roses 132–4
Britannia, *see* Great Britain
Brontë, Emily 107–8
Bronzino, Agnolo: *An Allegory with Venus and Cupid* 43–4, 80–1, 120, 135, 136
Brooke, Rupert 1, 2, 117

Buddhism 102
Bulgaria 210
Bunyard, Edward 192, 215
Burma 37
Burne-Jones, Edward: *The Legend of the Briar Rose* 132–4
Burns, Robert 79
business 207–21, 244

Cabala 99, 101
Cabbage Rose (*Rosa centifola*) 30–1, 34, 207–8, 210, 223
 and art 120, 121, 126, 129–31
Campion, Thomas 78
cane (stem) 16, 100
Carthage 24, 26
Casarti, Isabella 88–9
cash-crops 25, 27, 210, 213
Cashford, Jules 72
Catholicism, *see* Roman Catholic Church
'Cécile Brünner' rose 151–2, 160
Cecilia, St 60
cemeteries 87–91
Central Asia 27
Champney, John 144
chaplets 209, 222
Chardin, Jean-Baptiste Siméon 185–6
 A Vase of Flowers 128–9
Charlemagne, Holy Roman Emperor 184
Charles VI of France, King 77
Chaucer, Geoffrey 77, 78
 The Parliament of Fowls 73, 74
Cherokee Rose (*Rosa laevigata*) 40, 41
China 3, 5, 11, 16, 128, 139–43, 229
 and business 213
 and gardens 187–8

and trade 27
and varieties 26, 31, 35–9
China Rose (*Rosa chinensis*) 26, 35, 37–8, 135–6, 137–8, 142–3
Christianity 38, 56–60, 59, 86–7, 209, 211
and art 119–20
and gardens 184–5, 186–7
and mysticism 95–6, 101
see also Bible, the; Protestantism; Roman Catholic Church
Christine de Pizan: *Epistre au Dieu d'Amours* (*Epistle of the God of Love*) 77
Christopher, Thomas: *In Search of Lost Roses* 193, 222
Chymical Wedding, The 100
cinema 225–6, 230–2, 246–7
Clean Air Acts 200, 202–3
Clement of Alexandria 58
climbing roses 18, 37
Cochot, L. Simon and P. 162
Colderidge, Samuel Taylor 106
colour 5, 17, 34, 35–6, 37, 156
and blue 215–16
and floriography 113
and scent 222
see also red roses; White Rose; yellow roses
communism 178, 228
'Constance Spry' 194
Constantine, Emperor 58
cosmetics 25
Cotton Rose (*Hibiscus*) 40–1
Counter-Reformation 68
courtly love 74–7
Covid-19: 246
Crimea 26

Crivelli, Carlo: *Immaculate Conception* 120
cross 100–1, 102, 103
cruelty 116–17
Crusades 25, 29, 64, 65, 74–5, 186, 207
Cubism 178
culinary uses 32–3, 36, 65
culture 7, 8–10
Cupid 43, 44
cut roses 90–1, 136, 209, 213–14
Cybele 45

Damask Rose (*Rosa damascena*) 6, 7, 15, 17, 25–7, 144
and art 121, 123, 124, 130, 132
and gardens 186
and Islam 65–6
and Jekyll 34
and medicinal properties 212
and rose oil 209–10
and scent 223
and varieties 30
and Virgin Mary 55
Dante Aligheri: *Divine Comedy* 62–3, 64, 78, 165, 167
Darwin, Charles 112, 149
Darwin, Erasmus 111
Dawkins, Richard 9, 10
De Heem, Jan Davidsz.: *Vanitas Still-Life with a Skull, a Book and Roses* 126
death 83–93, 114, 228
deceit 116–17
Delbard (France) 217
Descartes, René 101
Desportes 189
Diana (goddess) 45

Diana, Princess of Wales 83, 218
Dies Rosalia (Feast of Roses) 209
Dione 46
Dionysus 46, 49, 50, 209
Diotima 50–1
distillation 207, 209, 210
Divine Virgin, *see* Virgin Mary
Dog Rose (*Rosa canina*) 6, 7, 13–15, 16, 155, 217
 and Britain 23–4
 and Christianity 56–7
 and gardens 184
Dorothy, St 60
Ducher, Fabien 217

East Asia, *see* China; Japan; Korea
East India Company 126, 136, 140
Eckhart, Meister 96
Eco, Umberto: *The Name of the Rose* 8
ecological crisis 12, 232, 233, 244
Edmund Crouchback 29
Eglantine Rose (*Rosa eglanteria*) 23–4, 32
Egypt 45, 83–4, 85, 209
Eliot, T. S. 166–7, 168, 169, 227
Elizabeth I of England, Queen 30
Elizabeth II of Great Britain, Queen 153
Elizabethan Age 28–9, 32–3, 99
Emerson, Ralph Waldo 105–6, 117
Emile (Rousseau) 107
'Ena Harkness' 160–1
'English Rose' 194, 213, 216
Enlightenment, the 97, 101, 106–7, 148
Epic of Gilgamesh 182
Eros 44, 50, 53, 88, 98, 109, 224
eroticism 84–5, 88, 98, 110, 112, 131

etymology 4–8, 47, 143; *see also* naming
Europa-Rosarium (Germany) 205
Evans, Sir Arthur 125
Eve 53, 60, 61, 72
evil 112–13
evolution 112

Fanshawe, Sir Richard 84–5
Fantin-Latour, Henri: *A Basket of Roses* 120–1, 129
fashion 121, 209, 230
Fatima (Portugal) 70
femininity, *see* women
Fertile Valley 3–4, 5
Field Rose (*Rosa arvenis*) 23, 24, 32
First World War 2, 89–90, 116, 172–3, 196
Flannery, Tim 232, 233
Floribundas 16, 18, 34–5, 153
floriography ('language of flowers') 74, 113–14
flower (corolla) 16–17, 34, 35–6, 37, 38
 and mysticism 96–7, 100
'Flower Power' 245
flowering period, *see* inflorescence; remontancy
Fludd, Robert: *Summum Bonum* 100
formal gardens 195–7
Fortune, Robert 141–2
Four Quartets (Eliot) 166–7
Four Season Rose, *see* Autumn Damask Rose
fragrance, *see* scent
France ix, 2, 31, 55, 74–5, 121
 and art 127–8

and breeders 145–6, 147–8
and gardens 188–9
and Grasse 207–8
and Lourdes 70
and modern roses 151–2, 162
and nurseries 216–17
and Provins 7, 29, 77, 211–12
and Rosicrucianism 102
see also Paris
Francis, Pope 55–6, 70, 218
Francis of Assisi, St 56, 60
Freud, Sigmund 80
Futaba (Japan) 205

Gallaccio, Anya: *Red on Green* 228
Gallica Rose (*Rosa gallica*) 7, 24, 25, 33–4, 77, 144
and art 119, 120, 123, 125, 128
and gardens 182–3, 184
and varieties 29–30
gardening 201–3, 213–15, 238–40
gardens viii–ix, 34–5, 181–201, 203–5
Gardens of Remembrance (NYC) 204
Garton Ash, Timothy 226
Gass, William 168–9
Gelasius, Pope 73
gender, *see* men; women
Genders, Roy: *The Rose: A Complete Handbook* 161
Gerard, John: *Herball Or Generall Historie of Plants* 28–30, 31–3, 34, 212
Germany 1, 2, 152, 153, 205; *see also* Hildesheim Cathedral
Giorgione 131
'Gloire de Dijon' (Lawrence) 170–1

Gnosticism 98, 100
Goethe, Johann Wolfgang: 'Heidenröslein' 109, 114
Golden Dawn, Order of 102
Golden Legend 60
Goncourt, Edmond de 224
grafting 155, 217
Grasse (France) 207–8
Grateful Dead viii, 247
Great Britain 23–4, 26, 28–9, 32–3
Great Mother Goddess (*Magna Mater*) 45, 46, 47, 52, 53, 56
Greece, *see* ancient Greece
Gregory VII, Pope 74
Grimm Brothers 133
Gris, Juan 178
Guadalupe (Mexico) 69
Guillaume de Lorris 75–6
Guillot *fils*, Jean-Baptiste André 147–8, 149–50

Hafiz 66–7
Gulistan 185
Hanbury, William 79
Harkness, Jack 11, 154, 159, 160
Hawarra (Egypt) 83–4, 85
H.D. (Hilda Doolittle): 'The Sea Rose' 174
heart, the 165
Hector 48
Heidegger, Martin 104
Heliogabalus 130–1
Heloise 88
Henry, Dr Augustine 142
Herbert, George: 'The Rose' 58–9
Hermeticism 99, 101, 102, 103
Herodotus 25
Herrick, Robert 85

hibiscus 40–1, 57
Hildegard von Bingen: *Physica* 211
Hildesheim Cathedral (Germany) 13–14, 16, 23
Hinduism 102
hips 16, 18, 33, 36, 40, 212
Hitler, Adolf 178
Hogarth, William: *The Graham Children* 121
Holda 56
Hole, Samuel Reynolds 195, 243
 A Book About Roses 190–1
'Hollow Men, The' (Eliot) 166
Holy Rose of Abyssinia (*Rosa abyssinica*) 83–4
Homer 124
 'Hymn to Demeter' 46
 Iliad 5, 48
Horace 224
Horticultural Society 140–1
hue, *see* colour
Huizinga, Johan 76, 78
'Hume's Blush Tea-Scented China' 137, 138
Huysmans, J.K.: *A Rebours* 114–15
Hybrid Perpetuals 147–8
Hybrid Teas 18, 34–5, 150–1
hybridizing 154–7

Ibn-el-'Awwam 215
Ibn-Sînâ (Avicenna): *The Canon of Medicine* 212
India 4, 31, 37, 65, 128, 136, 210
inflorescence 16, 17, 18, 37, 90, 204
Ingres, Jean Auguste Dominique: *Madame Moitessier* 121
Innocent II, Pope 74
intelligence 234–6, 237–8

International Cultivar Registration Authority (ICRA) 157
International World Peace Rose Gardens (IWPRG) 240
Iran 65
Ishtar 45
Isis 45, 51
Islam viii, 4, 31, 38, 64–7, 72, 95
 and art 123–4
 and gardens 185–7
 and rose oil 210
Israel 83
Italy 57, 88–9, 99, 144, 152, 205; *see also* Roman Empire

Jalbert, Brad 220
Japan 6, 26, 36, 39, 305, 221, 246–7
Jean de Meun 75–6, 77, 80
Jekyll, Gertrude 195, 201
 Roses for English Gardens 33–4, 191
Jerome, St 61
jewellery 121
Jones, Grace 230
Joséphine, Empress 127, 145, 188–9
Joyce, James 171–2
Juan Diego 69
Judaism 57, 58, 99, 132
Julian of Norwich 167
Jung, Carl 52–3, 80, 103–4
Jünger, Ernst: *Storm of Steel* 2, 116
Jupiter 46

Kasmir, Jane Rose 245
Kennedy, John 145
Kenya 213
Kew Gardens, *see* Royal Botanical Gardens (Kew)

Kiefer, Anselm: *Let a Thousand Flowers Bloom* 228
Knossos (Crete) 125
Koons, Jeff: *Large Vase of Flowers* 229
Korea ix, 6, 26, 36, 39
Kronos 46
Krüssmann, Gerd 32, 154
Kurdistan 26

'La France' rose 147–50
Lady Chatterley's Lover (Lawrence) 169
Lammerts, Walter E. 153
Lancaster, House of 29
Laos 37
Larkin, Philip vii
Law of Heredity 149, 154
Lawrence, D. H. 169–71
leaflets 16, 18
Light Rose Garden (China) 229
lilies 60, 113, 115
Lilith 131–2
Linnaeus, Carl 6, 15, 111
 Species Plantarum 136
literature 169, 171–2, 229–30
Lochner, Stephan: *Madonna in a Rose Arbor* 123
Loos, Alfred 177
Loudon, J. C.: *Arboretum* 146
Louis-Philippe of France, King 127
Louis the Pious, Emperor 56–7
Lourdes (France) 70
love 5, 44–5, 51, 73–81, 111, 229–30
 and Christianity 58, 59
 and floriography 113
 and modernism 165, 174–5
 and pink 221
 see also romance
Luna 53

Ma Yuan 39
Macartney Rose (*Rosa bracteata*) 136–7
macrocosm 99, 101
'Madame Antoine Meilland', *see* 'Peace' rose
madness 50
magic 99
Magritte, René: *The Blow to the Heart* 179–80
Malmaison, Château (France) 127, 145, 188–9
Mancuso, Stefano: *The Revolutionary Genius of Plants* 235–6
Manet, Édouard: *Olympia* 131
Mao Zedong 228
Marder, Michael 236, 239
Marian rose 61, 62, 68, 69, 70, 72, 120
Marie-Amelie de Bourbon, Queen of France 127
Marie-Antoinette, Queen of France 127
martyrdom 2, 59–60, 119
Mary, *see* Virgin Mary
Massys, Quinten: *An Old Woman (The Ugly Duchess)* 121
Master of the Legend of St Lucy: *Virgin of the Rose Garden* 122–3
Medici family 99
medicinal properties 28–9, 38, 40, 65, 211–13
Mehmet II, Sultan 65
Meilland, Francis 151–2
memes 9–10, 196

memorials 83, 85, 87, 90, 159, 196–7, 204
men 9, 46, 100, 111, 221, 244
Mendel, Abbé Gregor Johann 149, 153
metaphors 1, 84, 95–7, 100, 110, 114
 and modernism 164, 165, 168–70, 175
Mew, Charlotte
 'June, 1915' 173
 'On the Cenotaph (September 1919)' 90
Mexico 40, 69
microcosm 99, 101
miniature roses 18
modern roses 16, 34–5, 147–62
modernism 163–80
Molière 88
monotheism, *see* Christianity; Islam
mood 219
Moors, *see* Islam
moral corruption 112
Morris, William 176–7
Morrison, Jim 88
Moss Rose (*Rosa centifola muscosa*) 34, 188–9, 197, 198–9
Mother of God, *see* Virgin Mary
Mother's Day 208, 213
Mottisfont Abbey (Hants) 192, 197
Mrs Miniver (film) 247
Mt Carmel (Israel) 83
Mughals 4, 64, 65, 124, 185, 210
Muhammad, Prophet 64, 65–6, 123–4
Murdoch, Iris: *An Unofficial Rose* 214
Murillo, Bartolomé Esteban: *Saint Rose* [or *Rosa*] *of Lima* 123
Musk Rose (*Rosa moschata*) 17, 25, 31–2, 222–3

Muslims, *see* Islam
mutations 19, 137, 150
Mystic Rose (*Rosa Mystica*) 62–3
mysticism 95–104
myths 44–53

naming 157–62, 218–20
Napoleon Bonaparte 127
National Gallery (London) 119–21
National Memorial Rose Garden (Dublin) 196
National Rose Society 159–60, 190
Native Americans 6, 39–41
Nattier, Jean-Marc 121
nature 12, 45–6, 47, 49–52, 112, 182
 and China 139
 and Christianity 57–8, 59
 and death 84
 and Romantics 106, 108, 109
 and science 101, 148–9
Neoplatonism 51, 58, 99
New Perennialism 203–5, 238–40
Newman, John Henry, Cardinal 62, 95
Nicolson, Harold 198
9/11 attacks 83
Noisette, Philippe 145
Noisette Roses 144–5, 150, 151–2
Noor Jehan, Queen 210
Norman, Albert 160
North America 144; *see also* Native Americans; United States of America (USA)
Norton, Jonny 197
Nossis 48
Novalis: *Hymns to the Night* 109
nurseries 216–17

occult 99–101, 102, 103
oil, *see* rose oil
O'Keeffe, Georgia: *Abstraction White Rose* 179
old roses 192–4
Omar Khayyam: *The Rubaiyat* viii, 185
opium 114, 139
Ordre de la Rose Croix Catholique, du Temple et du Graal, l' 102
Ordre Kabbalistique de la Rose Cross 102
Orwell, George 175
Osiris 46
Oswald, Alice: 'Walking Past a Rose This June Morning' 246
Oudolf, Piet 203, 204, 239
Ouranos 46
Ovid 124
Owen, Wilfred: 'Conscious' 172–3

paganism 4, 44–53, 56, 86, 120, 124–5
paintings, *see* art
Pandemus 50
Pantheon (Rome) 57
Paolo, Giovanni di: *Scenes from the Life of Saint John the Baptist* 119
paradise 60, 63, 65–7, 78, 87, 185–6
Paradise Hills (film) 231–2
Parc de Bagatelle (Paris) 195
Paris 83, 87–8, 195–6
Parker, Dorothy 174–5
Parks, John Damper 138, 140–1
'Parks' Yellow Tea-Scented China' 137, 138, 140, 143, 146
Parsons, S. B. 87–8
'Parsons' Pink Rose' 137

patents 156–7
Paul, St 60, 86–7
Paul, William 162, 189, 191, 200
'Peace' rose 2, 7, 152–3, 157, 167, 196, 219
Péladin, Joséphin 102
Pentecost 57
Père Lachaise Cemetery (Paris) 87–8
perfume 31, 207–8, 222, 224
Pernet-Ducher, Joseph 2, 3, 33, 34, 151–2, 159, 161–2, 217
Perrault, Charles 133
Persephone 46
Persia 7, 38, 65, 66–7, 124, 212
 and gardens 185–6
 and rose oil 209–10
 and varieties 25, 26–7, 31
Persian Yellow (*Rosa foetida*) 151
petals, *see* flower
Piaf, Edith 5, 88, 230
Picasso, Pablo 218–19
planets 99
plants 14, 75, 99, 138–9, 141, 188
 and myths 46–7, 49
plastic roses, *see* artificial flowers
Plato 50, 51, 58, 99
Pliny the Elder 23, 24, 26, 211
poetry 1, 8, 30, 79, 106–17, 209
 and China 38
 and Christianity 58–9
 and death 84–5, 90, 92–3
 and gardens 185
 and Islam 66–7
 and modernism 164–71, 172–5
 and mysticism 95–6
 and myths 48, 49
 see also Shakespeare, William

Pogue Harrison, Robert: *Gardens: An Essay on the Human Condition* 181–2, 200
Pollan, Michael: *The Botany of Desire* 20
pollination 14, 19–20, 25, 48, 97, 100
poppies 113, 114
pornography 114
Porter, Robert Ker 186
Portland Roses 144
Poseidon 47
Prairie Rose (*Rosa setigera*) 40
Pre-Raphaelites 131–4
prickles 5, 14, 15, 16, 17–18, 97
 and Christianity 59, 61
 and sexuality 114
prostitution 114, 131
Protestantism 30, 67–9, 71, 87, 126, 190–1
Proust, Marcel 88
Provence Rose, *see* Cabbage Rose
Provins (France) 7, 29, 77, 211–12
pruning 18, 201, 204
Puritans 87
purity 60, 97, 113, 119–20, 122, 171, 184

'Queen Elizabeth' rose 153
Queen Mary's Garden, Regent's Park (London) 243, 244
Qu'ran, the 64

rambling roses 18, 39
Reagan, Ronald vii
Red Cross nurse 89
red roses 44, 59, 136, 138, 222, 230–1
 and communism 178, 228
 and floriography 113
 and love 73, 74, 79
 and mysticism 98, 100, 103
 and Valentine's Day 221
Redouté, P. J. 127–8, 140
Reeves, John 140–1, 143
Reformation 67–8, 87
religion, *see* Buddhism; Christianity; Hinduism; Islam; Judaism
remembrance 84, 91, 196–7, 204, 219–20
remontancy (repeat-blooming) 17, 25–7, 38, 137, 138, 144, 148
Renoir, Auguste 129–30
repeat blooming, *see* remontancy
Réunion 145
rewilding 238–40
Rhea 45
Rilke, Rainer Maria 92–3
 'The Bowl of Roses' 241
 Les Roses 167–9
Rivers, Thomas: *The Rose Amateur's Guide* 30–1, 146, 189
Rochas, Marcel 224
Roman Catholic Church 4, 30, 55–6, 60–4, 68–70, 71–2
 and art 121–3
 and mysticism 100, 102
 and sexuality 74
Roman de la Rose 75–7, 78, 80, 133
Roman Empire 4, 23–4, 26, 28, 38, 208–9
 and art 125
 and Christianity 58
 and death 85–7
 and gardens 182–4
 and medicine 212
 and mysticism 98
 and *Rosalia* festival 57
 and Venus 44

romance 2, 229–30
Romanticism 106–9, 112
Roosevelt, Eleanor 226
Rosa alba, see White Rose
Rosa canina, see Dog Rose
Rosa centifola, see Cabbage Rose
Rosa chinensis, see China Rose
Rosa damascena, see Damask Rose
Rosa fedtschenkoana 25, 26, 27
Rosa foetida, see yellow roses
Rosa gigantea 37, 137
Rosa indica, see Tea Rose
Rosa moschata, see Musk Rose
Rosa multiflora 36, 155
Rosa Mundi (solar wheel) 100
Rosa rugosa, see Beach Rose
Rosariae de L'Haÿ (Paris) 195–6
rosaries 63–4, 100
Rosarium 99, 103
Rosary of the Philosophers, The 99
Rose Annual 161
Rose of Lima, St 123
rose oil 4, 25, 48, 65, 209–10, 222
rose water 25, 27, 31, 211–13, 212, 222
rose windows 64
Roseraie Ducher (France) 217
roses vii–ix, 1–4, 8–11, 105–6, 233–4, 243–7
　and art 119–34
　and Asia 135–44
　and beauty 19–20
　and business 207–21
　and Catholicism 55–6
　and classification 15–16
　and death 83–93
　and etymology 4–8
　and France 145–6
　and intelligence 234–6, 237–8
　and Islam 64–7
　and love 73–81
　and modernism 163–80
　and mysticism 95–104
　and naming 157–62, 218–20
　and paganism 44–53
　and poetry 106–17
　and structure 16–18
　and varieties 23–40
　and wild 18–19, 20
　see also gardens; modern roses
Roses (Van Gogh) 130
Roseto Botanico Gianfranco and Carla Fineschi (Italy) 205
Rosicrucianism 101
Rossetti, Christina 117
Rossetti, Dante Gabriel: *Lady Lilith* 131–2
Rougetel, Hazel le: *A Heritage of Roses* 195, 201
Rousseau, Jean-Jacques 106–7, 112
Royal Botanical Gardens (Kew) 83, 137, 142, 144
Rubens, Peter-Paul: *Judgement of Paris* 120
Rugosas, see see Beach Rose
Rumi, Jalallub-din 66, 227
Ryman, Will 229

Sa-di: *Gulistan* 124, 241
Sackville-West, Vita 192, 193, 198–9
Saint-Exupéry, Antoine de: *The Little Prince* 7
saints 59–60, 123
Saladin 65
Salcedo, Doris: *A Flor de Piel* 228–9
Salons de la Rose-Croix 102

Sappho 8, 48
scent 25, 31, 84, 97, 108, 210–11, 222–4
Schongauer, Martin: *The Madonna of the Rose Garden* 123
Schubert, Franz 109
science 101–2, 107, 108, 148–9
Scots Rose (*Rosa pimpinellifolia*) 23
Second World War 13, 196
'Secret Rose, The' (Yeats) 164–5
Sedulius, Caelius 61
Serres, Michel 233
Seward, Barbara: *The Symbolic Rose* 166
sexuality 9, 44–5, 74, 110–12, 133
 and myths 47, 48, 50–3
 see also eroticism
sexually transmitted disease, *see* venereal disease
Shakespeare, William 6, 34–5
 A Midsummer's Nights Dream 32
 Romeo and Juliet 11, 222
 Sonnet 54: 7, 222
 Sonnet 130: 30
 Twelfth Night 78–9
Shining Rose (*Rosa nitida*) 39–40
shrub roses 18, 24, 192
Silesius, Angelus 104, 170
 Cherubic Wanderer, The 95–6
Singapore 217
Sissinghurst Castle (Kent) 192, 198–9
Skelton, John 30
'Slater's Crimson China' 136, 137–8
Sleeping Beauty 132–4
smell, *see* scent
Smith, Capt John 39
Smooth Rose (*Rosa blanda*) 40
Socrates: *Symposium* 50–1

Somme, Battle of the 89–90
Song Dynasty 35, 39
Sophia (wisdom) 98
'Souvenir de Claudius Pernet' 2, 152, 161
species roses 16, 142
Spenser, Edmund 84
 The Faerie Queene 85
spirituality, *see* mysticism
'sports' 19, 23–40
Stalin, Josef 178
Stein, Gertrude 173
Steiner, Rudolf 102–3
stem, *see* cane
Stendhal 20
still-lifes 119, 125–6, 128–9, 226
sub rosa ('under the rose') 44
sublime 109–10, 112
Sufism viii, 66–7, 95
Sumeria 3–4, 182
Sumner, William Graham 112
sun 100
Surrealism 179
Swamp Rose (*Rosa palustris*) 40
Swinburne, Algernon Charles 79, 102
 Dolores 115–16
 'The Year of the Rose' 116
symbolism 4, 9, 43–4, 98, 163–80
 and art 119, 121, 122
 and Christianity 58, 61, 70–1
 and floriography 113, 114
Synstylae 15–16
syphilis 110, 115
Syria 65, 209, 212

Tacuinum of Vienna 212
Tantau, Matthias 153
Taoism 139

Tate Modern (London) 227
tea 40, 139
Tea Rose (*Rosa indica*) 16, 38, 136, 148, 170–1
Tennyson, Alfred, Lord: 'Maud' 116, 167
Tertullian 58
Testout, Caroline 159
Thanatos 88, 109
Theo-Sophia 98, 99, 100
Theophrastus 25
Theosophical Society 102–3
Thérèse of Lisieux, St 55–6, 218
Thomas, Graham Stuart 32, 38, 197
 The Old Shrub Roses 192
thorns 5, 15, 44, 72, 92, 109
 and Christ's crown 59
 and love 79, 80–1
Thory, Claude-Antoine 128
Titian 131
 Venus of Urbino 124–5
Todd, Helen 1, 2
Tombstone (AZ) 39
Tour, Charlotte de la: *Le Langage des Fleurs* (*The Language of Flowers*) 113
trade 27, 31, 136, 139, 149, 186
Transoxiana 27
Trewavas, Anthony 235
troubadours 74–5
Tudor, House of 30
tulips 1, 2, 121, 188
Turkey 65, 210
Turkmenistan 27
Twombly, Cy 227–8

Uccello, Paolo: *Battle of San Romano* 120
United Nations 196–7
United States of America (USA) vii–viii, 1, 2, 73, 193, 240
 and modern roses 151, 152, 153
 and patents 156–7
 see also Native Americans
Urania 50, 51
Uranus 46
Uzbekistan 27, 185

vaginas 110, 114
Valentine of Terni, St 73–4
Valentine's Day 17, 44, 73–4, 221, 244
 and business 207, 208, 213, 214, 219
Van Gogh, Vincent 129–30
Van Noten, Dries 230
Van Sneek, Cornelius 61
vanitas painting 126
venereal disease 81, 110, 114–15, 115
Venus 43–5, 47, 81, 120, 124–5
Vibert, Jean-Pierre 162
Victorians 8, 114
Vietnam War 245
violence 2, 45, 77–8, 112, 114
Virgil
 Aeneid 46
 Georgics 26, 183
Virgin Mary 53, 55, 56, 57, 60–4, 68
 and apparitions 69–70, 71
 and art 120, 122–3
 and *Rosa Mystica* 95, 100
 and thorns 30, 61, 72
Vladimirski, Boris: 'Roses for Stalin' 178
Von Humboldt, Alexander 149
Von Jacquin, Nikolaus Joseph 136

war 77–8, 87, 90; *see also* First World War; Second World War
White Rose (*Rosa alba*) 23, 26, 29–30, 34, 79, 184
 and art 119, 120, 121
 and Christianity 60
 and floriography 113
 and mysticism 100
wild roses 18–19, 20, 125
Wilde, Oscar 88, 102, 113, 168
 'The Nightingale and the Rose' 163–4
Williams, William Carlos 173, 178, 244
 'The Rose' 174
Wilson, E. H. 142
Wilton Diptych 120, 122
wine 33
wisdom 97, 98, 100
Wolf, Naomi: *The Beauty Myth* 227
women 1–2, 9, 38, 53, 115, 230–2, 244
 and art 132
 and business 214
 and Catholicism 60–1
 and courtly love 77
 and Mary 62
 and mysticism 100
 and names 158, 160
 and pink 221
 and poetry 110, 111–12, 174–5
 and sexuality 74, 133
Wordsworth, William 106

Yeats, W. B. 164–6, 168, 169, 246
 'The Rose upon the Rood of Time' 102
yellow roses (*Rosa foetida*) 2, 33, 113, 138, 141–2, 146
 and modern roses 151, 152
York, House of 29–30

Zeus 46
Zola, Émile: *Abbé Mouret's Transgression* 115